MICHELANGELO

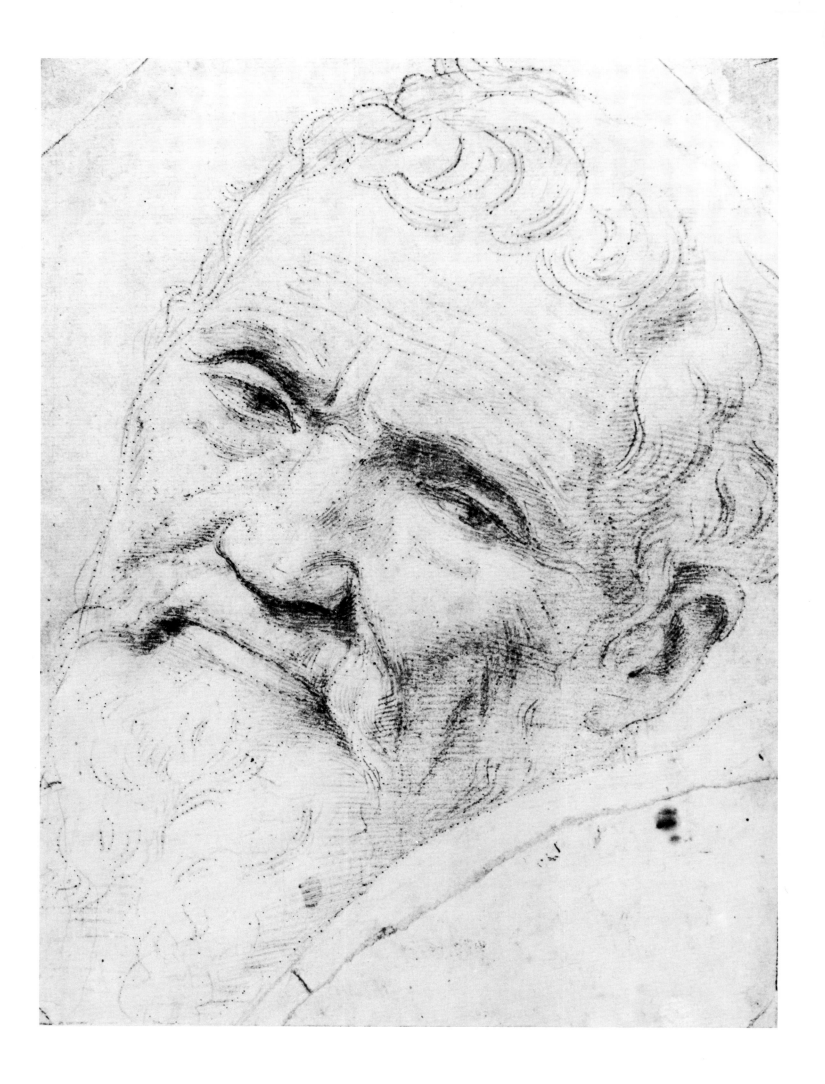

Mimmo Paladino

BERNARD LAMARCHE-VADEL

ALPINE FINE ARTS COLLECTION , LTD.

FOR YACINE
AND RAPHAEL

. . . .no thought is born in me that does
not have death carved in it.

MICHELANGELO

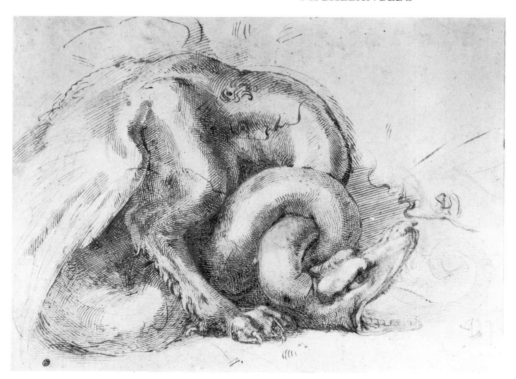

© Nouvelles Éditions Françaises, Paris

English translation © W.S. Konecky Associates, 1986

Translated from the French by Annie Gandon Heminway and Patricia Allen-Browne.

Reprinted with permission by William S. Konecky Associates, Inc.

This book is published in the United Kingdom by Alpine Fine Arts
Collection (UK) Ltd.

ISBN: 0-88168-131-8

Printed and bound in Singapore

Introduction

From early man inscribing on the walls of Lascaux identifying his needs, to Picasso identifying his pictorial venture in the context of an immense history occupying himself with recording the oscillation between the ordered and harmonious and the tragic and monstrous, from this community of titans, where Michelangelo stands as the ultimate concentration of skills in the service of an ideal of the largest possible expression of the subject and of his time, the writer can only be struck with an ambiguous ecstasy. This ecstasy does not arise from a facile emotionalism confronted by a manisfestation of a richness and a formal diversity without equal. Rather, standing before the work of this inspired artist there arises a simple and well-considered feeling—experienced by anyone—of fascination and a sense of the impossibility of rendering into words what precisely is beyond words: his logical and temporal articulation, the most expansive there is.

The conflict of interpretations that surrounds each of Michelangelo's works is the inevitable counterpart to an inexhaustible and constantly renewed translation of an unprecedented formal amplitude envisioned by the artist on a quest for the self and the consciousness of his time.

Consider "the true work of art belongs to its own time and to ours, that is to say, to its presence in front of us. Life is only of one time; art is of other times as well. It owes its deep reach to this double grip." If we agree, then the ambiguity of the writer's commentary summarizing even the emotionalism of the feeling of the sacred band in admiring exclamation must be reduced and confined by a frame fixed by four cardinal points; the work itself; the times in general (the economic, political, cultural, and religious times thereof) that served the work as its base; the long critical sedimentation that for more than 400 years has collected about Michelangelo's work and has also transformed this work into an object of particular knowledge; and finally, by the commentator himself and by the awareness that he portrays his time and that which that time can inspire for a renewed and enriched understanding of the phenomenon in question. From the previous analysis of these points, from their comparison as much as from their synchronization, the silhouette of individual consciousness and desire, the portrait of subjective implications and the order of reasons that are tied to form an imperishable name, would then emerge.

Considering Michelangelo's work itself, and the times in general when his work was progressively conceived, beyond the already exceptional life of the artist who was born in 1475 and died in 1564, we can only be struck by the complexity of information and exchanges, of the shiftings of power, the relations of his fellow artists, and the intense intellectual movement that surrounded the evolution of the artist and permeated his work. Michelangelo submitted himself to the immediate requirements of his epoch to the point that he became a prestigious representative of that epoch in history. But if Michelangelo has become and remains one of the most prestigious representatives of the Renaissance, it is because, in some way, he was able to dominate and represent it, by distancing himself from it like the exemplary interpreter of the profound, moral, and philosophical aspirations which established the general representation that the society of his time mirrored. There is already an immense field of study, which doubled itself almost immediately that consists of a reflection on the value of this representation in our time and throughout time, and the examinations of the reasons which, today more than ever, urge us to think that if Michelangelo is the sublime representation of his time, he is also— and this constitutes his eternal value—the representative through his work of the most powerful metaphor of expressive energy. Here each person can find the infinite echo of his particular desire to translate a moral ideal, and the contradictory amplitude of the body that serves this ideal but infringes upon it as well. The attachment to Rubens on one hand, and the attachment to the romantics on the other side, shows the oscillation found in Michelangelo's work. Here for the first time the body is shown as flesh and as such the flesh is transfigured by anatomy. These double prongs represent the ambivalence of the artist himself, the most spectacular drama ever: the origin of creativity when sight takes on the quality of vision.

Genius is a concretization of a definite moment. Michelangelo, painter, sculptor, architect, and we too often forget, poet, was an engineer of the expression of myth, which was the instinctive force of the *David* or the unlimited dissemination of the fresco of the *Last Judgment:* these moments are marked by fundamental often paroxiptical energies that always served the greatness of the artist.

It seems proper at the very beginning of this study, to pay homage to a man who devoted his life to the study of the phenomenon we are absorbed with today. Charles de Tolnay, whose numerous and invaluable studies made from impeccable documentation and an innate sense of synthesis, greatly facilitates our enterprise, but makes even more illusory the hope to renew or enrich a topic that he himself was able to explore in a most rigorous manner.

Three contemporary testimonies come to us to form the common source of most of the voluminous research that has been undertaken on the artist. The most important of these witnesses is the biography dedicated to Michelangelo by his student and confident, Ascanio Condivi, which was published in 1553 while the artist was still alive.

Three years earlier, in 1550, in a series called *Lives of the Most Famous Painters,* Vasari had dedicated a study to the great Florentine artist; and Michelangelo then took the trouble to thank Vasari although it seemed more praising the official figure than the biographer. This first and rather superficial, unorganized version was, in effect, corrected by Condivi's biography, no doubt inspired by Michelangelo himself.

In fact, Condivi lived close to the master gathering his teachings and obtaining his confidence; we only have to look at the amount of the facts borrowed from him for the second edition of Vasari's study to understand that in spite of protestations of amicable intimacy with his subject and the exceptional knowledge of the facts relating to his day-to-day existence, Vasari too often substitutes praise for a lack of detailed information. Yet, it is true that this biography traces a moral and very lively portrait of Michelangelo and allows us to understand the immense respect that surrounded the artist whose reputation was already well known throughout Europe.

Finally, we must add to these two essential references, the funeral oration by Benedetto Varchi, which summarizes the career of the artist. Besides the correspondence and the poems of the master, the contracts and official documents of the time supported the first great systematic studies undertaken at the end of the last century. Following this, certain little known episodes concerning the life of the artist have come to light.

If this book delves into the first sedimentation of information, its growth has been favored by the renewed interest for the sculptor of *Moses* at the end of the nineteenth century especially among the germanic aesthetes. This book is indebted to those, who throughout the twentieth century, have sifted through the abundant harvest of interpretations of the master. With their immense knowledge and lively reflections, Bernard Berenson, Eugenio Garin, Anthony Blunt, and André Chastel, without forgetting once again the *maitre d'oeuvre,* Charles de Tolnay, expressly help us to envision the personality and works of the giant of Florence.

Michelangiolo di Lodovico di Lionardo di Buonarroto Simoni, son of Lodovico di Lionardo Simoni and Francesca di Neri di Miniato del Sera, was born March 6, 1475, in the small village of Caprese, near Arezzo. An old illustrious Florentine family, the Buonarroti, until the middle of the fifteenth century, enjoyed a respectable fortune acquired and consolidated by trade and foreign exchange. Settled in the Santa Croce section of Florence since the thirteenth century, where the artist himself enjoyed living, Michelangelo's ancestors frequently held high state positions. There had been no artist among them, only one man of the Church, Fra Bene, who died in 1344, and one soldier. The Buonarroti family however prided themselves on several *priori* [business representatives in the government] from Florence and *Buonomini,* a citizen's committee representing the various sections in the Seignoria, where Michelangelo's father would become a member.

However illustrious, the grandfather's reverse of fortune and the father's carelessness plunged the family into financial ruin. In 1456, Michelangelo's grandfather was still a member of the Seignoria and in 1473, his father was a member of the *Buonomini,* then *podestà* (mayor) of Caprese and of Cheusi. The economic decline of the Buonarroti never ceased to obsess the artist who, once he acquired glory and wealth, would devote all his efforts to help his four brothers, establish his nephews and nieces by his intervention allowing them access to the Florentine aristocracy, and constantly dole out gifts of money, purchasing land and houses, which altogether represented a considerable inheritance.

Despite having simple tastes and disdaining riches, the artist had an inexpungable

desire to obtain wealth for himself and for his family. Similarly, he desired a social position to which it seemed he was more inclined toward the end of his life when he inspired the Condivi biography. In this volume, the artist pointed to the Counts of Canossa in his ancestry and thus he could show that thanks to the marriage between the sister of Henry II with a member of the Canossa family—from which his family descended having lost the name of Canossa by an unfortunate substitution—that the imperial blood flowed through his veins. The most astonishing feature of this conceit, to which may scholars have pointed without the ability to prove the reality of the connection, lies in the fact that when the artist, *monstre sacré,* declared his genealogical fantasy, Count Alessandro Canossa in 1520, honored by the appearance of such glory to his family, was eager himself to recognize the kinship that united them and begged the great artist henceforth to consider his home his own.

It is true that from the very beginning Michelangelo showed an impetuous aptitude for the practical arts. Placed in the care of a wet nurse whose husband was a stone cutter, the artist would later say in jest that he learned his craft while sucking the milk of the one who raised him. At the age of six, Michelangelo lost his mother. Condivi relates that the father of the future artist wanted his son to continue his studies and to that end he entrusted him to the care of the humanist, Francesco da Urbino. But rather than follow the teachings of the grammarian, young Michelangelo preferred to wander around the studios of the painters and sculptors where he met and formed a friendship with a young artist who was six years older than he, Francesco Granacci, then apprenticed to the studio of Ghirlandajo. Under the influence of the older friend, in spite of his father's strict opposition, Michelangelo managed to enter on an artistic career; on April 1, 1488, by contract, Michelangelo's father apprenticed his son to the brothers, Domenico and David Ghirlandajo. For this thirteen-year-old youth whose talents were so evident that the Ghirlandajo brothers began to pay the young apprentice for his services for the three years of the contract, here begins a career that led him during his lifetime to attain to a kind of immortality.

Entering the Ghirlandajo studio where he made the first drawings that have come down to us and that already express an idea of the tastes and the choices of this young artist, Michelangelo settled in the city that he would always be very proud of, at the heart of cultural and artistic development that would assure the radiance of the Florentine state. Product, conscience and expression of his time, the energy of Michelangelo's arguments, and of his peers as well, lies in the capacity, the quality of their interpretative concentration on the great philosophical and spiritual options of the moment when they work as much in their passionate adherence to an ideal of an affirmed culture as to an indomitable totality.

Contrary to the disastrous pedagogy that compartmentalizes the arts and encloses knowledge, so that the conscience of the young artist is tormented in the prison of a regional technique and expression, the Florentine culture of the Renaissance as much as European culture of the first half of the twentieth century had been the apex of the will of the synchronic, universal comprehension of the various fields of contemporary knowledge. Proof of erudition in theology, philosophy, mathematics, and the sciences was not required from the artists of the Renaissance; but it is proven that Leonardo da Vinci as well as Michelangelo qualified the depth of their aesthetic intent in different ways, by the accumulation of knowledge and of emotions foreign to their own field of inquiry, which led them naturally to conceive—much better than a superficial illustration—an orderly vision of the relation of man to the universe, a new spirituality, for which the future centuries would praise their genius.

As Wolfflin wrote, "To explain a style is to integrate it into the general history of its time according to its mode of expression; it is to show that in its language it doesn't say anything other than this epochal manifestation."[1] Michelangelo's work must be contemplated based on a series of principles, transitions, evaluations, to which his work bears witness.

Because he was a man of the strongest psychological ambivalences—from declarative exuberance to tragic nostalgia passing through a painful pessimism—Michelangelo, more than anyone else, could grasp the sublime balance of a great moment marked with contradictory tension. When politics was part of culture (and not the reverse), when art and faith were entwined, only then was it possible for the pathetic inscription of the will to spiritual freedom to grow. from which a reborn humanism was the crucible. The reign of Lorenzo the "Magnificent" was the apogee.

The Florentine cultural consciousness of which Michelangelo was both product and expression remains remarkable in four principal areas: science, religion, philosophy, and politics. A city of great commerce, Florence came to power first under Cosimo de Medici, the most

important house in the city whose political and commercial vitality opened the era of a dynastic power wherein the son of Cosimo, Piero dé Medici, nicknamed "the gouty" was succeeded by his heirs, Lorenzo and Giuliano.

The advent of the Medici, bankers and humanists, inaugurated in Florence a dynamic and ambitious government sharpened by the competition of the Italian republics and more particularly by the rivalry between the Medici state and the state of Milan governed by the Sforza's, and the pontifical city of Sixtus IV, then of the mighty Julius II. The culture of each republic received the greatest benefit from these external rivalries also marred by civil strife of which the Pazzi conspiracy in 1478 against the domination of the Medici constituted the most tragic episode. Giuliano would be assassinated in Florence while Lorenzo would escape the plot by a miracle. The Pazzi, rival family to the Medici, allied with the Pope who also feared the Florentine ambition, had not completely missed the target in trying to overthrow the dynasty. Since the time of Cosimo, the founder of the power of his line, the Medici held the keys of commerce in the city, and as bankers there was no transaction in which they were not involved or implicated. This led them to assume a double front, both political and cultural control of all affairs.

Pico della Mirandola

With inordinate intelligence and remarkable finesse, Cosimo presented the principle, and his grandson Lorenzo retained the lesson: that political power is nothing if not accompanied by a profound, ideological, and culturally wide-spread acceptance; that political power is preserved by the display of its legitimacy by the construction of a symbolic orchestration in which each day the city tests and retains its cohesion, plans the unity of its institutions and therefore the unity of its language.

All the large scale forms of cultural and civil administrative projects—heretofore unknown—from which Machiavelli drew inspiration in his contemporary reflections on power and strategy, were being nourished by several sources: Cosimo's construction of many churches, convents, and libraries; the Medici patronage in Florence of a generation of prestigious artists among them Masaccio, Ghiberti, Brunelleschi, and Donatello; and the labors of scholars and thinkers attracted by the democratic ideals of the city on the shores of the Arno.

As in any attempt of aesthetic and moral liberalization where the cult of pagan antiquity was rekindled and gave rise to many imitators, the Renaissance, especially in the papal entourage but also among the leisured as a whole, supported by economic growth in certain cities likewise gave rise to excess, extortion, and most particularly, licentiousness of all kinds. Abandoning its spiritual task, the implicated papacy under Alexander VI Borgia, was committed exclusively to material and political dealings. Moral corruption prevailed, which could do nothing but give rise to a protesting reaction in favor of reform, imperiously embodied in the exasperated character of Savonarola. The deeds and words in the inflamed sermons of the monk Savonarola exemplarily summarized the ambivalence of his epoch, the changes of the philosophical and moral ideas of which he was a propitiatory victim. Holding on to the foundation of medieval times that he sought to impose as an idea of purity and evangelical intransigence, Savonarola turned to the middle classes offering them virtue in the guise of reaction and what appeared to be archaic ideas. His fervor and his adamance against civil and ecclesiastical debauchery, the practice of leniency, the proliferation of images, paintings, or sculptures drawn from paganism, met with great popular enthusiasm. And Michelangelo himself was not insensitive to this moral and spiritual will. This sincere desire of reform, which Luther would revive successfully a few years later, was at first supported by the Medici as a new resource in their opposition to the power of Rome. But Lorenzo, perceiving the danger that Savonarola represented in engaging the underprivileged in a campaign that risked the privileges of the princes, later fought against it; even though the Medici dynasty had been distinctly elected and supported by these very forces.

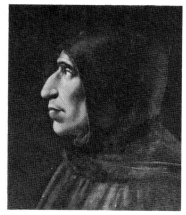

Savonarola by Fra Bartolommeo

Predicting the fall of Florence, Savonarola called on the highest international authorities to form a council that would have the task of deposing the Pope. Famine and plague were rampant in Florence at that time and because of his image as prophet, his people asked him for a miracle. In the end it was his powerlessness amidst violent agitation, which he ignited by his own sermons at San Marco, that led to his inevitable ruin. On the order of the Pope, threatening severe reprisals against the Florentine trading merchants in Rome, the Florentine government had to submit to the Pope's power. Savorola was tortured, judged, and condemned to death. In May 23, 1498, in front of the government palace, he was burned at the stake, his ashes thrown into the Arno, and with him the last echo of medieval severity disappeared, and high Renaissance was born. Michelangelo was twenty-three years old.

The reign of Lorenzo the Magnificent will, in its richness, sublimate the Renaissance ideal. The ideal will find its thinkers and its disciples in two principal characters of the prince's entourage who exerted indisputable influence on the intellectual education of the young Michelangelo. Leonardo da Vinci was undoubtedly an important thinker of the fifteenth century. As Eugénio Garin has perceptively said he was "at the same time a critic of philosophy in the name of Renaissance, humanist philosopher in the name of science, and idealist quite vague to the Florentine platonism in the name of experience,"[2] although he was also indebted to neoplatonism prevalent in the Medicean city. If, by the universality of his intellectual curiosity, his taste for the study of language, and his cult of expression, Leonardo is a typical product of the Renaissance, we still cannot count him among those who established, in the first instance, the great Florentine philosophical ideas that would enlighten the European fifteenth century so much that the influence of Florence under Lorenzo's reign will spread throughout the whole Christian world.

Both philosophers, Marsilio Ficino and Angelo Politian, to which we could add Pico della Mirandola (whose legendary breadth of knowledge embodied the Renaissance, although he neglected problematics) are obviously the two great figures who will govern the world of letters and introduce the general themes that will lead the culture and reflection of the prince's court, and support the stylistic evolution of the artists.

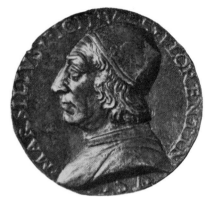

Marsilio Ficino

A fierce adversary of Savonarola, skillful tactitian as well as great teacher, whose influence spread throughout Europe over several generations, Canon Marsilio Ficino was the first among the educated to be installed at the court from the early days of the reign of Cosimo dé Medici. Characterized by the revelation of the tormented consciousness of suffering, death, and the essential fragility of reality, his major work, the *Theologia platonica,* denounced the general illusion of apparent reality. An experienced platonist, Ficino doubly reacting to Epicurus and Aristotle, condemned the resignation to individual pleasure or the senseless and anonymous conduct of life without significance or direction. Ficino did not reject the gravity of matter, nor did he deny the variety and the differences of its manifestations. If art represents the highest expression, the genius of human enterprise, philosophers must search for its hidden unity and meaning. Then an ontology becomes peremptory; Marsilio Ficino asked that we exceed the mere appearance of reality, an essential but insufficient springboard toward the only truth of the divine spirit, toward the celestial harmony, where beauty, love, and justice spread their unique quality into the world. As Eugenio Garin comments (and we can imagine the attraction that such a thought could have on Michelangelo): The Ficinien philosophy is an invitation "to see" though the eyes of the soul, the essence of things, an exhortation to love with the story of a personal experience that he offered as a model, an incentive to descend into the depths of consciousness, for interior illumination reveals the world. To do this, Ficino works with images that end by reducing the raw data of experience to a symbolic representation, but going always from the abstract to the concrete, from the static and fixed to the lively and personal. Faithful to the platonic theme according to which all reality comes from a "form," Ficino considered knowledge as a process that goes from the sensitive impression to the idea, and he approached it less by verbal concept than by suggestive image, alone able to make us perceive the supreme light.[3]

The poet and grammarian Angelo Politian embodies the great Florentine humanism characterized by a scholarly search of antique sources, a reading free of tradition and a finicky cultism of ideal expression as illustrated by Dante in the preceeding century. It is not then surprising to see the great sculptor occupy himself with poetic art, under the influence of Politian. The infinite resource of language, its study, and its history in the general anthropology, acquires a specific status that Lorenzo Valla, before Politian, had helped to establish at the universities.

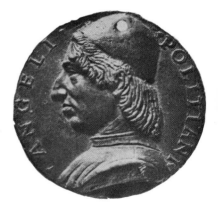

Angelo Politian

There is a common preconception that Michelangelo's time and city was entirely taken up with the reverie of a refined group of neoplatonic dreamers and subtle aesthetes; there is no doubt that from Cosimo to Lorenzo, the Florentine aristocracy was led to abandon the spheres of direct action in favor of more contemplative meditation, which in turn assured the Medici of relative peacefulness in their politico-commercial transactions. Yet we should not underestimate the growing role of scientists, astronomers, physicists, mathematicians, anatomists, physicians, and logicians, who were able by the extent of their discoveries or by their thinking to articulate a concrete content, on which fierce controversies between defenders of opposing doctrines influenced the cultivated public as a whole, and of course, from which no artist was estranged.

From this city that was the heart of intellectual endeavor and the artistic expression of the European fifteenth century, in the desire to signify the general spirit globally, we retain two traits, which are the major elements of the Medici administration that make Michelangelo—more than any other artist of his time—the representative of Florentine culture under the reign of Lorenzo.

First, the internal *density* of exchanges of all kinds characterized the organic density and amplitude of the political, social, intellectual, and commercial structures that the artist was able to interpret so marvelously with confidence and cohesiveness constituting an open synthesis. The second major trait of the politics of the Magnificent concerned itself with the dramatization, stakes, defense, and conquests of Florence threatened by the rivalries among the republics and the subdued jealousies that never failed to provoke in every aspect the ambitious politics of the Florentine state, and which resulted in its internal flamboyant successes. Dramatizing the desired contour, expanding the consciousness of his time or crucially questioning the deployment of the internal wealth of the state, Michaelangelo sensibly translated the spirit of this dramatization with subtle and grandiose stylistic departures. He alone was able to realize classical, normalized anatomical sculpture, which had been created earlier by his illustrious predecessor, Donatello. This peripheral addition (in the muscular expression of the *David* for example, which became the symbol of Florence) or critical departure, and the introverted coolness of the *Rondadini Pietà* brilliantly characterizes the double intensity of the expansionist and defensive strategies of Florentine politics and culture.

REFERENCES

1. Wolfflin, *The Renaissance and the Baroque*, p.175, Le Livre de Poche, Paris, 1967.

2. E. Garin, *The Middle Ages and the Renaissance*, p. 239, Gallimard, Paris, 1969.

3. Ibid, p. 230.

CHRONOLOGY

1475 On March 6th, Michelangiolo di Lodovico di Buonarrato Simoni is born at Caprese in the Cascentino in Tuscany. He is the son of Lodovico di Lionardo di Buonarroto Simoni, podestà [magistrate] of Caprese and of Chiusi, and of Francesca di Niri di Miniato del Sera. He is the second of his parents' five sons. Michelangelo is placed in the care of a nurse whose husband was a stone cutter.

1481 Michelangelo's mother dies. He studies grammar with the humanist Francesco da Urbino. He meets the painter Francesco Granacci, six years older, who encourages him to devote himself to drawing.

1488 In spite of his father's hesitation, Michelangelo enrolls in the studio of David and Domenico Ghirlandajo at Florence. His drawings reveal his gifts and arouse the jealousy of his teachers.

1489-
1492 Michelangelo does not complete his three-year apprenticeship. He then frequents the "Giardino del Casino Mediceo," a kind of arts academy where he discovers ancient sculpture and where he works under the guidance of the sculptor Bertoldo di Giovanni. As a result of an argument with Torrigiano, a fellow student, Michelangelo's nose is broken. Throughout his life, he will suffer from this physical disgrace. In the entourage of Lorenzo de' Medici, his protector, he meets the humanists Angelo Politian, Marsilio Ficino and Pico della Mirandola.

1493-
1494 Michelangelo creates sculptures for the prior of Santo Spirito. He studies anatomy through dissection. He is influenced by the moral teachings of Savonarola.

1494-
1495 Fearing the fall of the Medicis, Michelangelo leaves Florence for Venice and then Bologna where he creates sculptures for the church of San Domenico.

1496-
1497 Until the middle of 1496, he remains in Florence, then in June departs for Rome. He will remain there until 1501. He receives a commission on behalf of Cardinal Jean Bilhères de Lagraulas for a *Pietà* that will be placed in Saint Peter's Basilica. Michelangelo himself choses the marble at Carrera.

1501 Michelangelo returns to Florence where he creates several sculptures: the *Bruges Madonna* and some statues for the Piccolomini altar of the cathedral in Siena. He receives a commission to create *David* in marble.

1502-
1503 Michelangelo is commissioned for a new *David*, to be created in bronze (now lost) and for statues of the twelve apostles for Santa Maria del Fliore. Only one will be completed and only a sketch of it has come down to us, the *Saint Matthew*.

1504 Sculpture of *Pitti Madonna* and of *Taddei Madonna* and painting of *Doni Tondo*. A commission for the *Battle of Cascina*, to be placed opposite Leonardo da Vinci's fresco representing the *Battle of Anghiari*. Michelangelo only fin-

ishes the sketches; Leonardo's work will be destroyed and known only through the preliminary studies and a copy of Rubens. After the consultation of a group of artists, Michelangelo's *David* is installed in the Piazza della Signoria in Florence.

1505 Pope Julius II, patron of the arts, commissions his tomb to Michelangelo. The first plan is accepted, but the execution of the work will extend over a period of forty years, as the Pope's heirs ask for modifications and the sculptor stops work on several occasions to take on other commissions.

1506 In conflict with the Pope, Michelangelo returns to Florence. They reconcile a few months later. To celebrate his conquest of Bologna, the Pope commissions a bronze sculpture intended for San Petronio. After the Pope's subsequent loss of Bologna, the statue is transformed into cannon. Michelangelo announces his intention to buy land in Florence. He will carry out similar transactions in order to provide for his family.

1508 A project for a matching piece for *David* representing *Hercules and Cacus*. Only a baked clay model will be finished by 1528. Julius II wishes to transform Saint Peter's. He entrusts the work to Bramante, who protects Raphael and dislikes Michelangelo. In order to discredit Michelangelo, Bramante recommends him to the Pope, before any other sculptor, to decorate the vault of the Sistine Chapel. Michelangelo accepts half-heartedly.

1508- For four years, Michelangelo devotes himself
1512 to the creation on the ceiling of the Sistine Chapel, an immense work with 300 figures covering a surface of 1000 square meters. The work is physically painful, his rapport with the Pope tense, his fees paid irregularly and with reluctance. Help is minimal from his assistants Granacci, Bugiardini and da Sangallo. The master completes the fresco almost single handedly.

1513 Julius II dies in February. His heirs propose a new contract with Michelangelo reducing the number of sculptures decorating his tomb from forty to twenty-eight. Michelangelo undertakes the completion of *Moses* and the two *Slaves,* which will never be set on the mausoleum. They are now in the Louvre.

1516 A new contract for the *Tomb of Julius II* results in new restrictions.

1518- Pope Leon X, son of Lorenzo de' Medici, has
1519 known Michelangelo since childhood. In spite of his preference for Raphael, he entrusts the sculptor with the project of a façade for San Lorenzo in Florence, then commissions him to decorate the New Sacristy of San Lorenzo, which must shade the Medici tombs. Sculpture of the *Risen Christ* for Santa Maria sopra Minerva.

1523 The heirs of Julius II pressure him to complete the Pope's tomb. Michelangelo begins work on the Laurentian Library and on the tombs of Lorenzo and Giuliano de' Medici.

1527- The political situation at Florence is confused.
1532 The Medicis lose office to the gain of the re-

publicans. Michelangelo plans the fortifications for the city and directs their construction. He carries out a project for the Duke of Ferrara, *Leda*. In April of 1532 yet another contract with the heirs of Julius II. He decides that the monument will be erected at San Pietro in Vincoli, in Rome. It is still there today. He is enamoured with a young, noble Roman, Tommaso Cavalieri. He dedicates some poems to him and creates some drawings inspired by mythology.

1534 Michelangelo's father dies. The artist then returns to Rome where he fraternizes with the artistic and intellectual elite of the city. Pope Paul III entrusts him with the decoration of the great wall at the bottom of the Sistine Chapel. Michelangelo makes sketches for the *Last Judgment*. The plans are accepted. The immense fresco will be completed in 1541.

1536- He meets and forms a friendship with Vittoria
1537 Colonna, a woman of letters and fervent Catholic. Michelangelo dedicates some poems to her and under her influence creates some religious works—the *Christ on the Cross* and the late pietàs.

1538 The statue of Marcus Aurelius is erected in the Campidoglio in Rome. Creation of the bust of *Brutus* for Cardinal Ridolfi.

1544 Michelangelo becomes seriously ill and recuperates in Luigi del Riccio's home.

1545 Michelangelo draws up a plan for the tomb of Francesco Bacci. Paul III intervenes in order to facilitate the completion of Julius's tomb. He gives Michelangelo a commission for two frescoes for the Pauline Chapel in the Vatican—the *Conversion of St. Paul* and the *Crucifixion of St. Peter*.

1547 Death of Vittoria Colonna. Michelangelo studies the plans for the completion of the Farnese Palace and for the Piazza del Campidoglio in Rome. Paul III names him chief architect of Saint Peter's.

1550 Michelangelo completes the fresco of the Pauline Chapel, his last painting.

1553 Erection of a *Pietà* for the cathedral in Florence.

1555 Pope Paul IV of Carafa, the austere and rigorous founder of the Index, considers the nudes on the *Last Judgment* scandalous and orders them covered. However, he admires the artist and entrusts him with the plans for the cupola of St. Peter's.

1559- Pius IV, the successor to Paul IV, is a patron
1561 of the arts. He entrusts Michelangelo with architectural work: *Port Pia* in Rome, plans for the transformation of *Baths of Diocletian* in the church of Santa Maria degli Angeli. Michelangelo works on the *Rondadini Pietà*. He conceives the staircase for the Laurentian Library.

1564 The elderly sculptor again modifies the *Rondadini Pietà*. Almost 90 years old, he dies on February 18. He is buried at Santa Croce in Florence. On July 14, solemn rites are held.

POPES CONTEMPORARY WITH MICHELANGELO

SIXTUS IV (1471–1484). Francesco della Rovere. Orders the building of the "Sistine" Chapel.

INNOCENT VIII (1484–1492). Giovanni Battista Cibo, from Genoa.

ALEXANDER VI (1492–1503). Rodrigo Borgia.

PIUS III (1503:Aug.–Sept.). From the Piccolomini family of Siena.

JULIUS II (1503–1513). Giuliano della Rovere (nephew of Sixtus IV). Demolishes the ancient basilica of Saint Peter's and plans its reconstruction. Plans a monumental tomb, the vault for the Sistine Chapel, a bronze statue for Bologna, and the *Slaves,* which are now in the Louvre.

LEO X (1513–1521). Giovanni de' Medici, son of Lorenzo the Magnificent. The Medici Chapel and the Laurentian Library, both in Florence.

ANDRIAN VI (1522–1523).

CLEMENT VII (1523–1534). Bastard nephew of Lorenzo the Magnificent and therefore cousin of Leo X. Supports Michelangelo whenever possible.

PAUL III (1534–1549). Alessandro Farnese, Roman cardinal. Commissions the frescoes for the Pauline Chapel. Completes the Farness Palace. Places Michelangelo in charge of the work on St. Peter's in the Vatican.

JULIUS III (1550–1555). Cardinal Giovanni Maria del Monte.

MARCELLO II (1555). Marcello Cervini. Former cardinal, a reformist who becomes a reactionary. Reigns for three weeks.

PAUL IV (1555–1559). Gian Pieto Carafa, of Neapolitan origin. Suspends the Council of Trent. Institutes the Index and the Inquisition.

PIUS IV (1559–1565). Giovanni Angelo de' Medici (no relation to the great Medici family). Continues the work on St. Peter's by Michelangelo's disciples.

GENEOLOGY OF THE MEDICIS

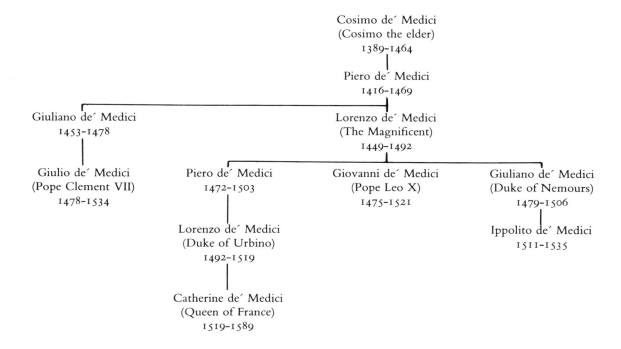

I

The First Drawings: The First Sculptures
1490–1502

We learn of Michelangelo's work in two ways. On one hand, a certain number of drawings, executed when the artist was apprenticed to the Ghirlandajo Brothers, have been preserved; however, other works, lost to this day, are mentioned in biographies of both Condivi and Vasari in sufficient detail for us to get a sense of their place in the evolution of the artist.

The young Michelangelo was employed to assist the master, Domenico Ghirlandajo, in the execution of an important commission. The work in question, commissioned by the Ricci and the Tournabuoni families, was the composition of a large fresco that would decorate the choir of Santa Maria Novella church. The Ricci owned the chapel but had been ruined financially, and the Tournabuoni committed themselves to pay for the work. The young Michelangelo acquired technical knowledge by executing many excellent drawings. However he drew so well that his master, realizing the superior skill of his assistant, took offense and broke their contract.

From the very first copies and interpretations of the masters that he made, the major formal themes of his own work were already present. Rather than yield to the fashion of his time for the refined mannerisms of the renowned Florentine artists Botticelli or Filippo Lippi, Michelangelo's masters would be Giotto and Masaccio, the masters of architectural sobriety, expressive monumentality, and classical force. Already his drawings reveal a manifest desire to establish the psychological identity of his subjects in a unique and compact form. Already, in the framework of this monumentality of the subject, which covers, encloses, and saturates the work, Michelangelo discovered the expressive richness of draping, underlining, qualifying, deepening, and obstructing the volume of the central monolith. A general quality must be noted here that would become the foundation of his work—an unprecedented force of exteriorization. Henri Matisse spoke of "the eternal conflict between drawing and color." We could reapply and amplify this phrase to Michelangelo, in terms of the eternal conflict between the construction or the analytical values tied to the subconscious desires of the artist. From the very first drawings, this duality, which will govern his work as a whole, was present, whether in the sketch of St. Peter in the style of Masaccio, or the sketch of the Louvre inspired by the fresco of St. John, after Giotto, or even better, the three standing figures, again after Masaccio, that Michelangelo sketched as a rigid, solid, synthetic construction adding organically skillful hatching that molded and retained an expression of sovereign fullness and strength.

There is no doubt that these drawings give sufficient evidence that from the time of his apprenticeship at the Ghirlandajo studio, the young artist attempted to reproduce in drawing a sense of the real volume of the figures. The break with his first master was probably mutually arrived at.

In the "school" of the Medici Garden near San Marco, where Lorenzo de´ Medici exhibited his antique collection, the prince, under the guidance of the old sculptor Bertoldo, Donatello's former student, authorized a few young people to come study and copy the exhibited statues. Through Francesco Granacci in 1490, Michelangelo was introduced to the gardens to begin his apprenticeship as a sculptor and was immediately noticed by the Magnificent.

Profiting from the availability of marble intended for the construction site of the library that Lorenzo had ordered to house his collection and that Michelangelo would later complete, the artist learned the technique of direct carving. Aside from a few reliefs, he made the first work, unfortunately lost, of his glorious career. Using as a model a work from Lorenzo's collection, Michelangelo sculpted the *Head of an Aged Faun.* Chroniclers report that Lorenzo happened to walk through his garden and glanced at the work of the young artist and was surprised that despite the fact that it was a representation of an aged faun, its teeth were intact. Chagrined, the young artist hurriedly remedied this unfortunate incongruity by digging and lowering the character of the teeth. When Lorenzo reappeared in the garden, he admired the sculptor's prowess and decided to include him in his suite, paying for his education and granting him meals and lodging for the sum of five ducats a month. The father of young

Jacopino del Conte:
Portrait attributed to Michelangelo.

Buonarroti was summoned by the prince and offered a position as excise officer as he had desired. Finally convinced of his son's talent, he allowed him the freedom to use his time to follow his aspirations.

Michelangelo, then fifteen years old, was probably conscious of his extreme precocity. Vasari relates that one day going to the Carmine Church with his fellow-student Pietro Torrigiano to study the Masaccio Chapel, Buonarroti, who enjoyed challenging his comrades and mocking them to the point of exasperation, provoked Torrigiano, on this occasion to the point that he punched him, breaking his nose. Michelangelo considered this an unbearable disfigurement all his life.

The first two works that came from his period in Lorenzo's garden introduce us to a stylistic dichotomy. We notice a new thematic paradox around which his entire work will be built. As Charles de Tolnay noted, it is remarkable to observe how, in light of this work, the criteria of progression, of inner genesis proved to be irrelevant and from his earliest years, the essential ideas were manifest stylistically as well as thematically. The first two marble reliefs clearly divide the artist's thematic sources as well as the stylistic means. The *Madonna of the Stairs* and the *Battle of the Centaurs and the Lapithae* were executed between 1490 and 1492, the *Madonna* probably before the *Centaurs*. A "schiacciato" relief, i.e., a relief of a shallow cut making an identation rather than a real fracture in the marble, the *Madonna of the Stairs* is obviously inspired by the relief of Donatello, whose influence w8as inevitable because of the intermediary Bertoldo. The *Madonna* exemplifies Michelangelo's sacred inspiration, characterized by a desire for measured and monumental composition without ostentation, ornament without peripheral excess, in short, classicism. From this *Madonna* emanates both the nobility of maternal sentiment, characterized by the effect of the envelopment of the encircled child in her arms and the folds of the garment, which form the spatial continuity and also by the profound spirituality concentrated in the expression of her face and the purity of the line that defines it. In the conception of this beaufiful relief, it should be pointed out that, besides the magnificent anatomy of the back of the Christ Child and the twisting of the right arm, which accentuates the enveloping gesture of the Virgin's left arm, there is the irregular contour of the draping that envelops the Virgin's body to provide her with a solid base in the lower part of the robe that rests on the cube where she sits. Between the regularity of the parallel lines of the stairs and the abstraction of the seat lies the contrapuntal value that is the foundation of the classical rhythm of this work. To realize this votive image, Michelangelo used a paralleled form of marble measuring 58.8cm by 40.2cm. As he did later in the making of bases of sculpture, the frame of the relief has the quality of the unpolished marble.

We must see of course the apparitional character of the work itself, detaching or revealing itself on the block, that which additionally accentuates the sharpness of the chisel's incision. Moreover, in this particular work the light border of the fabric accentuates the rhythm of the successive borders that characterizes the composition as a whole. Michelangelo's expressiveness most often takes on the form of interrupted narration. Many works, by the richness of evocation of the placement of the subject's hands in particular offer us an embryo of a story that gives us an idea of its meaning; however, it would be rash to determine the precise content. The *Madonna of the Stairs* and the *Battle of the Centaurs* are two exemplary versions of this general type of interrupted narration. If we examine the middle ground and the background of the *Madonna,* first in the middle ground, the two children seem to be holding some drapery. Among the several interpretations given, Charles de Tolnay, who is the unquestionable authority on this subject, believes it to be a symbolic prefiguration of Christ's shroud, a medieval theme represented in the form of two angels holding the shroud, otherwise it might be an ornamental motif having the function of framing and dramatizing the representation. Finally (and this has been little observed and even less interpreted), at the far right of the Virgin, the little child represented with a few strong lines seems to pull the drapery to him. In the background, there remain two children at the top of the stairs. Stairs, from the Old Testament to the commentaries of the time on the mediating Virgin, is a relatively simple symbolic theme in contrast to the two children, who pose an enigma. Their privileged position, their incompleteness, and their embrace must have some significance. But even today, in scholarly studies of Michelangelo's *oeuvre,* there is no convincing interpretation of these two figures. Here again the interrupted story allows this conflict of interpretations already mentioned and the conflict must be understood of course as the desire of the artist and as supplementary evidence of the richness of the meaning of each work.

The *Battle of the Centaurs and the Lapithae* illustrates Buonarroti's profane inspiration

as well as a stylistic mode as opposed to the preceding relief, *Madonna of the Stairs*. According to Condivi, the theme of the second relief could have been given to him by Politian; the philosopher struck up a friendship with the very young sculptor, initiating him into the Greco-Latin culture as well as into the theoretical debates that enlivened the court of Lorenzo. Sculpted in "mezzo-relievo" in one block of marble, this piece was completed a little before the death of the Magnificent. It is believed to date from early 1492. Condivi indicates that this battle represented the rape of Dejanira and the battle of the centaurs; Vasari interpreted it as an illustration of the battle of Hercules against the centaurs; while de Tolnay sees it rather as the rape of Hippodamia as interpreted by Ovid.

However innovative this work of stylistic series and obsessive motif of the male nude, which would concern the sculptor all his life, *Battle of the Centaurs and the Lapithae* was no less influenced by earlier Florentine artists. The young master's hand was manifestly guided by the influence of Antonio Pollaiuolo's engraving, the *Battle of the Nudes,* and even more by his last master Bertoldo, who had been inspired by a Roman sarcophagus in order to realize a bronze relief depicting a battle scene. Tied to antiquity by the mediation of the technique of Pisano, who before Michelangelo, had represented a melee, this work expands the declarative, expressive desire of the master's art.

The *Battle of the Centaurs and the Lapithae* represents an inextricable organic turbulence of male bodies, all twisted by dissimilar energies that entwine and separate them. Such is the meaning of this triple symmetry at different levels torn between the bodies and the marble, separated by contradictory efforts, i.e., to use the main idea of a value that is the true base of Michelangelo's entire work—to the continuous and diversified representation of energy.

Even at this early stage, the artist had mastered the representation of muscular energy; the portraits of Giuliano and Lorenzo dé Medici will exemplify psychological energy; while *Moses* will be the crowning achievement of spiritual energy. As to formal energy, his work in its totality asserts its perenniality.

In April 1492, Lorenzo the Magnificent died. At seventeen, Michelangelo had lost his protector and had to return to his family home where he created two quite different works.

The *Crucifix of San Spirito,* mentioned in Condivi's biography and commissioned, as were most of the master's works, would give him the chance to realize a minor work and once again to try his gift of synthesis. Rediscovered in 1963 by Lisner, this crucifix combines different heritages, i.e., hellenist, medieval, and classical, to which Michelangelo imposes the unity of a continuous movement where the inversion of the position of Christ's feet and head forces the upward gravitation of the entire piece, thus showing its profound spirituality. This crucifix, however unassuming compared with the works to come, nevertheless exerted a major influence in sculpture until the end of the sixteenth century and, by its discreet anatomic intention, once again confirms the artist's excellence in originating the unveiling of the body and its expression.

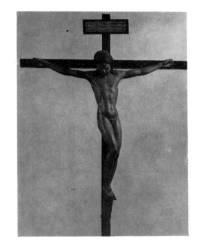

Crucifix of Santo Spirito (1492). Casa Buonarroti, Florence.

As we have noted before, Michelangelo's work proceeds from the oscillation of a sacred inspiration and a profane representation; the artist transferred, from one to the other, the formal discoveries and the spiritual contents of each series.

During the same period, in contrast to the *Crucifix of San Spirito,* the artist created *Hercules,* lost to us today. The Strozzi acquired this work, then most likely Francis I took it to Fontainebleau. Although there is no tangible evidence of this work, it seems however that a Rubens drawing, preserved in the Cabinet des Dessins in the Louvre, could be a copy of the master's work. "In a great block of marble that for many years remained exposed to the rain and wind, he made a *Hercules* four-arms high," Condivi relates to us. This work, if we look at the Rubens copy, reveals a sharp prefiguration of the *David*. In relation to *David, Hercules* is the reverse position resting on his straight left leg, the entire body drawn muscularly, the left hand hanging loosely—as *David's* right hand expresses a restrained voluntary muted force resembling the gracefulness of classical *contrapposto*.

The lost sculpture of this period was executed in Florence and commissioned by Piero de´ Medici, who had succeeded his father. It was under Piero's reign that disturbances began in the city. The French invasion of Italy by Charles VIII and civil strife along with the agitation stirred up by Savonarola and Piero's unpopularity contributed to the disruption of the power of the Medici.

A whimsical character, Piero de´ Medici ordered a statue made of snow from Michelangelo and then asked him to remain at court. The growing restlessness in Florence in the early months of 1494, forced Michelangelo to flee the city of his youth, to go first to

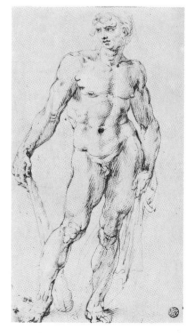

Hercules by Rubens after Michelangelo.

Venice, where Albrecht Durer was staying (there is no evidence that the two men ever met), then to Bologna, where the artist was received by the Bolognese gentleman, Gianfranco Aldovrandi, with whom he stayed for a year. Michelangelo executed three minor works there. He was entrusted with the completion of the tomb of St. Dominic, which Niccolo del Arca had not been able to finish. Thus, *Angel with Candelabrum, Saint Petronius,* and *Saint Proculus* were cut into marble.

These statuettes, influenced by Jacopo della Queraia or Donatello in the case of *Saint Proculus,* are of no special interest except for the sketch of the cutting of the draping. This prefigured later manifestations represented in the movement of the garment, which Michelangelo would use in his awesome psychological figurations of the characters that he portrayed.

In line with these divergent tendencies, Michelangelo returned to Florence for a brief stay at the end of 1495, where he sculpted two statuettes, *Saint John the Baptist,* then *Cupid,* which have disappeared.

The Medici temporarily lost power; Savonarola ruled; a democratic government under the aegis of a council was nominated; Michelangelo was deprived of protectors and commissions, and his *Cupid* was sold to Cardinal Riario of Rome by a merchant for an unworthy price. The artist, fearing danger in the city, left Florence where the plague had broken out, and went to Rome.

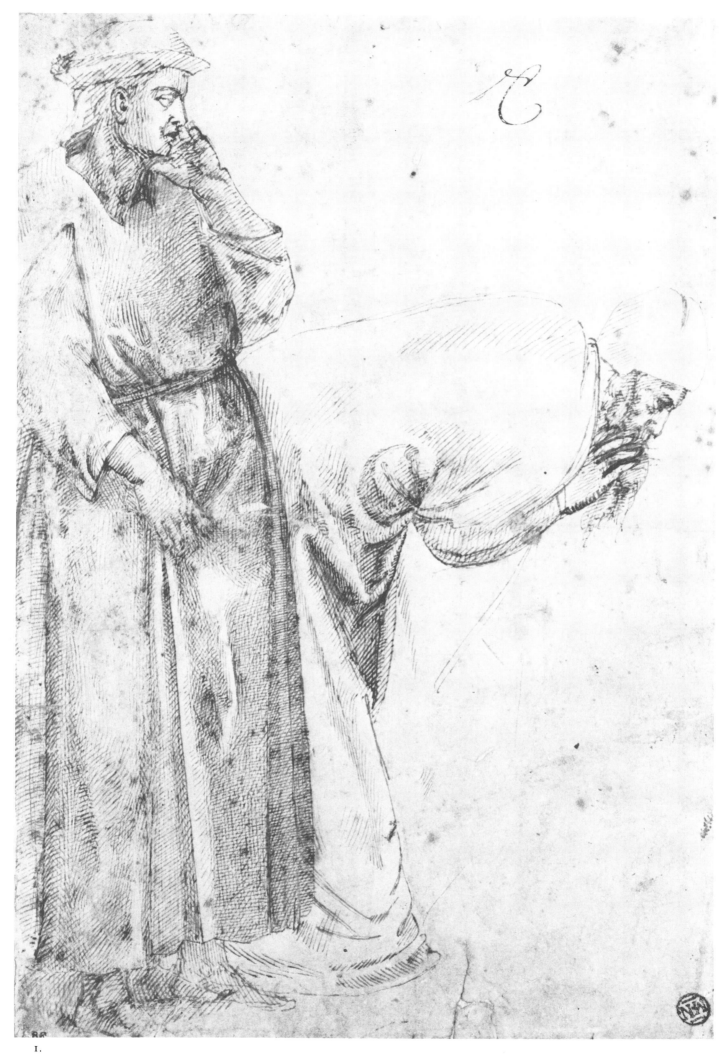

1.
TWO FIGURES (copy from a fresco by Giotto). Circa 1490; Pen and ink; 32 × 20 cm; Cabinet des Dessins,
Louvre, Paris

17

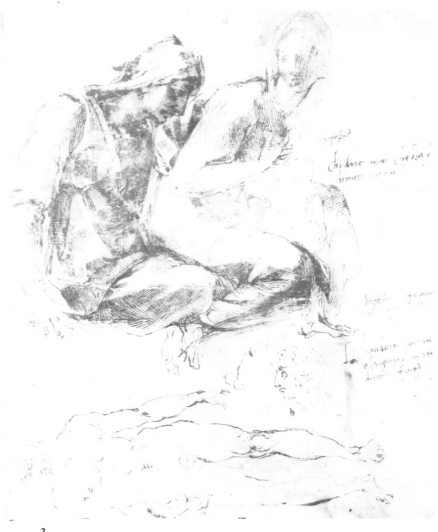

2.
ST. ANNA METTERZA (drawing inspired by "Madonna with St. Anne" by Leonardo da Vinci). Circa 1505; Pen and ink; 32.5 × 26 cm; Cabinet des Dessins, Louvre, Paris

3.
NUDE MAN. 1496–1500; Pen and ink; 37 × 23 cm; British Museum, London

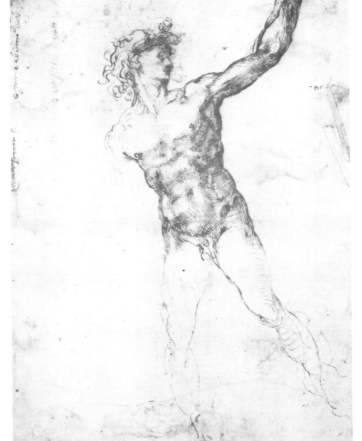

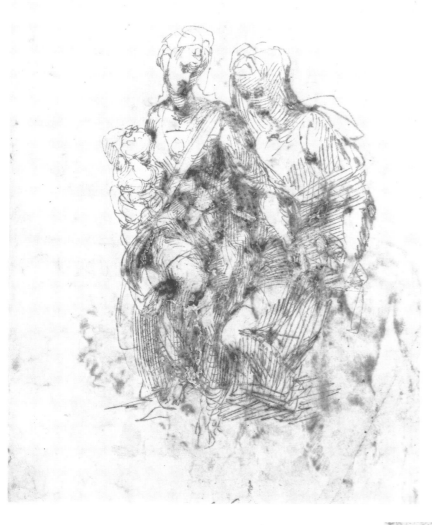

4.
ST. ANNA METTERZA. 1501–1502; Pen and ink;
26 × 17 cm; Ashmolean Museum, Oxford

5.
COPY FROM MASACCIO. Circa 1501–1503; Pen-
and ink; 29 × 20 cm; Albertina, Vienna

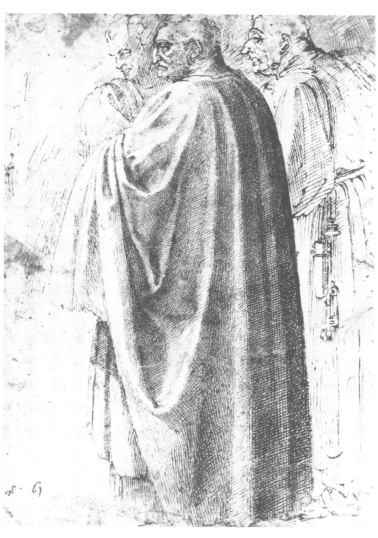

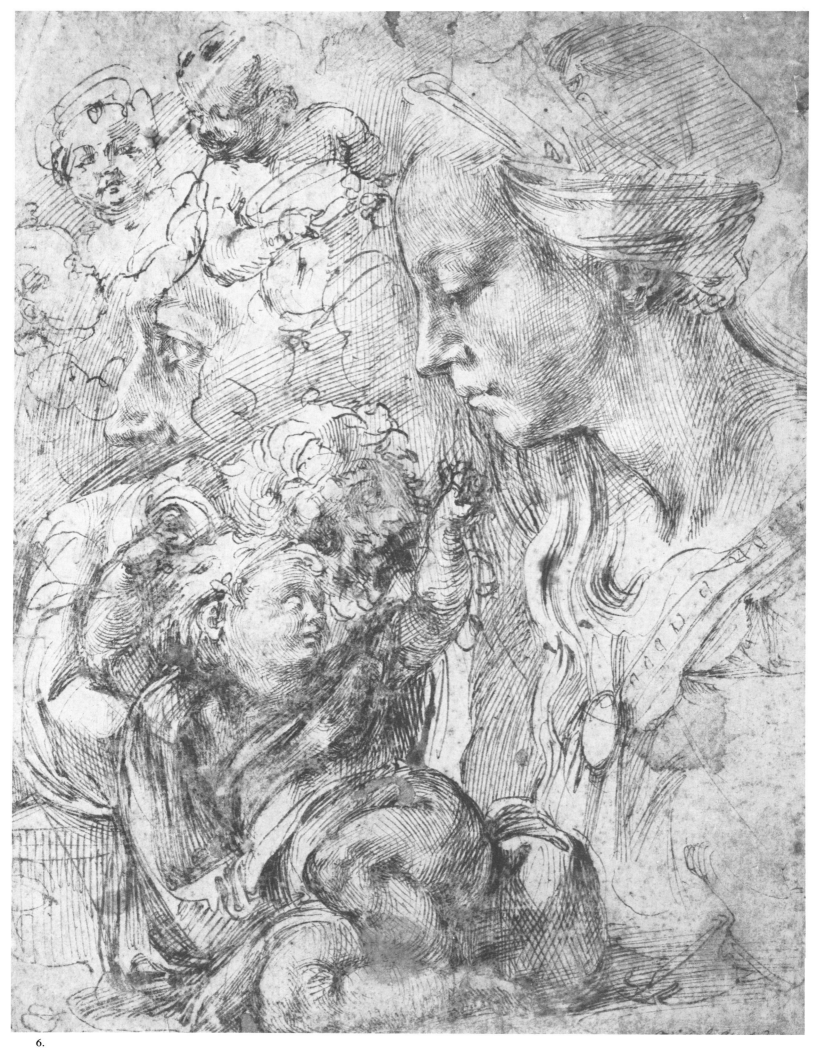

6.
STUDY FOR THE MADONNA TADDEI AND SELF-PORTRAIT OF MICHELANGELO. 1501–1502; Pen
and ink; 28.5 × 21 cm; Kupferstich Kabinett, Staatliche Museem, Berlin.

7. Facing page.
MADONNA OF THE STAIRS. 1489–1492; -Marble; 56.8 × 40.2 cm; Casa Buonarroti, Florence.

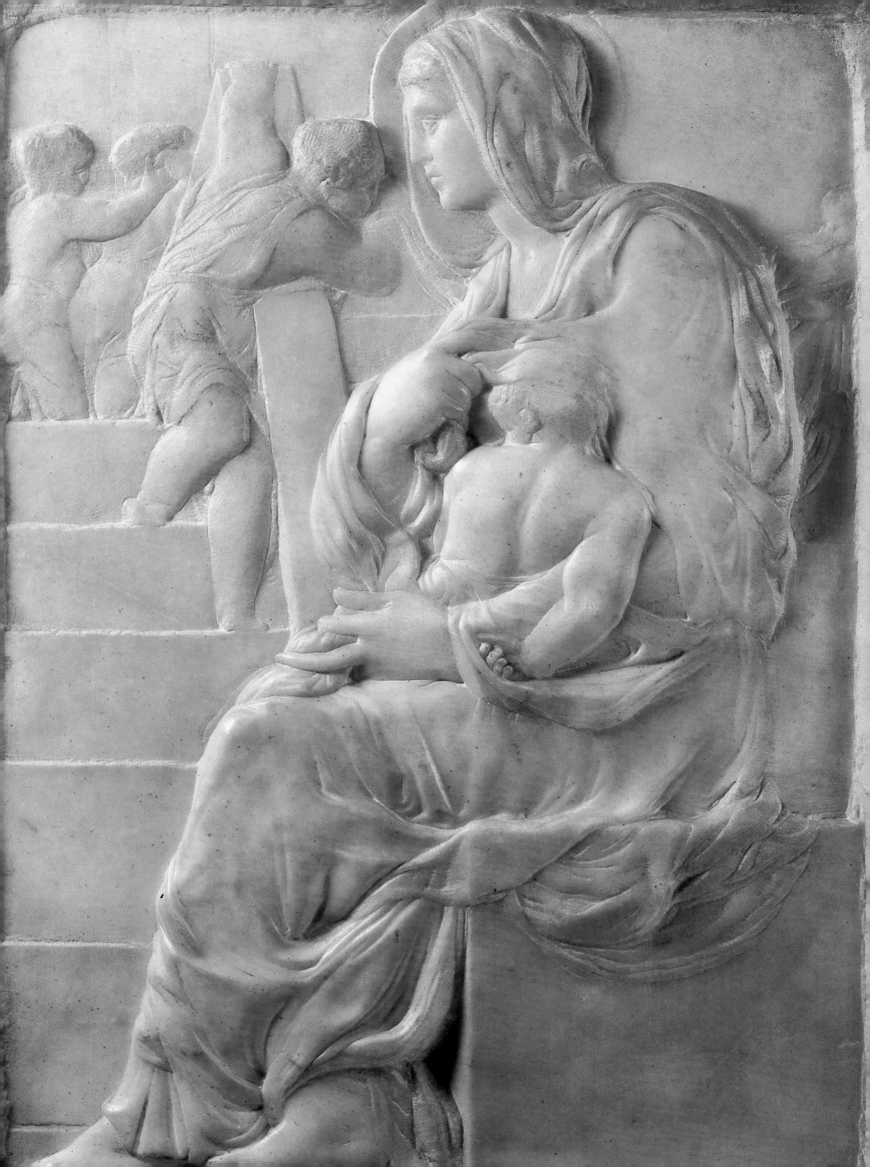

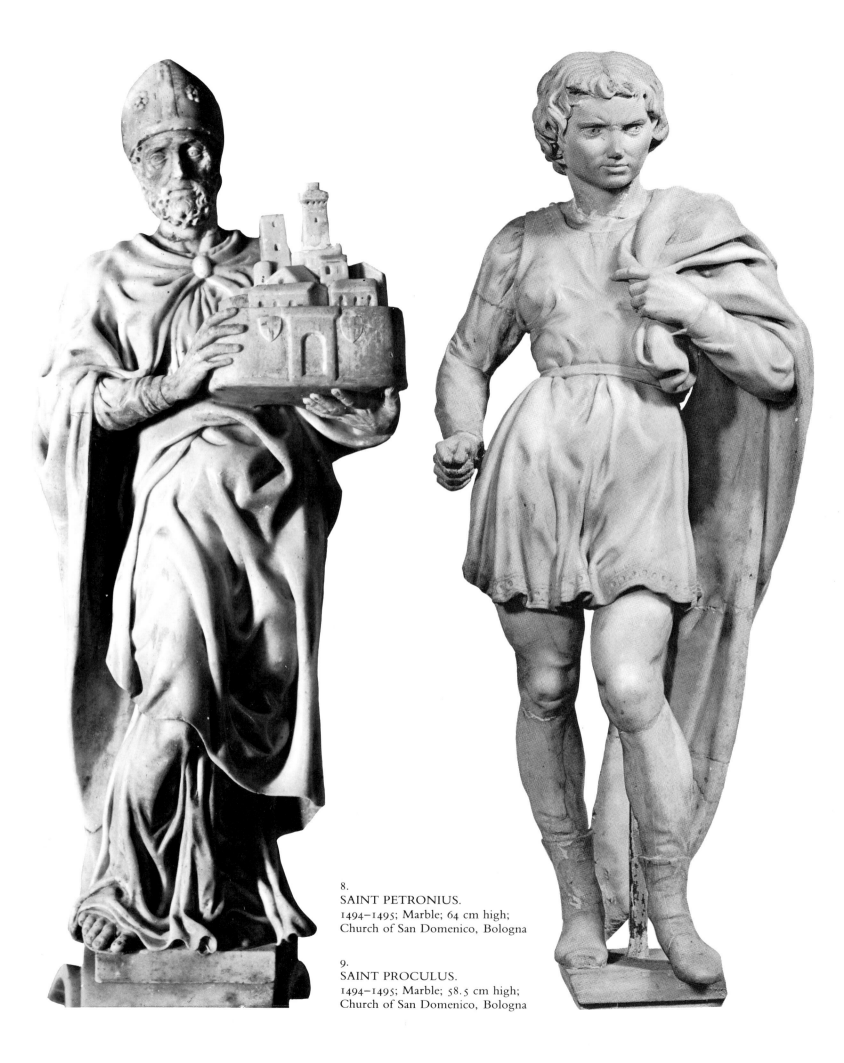

8.
SAINT PETRONIUS.
1494–1495; Marble; 64 cm high;
Church of San Domenico, Bologna

9.
SAINT PROCULUS.
1494–1495; Marble; 58.5 cm high;
Church of San Domenico, Bologna

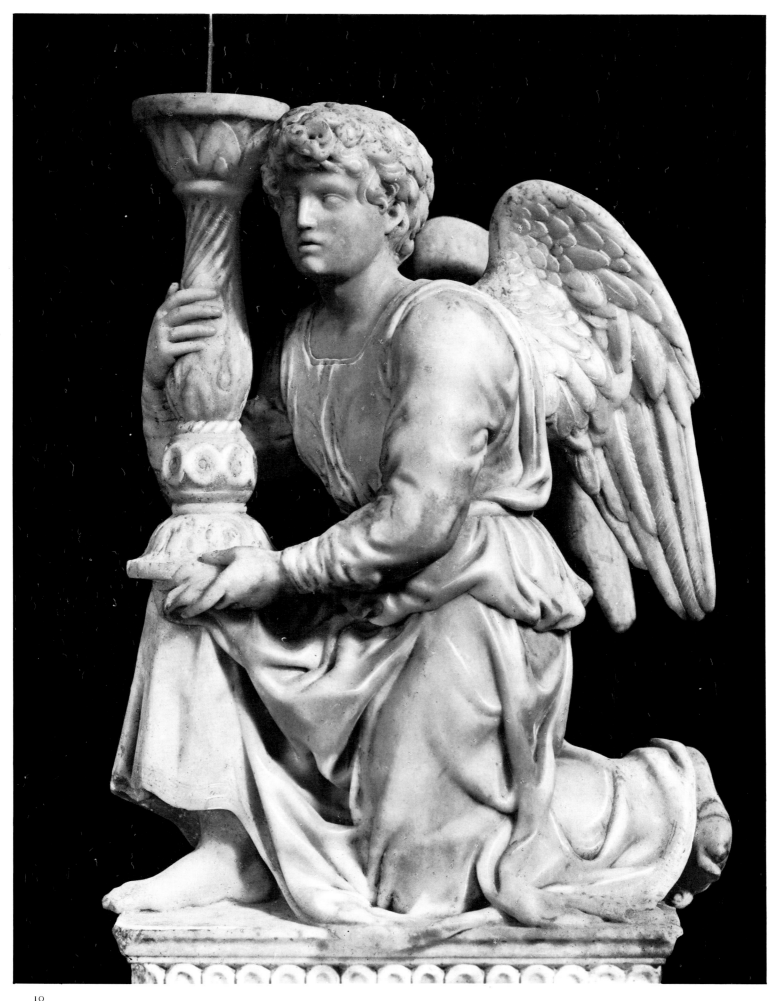

10
ANGEL WITH CANDELABRUM. 1495–1495; Marble; 51.5 cm high; Church of San Domenico, Bologna

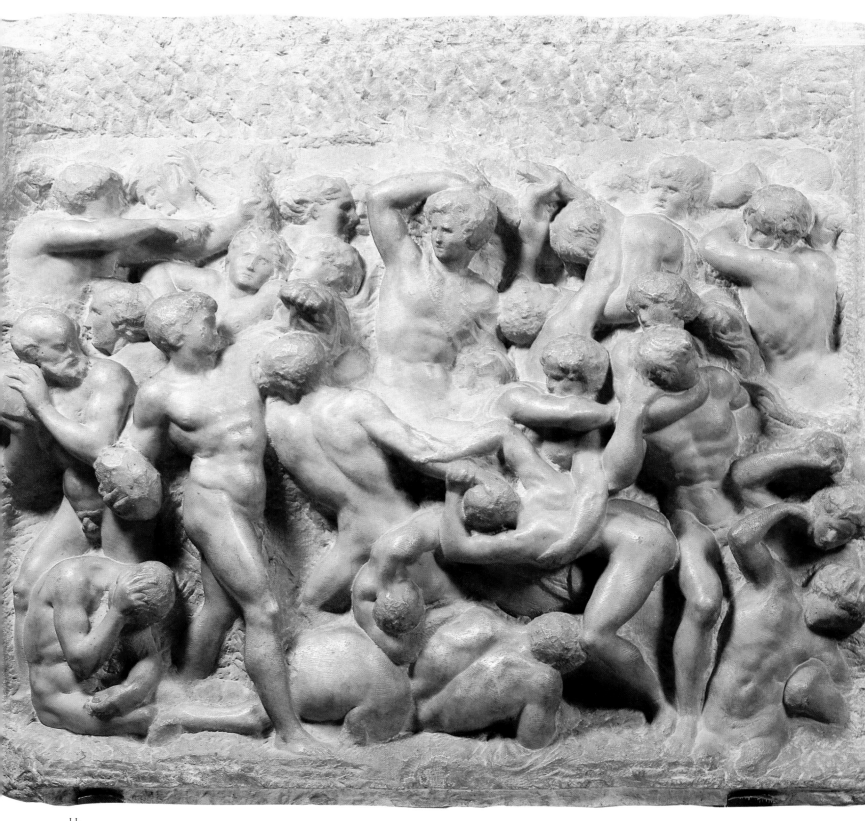

11.
BATTLE OF THE CENTAURS AND THE LAPITHAE. 1492; Marble; 84.5 × 90.5 cm; Casa Buonarotti,
Florence

II

The Stay in Rome: The Return to Florence
1496–1505

Michelangelo arrived in Rome on June 25, 1496. Under the patronage of Jacopo Galli, Cardinal Riario, and the French cardinal, Jean Bilhères de Lagraulas, he settled in the pontifical city for a period of five years. The excavations that took place in and around Rome unearthed a number of antique sculptures, which immediately became collector's items. This revival of interest in antiques, aside from inspiring numerous imitators, furnished the young Michelangelo with a technical and visual model on which he could establish his own vision. Two antithetical works date from this period, of which one, the *Venus with Two Cupids,* is of uncertain attribution.

Intended for the collector Jacopo Galli, the *Bacchus,* in contrast to the *Venus,* can be considered one of Michelangelo's first original masterpieces. The size of the general corporal expressiveness, where we can identify the god of wine and the wavering harmony of his bearing, provide an original repertoire of arrangements that will continue to assert itself throughout the work.

Although this piece is marked with the iconography of antiquity, the relative complexity of the subject's movements and the dazzling naturalism of the body constitute dramatic ruptures with antiquity and the medieval remnants still present in the art of the Quattrocento. Here, the sculptor interprets the pagan deity, Bacchus, as the incarnation of his most typical role.

The lasciviousness of the body draws attention to his drunkenness; the subtle rotation of the torso accentuates three protrusions—the lower abdomen and the knees—which throw the subject out of balance. Although clusters of grapes hang from his hair, his gaze is not diverted from the goblet, which he raises to the height of his acquisitive look and to his slightly opened mouth. The rotation of the torso presents a spiraling effect which is reinforced at the base of the Satyr whose bent leg invites us to look at the statue in its totality. As with most antiquities, this piece was intended to be exhibited out of doors. The Satyr was conceived as a natural base of support for Bacchus and at the same time a confirmation of his mythological nature.

Among Jacopo Galli's entourage, Michelangelo found his second patron in Rome in the person of the French Cardinal Jean Bilhères de Lagraulas, who, on August 27, 1498, commissioned a pietà, probably intended as an adornment for a tomb. This theme of the sorrowful Virgin gathering her dead son's body on her knees was a traditional one in the germanic states, most often executed in schematic form. By contrast, in this work, Michelangelo manifested the tradition, which he embodied and renewed, of Jacopo della Quercia to Donatello and then to Leonardo.

This work, which must count as Michelangelo's first spectacular success, in effect, combined or synthesized three epochs, inspired by three categories of artists. First, from the ancients the sculptor retained the general position between the folds that surround the nude body; then, from the Renaissance and especially from Donatello, the prodigious chiseling of the draped garments; and finally, from artists such as Quercia and from the medieval tradition, to which this work is tied, the profound spirituality, which emerges from this stone triangle where the redemption of the reclining body is inscribed in the enveloping figure of the Virgin. Condivi reports that although the artist's contemporaries unreservedly admired this great statue of Christianity, they were quite troubled by the youthful face of the Virgin. Besides the perceptible influence of Leonardo's classicism in the general composition and treatment of revealing luminescence in her face, Michelangelo himself gave Condivi the interpretation of this graceful face that had not yet reached its maturity. "Don't you know that chaste women retain their youth longer than others? Even more so a virgin whose body has never been changed by the slightest immodest desire."

Effectively, this work accentuates its geometric structure in the opposition of the horizontal to the vertical triangle, in the contrast of the nude to the draped figure, and also in

Assumed Selfportriat
(detail from "Saint Matthew")

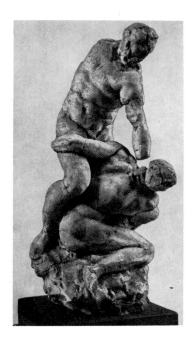

Hercules and Cacus (1528)
Casa Buonarroti, Florence

the contrast of the materiality of the body of the dead Christ to the immateriality of the complex network of fabric that emerges from the large circular base to meet in the corolla that frames the face of the youth Virgin. In the pontifical city of the Borgias, this work showed the depth of the great Florentine artist, the extent of his cultural and spiritual vision of at least three traditions and perhaps even a criticism of the excesses he saw. This immaculate Virgin was created to remind the Romans of their carnal excesses since she was not tranfigured by the maternal love for her son who wished to be the embodiment of the human condition. Michelangelo assumed this grave thought in his identity as a Florentine, and it assured the artist's fame throughout Italy. This work will be the only one signed on the band that crosses the Virgin's breast. The artist's nationality is inscribed.

Once his fame was established and his name firmly inscribed in the very center of the work that made him famous, he was commissioned to create a work destined for the Piccolomini Altar. History does not tell us the reason that he suddenly left Rome to return to Florence in 1501. We can only surmise that the artist, who had always been emotionally attached to Florence, was satisfied with his success in Rome, weary of the problems of settling his brothers there, and finally, aware that political calm had been reestablished in Florence after the death of Savonarola and the election of the city magistrate Pietro Soderini in 1502. These factors may have prompted him to return to the city of his youth where he would show further proof of his talent.

The return of the prodigal son to Florence was marked by a new commission that would establish Michelangelo's prestige throughout Italy. About forty years earlier, a group of weavers had brought an imposing block of marble from Carrara to make a statue of a prophet intended as decoration for the Duomo [Dome]. Dating from the previous century, this project had been conceived by Donatello; in 1476, Antonia Rossellino began a work, which was never realized; then Sansovino and Leonardo were considered; finally Michelangelo was commissioned. Considering the importance of the proposed work and the glory that it could reflect on his name by the execution of this monumental statue, the artist signed the contract on August 15, 1501. *David* was begun on September 13, 1501. Measuring more than 4 meters, it was completed in April 1504. Aside from the prodigious modeling this marble represents, there is no doubt, as Vasari remarked, that in the eyes of the Florentine people and Michelangelo himself, this work held a symbolic virtue for the Florentine state. The sculptor restricted himself to describing a hero. In this enterprise of a moral and perhaps political nature resides a portrait of the virtues that represented—in the eyes of the artist—the Florentine spirituality in its quality of liberty. If the unveiling of the work marked the sign of popular identification with the statue, which would become the symbol of the city, we must find the reason for that identification in the quality of the protrait of the Florentine ideal, which Michelangelo was able to discern.

Set vigorously on his right leg, the *David* takes on the traditional attitude of the *contrapposto;* the assymetry of his limbs simultaneously reveals a contracted reserve of energy and a possible relaxation assuring the projection of the subject. This balance between the restrained force and the movement of this projected force constitutes a structural dynamic through which the work reveals its unity and the harmony of its general outline. From the adjacency of the significant details to the greatness of the construction principles, Michelangelo developed two synthesized ideas in a conception that never ceased to haunt him: the victory of the sublime over the material. The first idea crystalized by this work is a technical one; while several artists were forced to give up this project, Michelangelo was able to exhibit his superb skill, combining a balanced concept of the whole with an art of perfected detail. Besides the robust quality of the torso and the legs, the anatomic accuracy of certain parts of the body call for particular attention by the richness of interpretation that the artist was able to bring to the work. It is obvious that David's right hand, disproportionate to the rest of the body, sums up the sculptor's intention. Veined, muscular, and knotted, this hand is a willful energy source whose wrist is curved inward as a sign of repose and concentration. Similarly, David's face, seeming to take up an invisible challenge, peers out at the space on his left where any danger could emerge; still spontaneous, yet somehow sad and no doubt sensitive, the young warrior masters the space that he overlooks. But because he also masters himself, the sense of his inalterable force is connected with the truth of his vision and his objective.

The second concept that characterizes this masterpiece is of a spiritual and civic nature. Protector of the threatened mother land, nude, and relying on himself alone, David is an identifiable model who, allows the symbolic interpretation to all, from the citizen to the

nation. When the *David* was nearly finished, a group of the most illustrious artists in the city was summoned to discuss the location that would be accorded to the statue: including Leonardo, Filippo Lippi, Botticelli, Giuliano and Antonio da Sangallo, Andrea della Robbia, Cosimo Roselli, to cite only the most notable participants in the deliberations. After lengthy and arduous debates, the main entrance to the palace of the Seignoria was chosen as the official site following Michelangelo's own wishes. Installed in May 1504 on the designated site, the statue was stoned by some citizens, most likely because of the pagan nudity of the representation; in September the statue was unveiled to the public.

After this masterly work, realizing his vocation and accomplishing conclusively everything he had set out to do, at twenty-nine, Michelangelo was recognized by his fellow citizens as the greatest Italian artist. A second *David,* this one in bronze, which we have lost trace of today, was created by the artist for Pierre de Rohan; a drawing that has been kept in the Louvre, indicates that it was only a variation of his masterpiece, following the wishes of the buyer, and was inspired by Donatello's *David,* which decorated the court of the Seignoria at that time.

Two other works have survived from the same period: a marble sculpture in relief and a painting that heralded Michelangelo's great career as a painter, which he was about to embark upon. Purchased by a Flemish merchant, the group called the *Bruges Madonna* or *Mouscron Madonna,* after the name of its buyer, is a piece measuring 1.28 meters high, and preserved in perfect condition in Bruges in a chapel built for this same Pierre Mouscron. Albrecht Dürer admired it when he visited the city on April 7, 1521. The statue was created between 1501 and 1504 and deserves careful contemplation since in effect it summed up the two distinct parts that characterized the stylistic evolution of the artist during those years. Despite the perfect harmony of the piece due to the contrast between the Virgin and the Child, we notice two formal styles. The Virgin is obviously allied to the general style of the *Pietà* preceding the Roman *Pietà;* the Child belongs to the new cycle dominated by the *David.*

The chisel had once again carved an intense moral portrait. Imposing, with princely reserve, measured care, and subtle magnitude, the Virgin and the Christ Child are idealized quite simply. The fabric, chiseled more smoothly than the *Pietà,* contributed to the abstract majesty of this Virgin who sits straight but without stiffness. The plump Christ Child who emerges from the draped garment, by contrast, alludes to Michelangelo's burgeoning anatomic expansionism. The figure of the Christ Child, composed of multiple round shapes in descending movements in which he symbolizes both his carnal nature and his descent to earth, is connected to his mother by his left hand in a celestial spirituality of his origin. As with the enlargement of David's right hand, the Christ Child appears here to be in oversized scale compared with the unity of the group. There is no doubt that the sculptor inferred the direction of his new stylistic interest as well as the symbolic primacy of the Christ Child over his mother.

The *Doni Tondo,* painted during the same period, can be seen today in the Uffizi gallery. It was created for Angelo Doni on the occasion of his wedding with Maddalena Strozzi. The sculpture's craft, which is quite visible in this work, has drawn a kneeling Virgin frontally *contrapposto.* Her chest is turned, arms are stretched out to receive the Christ Child from St. Joseph's who is placed behind her. The background of the tondo is composed of a group of nude men arranged in a semicircle that frames the main scene, although it has no relation to it. To the right of the Holy Family, outside of the scale, St. John's head appears, somewhat unreal, forming the vault for the painting. Many critics have noticed the influence of Signorelli's *Madonna and Child* in this work; others with reason, see the first elements of mannerism where Pontormo, Rosso and Bronzino found a model for chromatic arrangements. Like the *Bruges Madonna,* the *Doni Tondo* is based on two registers. The neoclassical background, well balanced and of a perfectly pictorial realization, is opposed to the group in the foreground, demostratively adhering to architectural rules, sculptural rather than pictorial, in cool, contrasting colors. Obeying an ascending movement of a broken line, the group is not the least passive, reinforced by the masculine character of the Virgin and the huge drawing that ties the figures together. Here again, by his very placement, perched on his mother's shoulder, the Christ Child is clearly in a privileged position following a medieval iconography principle, i.e., arranging of figures according to their symbolic importance.

In the fever of work that characterized those years until he received the order by Pope Julius II in 1505 to return to Rome, Michelangelo created a series of marble reliefs: a tondo for Bartolommeo Pitti, another for Taddeo Taddei, a sculpture in full relief representing

St. Matthew. This stay in Florence ended with the eventful encounter with Leonardo da Vinci regarding the creation of commissioned work.

In the series of reliefs mentioned above, where the intensity of each relief is enhanced by its unfinished quality, the artist illustrated his desire to reaffirm the creation of monumental art. Here, however, Michelangelo set aside his obsession for detail to the benefit of the constructive values of the group for a greater presence of the synthesized mass.

Here we must recognize the diffused influence of Leonardo da Vinci, who, according to Vasari, was welcome with jubilation on his return to Florence in 1500. Most assuredly his return affected Michelangelo. In this series we can perceive Leonardo's influence in the synthetic and continuous treatment of the figures and the context, which contrasted sharply with the style of Michelangelo's earlier work.

The *Madonna and Child* of the Pitti Madonna is a massive figure connected to the block of marble by the intermediate and apparitional figure of the young St. John. The ample but simple draping of the Virgin's mantle encircles and envelops the base of the figure accentuating the interior circular structure that strengthens the circular frame of the work. This circular composition is manifest even more so in the marble tondo made for Taddeo Taddei, where the bodies of the Virgin and St. John underscore the real circumference of the tondo and frame the Christ Child, whose body diagonally crosses the central space. While the Virgin's head and Christ's body are clearly defined, the general relief is roughly sketched. As is the case of the sculptor's later work however, their unfinished quality, far from minimizing the effect, augments the symbolic significance with the choice of the oppositions that are executed, each bound to the double fate of force and matter.

In the spring of 1503, the weaver's guild commissioned Michelangelo to create statues of the twelve apostles intended as the decoration for Santa Maria del Fiore church, of which he would complete only one, despite the fact that the commission called for one per year for which he would be compensated with a house furnished with a studio, made to his specifications. Probably preoccupied by the work on the *David,* Michelangelo had only sketched the *St. Matthew,* which he would take up later. Sculpted by direct carving, this work is very moving for diverse reasons. First, the extraordinarily abstract movement of this figure is unlike any lifelike model where the body like an embryo seems to want to detach itself from the stone matrix that holds it. Then, the symbiosis of St. Matthew and the mass emerges laterally in the superb expression of both desolation and desire. Finally, we can feel the tragic emotion that emanates from the profile of the *St. Matthew.* His neck bulges with energy and the face is marked with resignation. These works prefigure the slaves of the tomb of Julius II.

The mayor of Florence, Pietro Soderini, was obviously pleased by the simultaneous presence of the two Renaissance masters, who later would be joined by a third—Raphael, then apprenticed to Perugino in Perugia. It is not known how the competition between Leonardo and Michelangelo came about; the fact remains that the two masters were commissioned to create a fresco and that each representation would be displayed on a wall in the proconsul's chamber in the Assembly Hall. Leonardo, approached first, was settled in the Pope's Hall in Santa Maria Novella church where he was making the preparatory drawings for some cartoons. Stimulated by the competition, the two men, who detested one another, based the subjects of their paintings on battles that were drawn from the heroic history of Florence. Leonardo represented the *Battle of Anghiari,* whereas Michelangelo represented the Florentines against the Pisans in the *Battle of Cascina.* Unfortunately, the two works were destroyed and the cartoons were lost. Only the sketches remain as well as some copies of the works. Rubens reproduced the central part of the *Battle of Anghiari* in a charcoal drawing. Around 1542, Aristotele da Sangallo made a copy of the central part of the cartoon of the *Battle of Cascina.* While Leonardo showed a real battle scene, Michelangelo merely presented an anecdote of the troops bathing in the Arno for the simple reason that he would be able to exhibit his spectacular technique in the representation of assembled nudes.

In the Michelangelo sketch or the da Sangallo copy (since for unknown reasons the fresco was never executed), we see an artist in full command of his technique moving toward virtuosity. The cartoon of the *Battle of Cascina,* his last work during that stay in Florence, was exhibited to the public. Michelangelo was praised in the city of his youth; his work was considered a model for generations of artists who found the source of their inspiration in his *oeuvre.* Already the fate of the "divine" was sealed in a new journey. The greatest patron of all time had just succeeded to the papal throne. Julius II ordered Michelangelo's return to Rome. The artist obeyed.

12. Facing page.
BRUGES MADONNA or MOUSCRON MADONNA (detail)

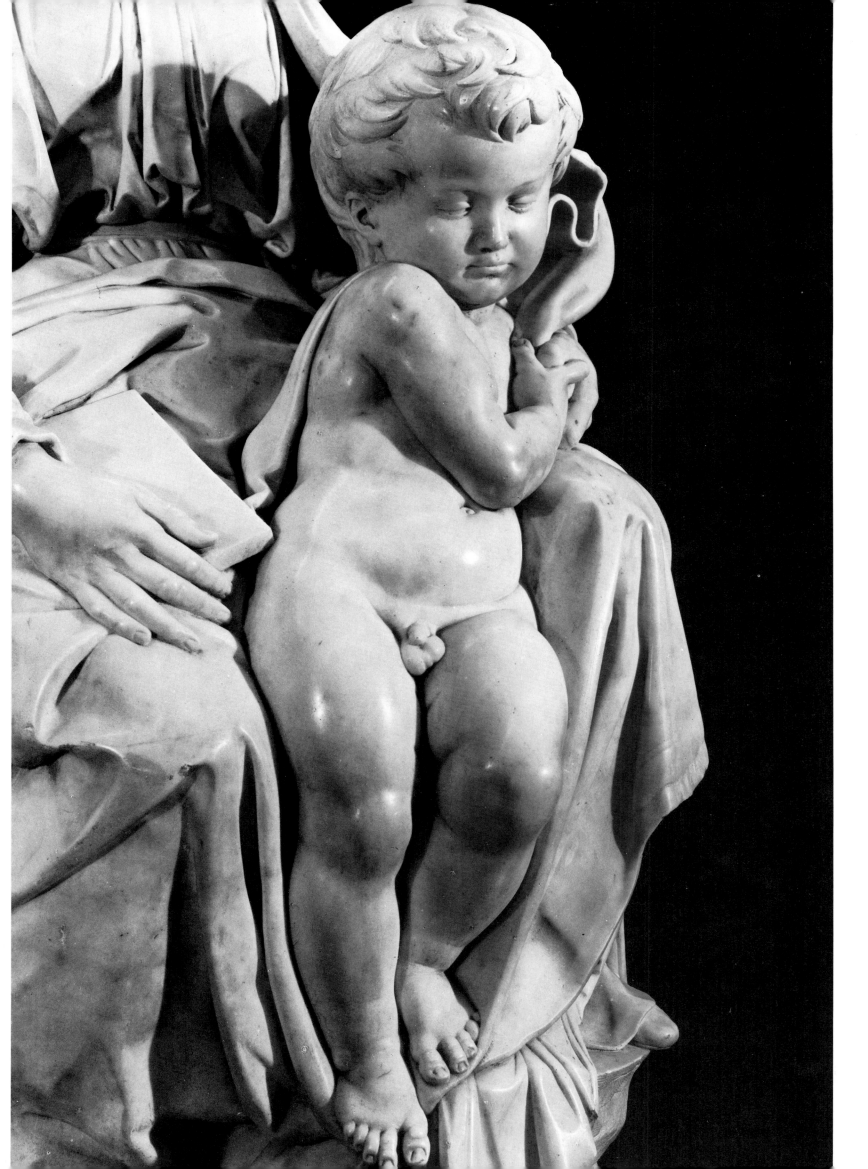

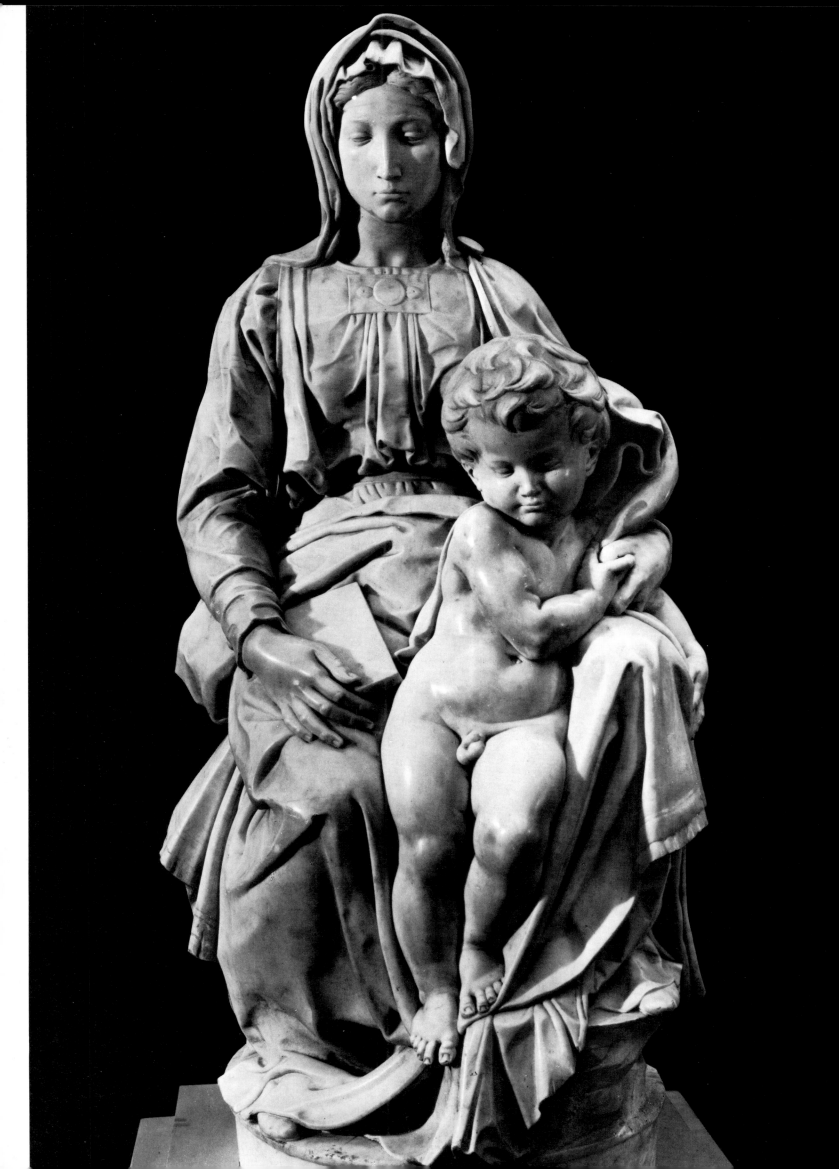

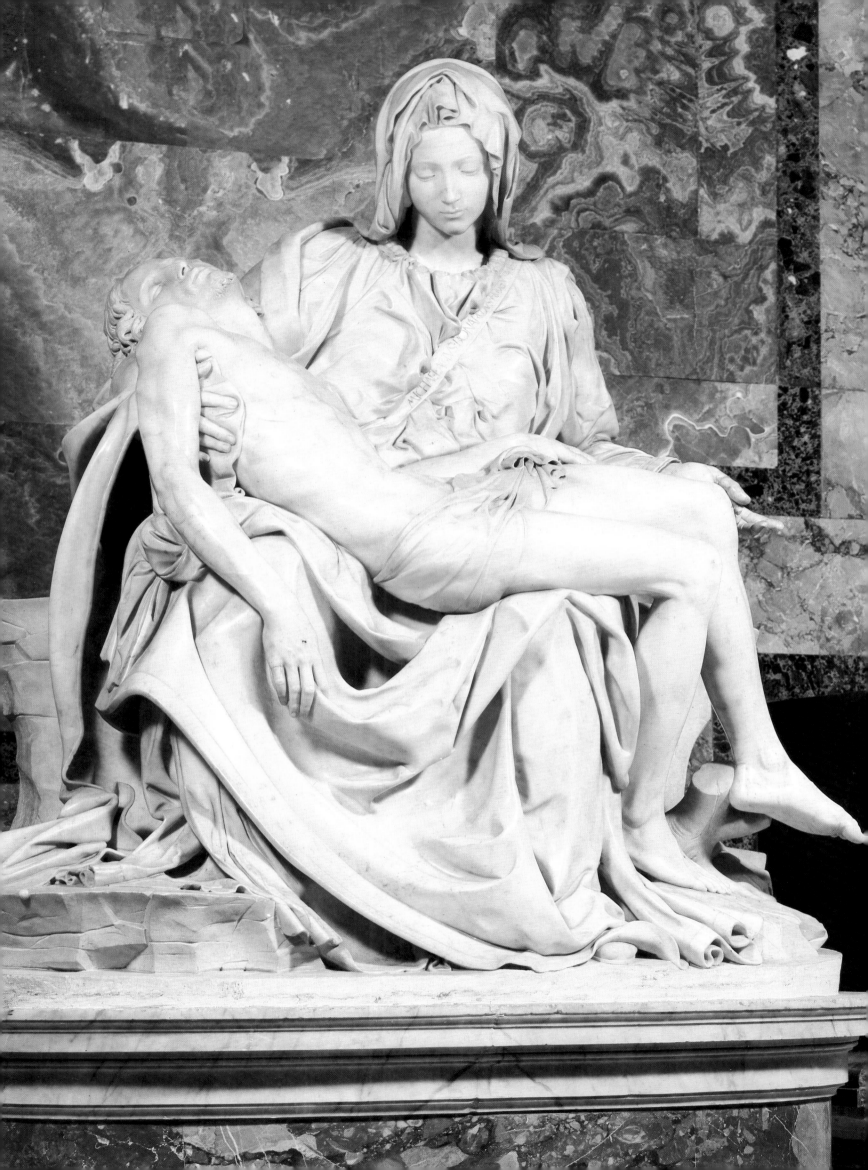

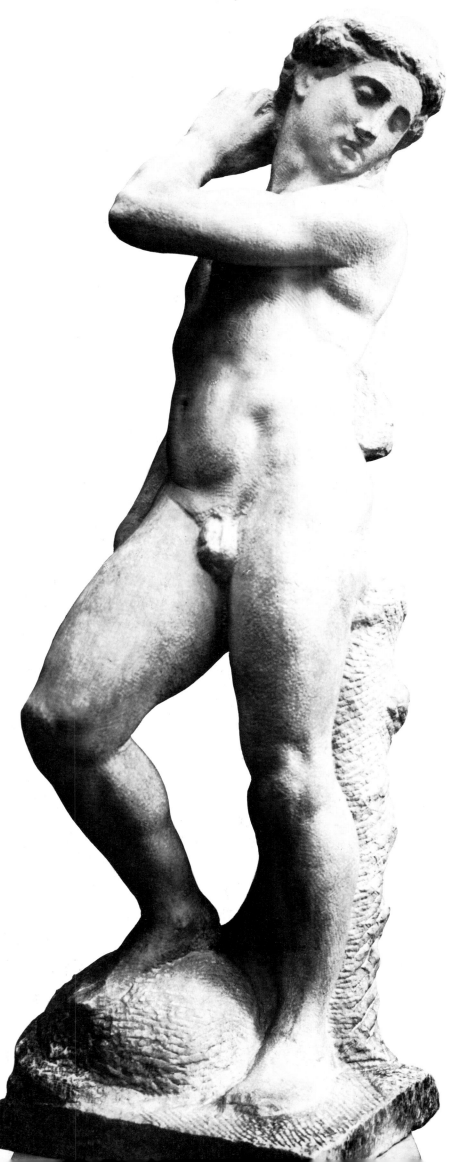

13. Preceding left page
BRUGES MADONNA
or MOUSCRON MADONNA. 1501–1504; Marble;
128 cm diameter; Notre-Dame Church, Bruges

14. Preceding right page.
PIETA. 1498–1499; Marble; 174 cm diameter;
St. Peter's Basilica, Vatican, Rome

15. Left.
DAVID—APOLLO. 1525–1531; Marble;
146 cm diameter; Bargello National Museum, Florence

16. Facing page.
BACCHUS. 1496–1497; Marble; 203 cm diameter;
Bargello National Museum, Florence

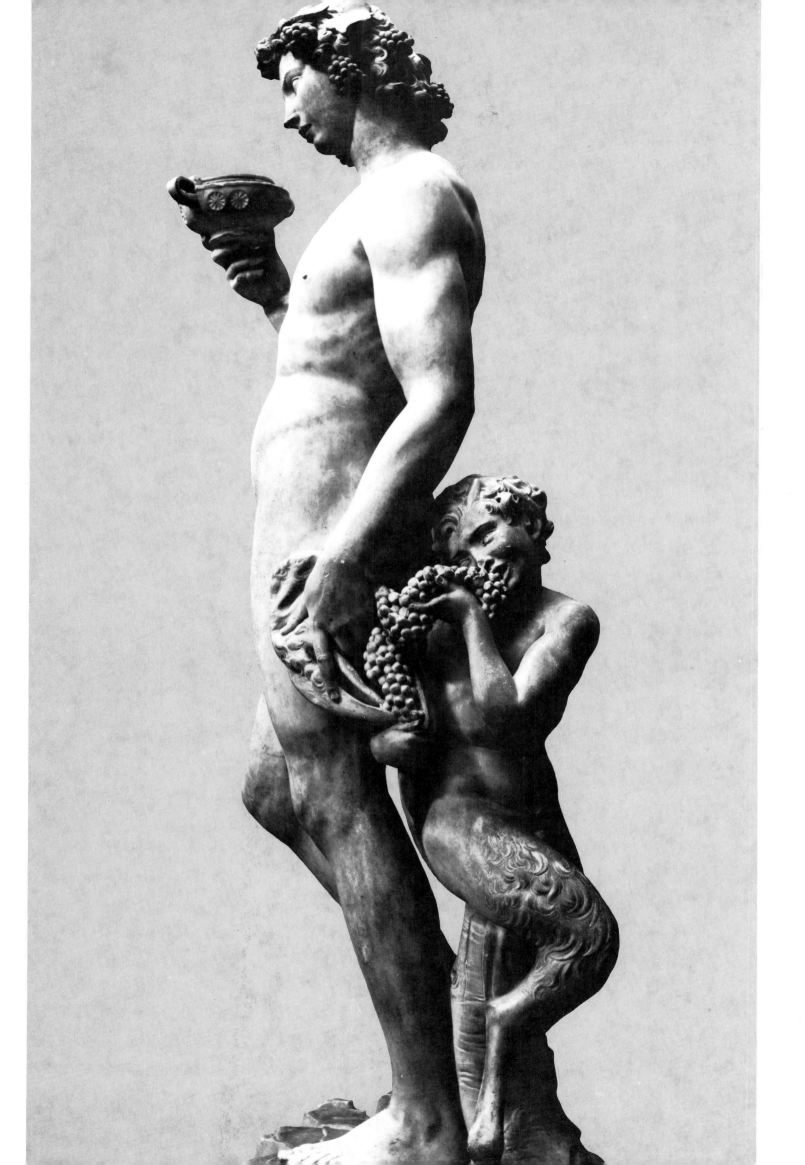

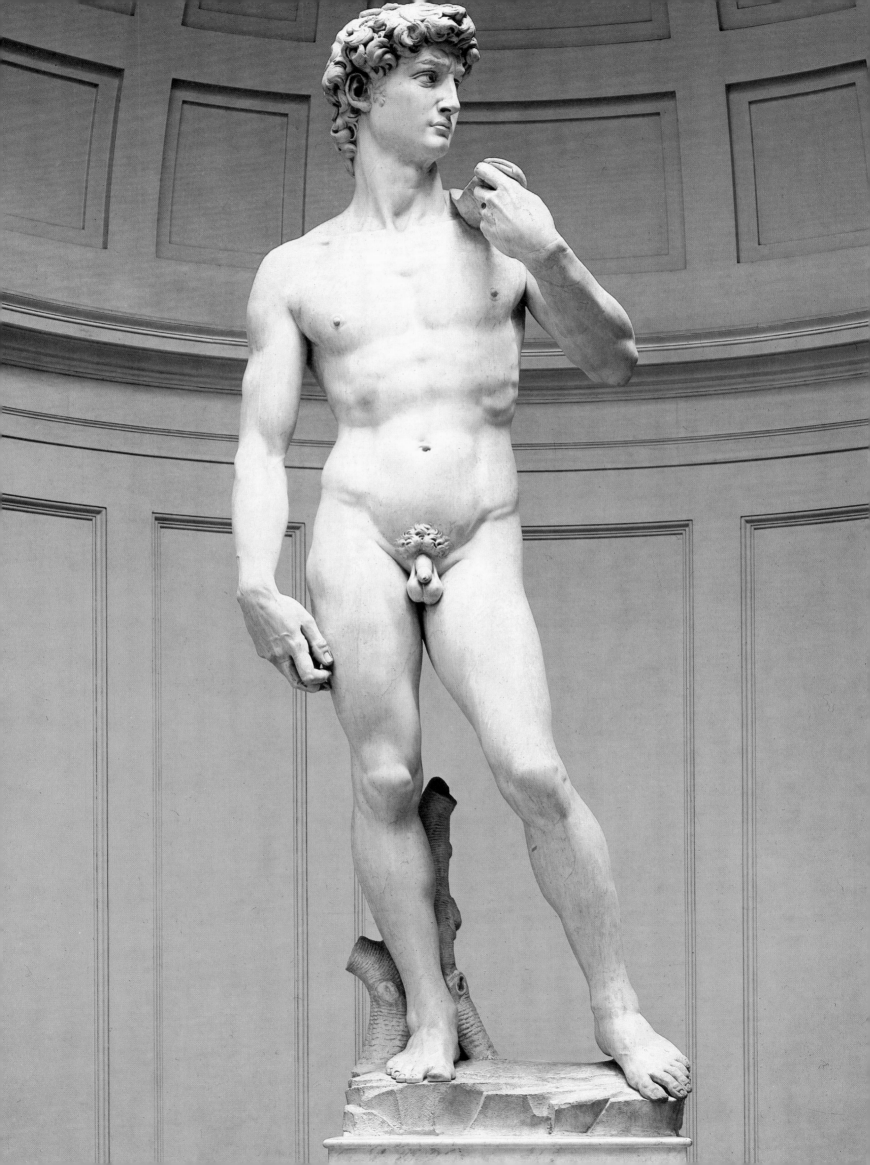

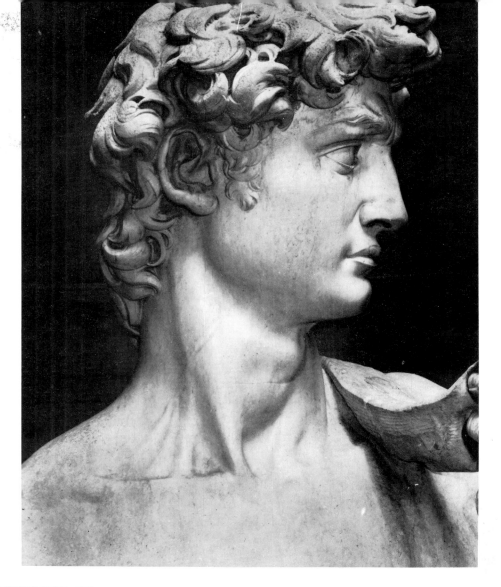

17. Facing page
DAVID. 1501–1504; Marble; 434 cm; Accademia Gallery, Florence

18–19.
DAVID (detail)

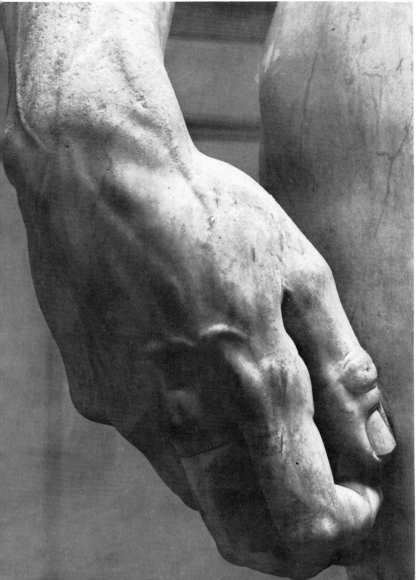

20.
STUDY FOR THE DAVID IN BRONZE (lost)
AND THE DAVID IN MARBLE. Circa 1501–1502;
Pen and ink; 26.6 × 20 cm; Cabinet des Dessins,
Louvre

21.
SAINT MATTHEW. 1505–1506; Marble; circumfer-
ence 261 cm; Accademia, Florence

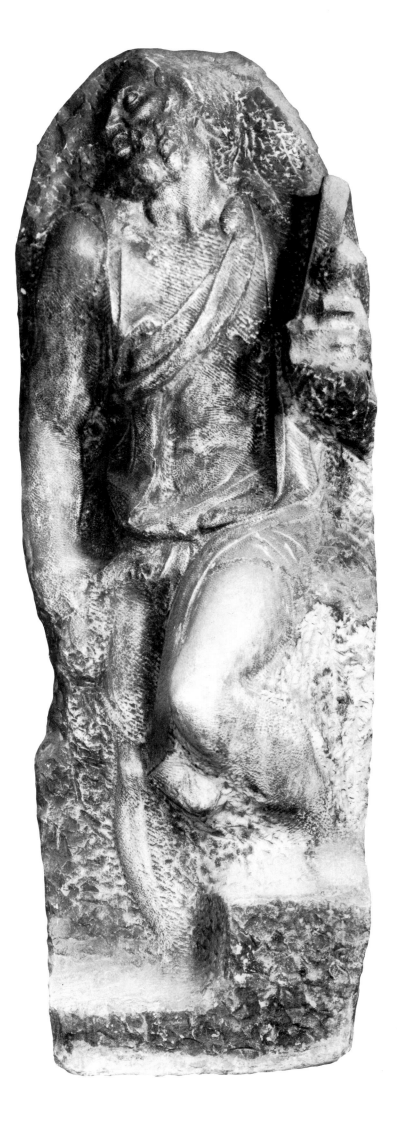

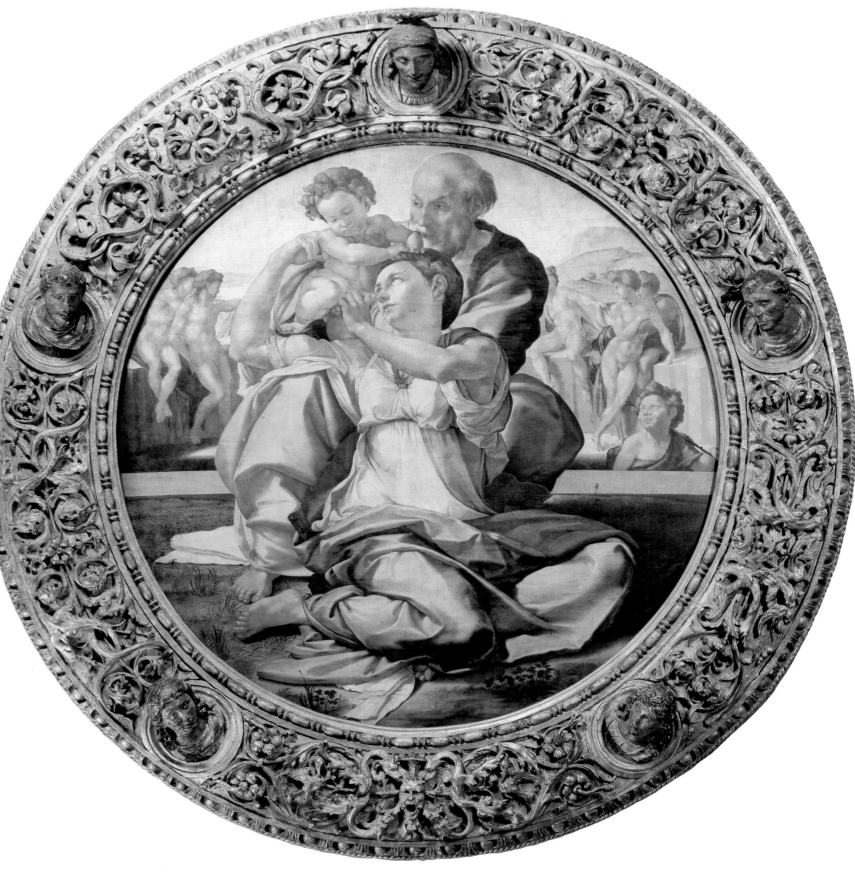

22.
DONI TONDO. 1503–1504; Tempera on wood; 120 cm diameter (with the frame); Uffizi, Florence

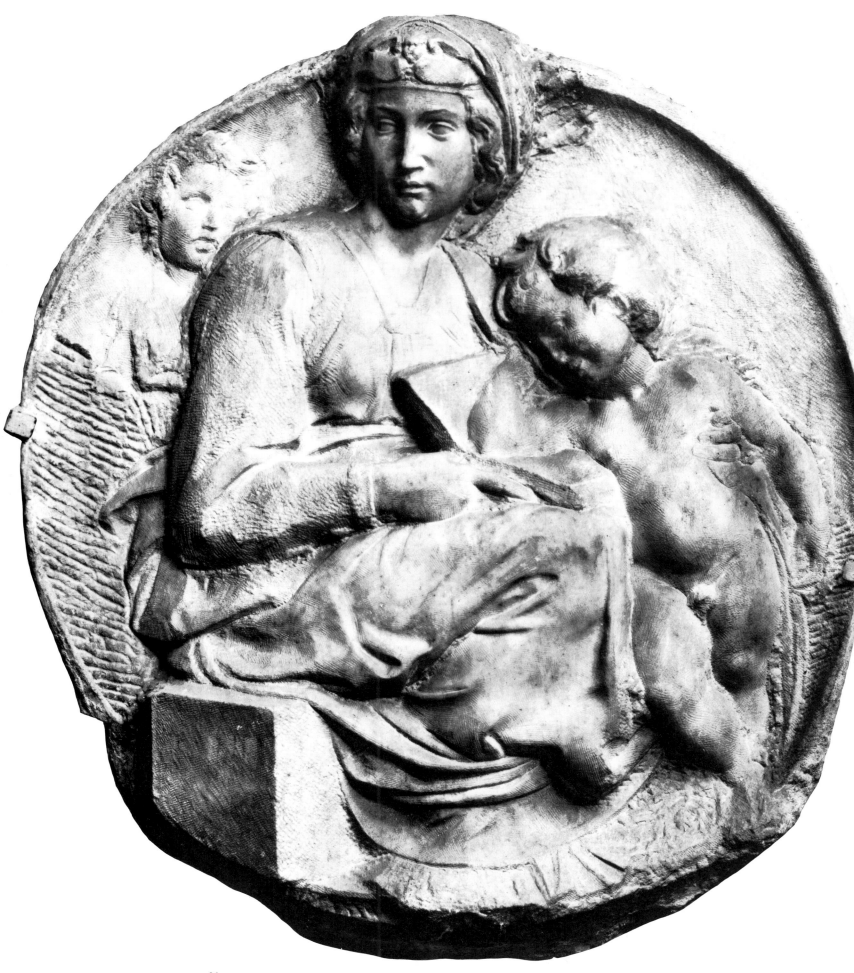

23.
PITTI MADONNA. 1503–1504; Marble; 85 × 82 cm; Museum of Bargello, Florence

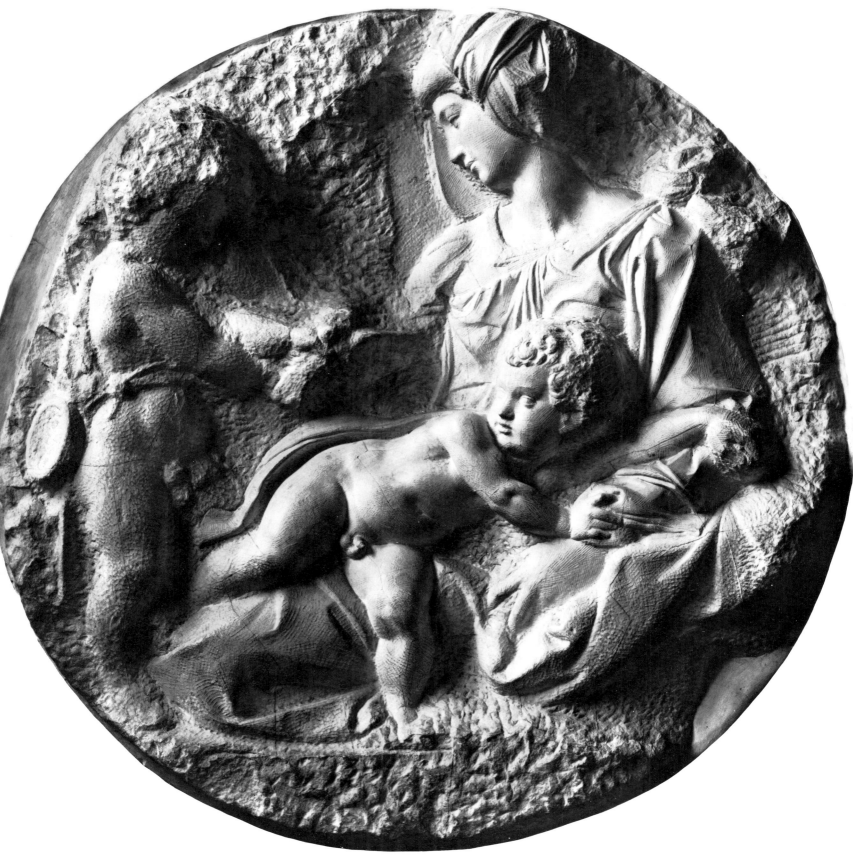

24.
TADDEI MADONNA. 1502–1504; Marble; 109 cm diameter; Royal Academy, London

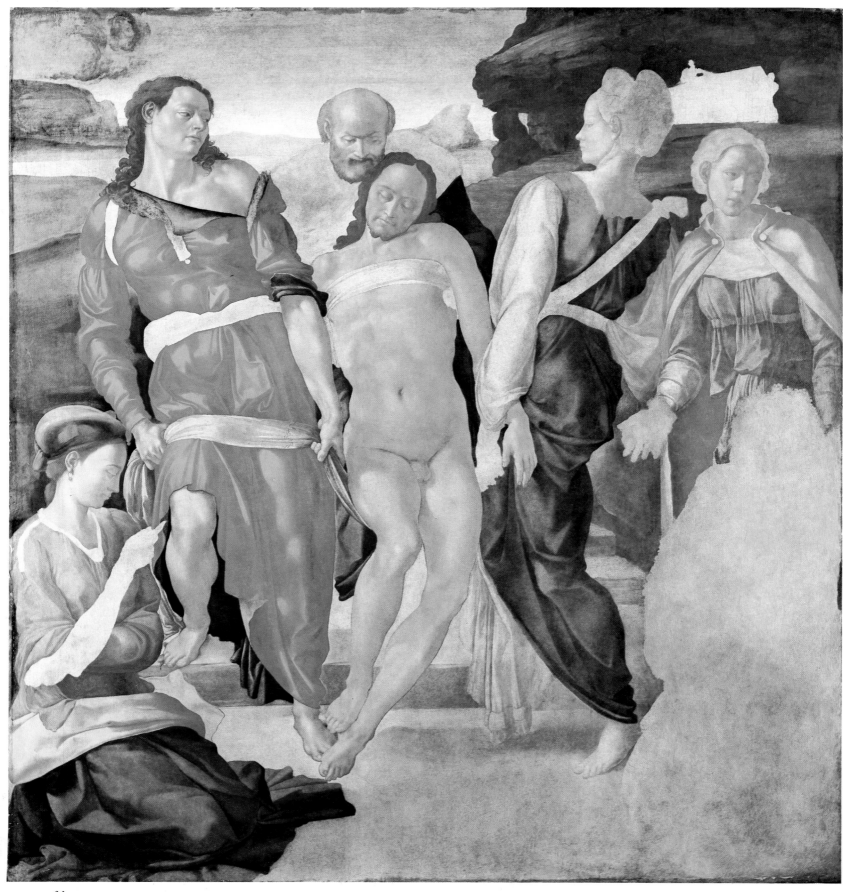

25.
TOMB SCENE (attributed to Michelangelo). Circa 1511; Tempera and oil of wood; 159 × 149 cm; National Gallery, London

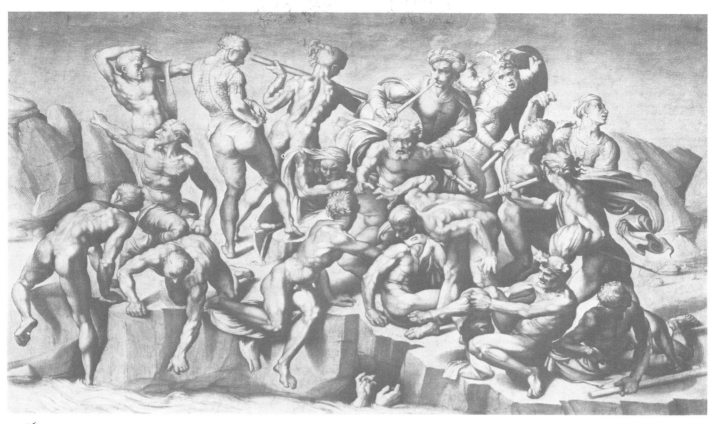

26.
ARISTOTELE DA SANGALLO: COPY OF MICHELANGELO'S CARTOON "The Battle of Cascina" (1505).
Circa 1542; Grisaille drawing; Courtauld Institute of Art, Holkam Hall; Leicester Collection

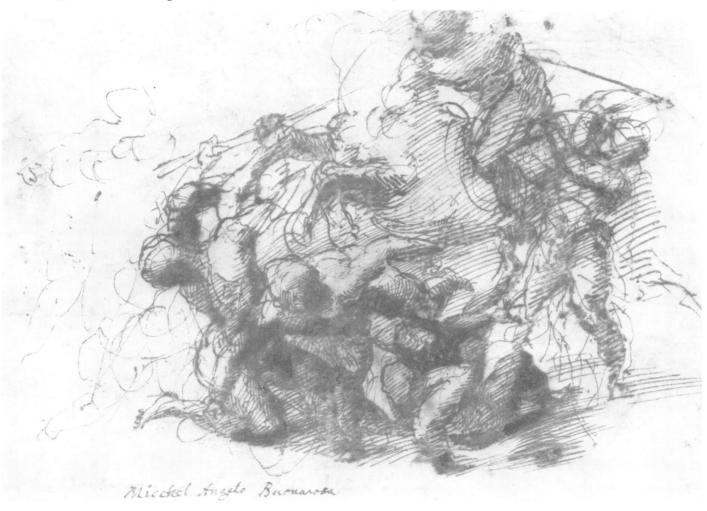

27.
COMBAT OF CAVALIERS AND SOLDIERS. 1504; Pen and ink; 18 × 25 cm; Ashmolean Museum, Oxford

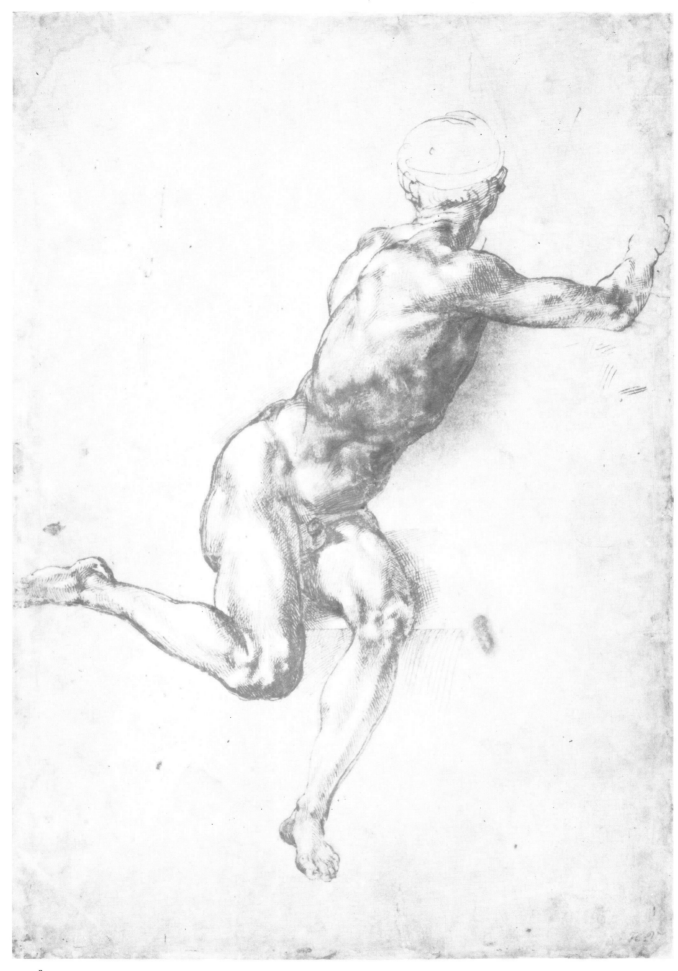

28.
STUDY FOR "THE BATTLE OF CASCINA". 1504; Pen and ink; 42 × 28.5 cm; British Museum, London

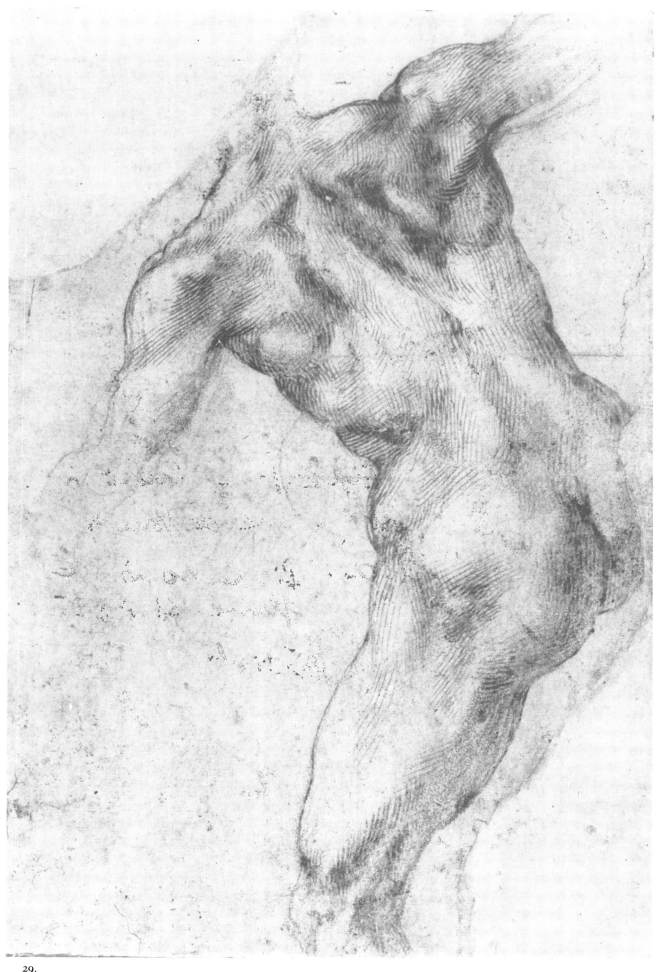

29.
STUDY FOR "THE BATTLE OF CASCINA". 1504; Pen and ink and charcoal; 26 × 17 cm; Ashmolean Museum, Oxford

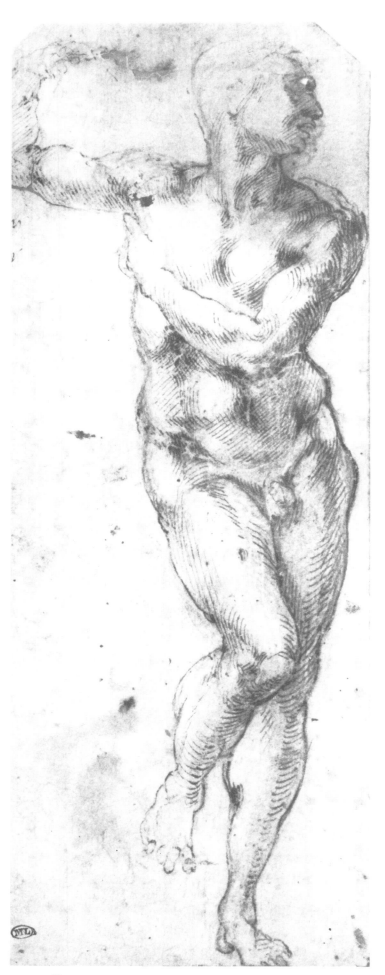

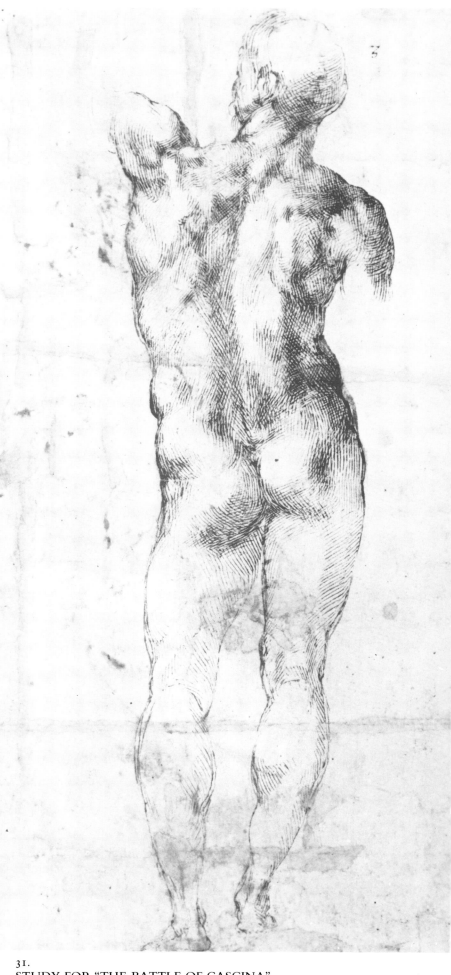

30.
STUDY FOR "THE BATTLE OF
CASCINA." 1504; Pen and ink; 25 × 18 cm;
Cabinet des Dessins, Louvre, Paris

31.
STUDY FOR "THE BATTLE OF CASCINA".
1504; Pen and ink; 39 × 20 cm; Albertina, Vienna

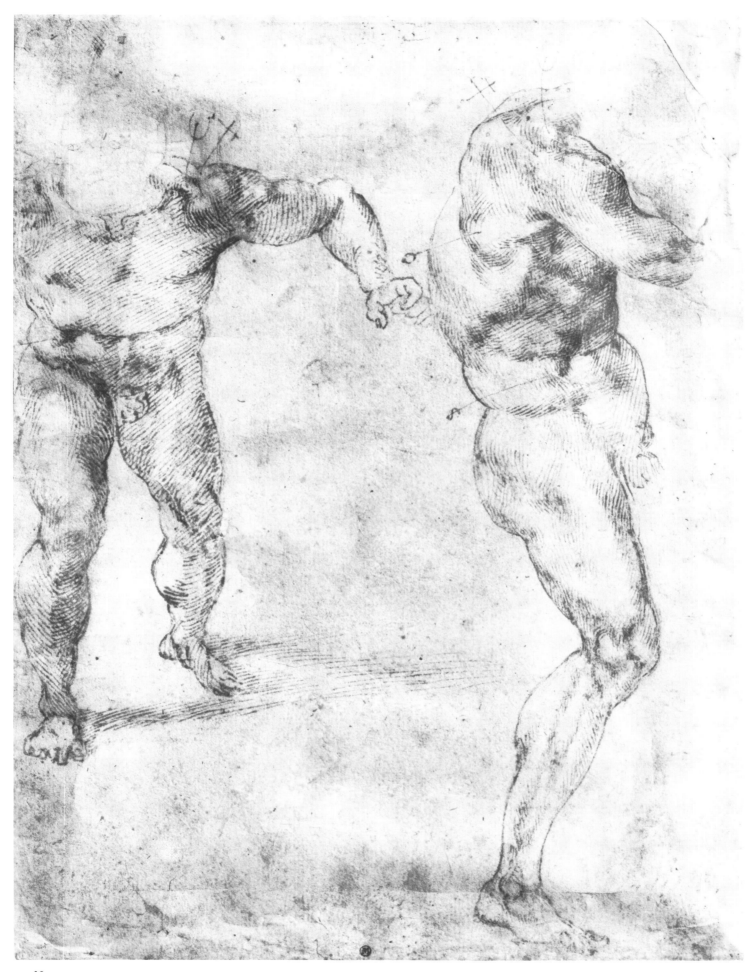

32.
STUDY FOR "THE BATTLE OF CASCINA". 1504; Pen and ink and charcoal; 26 × 19 cm; Albertina, Vienna

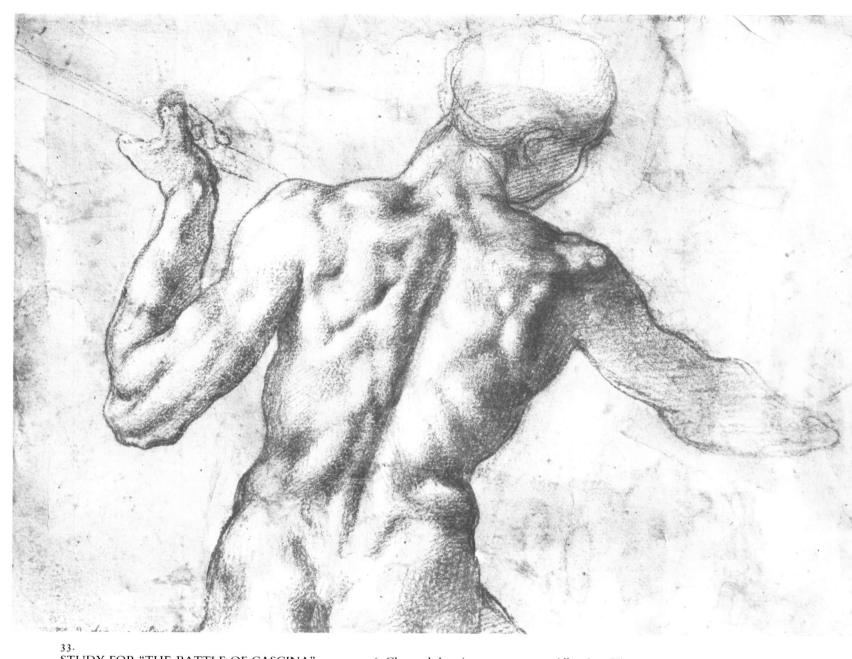

33.
STUDY FOR "THE BATTLE OF CASCINA". 1504–1506; Charcoal drawing; 19 × 27 cm; Albertina, Vienna

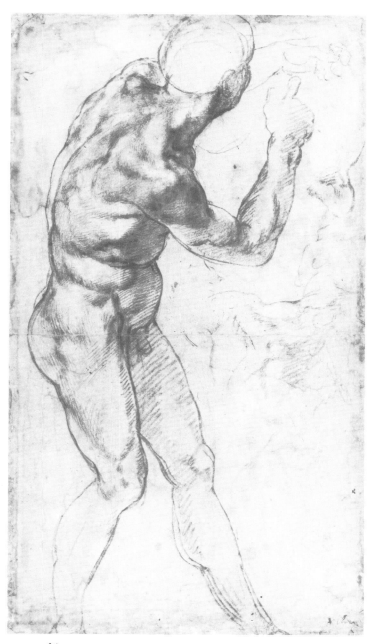

34.
STUDY FOR "THE BATTLE OF CASCINA".
1504–1506; Charcoal drawing; 40.4 × 22.4 cm

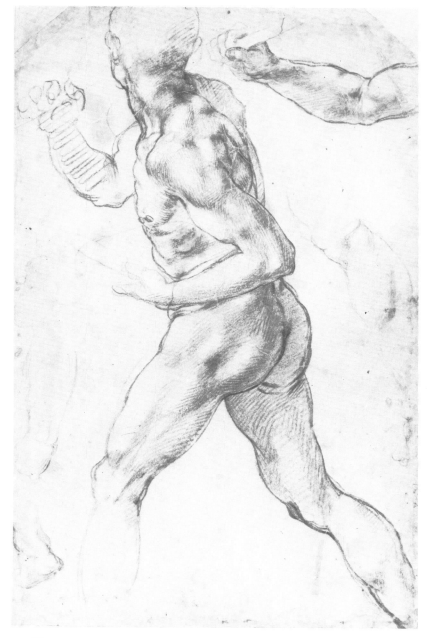

35.
STUDY FOR "THE BATTLE OF CASCINA".
1504–1506; Charcoal drawing; 40 × 3 **b** 26 cm

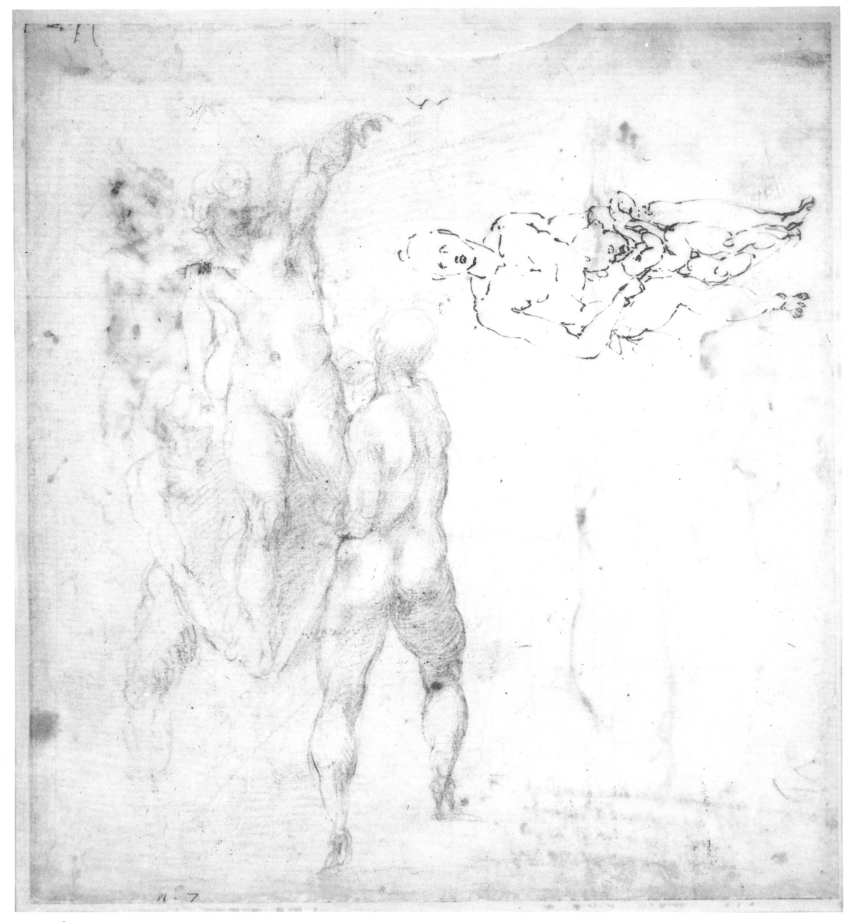

36.
STUDY FOR "THE BATTLE OF CASCINA" AND THE BRUGES MADONNA or MOUSCRON MAD-
DONNA. 1504; Pen and ink and charcoal; 31.7 × 28 cm; British Museum, London

III
The Vault of the Sistine Chapel
1508–1512

On August 18, 1503, Michelangelo was in Florence concentrating on several pieces, among them the statue of *David,* which is now in Rome. Pope Alexander VI Borgia died, and Pius III Piccolomini succeeded him for twenty-six days. In October, Giuliano della Rovere took the name Julius II. his pontifical reign lasting ten years.

Universally hated, Alexander VI not only dangerously weakened the spiritual power of the Church by countless incidents of extortion and debauchery, but he allowed the pontifical state to split between French and Spanish interests. Proud, authoritarian, and ambitious, Julius's first goal was to reestablish the temporal power of the Church. This he achieved first by forming some valuable alliances while fighting against those states that offered resistance to him. At the same time, faced with the spiritual and theological disorders within the Church, Julius convened the Lateran Council in 1512 to redefine the theological precepts of the Church; however, the Council was not sufficiently effective to prevent Luther's reform several years later. Finally, hoping to dramatize the renewal of Roman power by placing it historically in a setting worthy of his ambitions, Julius enrolled, sometimes by force, the finest artists of the Renaissance to create a unique panoply for the vigorous pontificate. Architecture was one of the obsessive themes of this prestigious policy, and the new Pontiff immediately called upon Giuliano da Sangallo, one of the most renowned architects in all of Italy. Sangallo, a close friend of Michelangelo, introduced him to Julius II and it was Sangallo who urged the Pope to hire this great Florentine artist.

After much hesitation, Michelangelo was commissioned to create the *Tomb of Julius II,* to be placed in St. Peter's Basilica, which had been built in the early ages of Christianity. Over a period of time, this sanctuary had been remodeled with many additions—chapels, apartments, cloisters, courtyards, and buildings of all kinds. Placed next to the Vatican Palace, this mosaic of construction, resembling a fortress, had been renovated several times. For a man consumed with power and prestige, this asymmetrical and unbalanced building was the worst possible symbol. When Michelangelo received the commission and went to Carrara to chose the marble, Sangallo successfully convinced the Pope to restructure the buildings; however, Julius gave the commission to Bramante, another famous architect. Bramante proposed a very grandiose project, i.e. to demolish the ancient structure and replace it with an imposing edifice that would dominate all of Christianity. Julius, of course, was enthusiastic about such an idea. The two architects drew up plans and Bramante's, superior in many ways, was chosen, even though the work initially had been promised to Sangallo. The offended architect eventually left for Florence.

When the demolition of the old sanctuary began, Bramante, who at that time had great influence over the Pope, began to intrigue against Michelangelo, in favor of Raphael. First, the colossal project of his tomb, to be on three levels, and composed of some forty statues, no longer fit into the new scheme; then, Bramante insinuated that the construction of a tomb would be a bad omen. By the time the marble and the stone cutters arrived in Rome, Julius refused to finance the project. Instead, following Bramante's suggestion, he proposed that Michelangelo paint the vault of the Sistine Chapel. Bramante thought that this proposal would result in Michelangelo being disqualified since painting was not an area where he was well known.

Condivi tells us that one day a guard prevented Michelangelo from entering the palace where the artist was supposed to have access without being announced. Michelangelo turned away, sold all his belongings, and fled to Florence.

The Pope sent three letters to the highest Florentine authorities, represented by Pietro Soderini, calling for the immediate return of the artist. Soderini, fearing reprisals from the Vatican, asked Michelangelo to return to the Pope. During that period, an unusual incident occurred. Michelangelo was convinced that Bramante and Raphael were conspiring to get rid of him and eventually kill him. He was looking for ways to avoid the fateful return to Rome

Michelangelo painting the ceiling of the Sistine Chapel (pg. 49)

when the Grand Turk Bajazet II, through an emissary Franciscan monk, asked the artist to construct a bridge on the Golden Horn, connecting Istanbul and Beyoglu. The project, however, was never pursued. But during that time, Julius II, the warrior Pope, had engaged his armies to regain Bologna and Perugia, former pontifical cities. Both cities surrendered to the power of the Pope. To celebrate his victory over the Bolognese, and perhaps on Bramante's malevolent instigation, Julius summoned Michelangelo to Bologna to force him to work on a hugh bronze portrait of the Pope as conquering hero. The statue was to be placed on the fascade of San Petronio Church. This masterpiece was unveiled on February 21, 1508. But on December 30, 1511, the Bentivoglio, the ruling family of Bologna, regained power and one of their first actions was to destroy the statue and melt it for cannon. While Michelangelo was working on the sculpture, the Pope was augmenting his diplomatic and warlike intrigues. At first he allied himself with the French against the Venetians, then he formed a bond with the Genoese, who had just revolted against the French, but hearing that Louis XII was preparing a campaign against Tuscany, the Pope finally allied himself with the Venetians against the French. Fearing a counter-council organized by Louis XII in Pisa, Julius withdrew to Rome.

Condive relates a significant anecdote regarding this statue of Julius II and the relationship between the two men. In order to morally characterize this effigy, the artist asked the Pope whether he would like to have a book in his left hand, to which Julius answered, "A book? No, a sword! I am not a scholar." Then looking at the right hand [of the statue], which was indicating the sign of benediction, the Pope smilingly asked, "Is your statue giving benediction or malediction?" Michelangelo answered, "It threatens the people, Holy Father, if they do not obey." When the statue, which would ultimately be destroyed, was finished and set in place, the artist went to Florence and later rejoined the Pope in Rome. Probably under the influence of Bramante, Julius abandoned the project of his tomb and commissioned Michelangelo to create a painting that would cover the vault of the chapel of Sixtus IV. Despite the protestations and arguments regarding his capacity, the Pope's authority asserted itself over the artist's doubts and reluctance for such a work, and finally on May 10, 1508, Julius signed the contract to engage the immediate creation of the commission that Michelangelo would deliver in four parts, the last one completed in October 1512. Measuring 40 meters long and 30 meters wide, it took only four years to realize this fresco, the greatest artistic treasure of all time.

The initial plan for this monumental decoration was limited to the barrel vault; but the preparatory drawings led the master to extend the fresco to the lunettes, spandrels and tympana, which link the ceiling to the gallery of the papal portraits painted at the end of the Quattrocento. Despite his protestations, the vault of the Sistine Chapel, is the culmination of Michelangelo's genius: a synthesis of the diverse features of his previous work, a general mythology of humanity from Genesis to Revelations, and a spectacular discourse of his culture and thought, combined with unprecedented technical prowess. This from one who said that painting the vault was not his metier. His conception of the work involved a decisive break with the traditional approach to projects of this kind. He was not only to work within restrictions imposed by the structure of the vault, but to use this curved surface to express the symbolic foundation on which he wished to place the sequences of the Old Testament narration. He transcended the restrictions inherent in the structure in turn inspiring a double sensation for the spectator, visually indicated by the penetration of the points of the tympana between the figures of the Seers and the four ligatures of the spandrels.

First, giving a feeling of imperious domination, the vault controls the entire building and its space at the level of the lunettes, but at the same time there is the sentiment of aspiration along the line of the vertical towards the biblical scenes located on the dorsal spine of this masterpiece. Placed on three levels some 300 figures illustrate the great Christic mythology. Sixteen lunettes appear in the center of the base of the vault where there are some tablets bearing the inscriptions of the Gospel according to St. Matthew. These *lunettes,* in poor condition today, more or less represented secondary Old Testament characters. The second level, the *tympana,* the *spandrels,* and the thrones of the *Seers* lead us to the median and superior space of the biblical scenes through the medium of the *ignudi,* placed at the four corners of these scenes. Some small decorative figures finally punctuate and complete the ensemble. The *putti-porte-ecriteau* [cherubs bearing inscriptions] between the lunettes and their bases identify the prophet or the sibyl placed above them. At the top of each spandrel and tympanum there are bronze nudes, two of them placed on each side of the ram's skull that dominates them in the center. These nudes could be an allusion to primeval man. At the base of the pilasters in *trompe l'oeil,* placed on each side of the throne, a pair of *putti-caryatides*

encase the *Seers* laterally. These figures are in fake marble and give the impression of sustaining the cornice that surrounds the biblical scenes. The *ignudi* are connected at their base by a secondary theme, i.e., *medallions,* which represent biblical scenes such as the destruction of the tribe of Ahab, the Sacrifice of Abraham, and Elijah ascending to the heavens in the chariot of fire.

Measuring some 1000 square meters, the immensity of the work necessitated assistance and the master called upon several loyal Florentine painters, among them Granacci, Aristotele da Sangallo and Bugiardini, who sometimes created secondary figures. Over a period of four years, the work progressed from the chapel entrance to the altar by the entire cross section except for the lunettes, which were painted afterward. Michelangelo's first concern was to create a story within the architecture or a division of the vault itself, which as we have already stated, would allow him to preserve and accentuate visibly the curved structure. By placing the central scenes outside the architectonic tension of the lateral zones, he created an illusion of perspective from an unveiled, dominant and soothing, airy space from the entrance to the altar, where the artist reveals a progressive cycle of nine scenes from Genesis, from *Noah's Drunkenness* to the *Division of the Light from the Darkness.* The first series of three paintings tells of the tribulations of mankind illustrated by the biography of Noah, his *Drunkenness,* the *Flood,* his *Sacrifice.* The second series represents *Original Sin* or the *Temptation of Eve,* the *Creation of Eve,* and the *Creation of Adam.* The third series represents the origin of the universe. *God Separating the Waters from the Earth,* the *Creation of the Sun and the Moon,* the *Division of the Light from the Darkness.* As de Tolnay noted, "In the vault of the Sistine (Chapel), there is a double ascension. Ascension from the bottom to the top through the three zones symbolizes the three degrees of existence, and ascension in the progression of the historic cycle that goes from the story of Noah to the scenes of the Creation." From the immense procession of bodies to this sublime narration, a double contradictory effect is created that no other artist before or after Michelangelo could express on this scale. Critics of the Sistine Chapel, with some awkwardness at times, have studied the extraordinary symbolic richness of each detail in the composition as much as the original character of the ensemble from the theological as well as the platonist point of view. In some particularly admirable sequences, Michelangelo knew how to reach an unforgettable power of concise expression through amazing figurative foreshortening definitively stated in the famous *Creation of Adam;* nevertheless, the clarity of the fresco's avocation is due to scrupulous adherence to the text and to tradition. These symbolic meanings and figurative aspects alone, in spite of the master's previous works that prefigured his stylistic development, must have astonished Michelangelo's contemporaries standing under this systematic imperial nudity, under this vault of tormented flesh, of open nudity, of complacent anatomies. Here, properly, we touch on the core of the unique intensity of his work in the western world. Where rioting might have occurred, passionate admiration triumphed.

Admiration triumphed because the artist, armed with two energies thought to be contradictory—spiritual and physical—understood that it was necessary to force their synthesis until he expressed each energy with the other. Certainly, Noah is naked, his sons as well. Most likely the *Flood* is a flood of anatomy, and the *ignudi,* which sustain the central tableau, are the manifestation of an ideal nudity in itself. But each nudity, in the continuous swarming of these amazing bodies, is a means of expressing the unique imprint of a personality of a state of mind in its most obvious effects. This nudity is not totally naked; it is covered with an immense narrative and declarative direction. What we see, what the master knew how to express sumptuously, is in fact the naked truth of the promotion of man stripped bare as he advances toward his idealization in the celestial world.

Michelangelo answered to the power of the highest abstraction in the most concrete way. Such is the law of the greatest masterpiece of Christianity.

THE IGNUDI

We know the reservations that were entertained among those in the Pope's entourage regarding the representation of the nudes, which were considered too numerous. But we know that the artist was insistent upon maintaining these motifs, which unified the entirety of his work and established the role of a plastic moral and a sexual ideal, synthesized within the force of the masculine nude.

It is likely that starting with the *Battle of the Centaurs,* Michelangelo modeled his

work after antiquity, the prevailing fashion of the time; but mainly the artist represents the fall of medieval art, the manifest accomplishment of the Renaissance and the origin of mannerism and romanticism, the presentation of the body as a means of expression upon which the artist can project his individual interpretation. In the renewed and incessant twisting of the body, Michelangelo showed his desire to rediscover the energy of the "human" figure not yet fully realized in the social and cultural network; but most of all, he shows the subjective debate that awakened in him the general thematic that inspired him.

The ornamental motif of the *ignudi* of the ceiling should have remained secondary in the composition, where they function doubly as the tradition *putti-angelot* inscription bearers and as transitional figures in the hierarchy of the represented orders. Even though many authors (i.e. Vasari, Burckhardt, then Chastel, who devoted their studies to those motifs,) have so interpreted them; on the contrary, the ignudi occupy an important autonomous place in the plan of the ceiling; the symmetrical couples surround the sacred scenes, but if we consider the order and direction of the placement in the vault, we see that these couples serve to introduce the biblical scenes.

These superb bodies with thoughtful and frightened expressions, disheveled with feminine heads and masculine bodies, exposing their own nudity, are essential transitions rather than minor figures. Vasari considered them the representation of the golden age of the pontificate of Julius II. Above all, this golden age is an age of the figure in western culture and for that reason and in spite of himself, Michelangelo fanned the flames of the Reformation. This inordinate advent of the body in its representation and in its purely aesthetic authority marks a decisive turning point in the West regarding the status of allegiance of the body to the law. Michelangelo's enemies were not wrong; his work shows a retreat of investment from the legal dispositions of the religious discourses on the pictorial codes toward new values sustained by the liberal and leisure classes, which are values of pleasure. For a long time faith was maintained as a group of constraints, a world penitence preparing for celestial bliss. However, the Renaissance claimed to substitute this painful vision of existence for a vision that already identified life on earth with an abundance of celestial virtues, among them beauty, grace, pleasure and even luxury, which occupy an important place. The arts and in particular Michelangelo's art, present themselves as a mediation of continuity of essence between the visible and invisible. The whole of Michelangelo's work expresses this dichotomy, and the body serves as its chief symbol. On one hand, he multiplied the marks of the corporal substance, but this multiplication of attributes in itself offers a depth of structure and expression never seen before which leads to an idealization, to a spiritualization of this magisterial symbol.

The ignudi, in spite of the awe they inspired when the vault was unveiled, were nevertheless perceived, because of their density and their excessive beauty as belonging to a level that is no longer of our world, as prefiguring values of the sphere of the divine. This joining of worlds to represent a doubly significant body could explain the place of the *ignudi;* it is the same will of expression of continuity that some years later will maintain the unity of the extravagant circulation of anatomies, from bottom to top and from top to bottom, which figure in the *Last Judgment.*

37. Facing page
VIEW OF THE SISTINE CHAPEL. The Sistine Chapel is located to the right of St. Peter's Basilica of Rome in Vatican City.

38. ff.
VIEW OF THE ENTIRE CEILING. 40.23 m × 13.40 m. The reference numbers in the illustration on pages 54–55 correspond to the numbers identifying the plates and the numbers listed below.

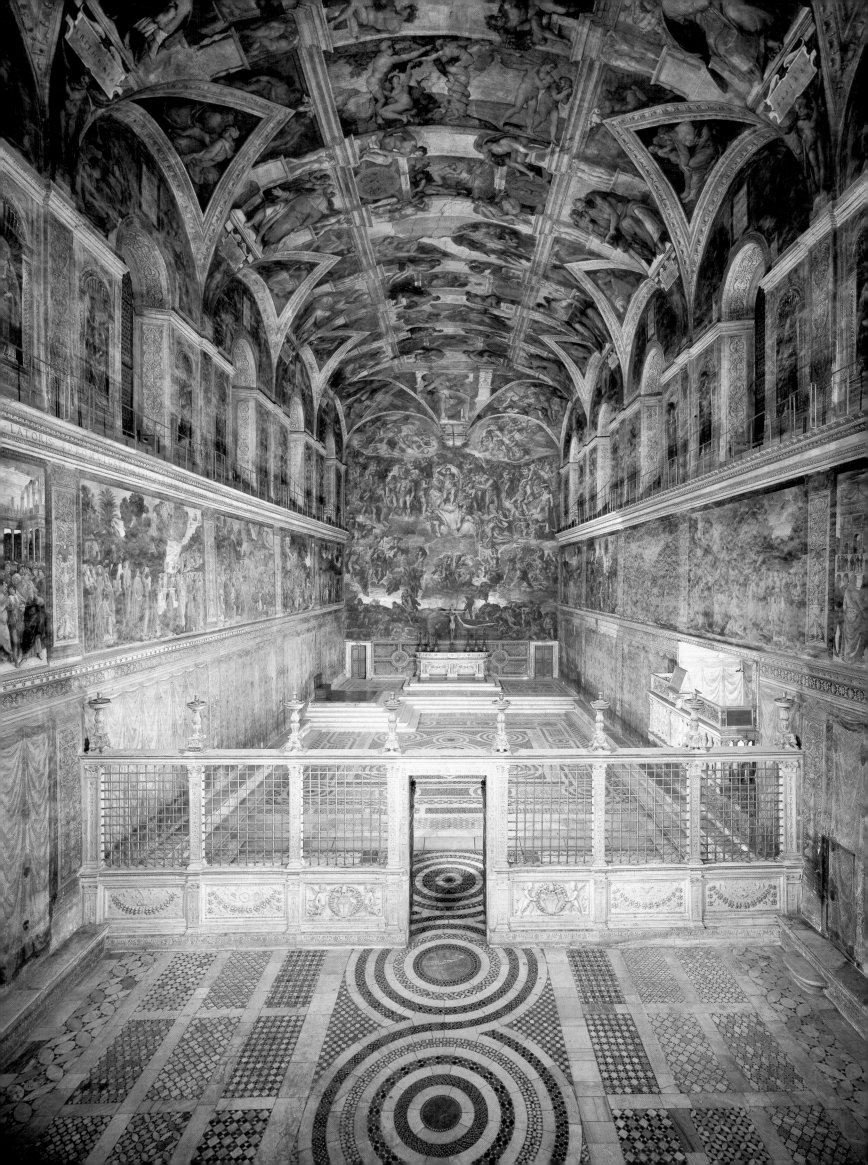

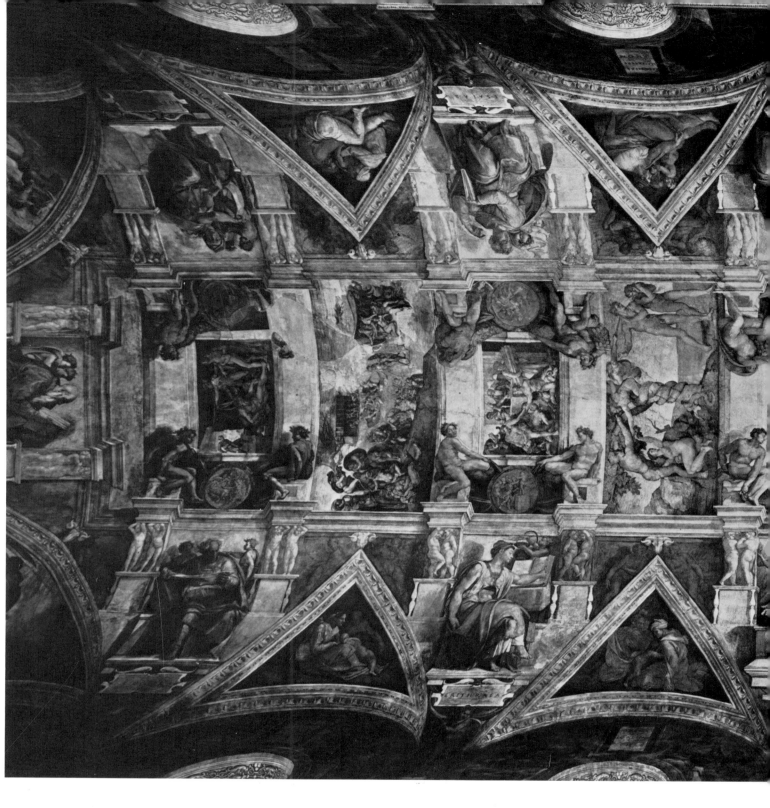

ENTRANCE TO
THE SISTINE
CHAPEL

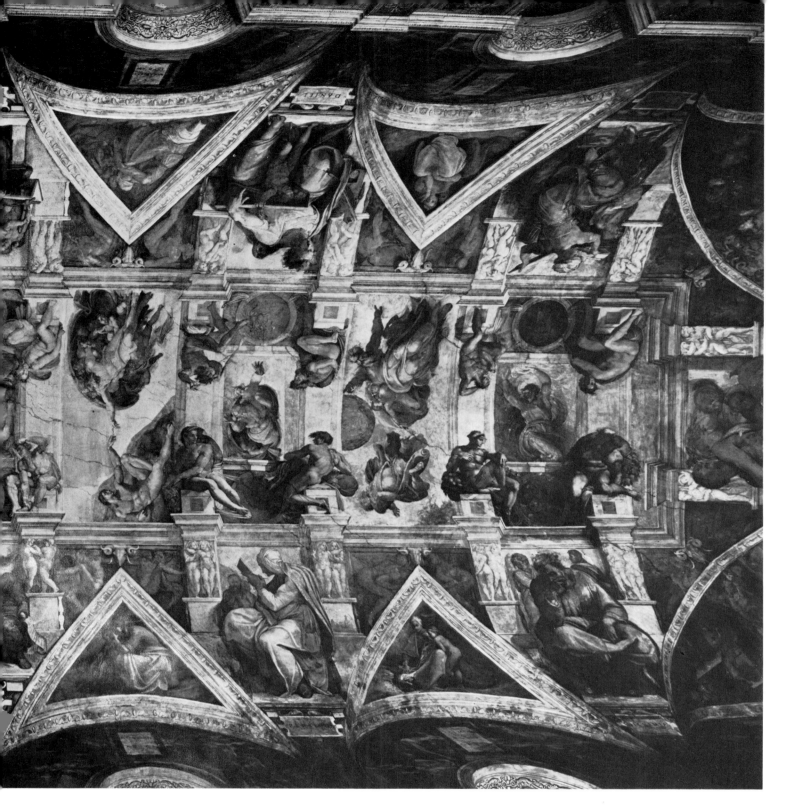

ALTAR AND FRESCO
OF THE LAST
JUDGMENT

JOSAPHAT-JORAM

ASA
III. 92

DANIEL
III. 59

DAVID - SALOMON

JESSÉ
III. 90

NAASON

SIBYLLE
LIBYQUE
III. 64

SERPENT D'AIRAIN
III. 87

PHARES-ESRON-ARAN

CRÉATION D'ADAM
III. 45

SÉPARATION
DES EAUX
III. 41

IGNUDI
III. 81

CRÉATION DES ASTRES
III. 40

IGNUDI
III. 79

SÉPARATION
DE LA LUMIÈRE
III. 39

JONAS
III. 63

IGNUDI
III. 76/77

IGNUDI
III. 78

ROBOAM
III. 94

SIBYLLE
PERSIQUE
III. 62

SALOMON
III. 96

JÉRÉMIE
III. 68

SUPPLICE D'AMAN
III. 88

ABRAHAM-ISAAC-JACOB

ROBOAM-ABIAS

BOOZ-OBETH

AMINADAB
III. 104

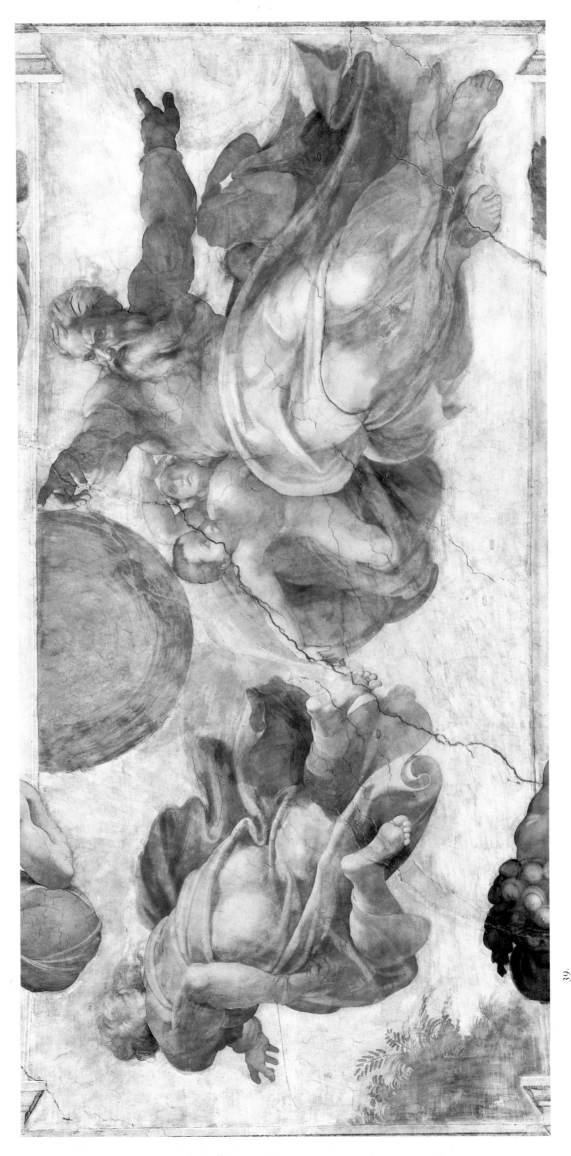

Biblical Scenes. Of the 9 scenes, 4 make up the entire central part
5 smallest ones are flanked on the narrow sides by pairs of "ignudi."

39.
CREATION OF THE SUN AND THE MOON. 280 × 570 cm

40. Facing page.
DIVISION OF THE LIGHT FROM THE DARKNESS. 155 × 270 cm

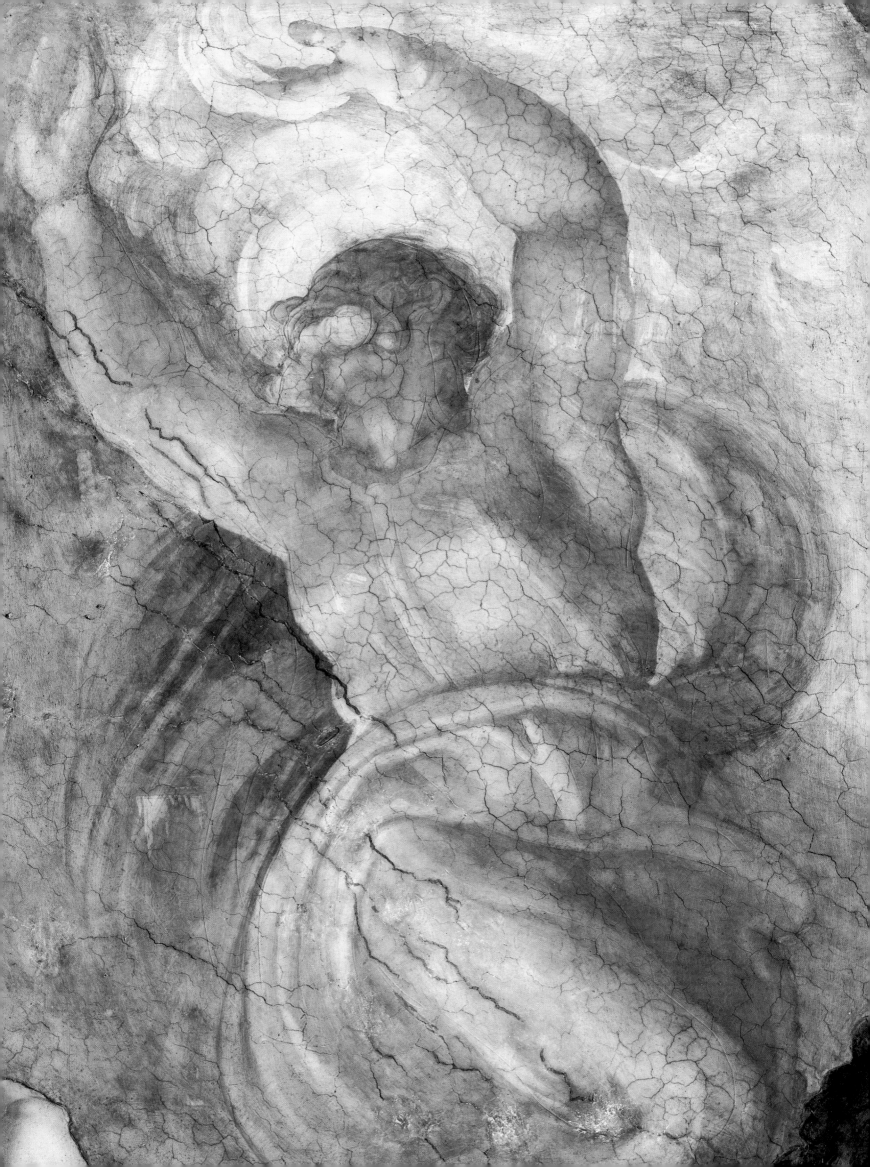

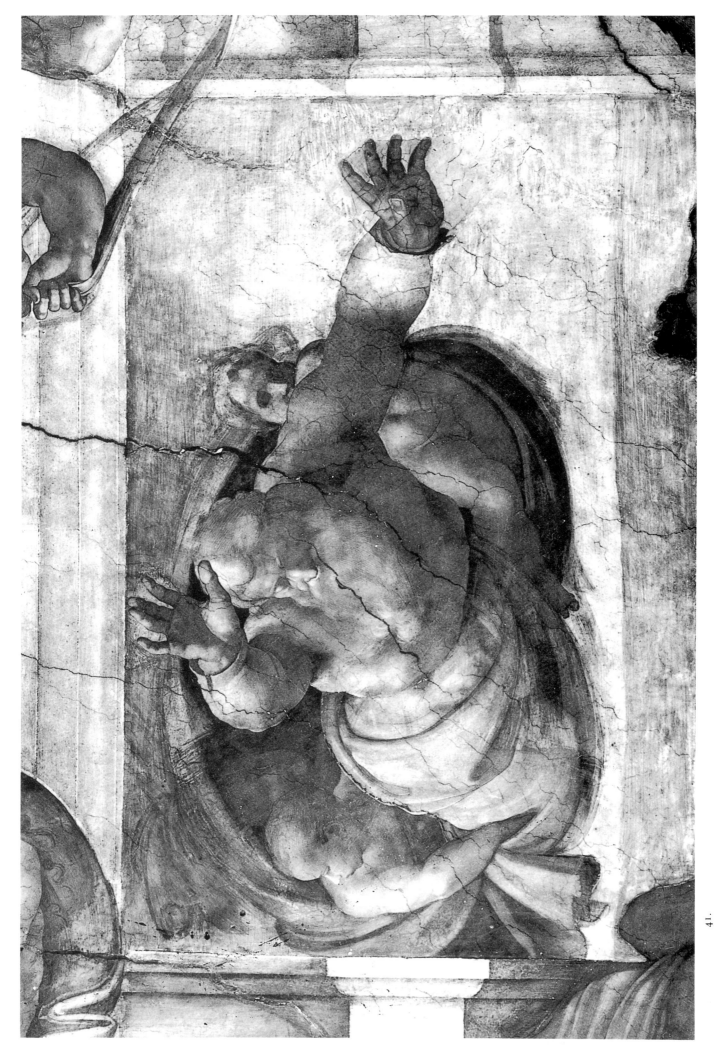

41.
GOD SEPARATING THE WATERS FROM THE EARTH. 155 × 270 cm

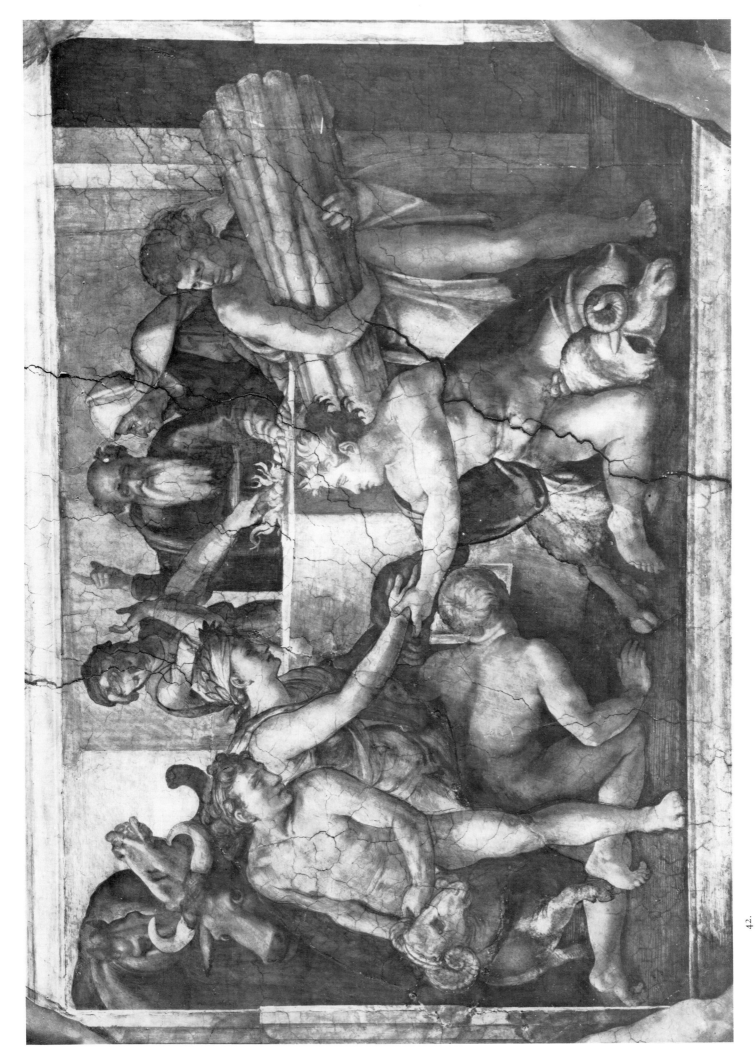

42.
NOAH'S SACRIFICE. 170 × 260 cm

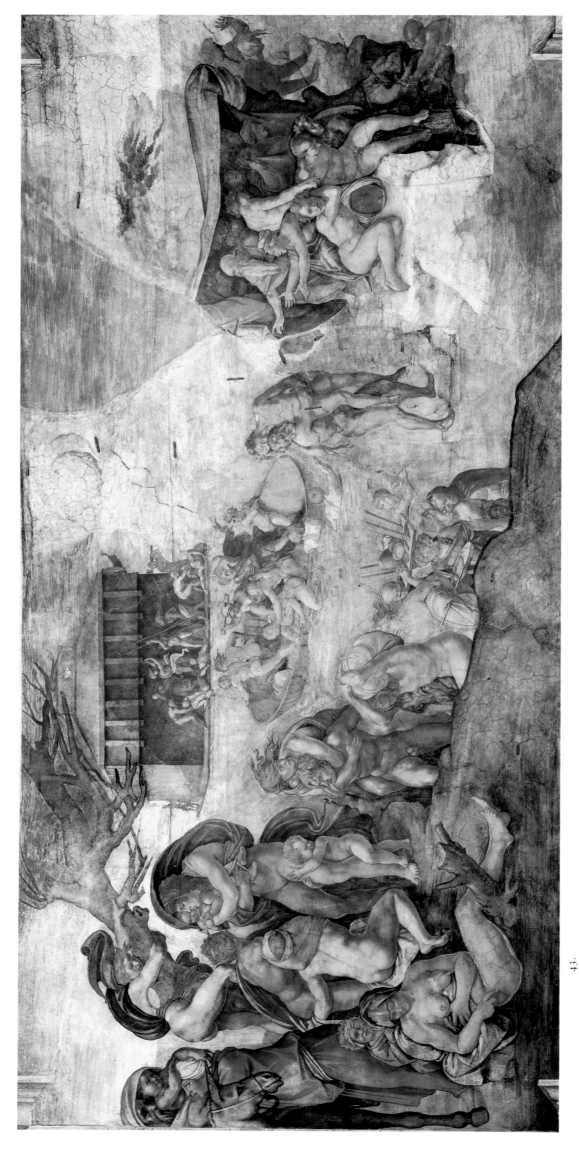

43.
THE FLOOD with contributions from assistants. 280 × 570 cm

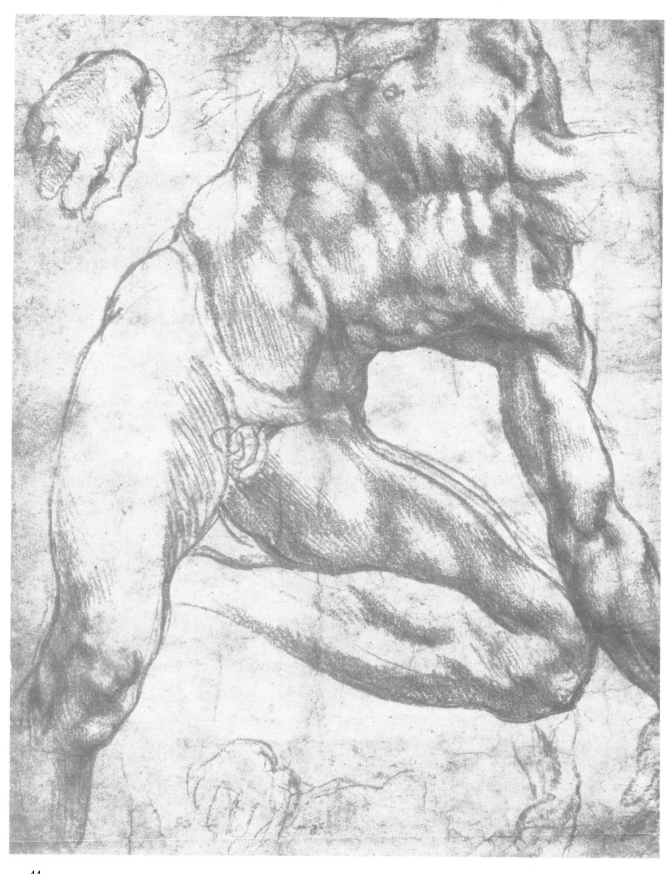

44.
STUDY FOR THE "CREATION OF ADAM." 1511; Red chalk drawings; 19 × 36 cm; British Museum, London

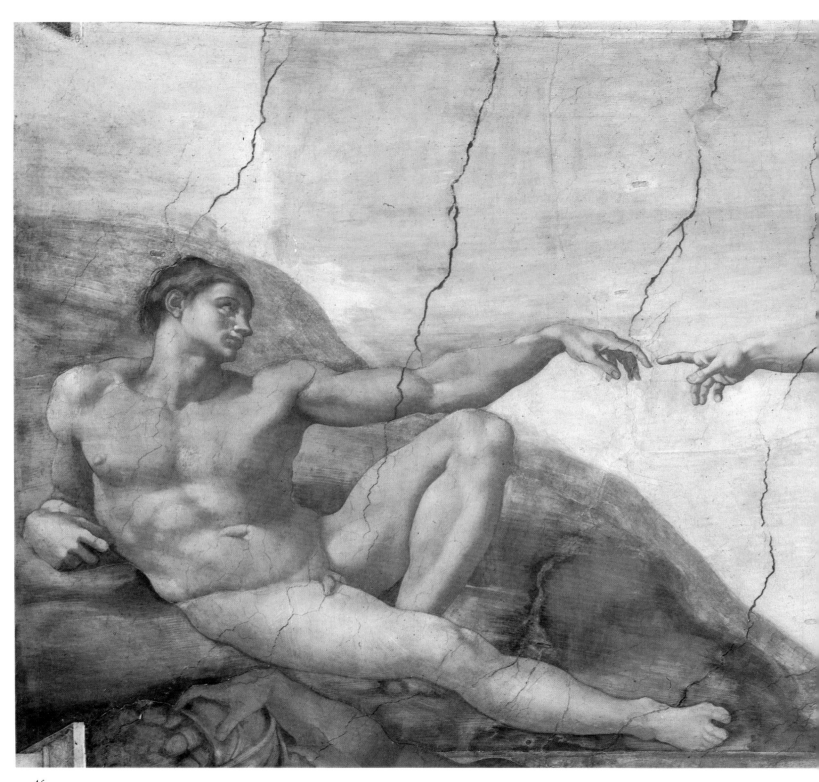

45.
CREATION OF ADAM. 280 × 570 cm

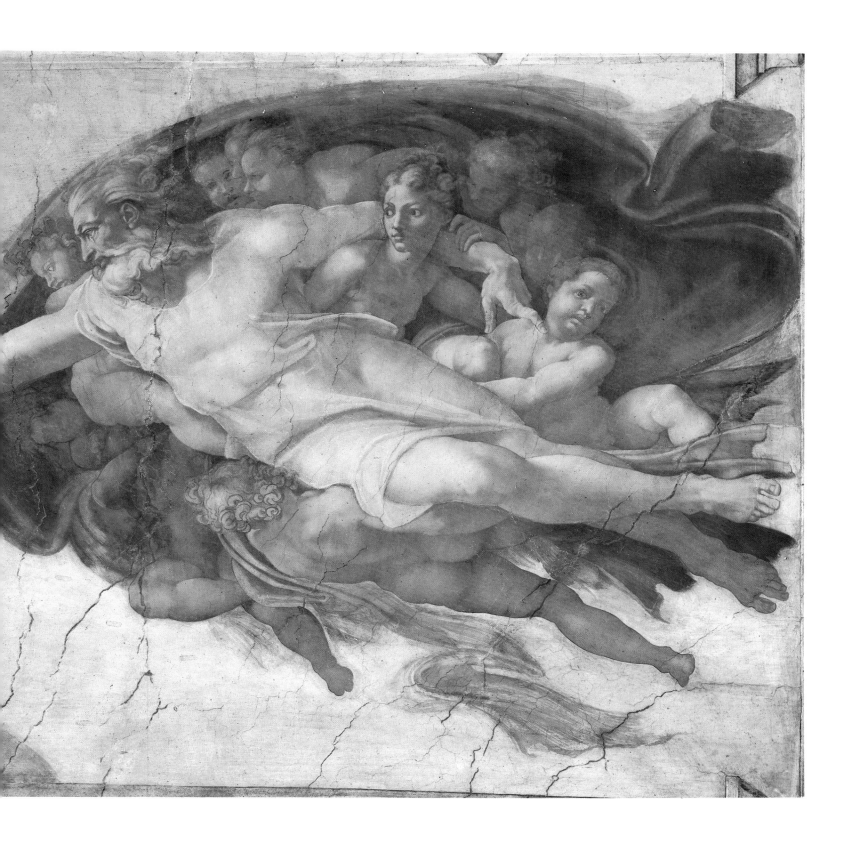

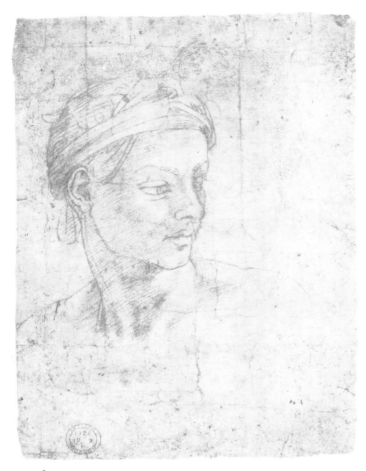

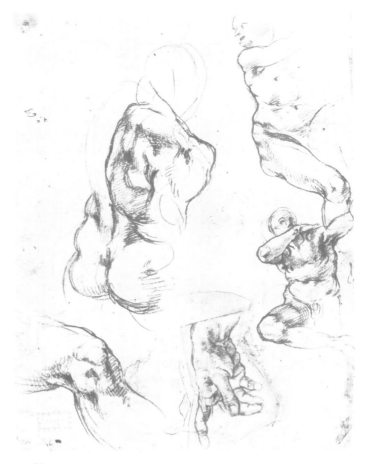

46.
STUDY FOR THE IGNUDO TO THE LEFT OF
THE PERSIAN SIBYL. 1511; Red chalk; 35 × 19
cm; British Museum, London

47.
STUDY FOR ADAM'S ELBOW AND THE ANGELS
FOR THE "CREATION OF ADAM". 1511; Red chalk
and charcoal drawing; 29.6 × 19.5 cm; Teyler, Haarlem

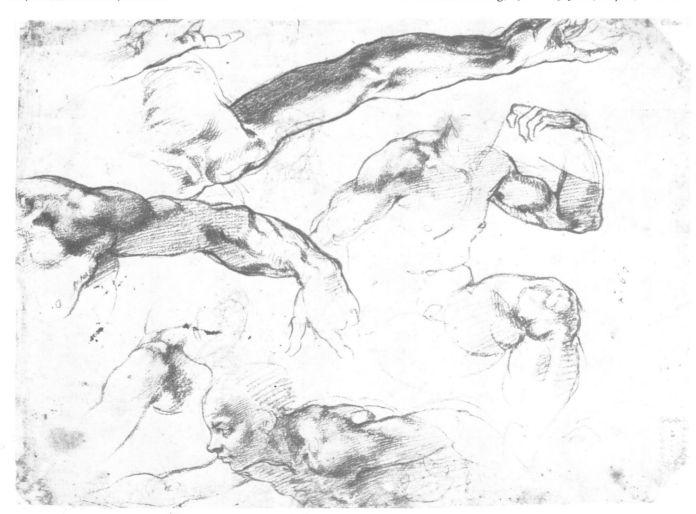

48.
STUDY FOR THE ARMS OF GOD AND THE ANGELS FOR THE "CREATION OF ADAM". 1508; Red
chalk and charcoal; 21.5 × 28 cm; Teyler, Haarlem

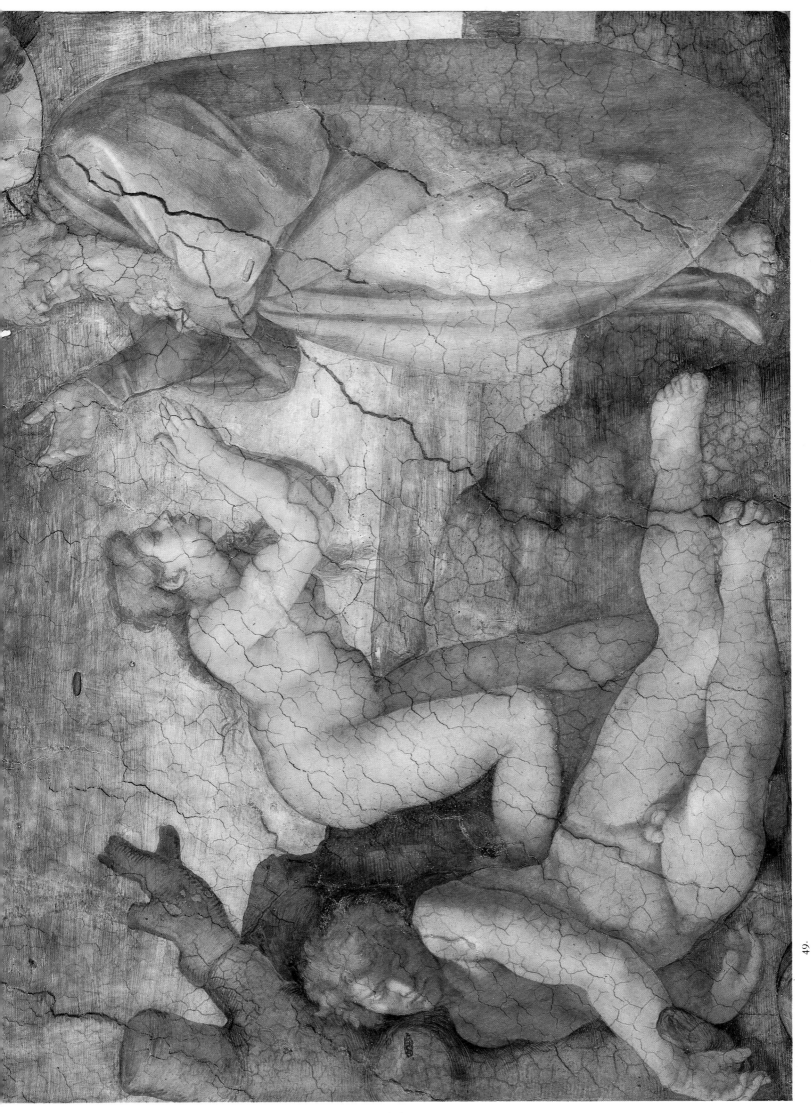

49.
CREATION OF EVE. 170 × 260 cm

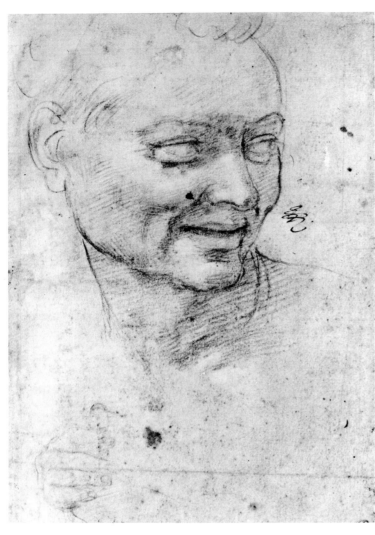

50.
STUDY FOR THE IGNUDO TO THE LEFT OF
ISAIAH. 1508; Charcoal drawing with touches of
white lead; 30 × 20.5 cm; Cabinet des Dessins,
Louvre, Paris

51.
SKETCH OF THE CEILING AND STUDIES FOR
THE ARMS OF THE PERSIAN AND DELPHIC
SIBYLS. 1508–1509; Pen and ink and charcoal; 27 ×
38 cm; British Museum, London

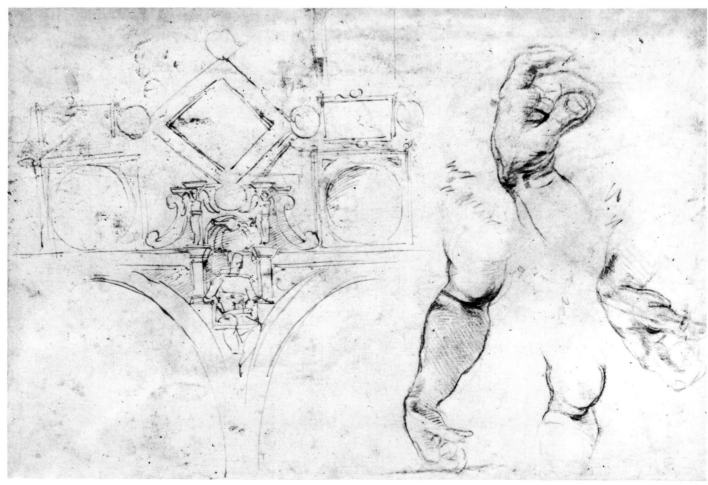

52.
STUDY FOR THE IGNUDO TO THE RIGHT OF
THE DELPHIC SIBYL. Charcoal drawing; 24.5 ×
15.8 cm; British Museum, London

53.
STUDY FOR THE ARMS FOR THE "NOAH'S
DRUNKENNESS". Charcoal drawing; 21.5 × 15.8
cm; Boymans—van Beuningen Museum, Rotterdam

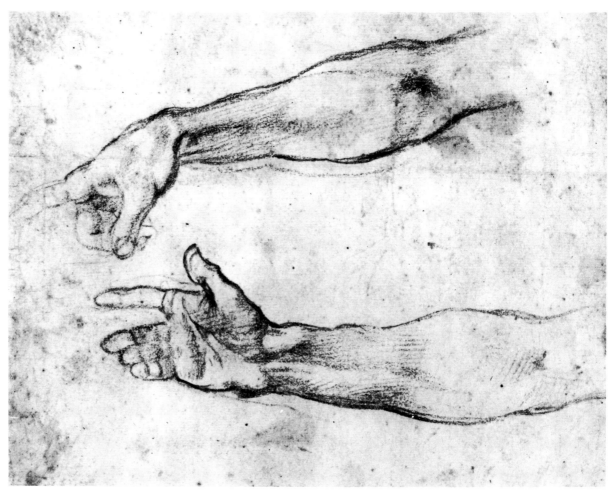

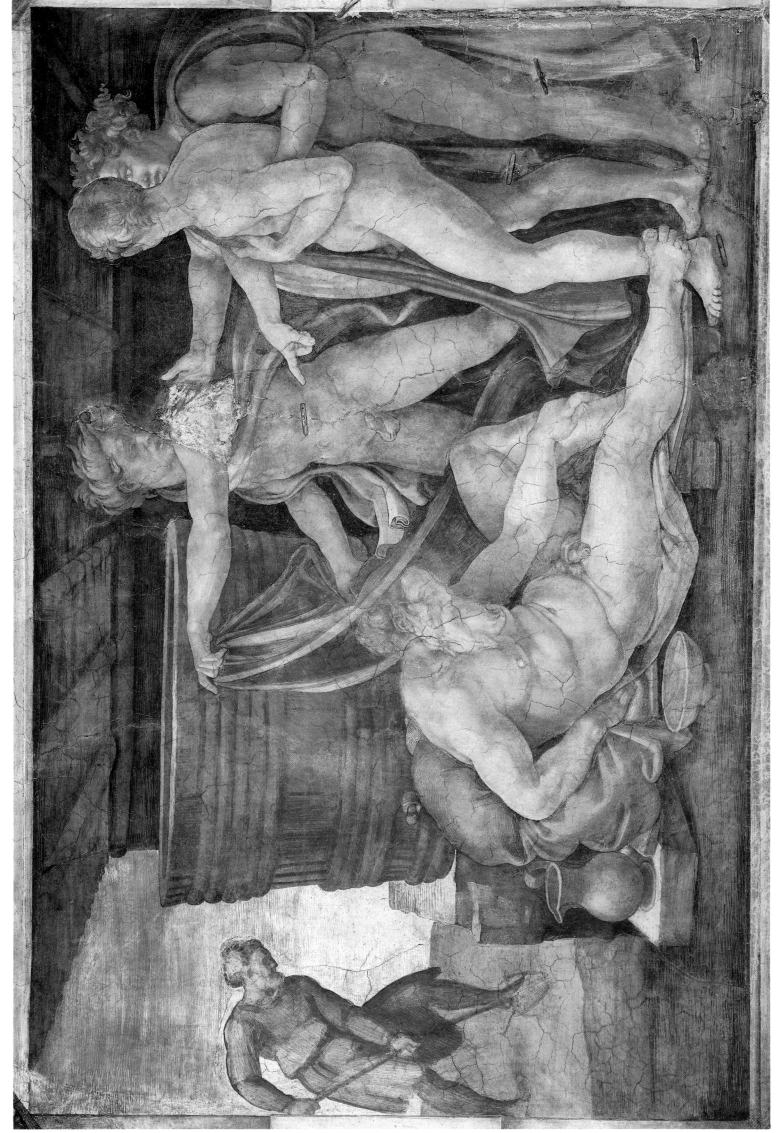

54.
NOAH'S DRUNKENNESS. 170 × 260 cm

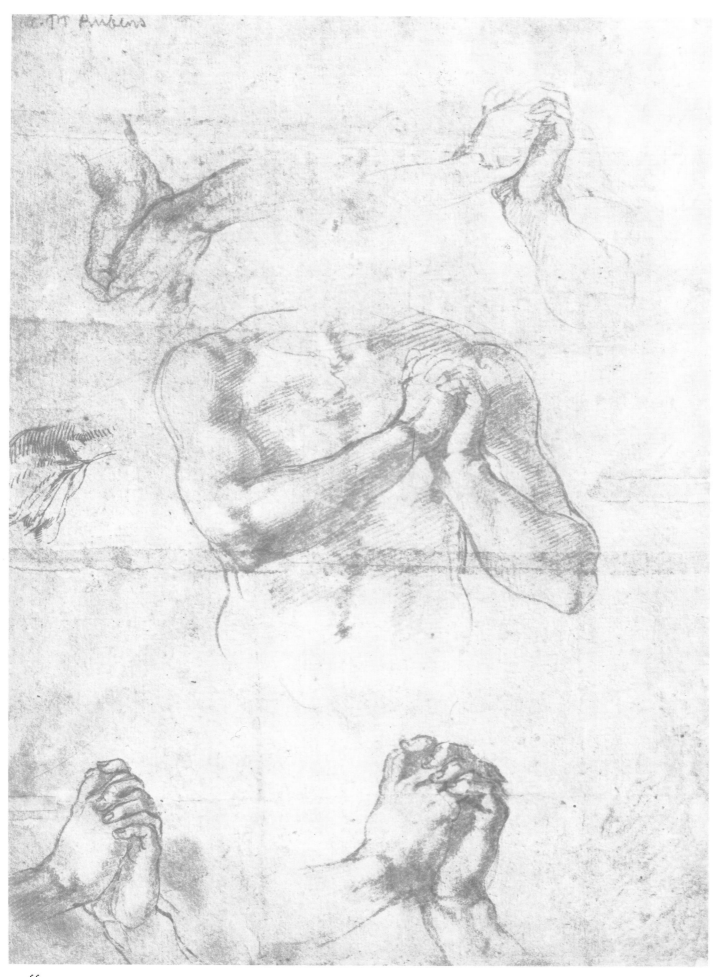

55.
PRESUMED STUDY FOR "ORIGINAL SIN". Circa 1510; Red chalk drawing with traces of pen and ink; 26.7 × 19 cm; Albertina, Vienna

56.
ORIGINAL SIN. 280 × 570 cm

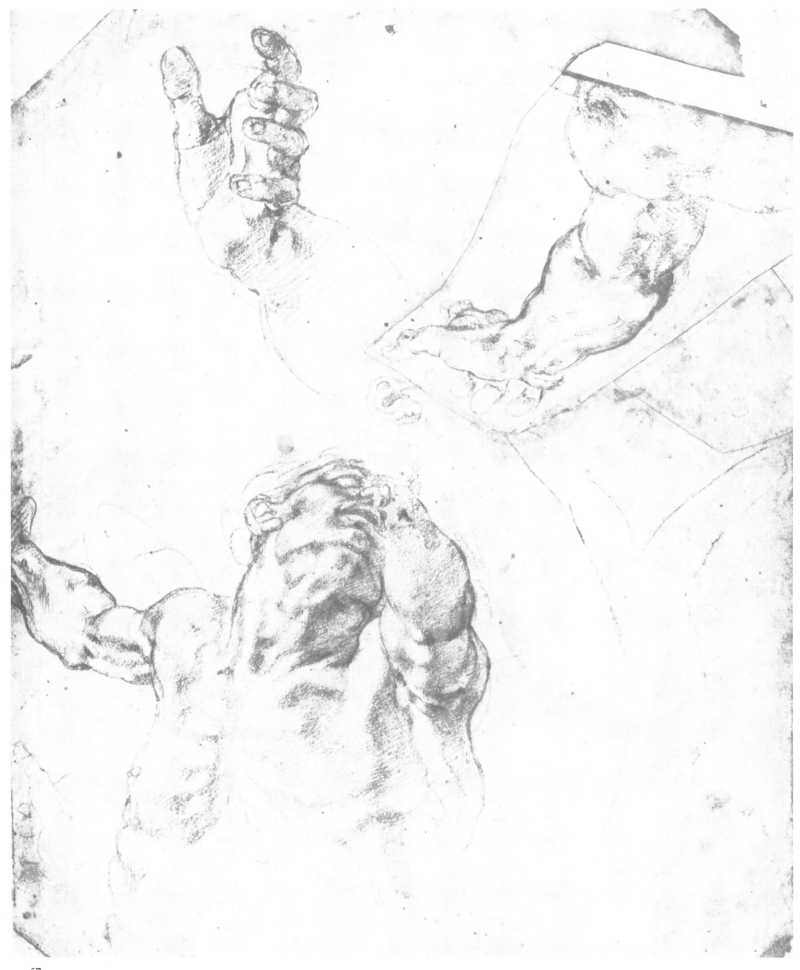

57.
STUDY FOR THE SPANDREL "HAMAN'S PUNISHMENT". 1511; Red chalk drawing; 25.3 × 19.9 cm;
Teyler, Haarlem

Seers: 7 Prophets and 5 Sibyls. Each seer is framed by pairs of "putti-caryatids." The putti inscription bearers show the name of the seer on a fake-marble sign. Fresco paintings, executed between 1509 and 1511.

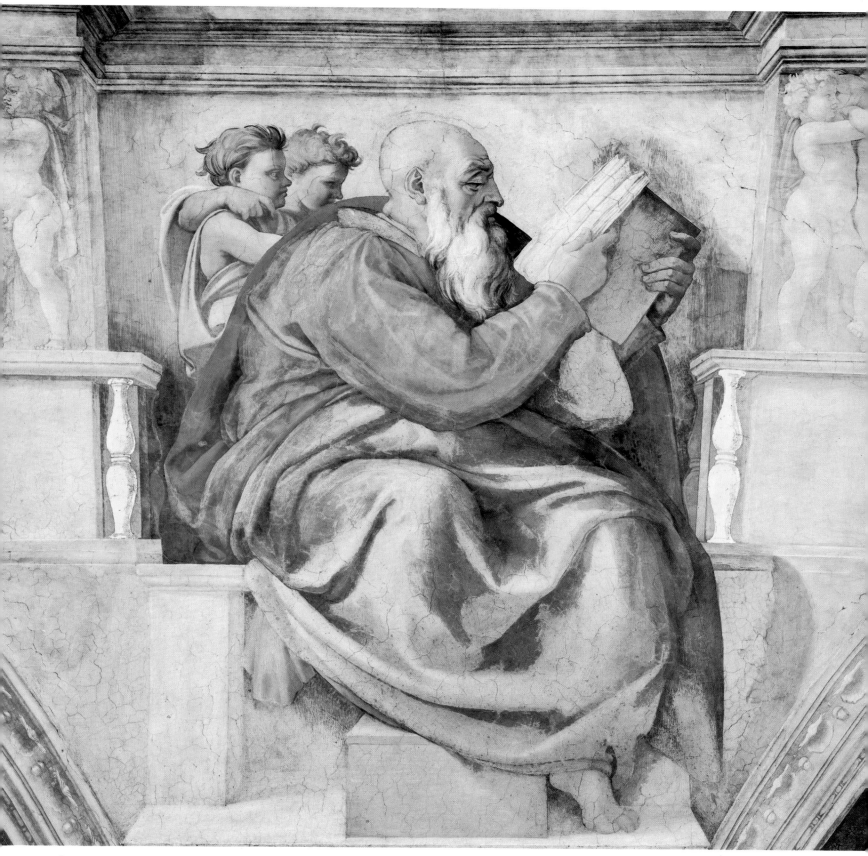

58.
ZACHARIAS. 360 × 390 cm

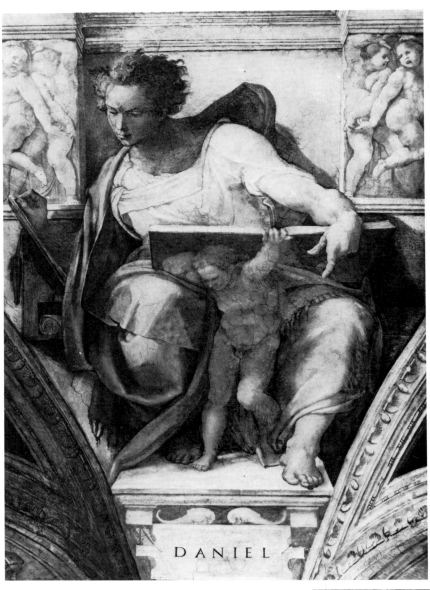

59.
DANIEL. 395 × 380 cm

60.
ISAIAH. 365 × 380 cm

DANIEL

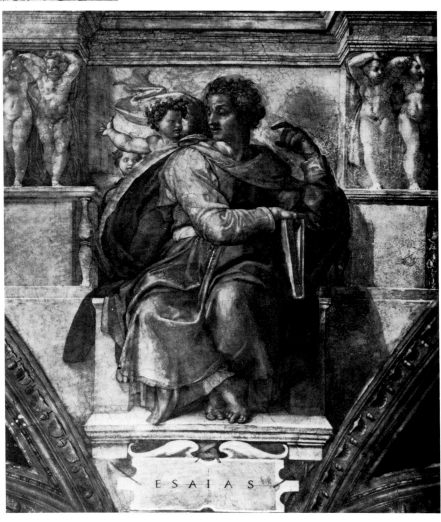

ESAIAS

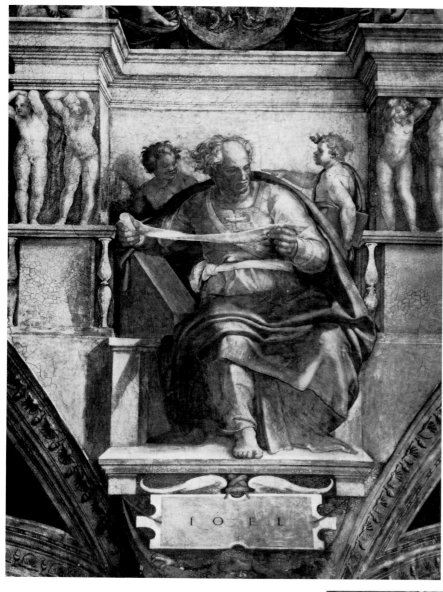

61.
JOEL. 355 × 380 cm

62.
PERSIAN SIBYL. 400 × 380 cm

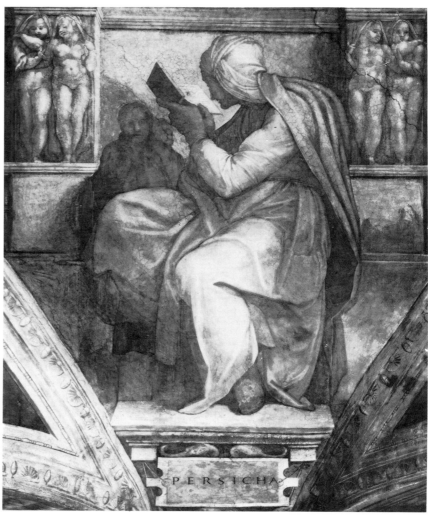

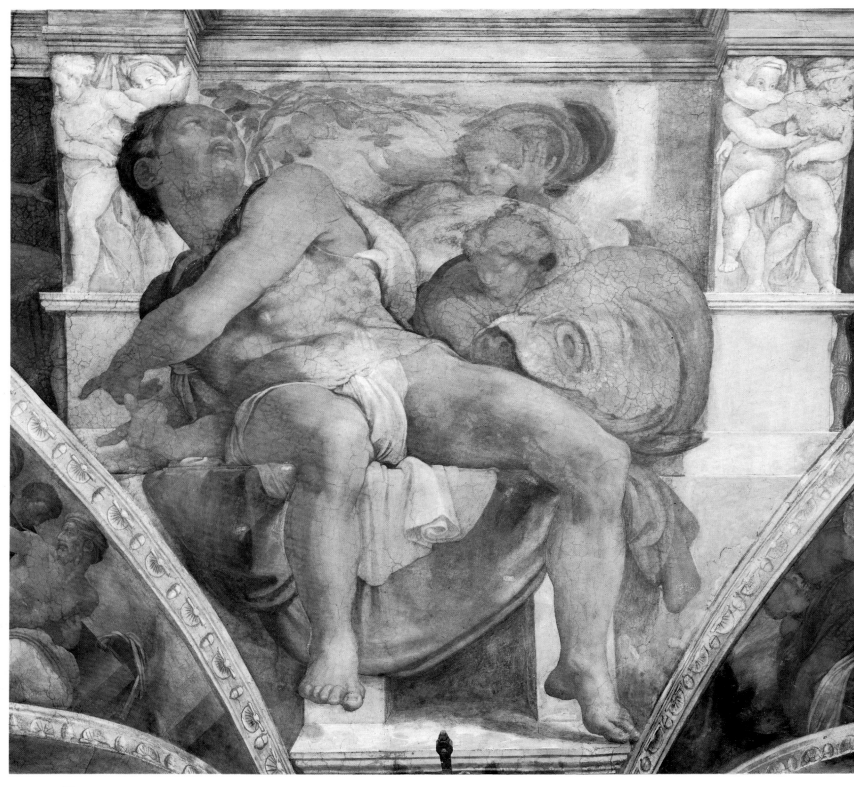

63.
JONAH. 400 × 380 cm

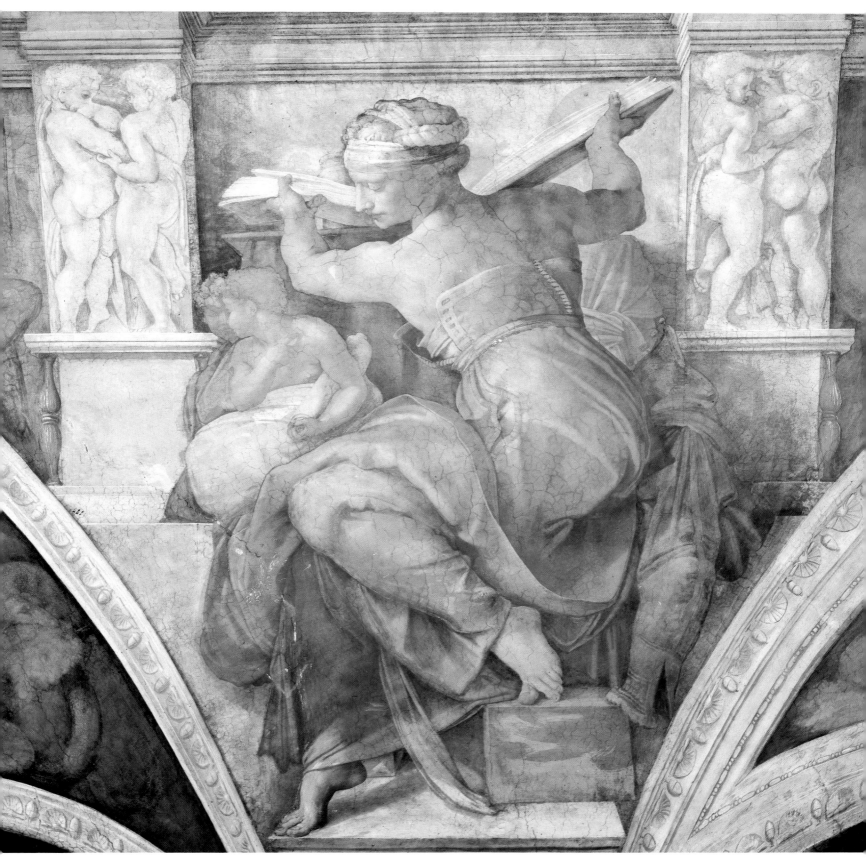

64.
LIBYAN SIBYL. 395 × 380 cm

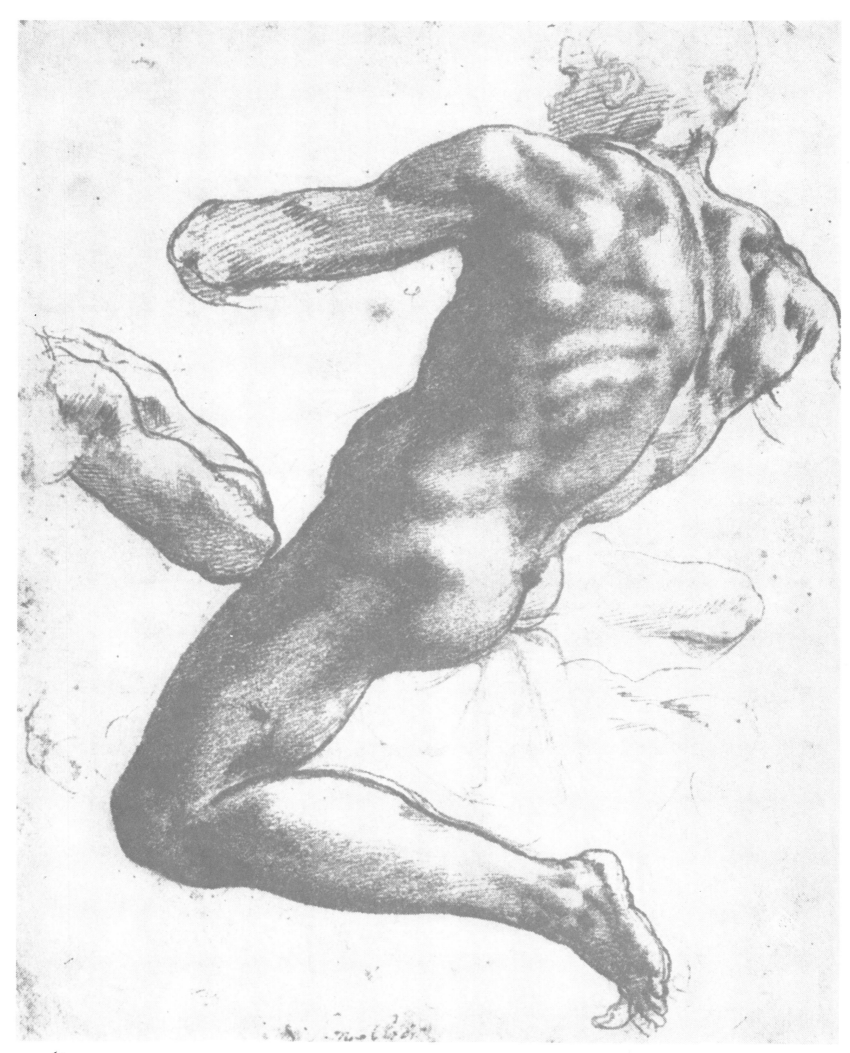

65.
STUDY FOR THE IGNUDO TO THE RIGHT OF THE PERSIAN SIBYL. 1511; Red chalk and charcoal
drawing; 27 × 23 cm; Teyler, Haarlem

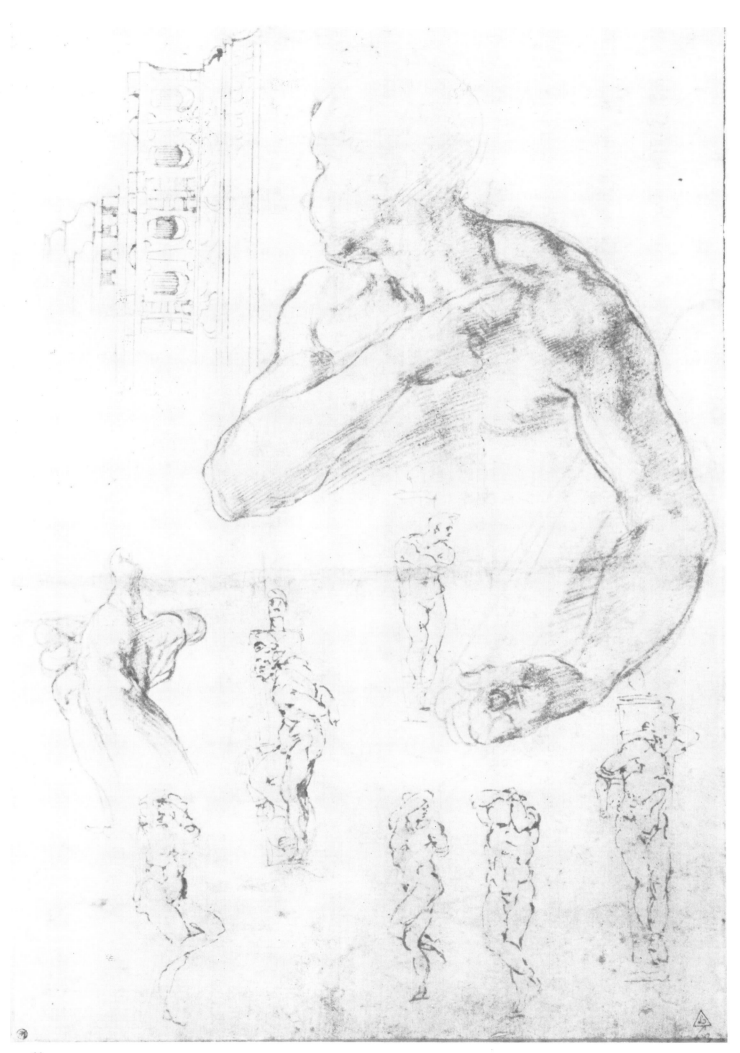

66.
STUDY FOR A PUTTO AND THE RIGHT HAND OF THE LIBYAN SIBYL, THE TOMB OF JULIUS II.
Red chalk and ink drawing; 28.5 × 19 cm; Ashmolean Museum, Oxford

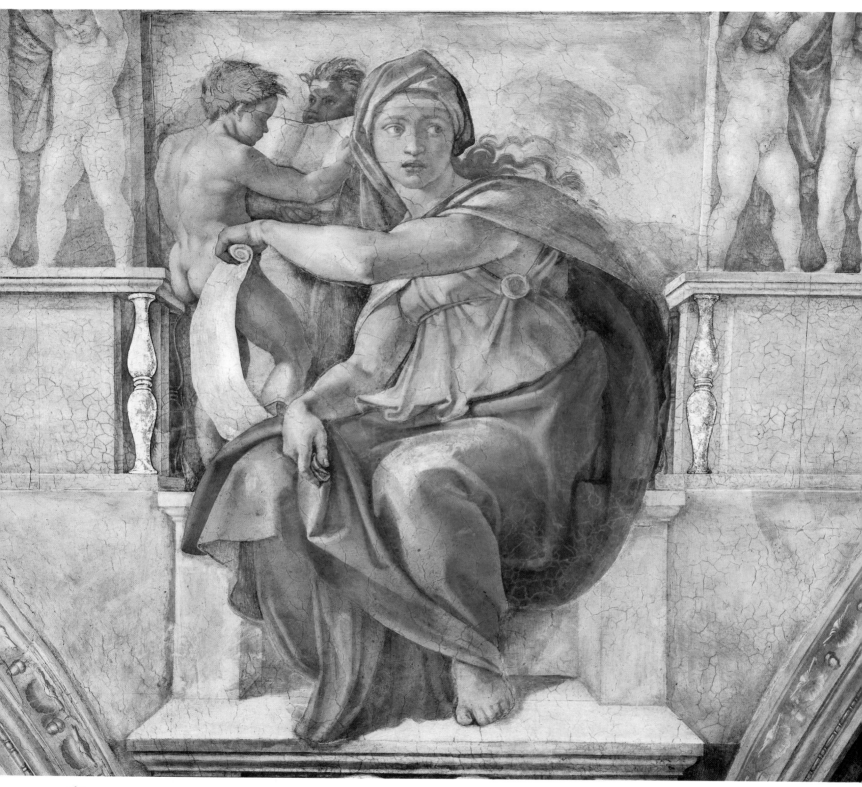

67.
DELPHIC SIBYL. 350 × 380 cm

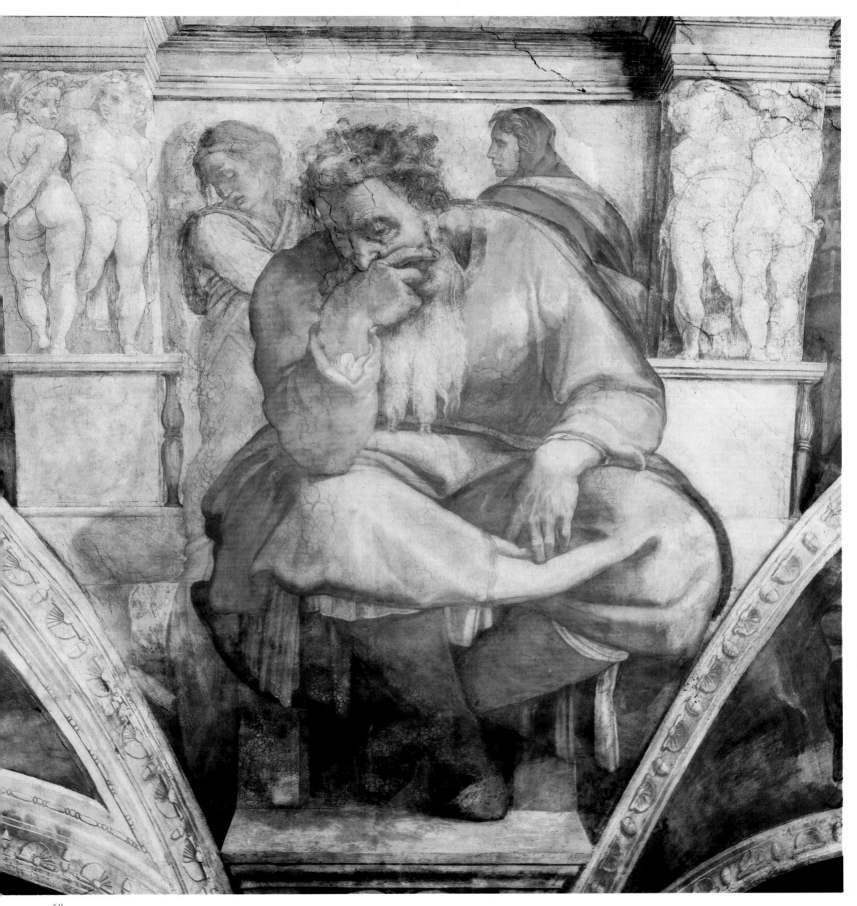

68.
JEREMIAH. 390 × 380 cm

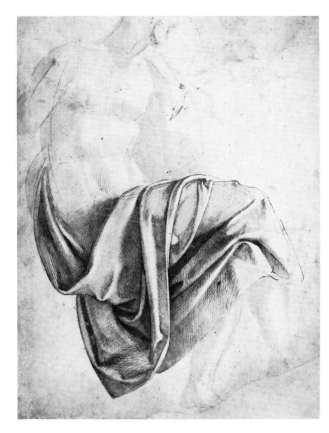

69. Right.
STUDY FOR THE ERITREAN SIBYL. 1508–1509;
Charcoal and ink drawings; 39 × 26 cm; British Museum, London

70.
ERITREAN SIBYL. 360 × 380 cm

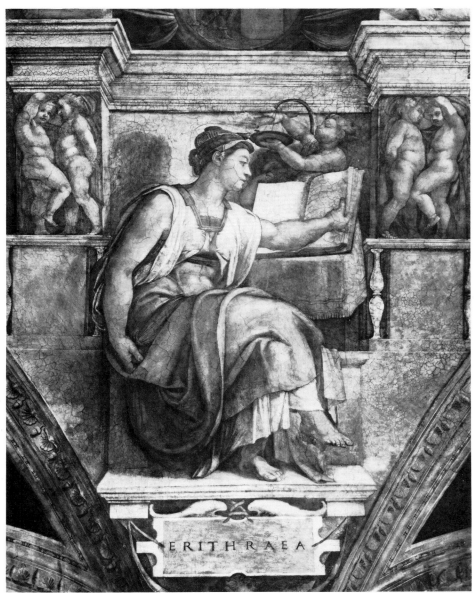

ERITHRAEA

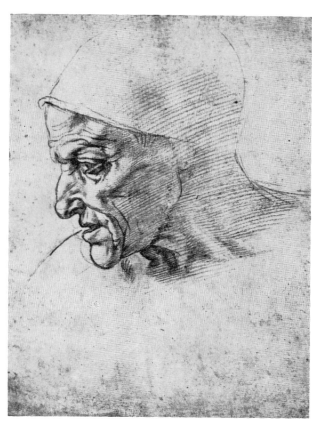

71.
STUDY FOR THE CUMEAN SIBYL; 1510; Char-
coal drawing; 31.5 × 23 cm; National Library, Turin

72.
CUMEAN SIBYL. 375 × 380

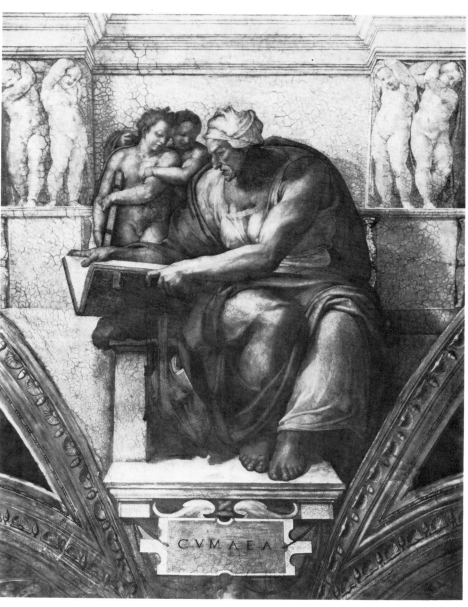

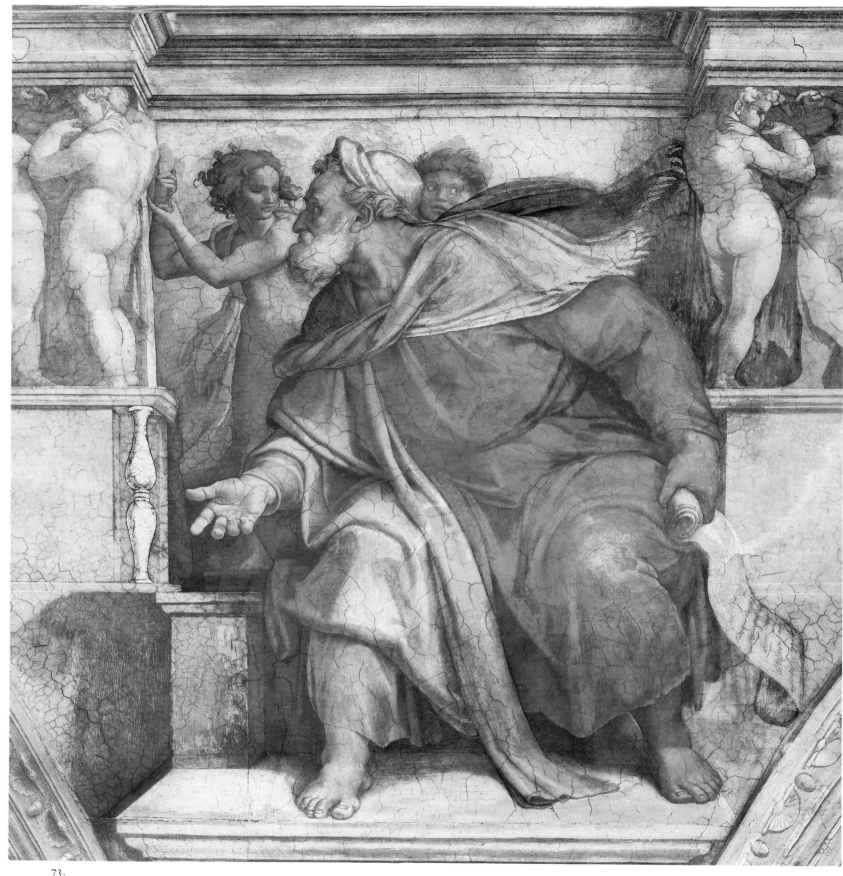

73.
EZEKIEL. 355 × 380 cm

The Ignudi (male nudes). Ten pairs of "ignudi" border the 5 small biblical scenes. The bronzelike medallions, representing a biblical scene, separate the two figures.
Fresco paintings, executed between 1508 and 1511.

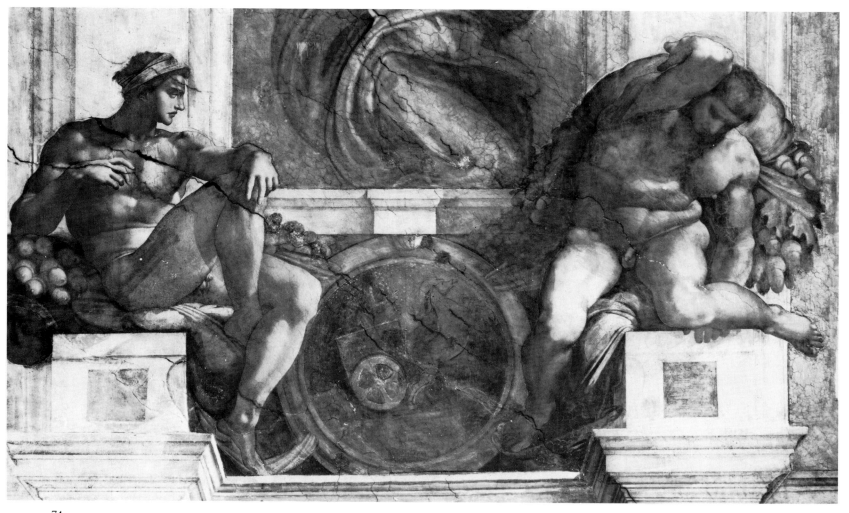

74.
PAIR ABOVE THE PROPHET JEREMIAH. 200 × 385 cm

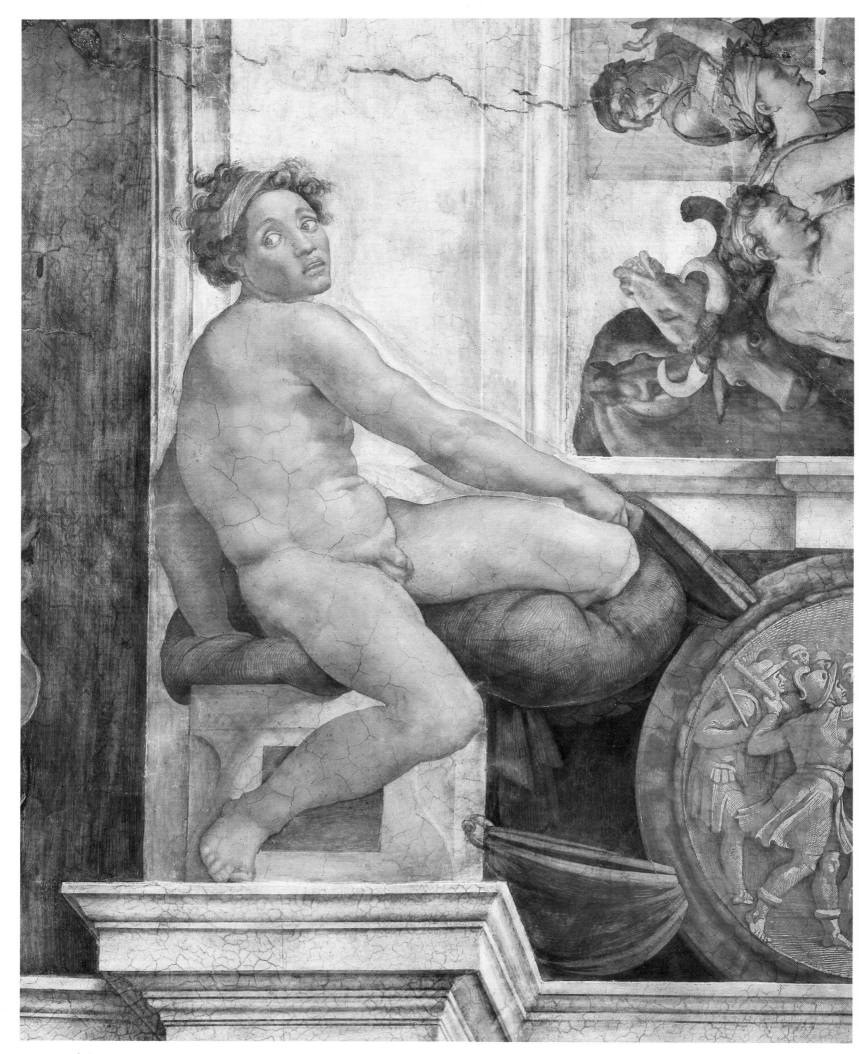

75/76.
PAIR ABOVE THE ERITREAN SIBYL. 190 × 390 cm

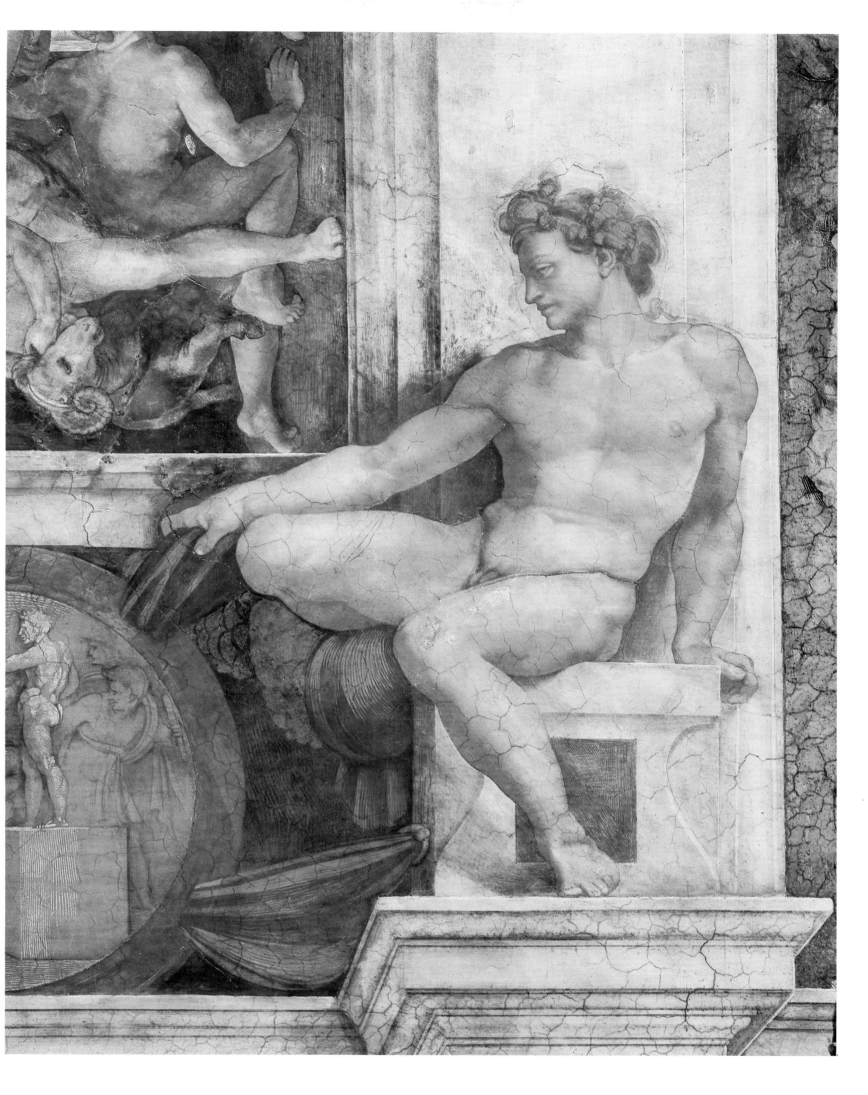

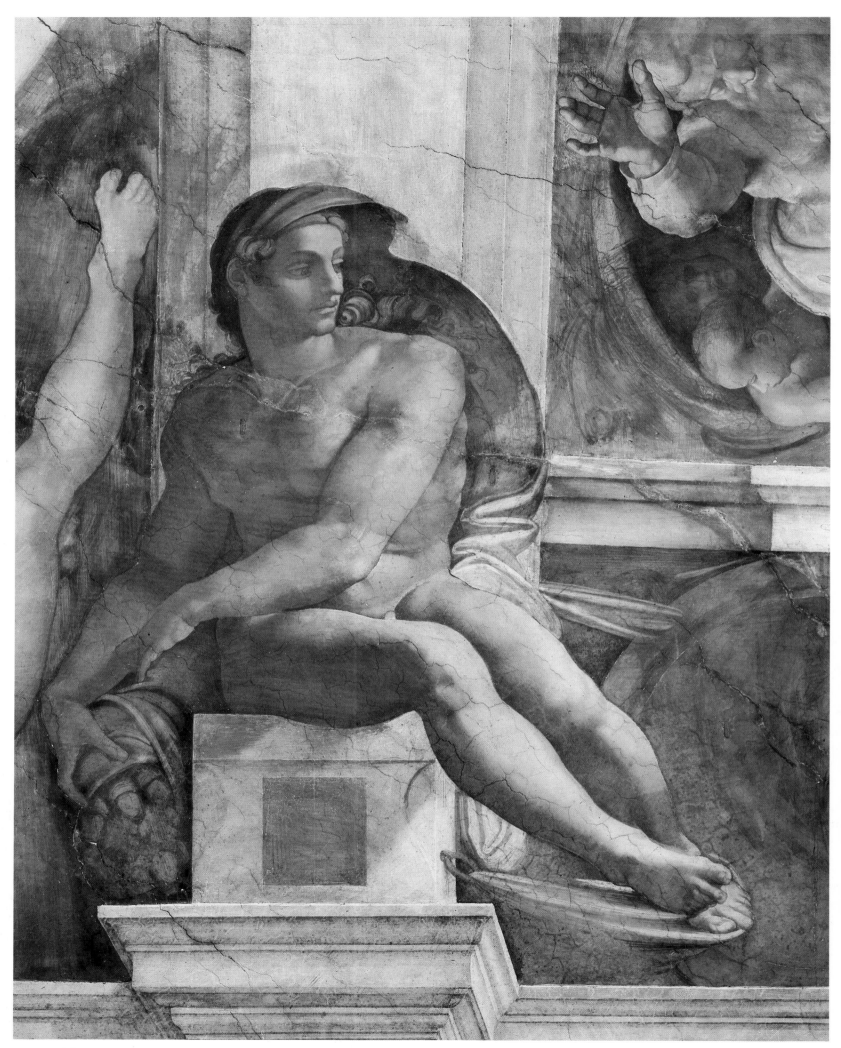

77/78.
PAIR ABOVE THE PERSIAN SIBYL. 200 × 395 cm

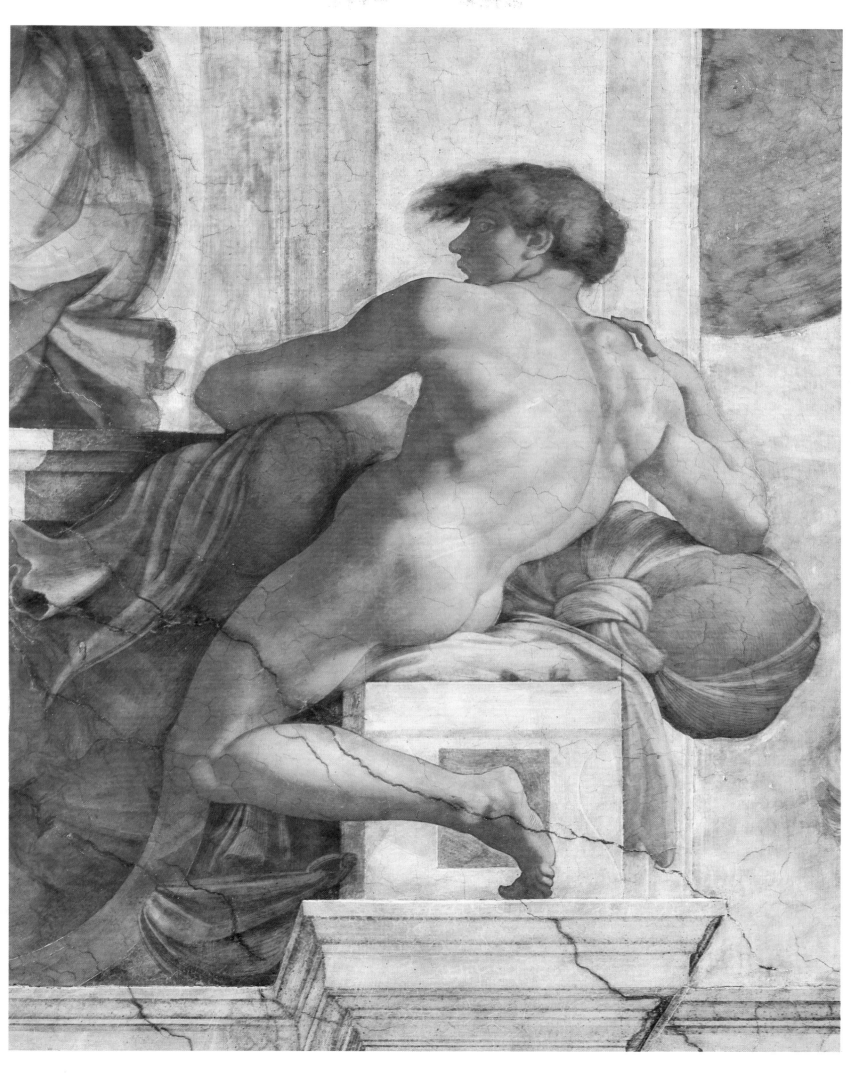

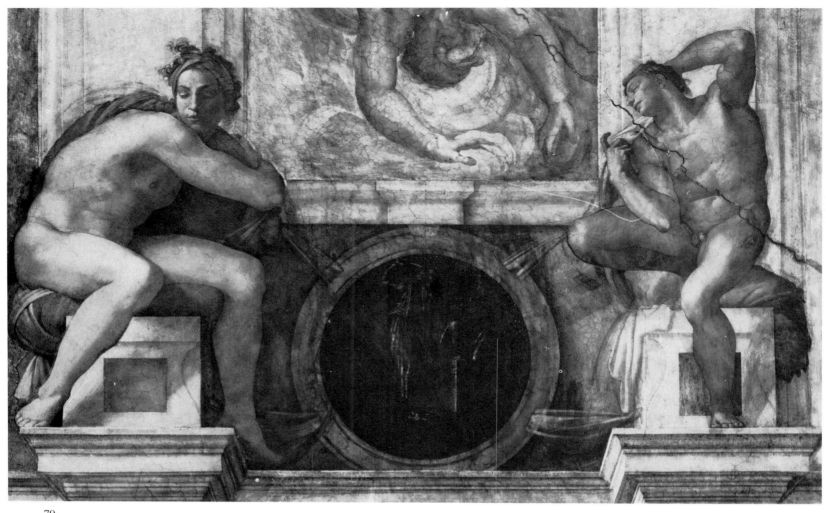

79.
PAIR ABOVE THE LIBYAN SIBYL. 195 × 385 cm

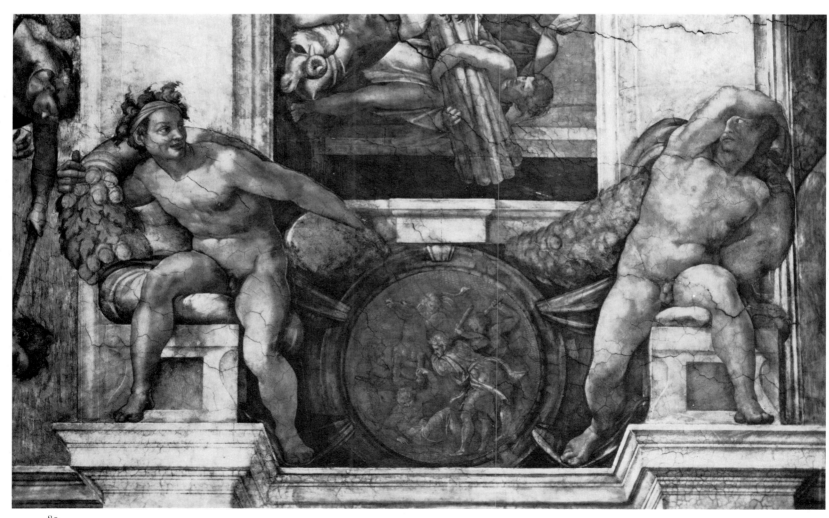

80.
PAIR ABOVE THE PROPHET ISAIAH. 190 × 385 cm

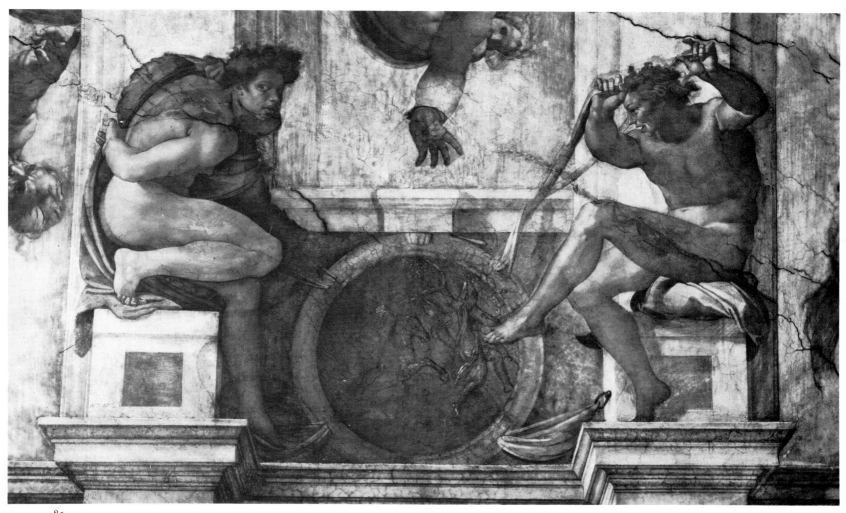

81.
PAIR ABOVE THE PROPHET DANIEL. 195 × 385 cm

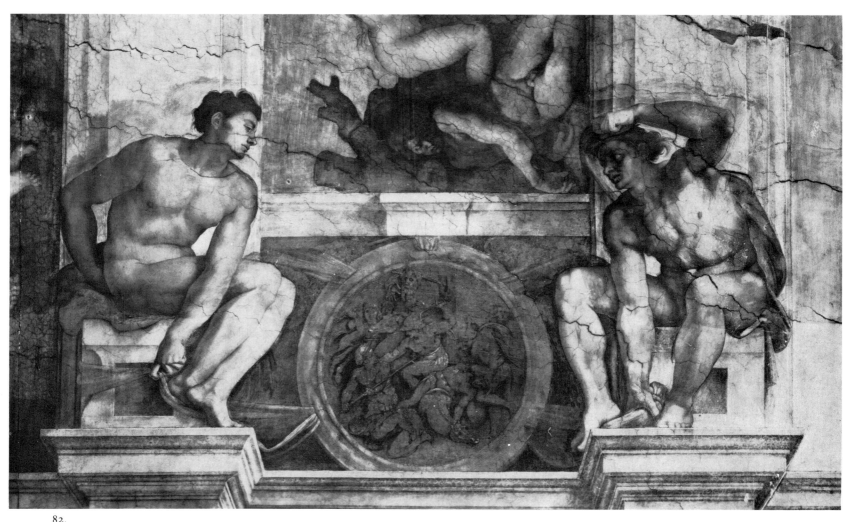

82.
PAIR ABOVE THE PROPHET EZEKIEL. 195 × 385 cm

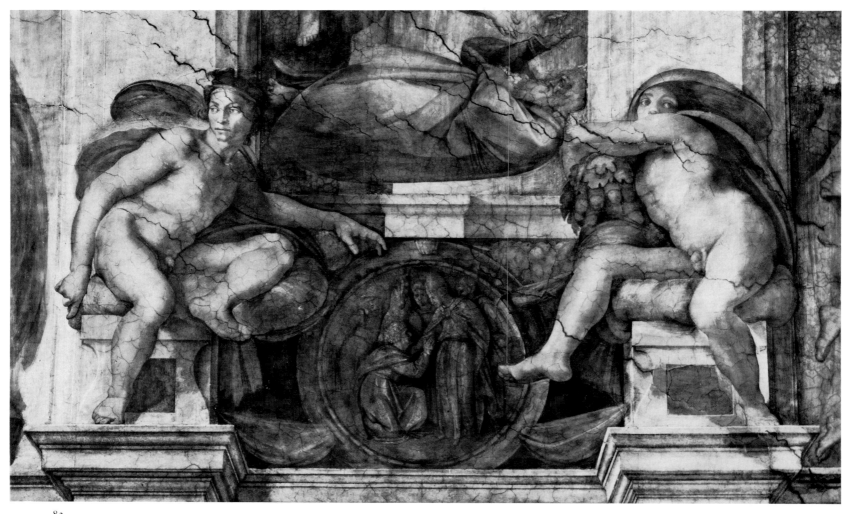

83.
PAIR ABOVE THE CUMEAN SIBYL. 195 × 385 cm

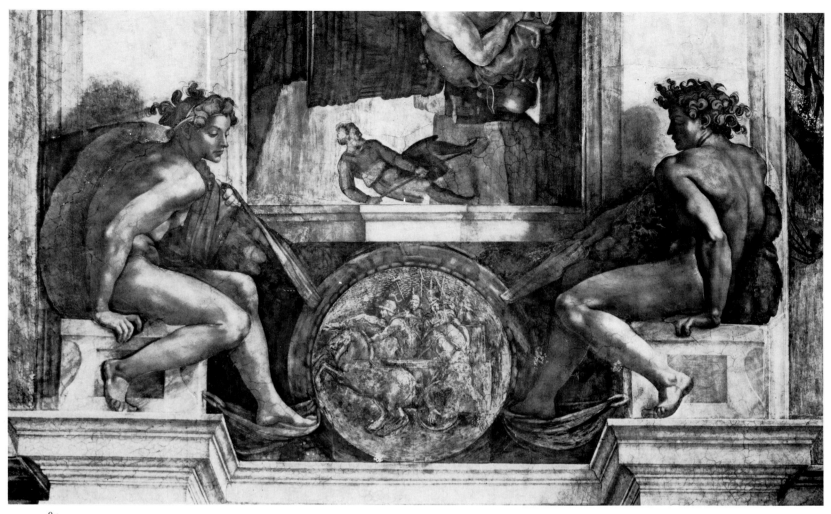

84.
PAIR ABOVE THE PROPHET JOEL. 190, 395 cm

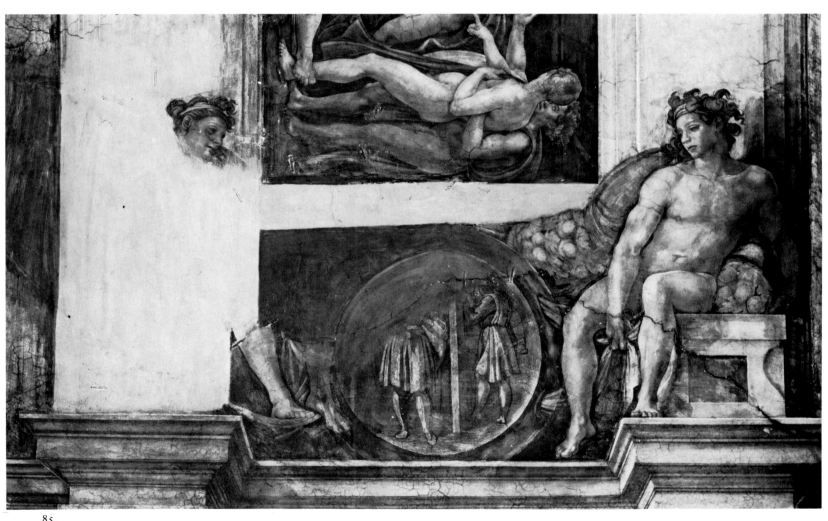

85.
PAIR ABOVE THE DELPHIC SIBYL. 190 × 385 cm

Corner Spandrels. Four scenes placed in the corners of the ceiling. Executed between 1509 and 1511.

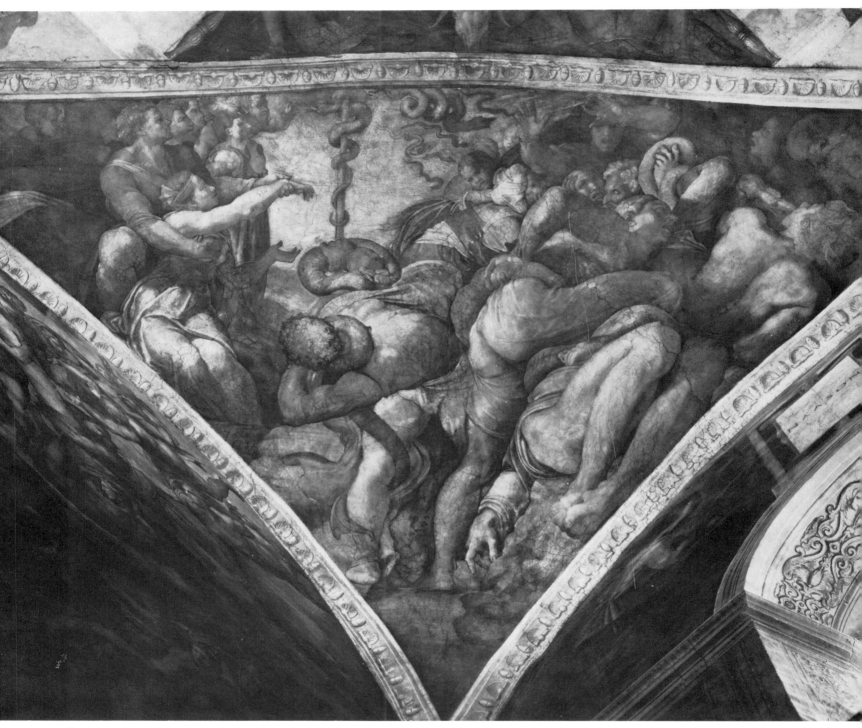

87.
THE BRAZEN SERPENT. 585 × 985 cm

88. Facing page.
HAMAN'S PUNISHMENT. 585 × 985 cm

89. Following left page.
DAVID AND GOLIATH. 570 × 970 cm

86. Following right page.
JUDITH AND HOLOFERNES. 570 × 970 cm

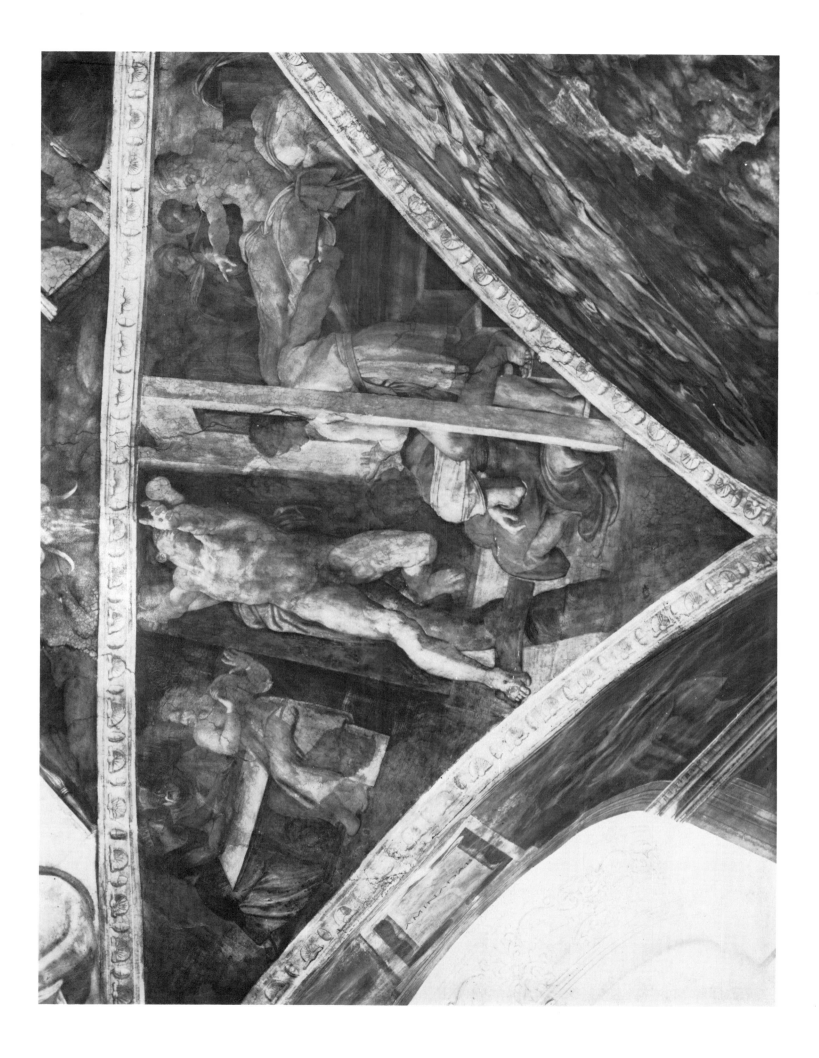

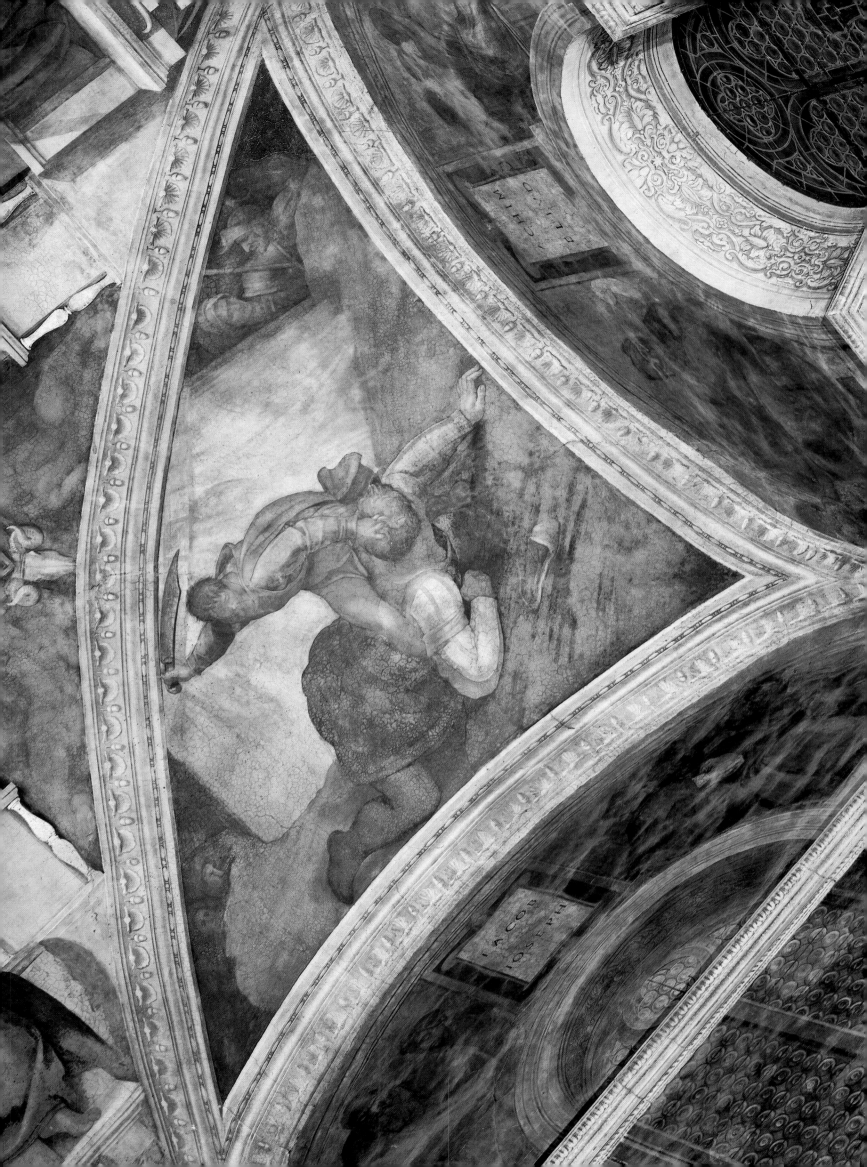

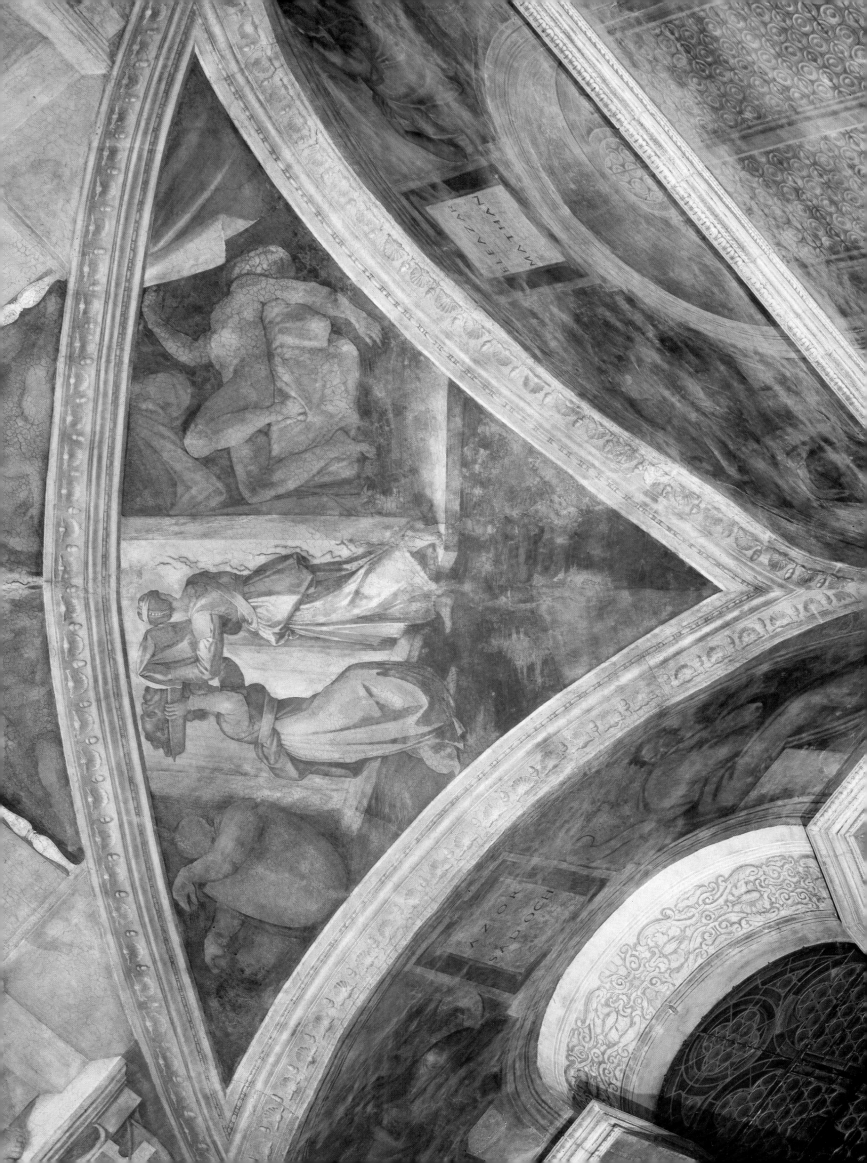

The Tympana. Eight scenes in triangular form, with a ram's skull above the top angel. There are some bronzelike nudes on the lateral sides. Executed between 1509 and 1511.

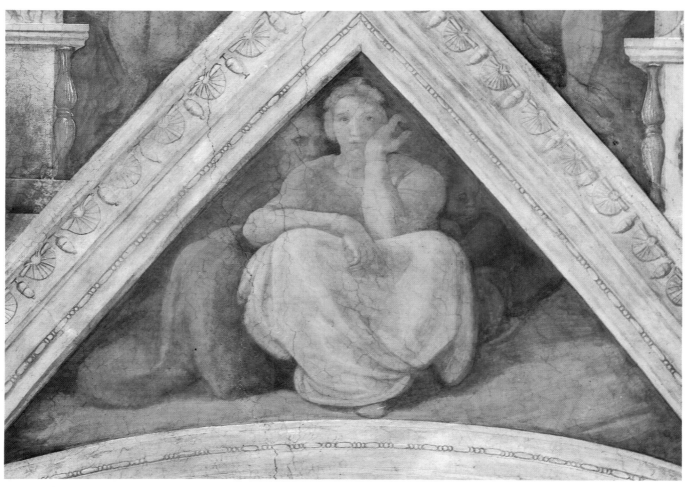

90. Above.
THE FUTURE KING JESS. 245 × 340 cm

91.
THE FUTURE KING JOSIAH. 245 × 340 cm

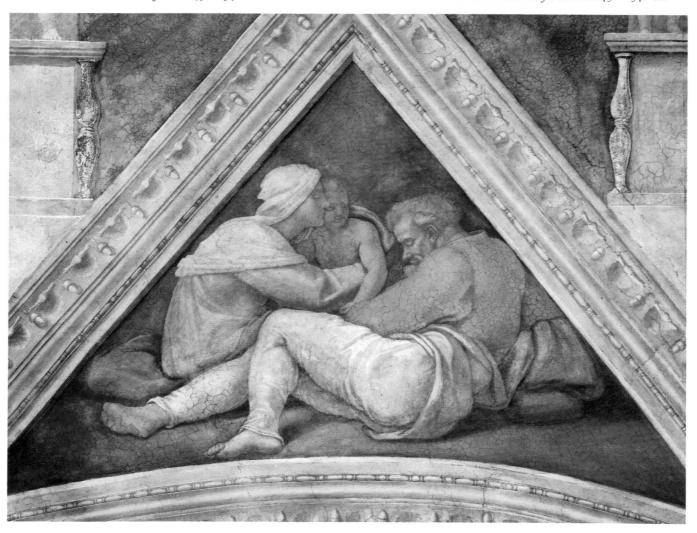

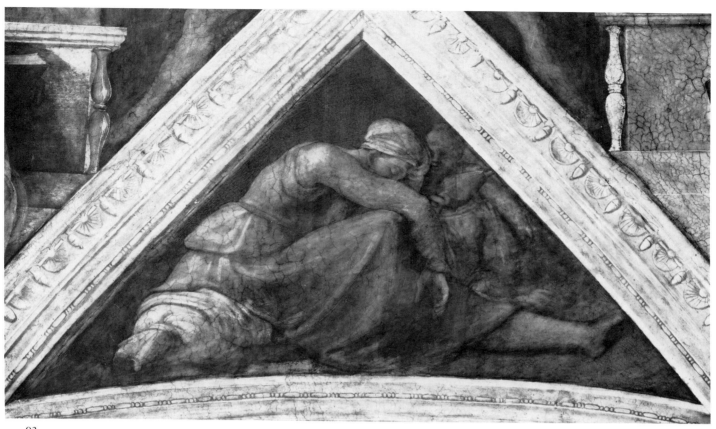

92.
THE MOTHER OF THE FUTURE KING ASA. 240 × 340 cm

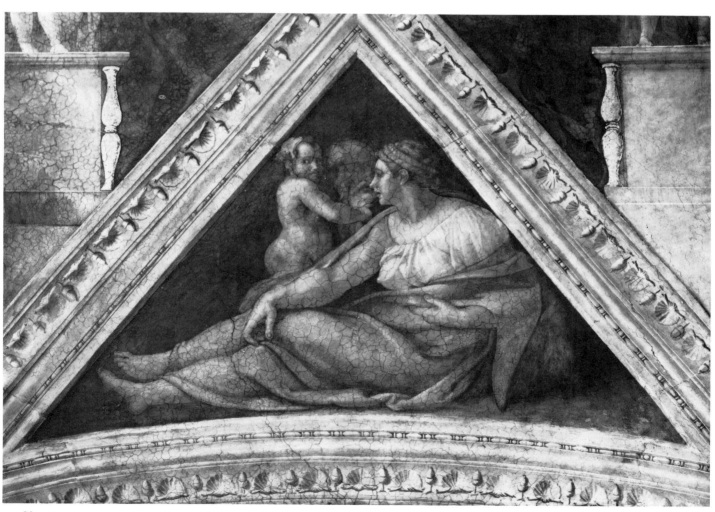

93.
THE FUTURE KING HEZEKIAH. 245 × 340 cm

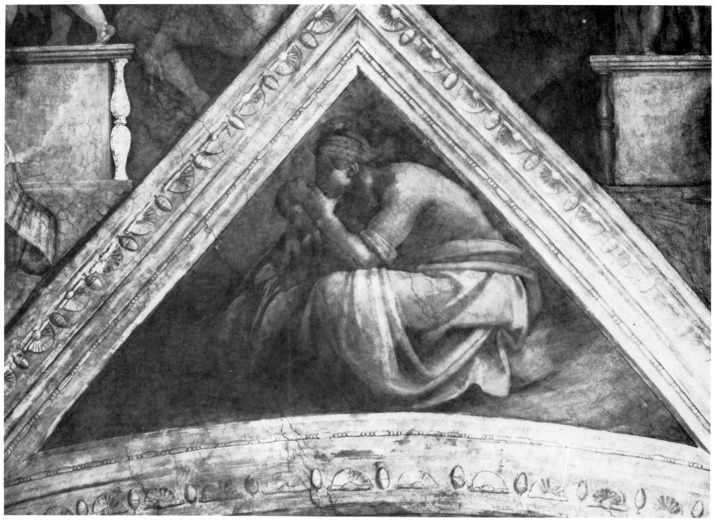

94. Above.
THE FUTURE KING REHOBOAM. 240 × 340 cm

95.
THE FUTURE KING AHAZIAH. 245 × 360 cm

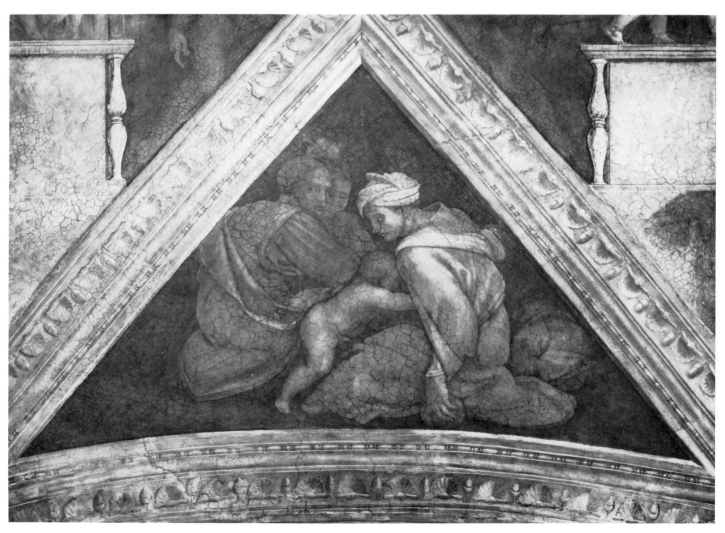

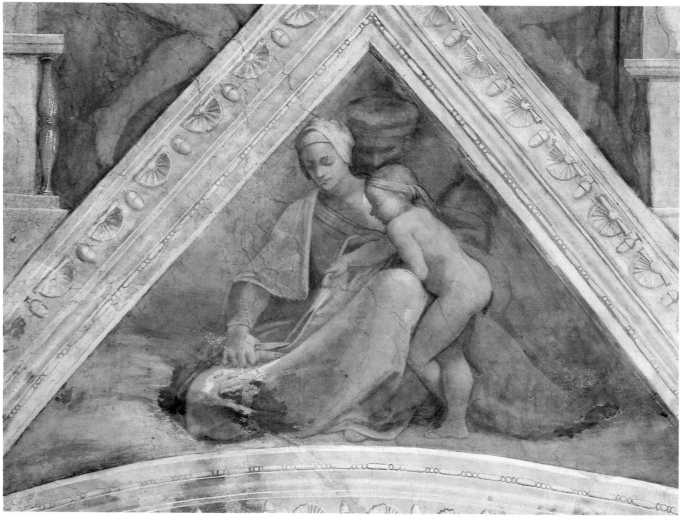

96. Above.
THE FUTURE KING SOLOMON. 245 × 340 cm

97.
THE FUTURE KING ZOROBABEL. 245 × 340 cm

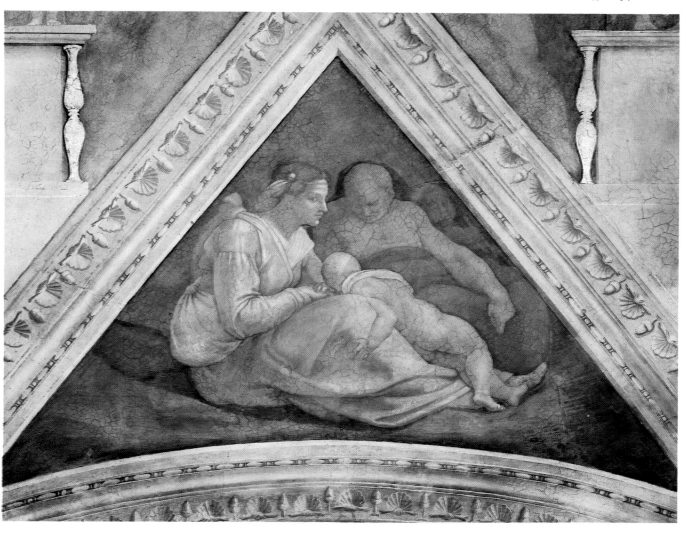

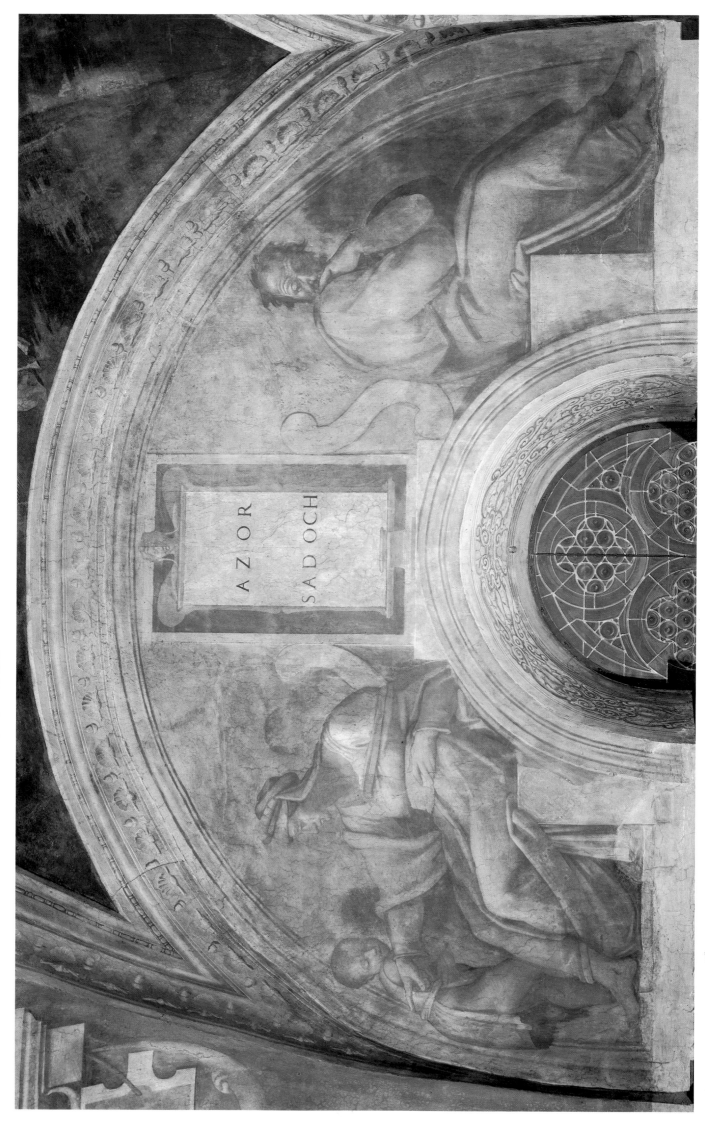

Lunettes. Sixteen semicircular scenes, intended as a liaison between the vault and the walls, represent Christ's ancestors before Abraham. Executed between 1511 and 1512.

98.
AZOR, SADOC

99.
ELEAZAR, NATHAN

100.
JOSIAS, JECHONIAS,
SALATHIEL

101.
ACHIM, ELIU

102.
JACOB, JOSEPH

103.
ZOROBABEL, ABIUD,
ELIACIM

104.
AMINNADAB

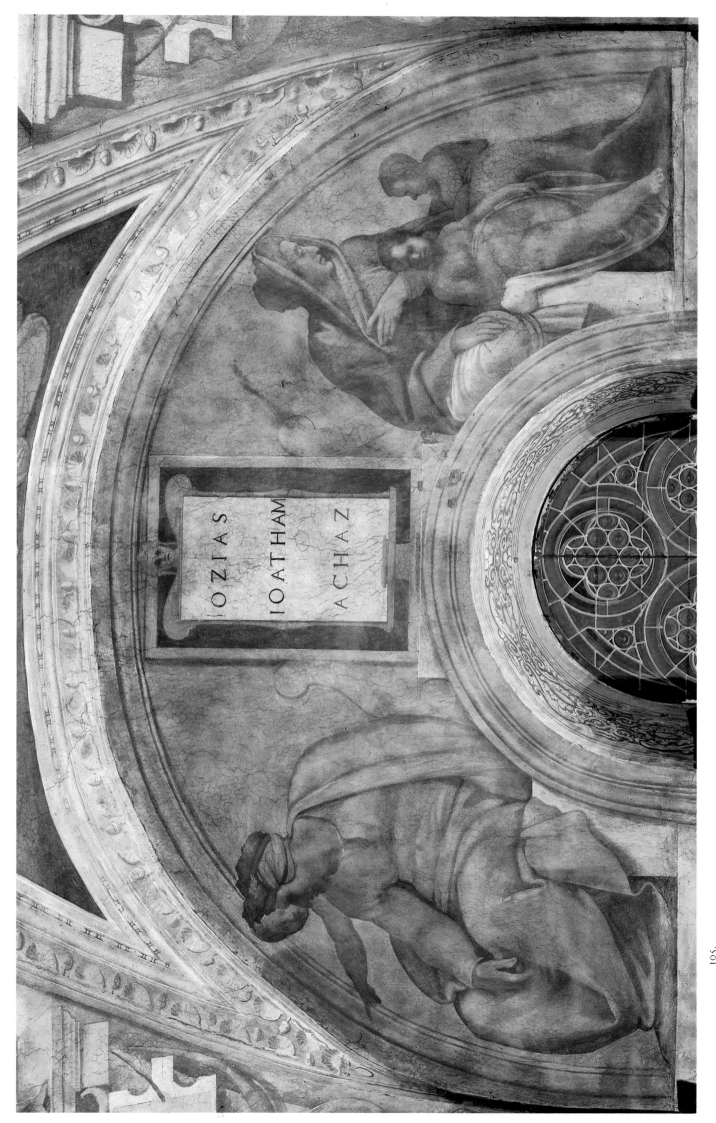

105.
OZIAS, JOTHAM, ACHAZ, ASA, JOSAPHAT, JORAN, ROBOAM, ABIAS, JESSE, DAVID, SALMON,
SALMON, BOOZ, OBED, NASSON

IV

The Tomb of Julius II: The Medici Chapel
1505–1545

On February 21, 1513, Julius II died; in his will, he requested that Michelangelo build his tomb and left ten million ducats for its realization. Approximately forty statues were supposed to decorate this new project. Between 1513 and 1516, Michelangelo sculpted two *Slaves*, destined for the tomb. In his subsequent revision of the monument, these *Slaves* were never included. In 1544 the artist gave the two statues to Roberto Strozzi, a Florentine, exiled in France, who in turn gave them to Francis I. Francis later presented the statues to Constable of Montmorency, who used them to adorn the façade of his château. In 1632, Cardinal Richelieu placed them in his own château; after the Revolution, the statues entered the permanent collection of the Louvre. In the same series of plans for the tomb, Michelangelo drew the sketches for *Moses*, the masterpiece which would be placed in the center of the lower level of the tomb, whose completion would not be definitively realized until 1545. The *Sleeping Slave*, also called the *Dying Slave* is a ronde-bosse of marble [chiseled in relief], whose height measures 2.29 meters and is clearly more advanced in its execution than the *Rebel Slave*, except for the figure of the monkey behind the body, holding a mirror in its hand. Of the *Sleeping Slave*, Condivi wrote that it represents art incarnate which has fallen asleep following the death of Julius II. The subject is, in fact, the ideal body of an adolescent boy, dozing and relaxing in a slightly equivocal pose. The hands of the slave seem to support the body at the same time as they caress it or even gently push away the light ties that bind his chest as if in a dream. Drawn in *contrapposto*, the body is muscular without being exaggerated and is organized in levels to create a harmonious counterpoint of stability and imbalance on the almost perfect vertical axis of the left side, which assures the organic unity of the whole. The right side of the slave, curved inward, seems to be the fulcrum of slumber whereon resides the circular movement of the chest contained in the rhombus formed by the two folded arms. Planned in geometric balance, this slave is an unconscious body, offering itself in voluptuous resignation.

In contrast, the *Rebel Slave* belongs to a group of germinal sculptures of Michelangelo, sculptures where the master expresses the metaphor of his craft, carving a form at the same time as he expresses his profound conception of human existence, forcing it out of the primal indifferent energy of the marble toward the ideal figure, tempted by the resemblance to a mythic celestial being. It is easy to understand why Michelangelo was never able to resolve the problems inherent in the art of portraiture. These germinal sculptures, from the *Battle of the Centaurs* to the last *Pietà*, even the unfinished *Saint Matthew*, express the same tension between the apathy of the marble and the necessity of a face, of an energy in gestation, where the form brings the drawing to life. The *Rebel Slave* represents a compact mass of muscular force in action, trying to liberate the arms tied behind the figure. By rooting the right leg onto a natural step, the sculptor accentuates the tension to which the whole of the body is subjected all the way to the head, which is tilted toward the left shoulder in a supreme effort to free himself; the slave, eternally tied, is at the dawn of resignation. The monstrous mass of his shoulders and of his back have reached the limits of his capacity, the resistance remains, the desolation of a face, imploring heaven, is already evident.

A monument to domination and wrath, a monument to passion and will, *Moses* is a psychological monument. Between the Bolognese portrait of Julius II and the prophets of the Sistine Chapel, which it somewhat resembles, *Moses* belongs to the cycle of enthroned figures, where the artist of works from *David* to the Medici portraits of San Lorenzo, established an intense and ideal moral statement of the persons represented. The lawgiver of the Jews is presented here in a complex articulation, endowing the sculpture with all its richness, yet allowing for a multiplicity of contradictory interpretations, summarized by the lengthy study which Freud devoted to the work, which demonstrates explicitly that what were originally though to be numerous aberrations were merely errors in observation. This sculpture can be codified by two complementary registers, its study of anatomy, and its permanency. The significance of *Moses* resides in his character, in the movement which distinguishes the sculp-

ture, in the personality which gives it life; the hero is also identified in the context of a decisive moment of his existence.

In order to represent the personage who symbolizes liberation from the Egyptian yoke, Michelangelo drew the lines of a muscular, patriarchal colossus, who is official, vunerable and passionate at the same time. In addition to Freud's interpretation, Henry Thode has probably synthesized the best description of the statue.

> Here, as always, Michelangelo envisioned the depiction of a character type. He draws the figure of a passionate leader of men, who, conscious of his task as a divine lawgiver, clashes with the incomprehensible human opposition. There is no other means to characterize such a man than to emphasize the energy of the will by bringing to light an emotion which shines through the apparent calmness of the exterior, an emotion which is shown in the movement of the head, the tension of the muscles, the position of the left leg. It is the same means of expression he used for *Active Life,* the statue of Giuliano in the Medici Chapel. This general characteristic is emphasized by highlighting the conflict through which such a brilliant molder of men, raises himself to the level of generalities: anger, contempt, pain attain a universal expression. Without this, it is impossible to understand the essence of this superman. It is not an historical figure that Michelangelo has created, but a universal character of insurmountable energy, conquering the rebellious world. And in so doing, he has combined the features from the Bible and from his own life, with the impression of the personality of Julius II and also—I would willingly believe—the fighting spirit of Savonarola.

While the moral intensity of the personage is now well established, he still seems to be engaged in some action, which cannot be determined at first glance, nor can we place the moment, the rise or fall, in which the sculptor has chosen to immobilize his subject. This initial vagueness lies in the dual conception of the statue, in the thoughtful and well established permanence of the character, who however encounters an activity or a series of internal perturbations that contradict the undaunted external bearing of the figure. The projection of the left foot deeply into the interior portion of the sculpture, the disorder of the curls of his beard at the right side, while the face of Moses is turned toward the left, the right index finger that compresses and holds back the beard, and finally The Tablets of the Laws, which we believed for a long time, due to blind submission to the text of the Bible, that Michelangelo had depicted at the moment when they were about to be smashed to the ground, even though the right arm of Moses holds them firmly against his side and on the base of the chair where he is seated; the traditional interpretation of these synchronized movements echoing the biblical text, can be summarized in the following argument: Moses has come down from the mountain, where God had engraved the Laws of the people of Israel on the Tablets. As Condivi describes it, "He is seated like a Sage in meditation," when suddenly for some reason something attracts his attention on the left, where he angrily discovers that the people have forged the idol of a golden calf; Moses, in his fury, is about to hurl himself at the idolaters to annihilate them; this involuntary movement is expressed by the horror, the dread, the action directed towards himself before turning it outward, the right hand holding back his full beard, the Tablets sliding and about to crash to the ground, the left foot already lending support for the imminent plunge.

Freud's text, with great insight, points out the inconsistencies of this description regarding the statue itself. The precision of Freudian analysis confirming the conclusion of other studies proves, on the contrary, that Michelangelo has captured Moses at the movement when his anger has subsided, and renouncing the movement that would draw him away, he prefers to protect the Tablets from falling by suppressing his rage. Freud concludes:

> What we see is not is not the beginning of a violent action, but the remains of an emotion which has died out. He had wanted in a burst of rage, to rush, to take revenge, to forget the Tablets, but he has conquered this temptation, and thus will remain seated, his furor controlled in a sorrow mixed with contempt. Nor will he throw the Tablets onto the stone to break them, for, it is because of them that he overcome his anger, it was to save them that he overcame his passionate rage. While he was surrendering to his indignation, he had to neglect the Tablets, to withdraw the hand that was holding them. They began to slide, they were in danger of breaking. It was that moment that he came to his senses.

1505 plan

1516 plan

1513 plan

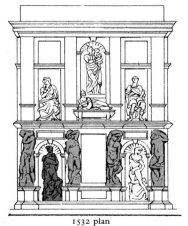

1532 plan

Charles de Tolnay's drawing re-constructions of the Tomb of Julius II.

He thought of his mission, and because of it, he refused to satisfy his passion. He pulled back his hand suddenly and saved the Tablets before they could fall. He remained in that waiting position, and that is how Michelangelo represented him as the guardian of the tomb. A triple stratification in the vertical direction can be seen in this statue. The features of the face reflect the emotions which have become dominant, the middle of the body reveals the signs of repressed movement, the foot indicates by its position the planned action, as if the control of the self had progressed from top to bottom.

From 1505 to 1545, Michelangelo worked continuously on the tomb of Julius II. Even though successive commissions that the artist received often distracted the sculptor from his work, the heirs of the Pope were always there to remind him of their rights established in the contract. From the time of the initial proposal of a monumental and grandiose tomb to to the work actually realized, six versions followed one another. It was on August 20, 1542 that a new and final contract would stipulate which figures would be placed in the entire tomb. The *Slaves* were finally rejected by the sculptor, who no longer believed that he could integrate them into the structure. From his previous projects, the sculptor only retained *Moses,* placed in the middle of the lower level of the monument, between the two full length figures of *Active Life* and *Contemplative Life.* The upper story, where *Moses* and *St. Paul* were originally planned, would now be occupied by a prophet and a sibyl dominated by a statue of the *Madonna and Child,* placed in the upper center of the structure in the corolla of a niche. At the feet of the Virgin, on the sarcophagus, lies the Pope with his head raised. There is no doubt that this monument, so diverse stylistically, corresponding on each level to a different conception, decorated by sculptures of minor importance on the upper level, was not one of the artist's major successes. The *Prophet,* the *Sibyl* and the *Madonna,* works of Michelangelo's assistant, Raffaello de Montelupo, lack noteworthy expression; the statue executed by Tommaso Pietro Boscoli, the architect of the upper level, the Papal shield at the top of the monument, were all the work of assistants of the master. In contrast, on either side of *Moses,* the two figures of *Rachel* and *Lea,* were the last states completed by the hand of the master. *Rachel* or *Contemplative Life,* as Dante described it in *Purgatory,* expresses religious vocation. The general ascending motion of her body, seen in the folds of her garment to her raised head, gazing heavenward, her folded hands expressing the elevation of her spirit towards the celestial regions. As de Tolnay described her, "Faith is conceived by the artist as a dissolution of the being into a superior sphere." In contrast *Lea* is an earthy woman, almost heavy, lush in calm and balanced physicality. The thick and peaceful roundness of the statue evokes the feeling of a quiet softness together with a generous and noble abandon.

Installed in San Pietro in Vincolo, the Mausoleum of Julius II, despite its almost disparate characteristics, following the new inclination of the artist, is still a moving testimony to faith and energy. While we can certainly regret the lack of coordination between the two levels, and the relative banality of the statues of the upper level, we cannot deny that the fascinating power of *Moses,* and the spirituality of *Lea* and *Rachel* make this monument a remarkable masterpiece of the master.

With the deaths of Leonardo in 1519 and Raphael the following year, Michelangelo stood alone; Sebastiano del Piombo, his disciple in Rome, was not his equal, nor was Giulio Romano, Raphael's disciple. Although the façade of San Lorenzo, which was to have been an ostentatious manifestation of the power of the Medicis, was abandoned, Leo X and the Cardinal decided to construct a chapel next to the church to house the tombs of the Dukes Giuliano and Lorenzo de´ Medici. This project, once again, would have some difficulty in being realized. While Giulio de´ Medici was fighting the French in Lombardy, Leo X died suddenly in 1521. In 1522, Adrian VI of Utrecht succeeded Leo X. The heirs of Julius II despairing of finally seeing the tomb completed, asked the new Pope for arbitration so that Michelangelo could devote himself to the work, for which he had been paid in advance; at the same time the Cardinal de´ Medici wanted to resume the project of a monument worthy of his family which would be entrusted to the master. Michelangelo, in favor of this project, asked the Pope to free him from his obligations to the heirs of Julius II. The death of Adrian VI, who reigned less than a year, left the decision in abeyance. On November 19, 1523, the Cardinal Giulio de´ Medici was elected Pope and took the name of Clement VII; and this election served the interests of the Florentine artist. In fact, the construction of the sacristy of San Lorenzo was immediately approved and the construction of the library rejected. Michelangelo began work on two statues, among the only portraits he ever executed, even if they bear no resemblance to the

subjects, Giuliano and Lorenzo de´ Medici, descendants of Lorenzo the Magnificent. These two statues which today dominate the respective tombs of the two men in the general context of the architecture of the sacristry, epitomize the formal and spiritual difficulties of the artist, as well as the aforementioned twofold etching of principles and expression. The general plan of the Medici Chapel, a hierarchic and abstract matrix of geometry and light and the volume of the chapel itself, enhanced by the subtlety of the tomb, is the most significant manifestation of the multiple resources of the art of Michelangelo.

Giuliano de´ Medici
(Duke of Nemours)

In the first project, Michelangelo had conceived a central cube, each side of which would house the tomb of the two generations: Lorenzo the Magnificent and his brother Giuliano, then those of the Duke of Urbino and the Duke of Nemours. The hugh central structure, for reasons of the general harmony of the building, was abandoned in favor of four lateral tombs on each interior side of the chapel: finally the project was reduced to two tombs for the dukes. These tombs are formed by superimposing three levels from the bottom to the top, first the sarcophagus containing the remains of the captain surmounted by two reclining figures in parallel and opposite positions, which represent moments in time, *Dawn* and *Twilight,* for the tomb of Lorenzo, *Night* and *Day* for the tomb of Giuliano. The upper part consists of three niches, or false windows, the central niche containing the statues of the dukes, both in seated positions. It is probable that Michelangelo drew a symbolic journey from the location of the remains to the portrait; the official shape of the sarcophagus, the remarkable opaqueness and density of the coffins express the cold brutality of death, but we must note the symbolic opening of the tops of the coffins between the statues of time, which leaves a space leading to the figures of the dukes. These temporal figures, mysterious, eternal but also physical and restless, we might call them contingent, weighty, and ethereal, are the condensed narration of the human existence which governs those who, beyond death, could remain heroes for the living. These heroes reveal the source of their energy by both fixing their gaze on the *Madonna and Child,* enthroned on the altar, positioned against the wall facing the entrance of the building. It is evident that the fascination evoked by this spatial organization is due to the metaphysics expressed in a diversified and formal progression. The two captains are represented in uniforms of antiquity, which serve to idealize the warriors; their poses, however, are dissimilar. Giuliano is shown as a man of action, neck tensed, head scanning the horizon, holding on his lap his commander's bâton, his bearing is reminiscent of *Moses.* Lorenzo, on the other hand, is depicted in a moment of reflective repose, almost languid, he is dreaming under the visor of his helmet. His left elbow is supported by a small box on which is engraved the mask of a bat. The general posture of Lorenzo is derived from the prophet Isaiah as he appears on the ceiling of the Sistine Chapel. The two couples of the *Figures of Time* placed under the statues of the dukes are unfinished. *Night* and *Day* which decorate the tomb of Giuliano, *Dawn* and *Twilight* on top of Lorenzo's sarcophagus is a *ronde-bosse* of marble, an allegoric symbol, which represents more vividly than any other statue, the artist's own vision of existence.

Lorenzo de´ Medici
(Duke of Urbino)

A very intense and vague melancholy caresses these bodies, where a sense of drama and sincere weariness coincide. These powerful and demonstrative bodies, which require immediate expression of the concept they represent, are also very sluggish as if they were awaking to a definitive and perfect form which they can never achieve. It is not known if someone insisted on the duplicate character of these pieces, on the heterogeneous carving of their bodies; Michelangelo inscribed in that incoherence, miraculously preserved, his own existence and all existence, between the world and reason; these statues are inventories of the disparity of feelings and events. This disparity, this continuous accident of human existence, the unfathomable latent energy of these statues places them in the metaphysical unity of the representation of a exemplary destiny.

In order to ensure the connection between the parts in any spatial organization, it is appropriate to establish a unifying center, an axis for the distribution of orders in a hierarchy, an indication of the course each of the different categories will take. In this chapel, where the materiality of history in time abounds, Michelangelo, faithful to his principles, has not forgotten to crown this superb formal orchestration with the symbol which assures perspective, using as an intermediary, the gazes of the captains, which consider in the *Madonna and Child,* the source and destination of their existence. This pensive Madonna, whose child is turned toward her breast, seems doubly abstract. While the Christ child is perfectly cut and polished, she remains unfinished herself, reserved, at the center of all these figures, she appears to be more than she is, serious, spiritual, but maternal in the way her left hand holds the little body, for this group of statues, haunted by the melancholy of the figures of time lying on death. The

Virgin culminates in the vision of ultimate return, where the circle of destiny unites in the tranquility of the figure of the divine.

In closing, we cite de Tolnay, who brings a sensitive conclusion to this sublime work which he compares to the plain-chant of the Sistine Chapel: "While in the vault of the Sistine, Michelangelo predicted, through the 'ritorno a Dio' the ascent of man toward the divine, in the Medici Chapel he evokes through the life of the soul beyond the grave, an existence of contemplation of the essence of life which reminds us of the souls in the dark region, Hades. These characters are deprived of action and are only shadows of living existence, phantoms of memory, freed from human tribulations. If the vault of the Sistine represented humanity's past [Genesis] reflecting its future ["deificacio"], the Medici Chapel represents the image of the future of souls which is shaped by all the past. While the vault which glorifies the triumph of the creative and active forces, was the "ideal portrait of the soul of an artist at the height of his life, the Medici Chapel, full of mournful poetry and contemplative wisdom, is the image of a man who already feels his end approaching."

Julius II continuously waged war, multiplying and changing his alliances according to his interests, frustrating the plots of the States against the pontifical power. In opposition to the Council of Rome, called in October, 1511, a heretical council was convened in Pisa under the protection of the Florentine gonfalon, Soderini and the Cardinal Soderini; the Pope decided to dismiss the Great Council of Florence and to restore the power of the city to the Medicis. Julius II nominated Cardinal Giovanni dé Medici, who had been leading a fatuous life in Rome as a member of the Pope's entourage, as Papal legate to Bologna, which he was authorized to reconquer and then to subdue Florence. Taking advantage of the disappointment of the aristocracy faced with the fact that Soderini was preserving the democratic Great Council's prohibition of the access of power to the great families, and making the most of the apostasy of Soderini, Cardinal Giovanni de' Medici started an underground campaign against the gonfalon with the complicity of his sister, Lucretia. By a complex series of plots, and blood battles, such as the battle of Ravenna in 1512, which numbered ten thousand dead, the French gaining a victory over the Spanish, an unexpected reversal of power in favor of the Pope, the Cardinal de' Medici, at first a prisoner of the French army succeeded in escaping, then aided by his brother, Giuliano de Medici, and their political party in the city, he devoted himself to deposing Soderini, which was soon accomplished. Sometime later, the Medicis again became the rulers of Florence.

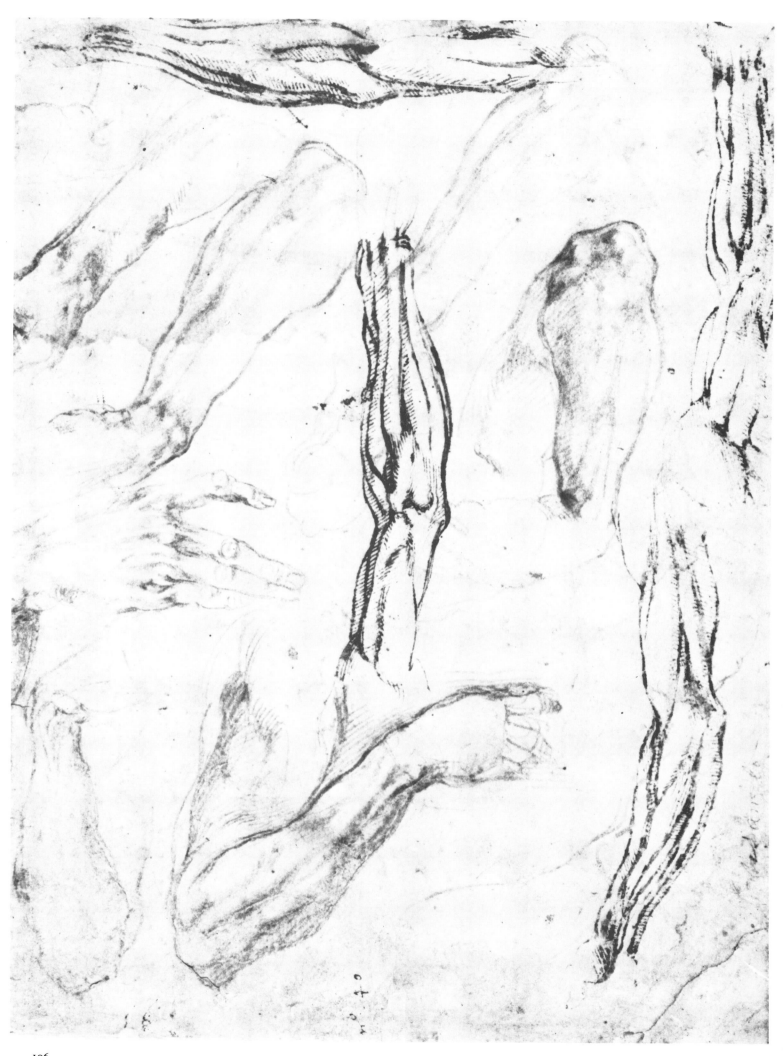

106.
STUDY OF THE ARMS AND HANDS FOR THE SLAVES. Ink and red chalk drawing; 28.6 ×20.8 cm;
Teyler Museum, Haarlem

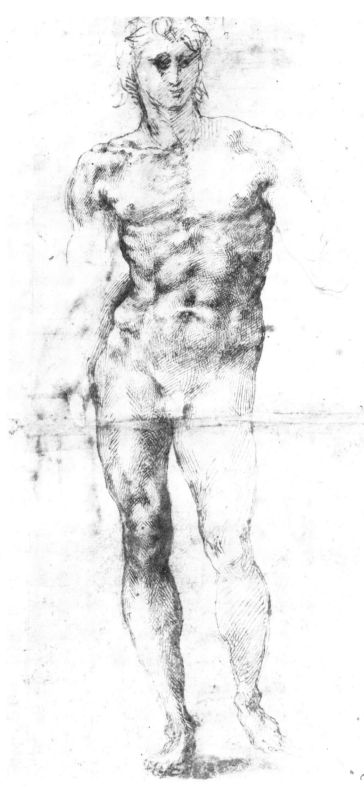

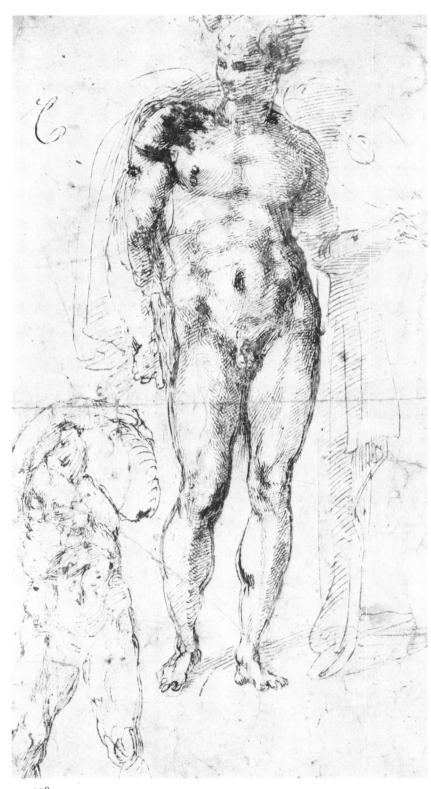

107.
NUDE. Pen and ink drawing; 34 × 16.5 cm; Cabinet des Dessins, Louvre, Paris

108.
STUDY FOR A SLAVE or APOLLO-MERCURY.
1505; Pen and ink drawing; 40 × 21 cm; Cabinet des Dessins, Louvre, Paris

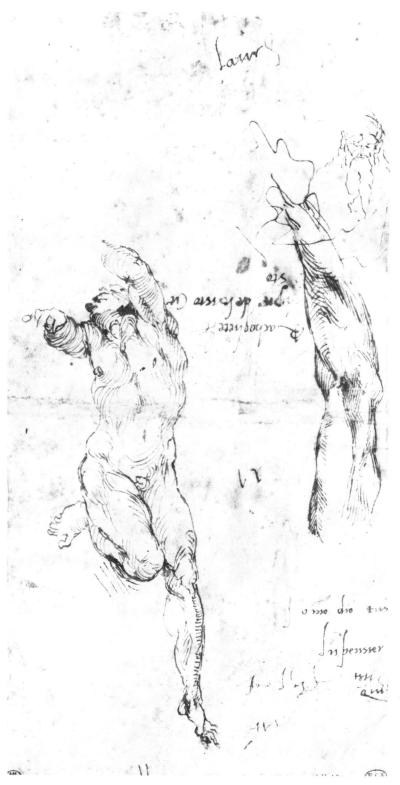

109.
STUDY FOR A SLAVE. Between 1506 and 1524;
Pen and ink drawing; 37.5 × 20 cm; Cabinet des Des-
sins, Louvre, Paris

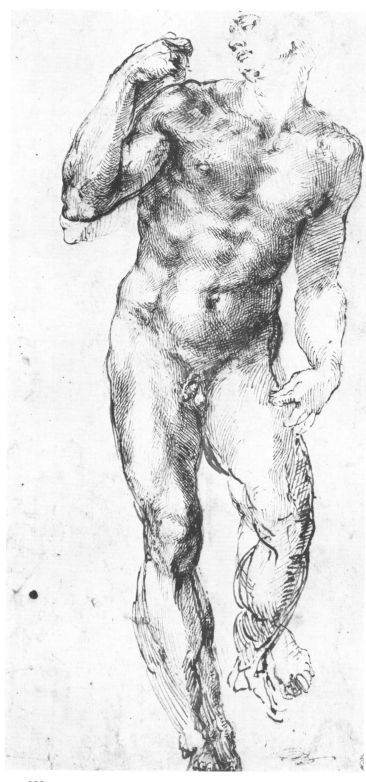

110.
STUDY OF A NUDE AND THE HEAD OF
MOSES. 1505; Pen and ink drawing; 34 × 19 cm;
Cabinet des Dessins, Louvre, Paris

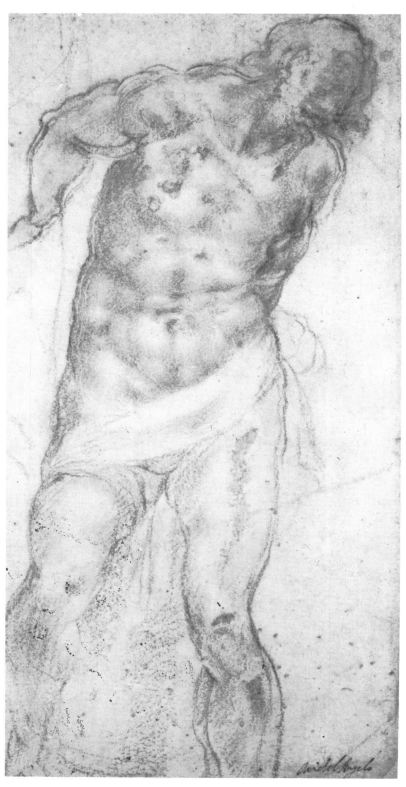

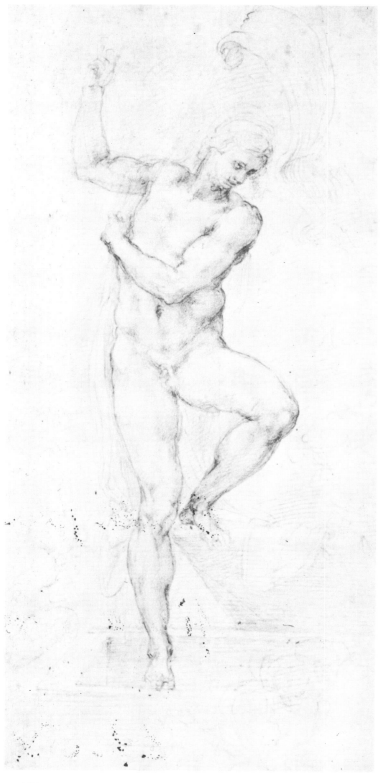

111.
STUDY FOR THE "REBEL SLAVE". 1505; Charcoal drawing; 27.5 × 39 cm; British Museum, London

112.
STUDY FOR CHRIST RISEN. 1513–1518; Charcoal drawing; 40.6 × 26.6 cm; British Museum, London

113. Facing page.
TOMB OF JULIUS II. Arrangment of the monument. 1st level is by Michelangelo; 2nd level was sculpted by his students. Church of S. Pietro in Vincolo, Rome

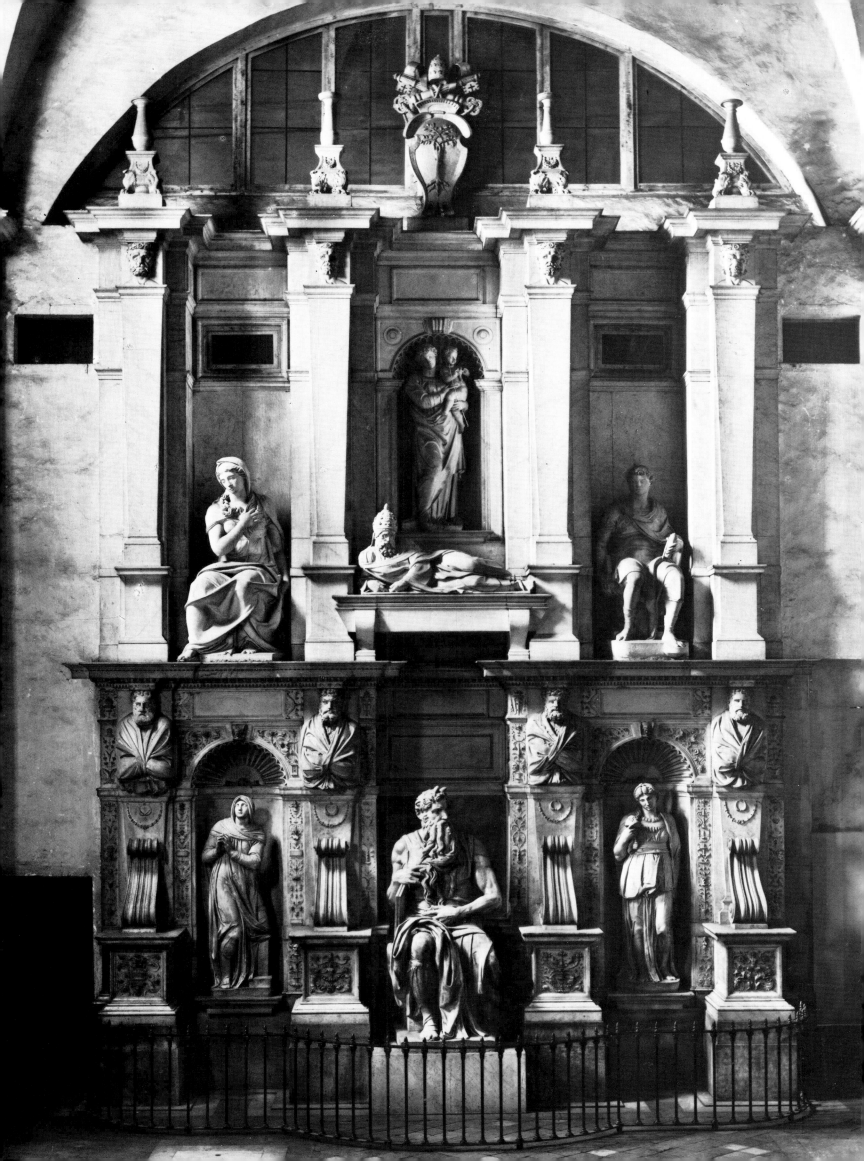

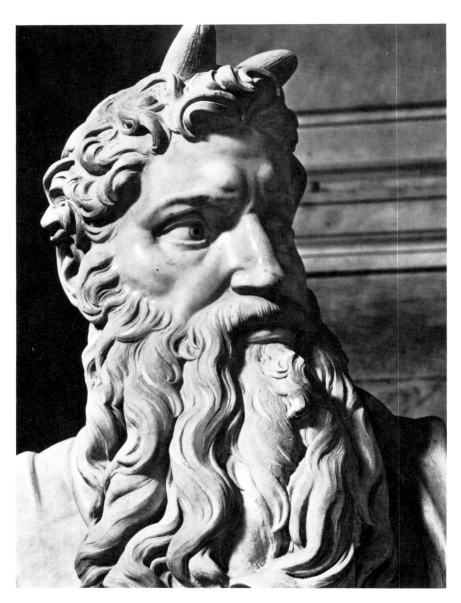

114–115.
MOSES. (detail)

116. Facing page.
MOSES. 1513–1515; retouched in 1542; marble; 235
cm high

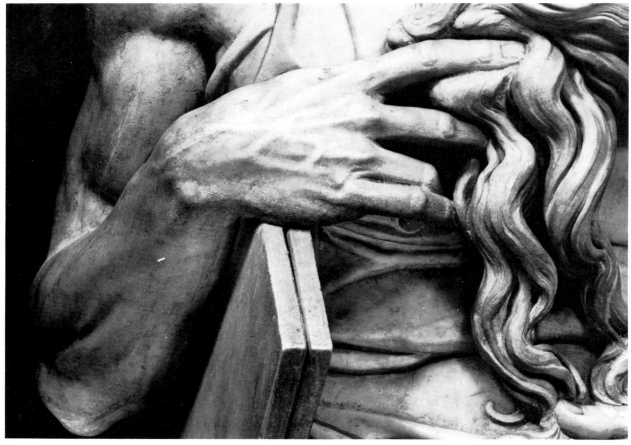

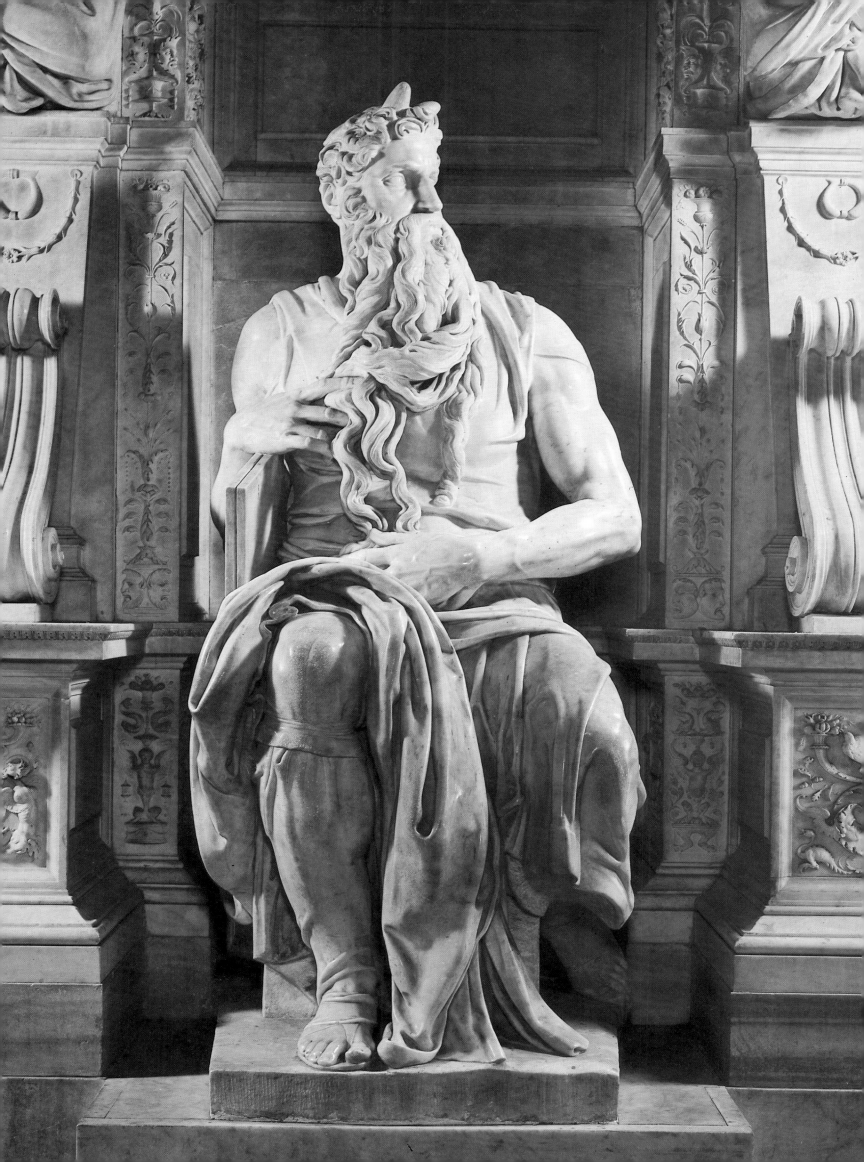

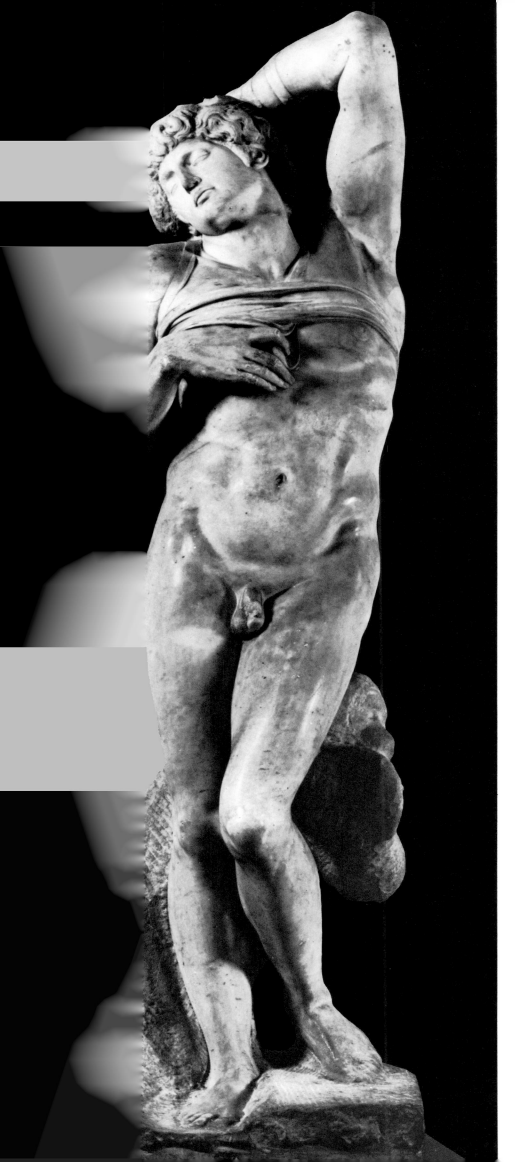

THE "SLAVES"
Appearing on different plans for the Tomb of Julius
II, eliminated from the final plan, they are dispersed
in different museums.

117.
THE DYING SLAVE or SLEEPING SLAVE. Circa
1513; Marble; 229 cm high; Louvre, Paris

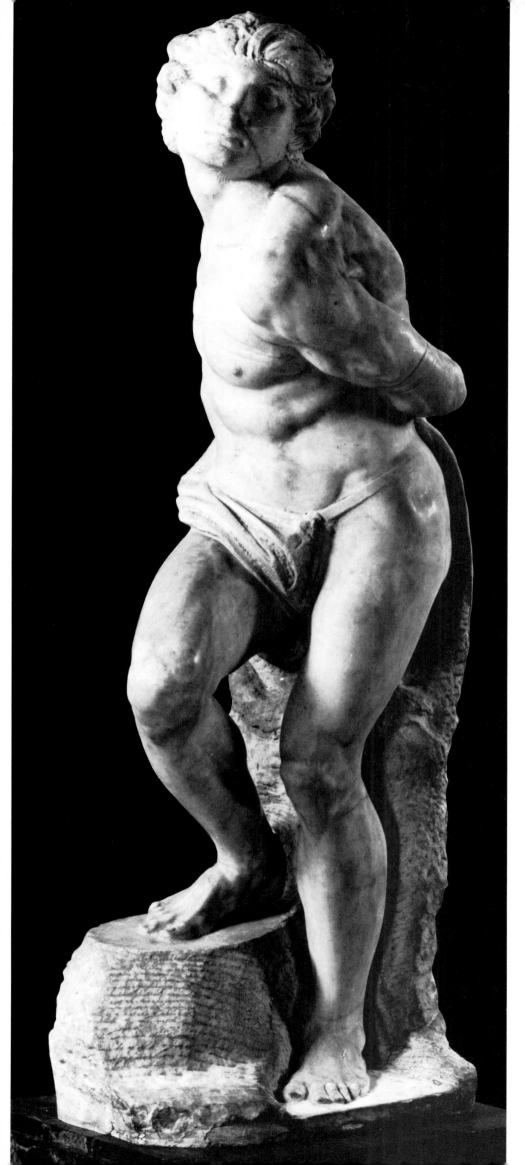

118.
REBEL SLAVE. Circa 1513; Marble; 215 cm high;
Louvre, Paris

119

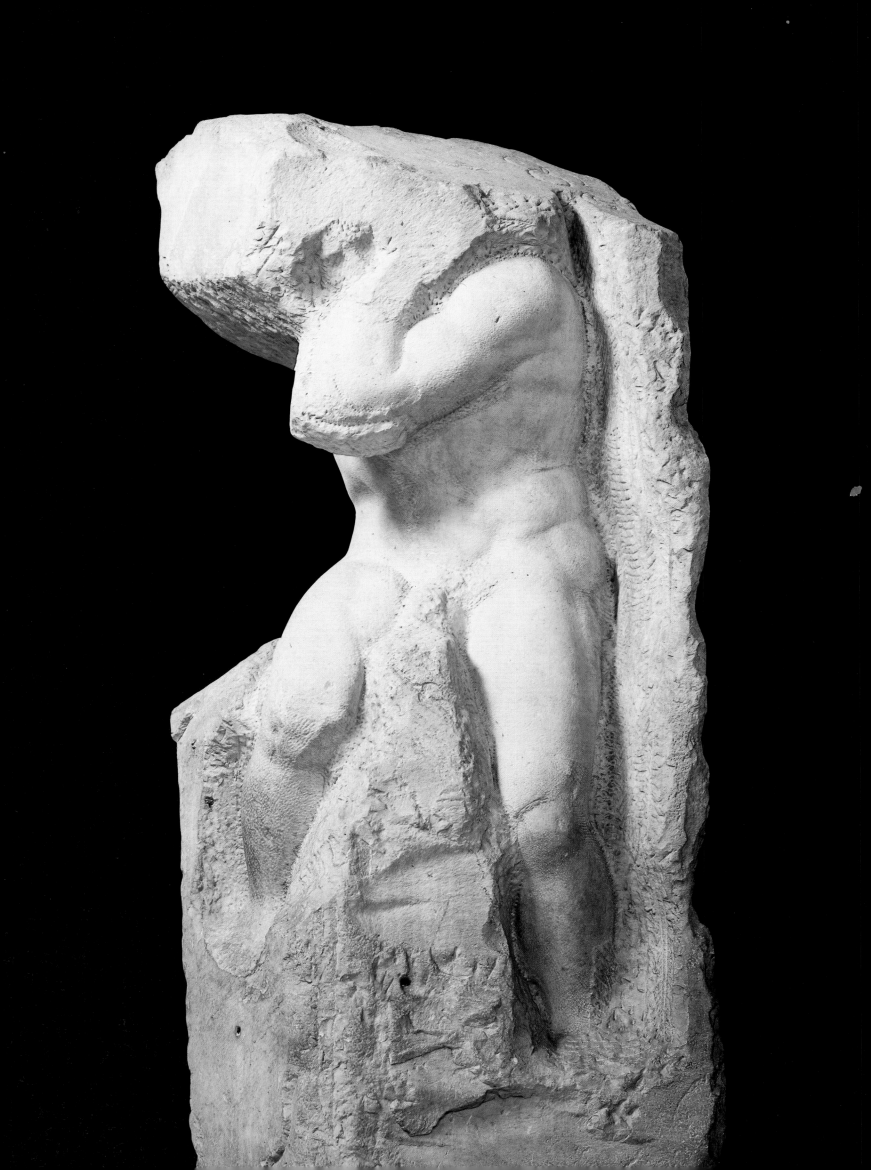

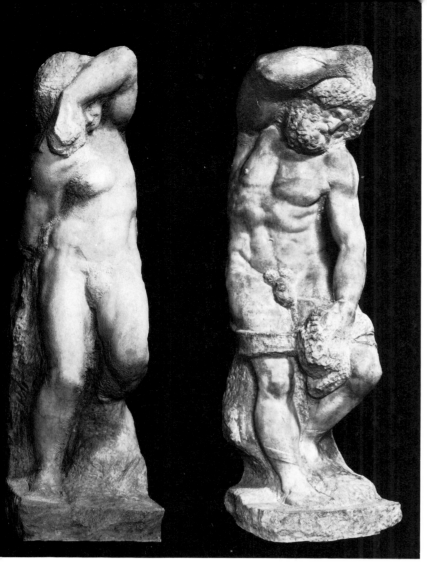

119. Facing page.
ATLAS SLAVE. 1519–1530; Marble; 277 cm high;
Accademia, Florence

120.
YOUNG SLAVE. 1519–1530; Marble; 256 cm high;
Accademia, Florence

121.
BEARDED SLAVE. 1519–1530; Marble; 263 cm
high; Accademia, Florence

122.
FIFTH SLAVE. (attributed to Michelangelo); Circa
1532; Marble; 234 cm high; Casa Buonarroti, Florence

123.
REAWAKENING SLAVE. 1519–1530; Marble; 267
cm; Accademia, Florence

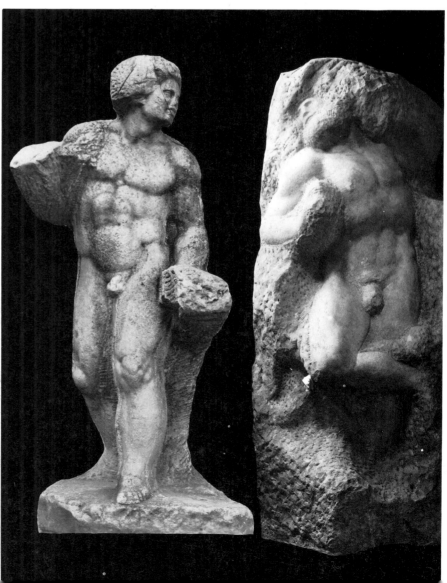

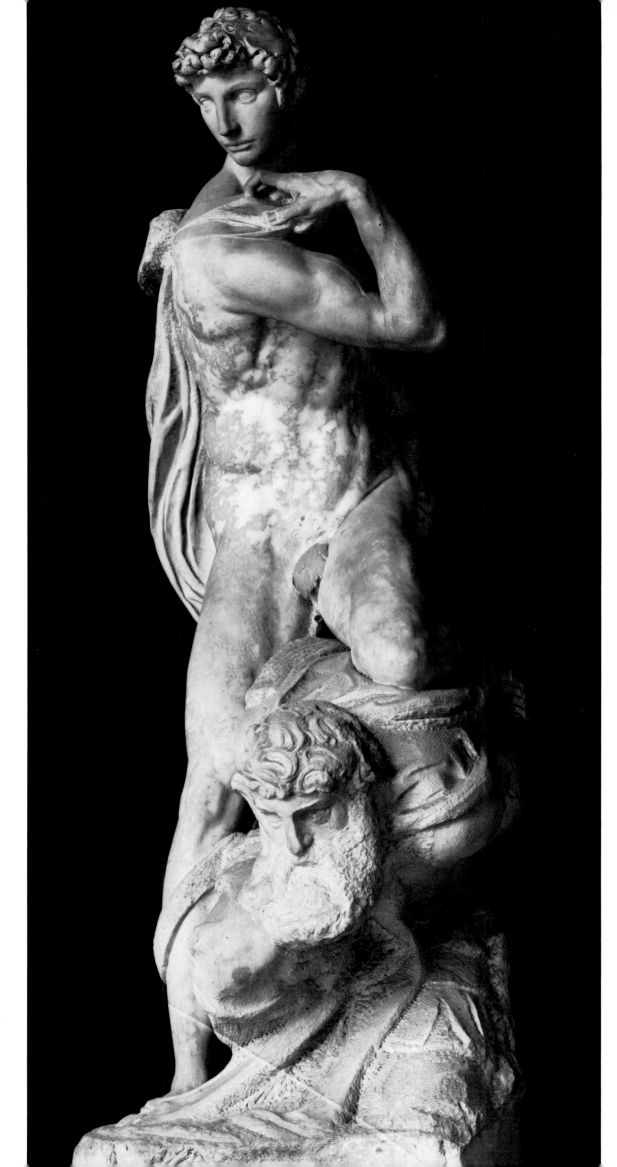

124.
VICTORY. Circa 1532; Marble;
261 cm high;
Palazzo Vecchio, Florence

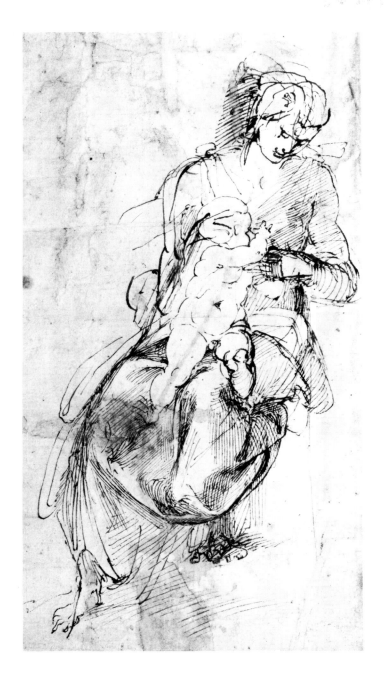

THE MEDICI CHAPEL, SAN LORENZO

125.
MADONNA OF THE MILK. Circa 1505–1506; Pen
and ink drawing; 39 × 20 cm; Albertina, Vienna

126.
SKETCH FOR THE MEDICI TOMBS. 1520–1521;
Pen and ink drawing; 21.6 × 21 cm; British Museum,
London

127.
STUDY FOR MADONNA OF THE MILK. Circa
1505–1506; Pen and ink drawing; 37.5 × 20 cm;
Cabinet des Dessins, Louvre, Paris

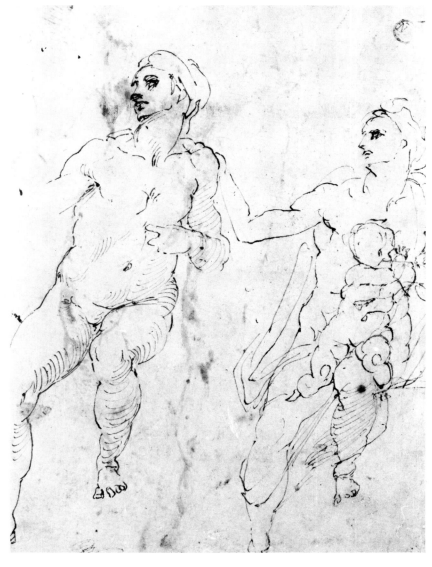

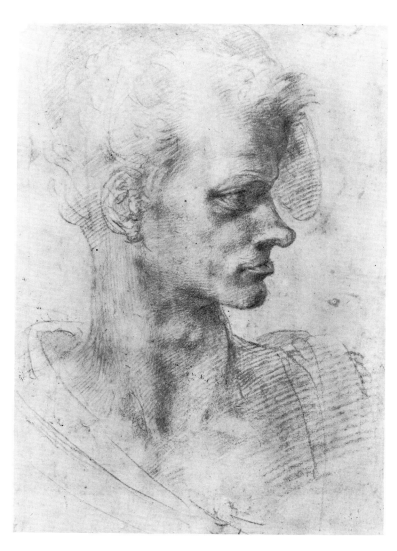

128.
PROFILE (STUDY FOR AN EVANGELIST).
1517–1518; Red chalk drawing; 38 × 19.5 cm; Ash-molean Museum, Oxford

129. Below.
STUDY FOR THE RESURRECTION. (Plan for a lunette at the entrance of the Medici Chapel); 1520–1525; Red chalk drawing; 15.5 × 17 cm; Cabinet des Dessins, Louvre, Paris

130.
STUDY FOR THE HEAD OF SAINT DAMIAN.
1517–1518; Red chalk drawing; 15.5 × 12 cm; Ash-
molean Museum, Oxford

131. Below.
STUDY FOR "NIGHT". 1520–1521; Charcoal drawing;
18 × 19 cm; British Museum, London

132.
STUDY FOR THE CRUCIFIXION OF SAINT COSMAS AND SAINT DAMIAN. 1517–1518;
Pen and ink drawing; 24 × 16.5 cm; British Museum, London

126

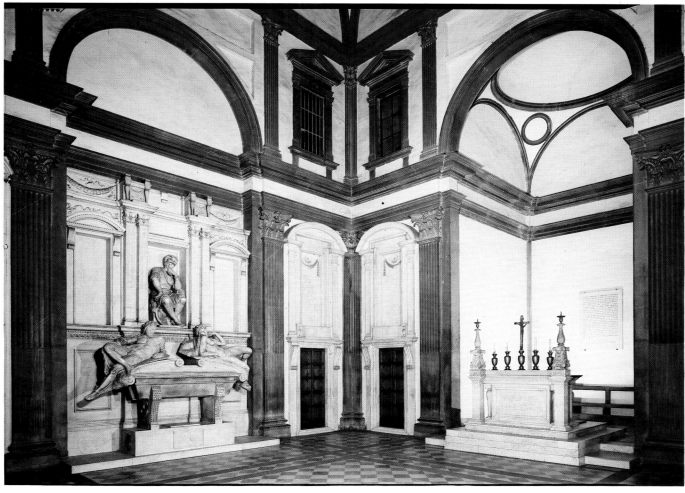

133-134.
VIEWS OF THE NEW SACRISTY OF SAN LORENZO IN FLORENCE. The sarcophagus, placed under the statue of the *Madonna and Child,* contains the remains of Lorenzo the Magnificent and his brother Giuliano. To the left of the altar, the tomb of Giulio, Duke of Nemours; to the right the tomb of Lorenzo, Duke of Urbino, son and grandson respectively of the Magnificent.

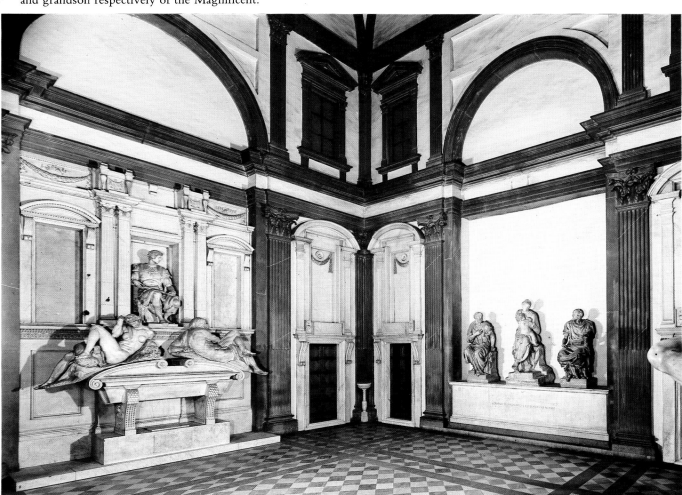

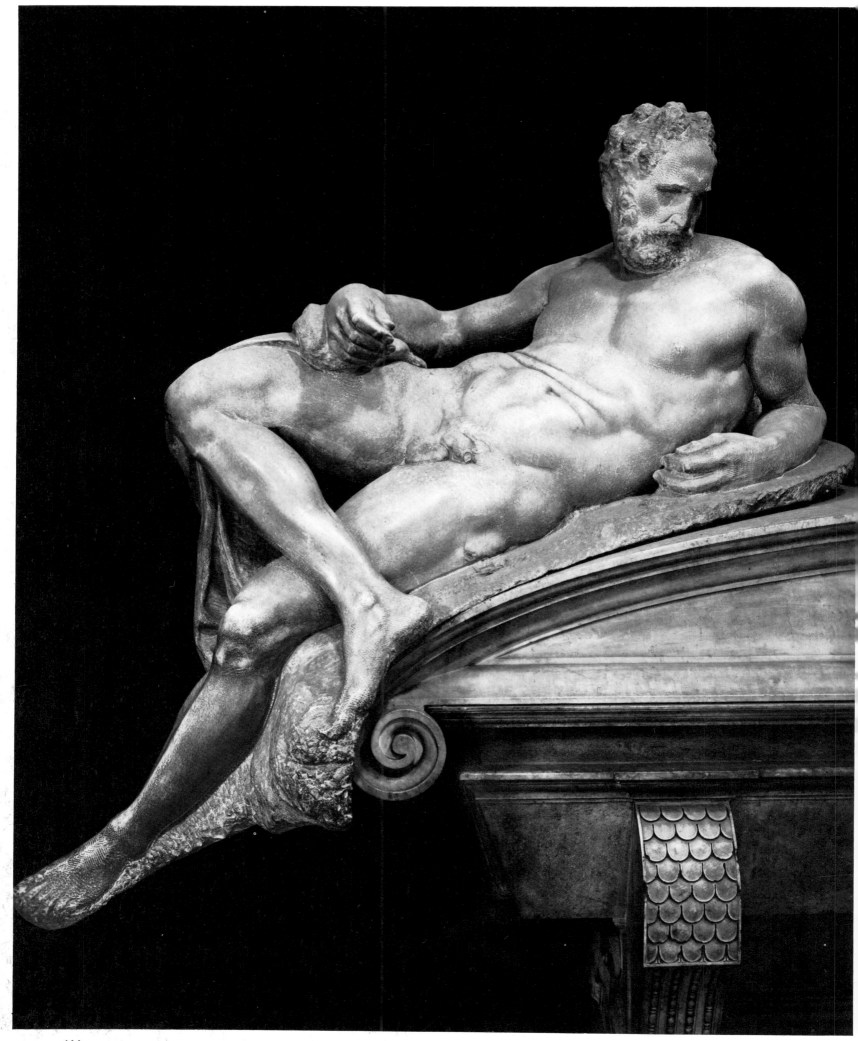

135.
TWILIGHT. Detail of the tomb of Lorenzo de´ Medici. 1524–1531; Marble; 195 cm long

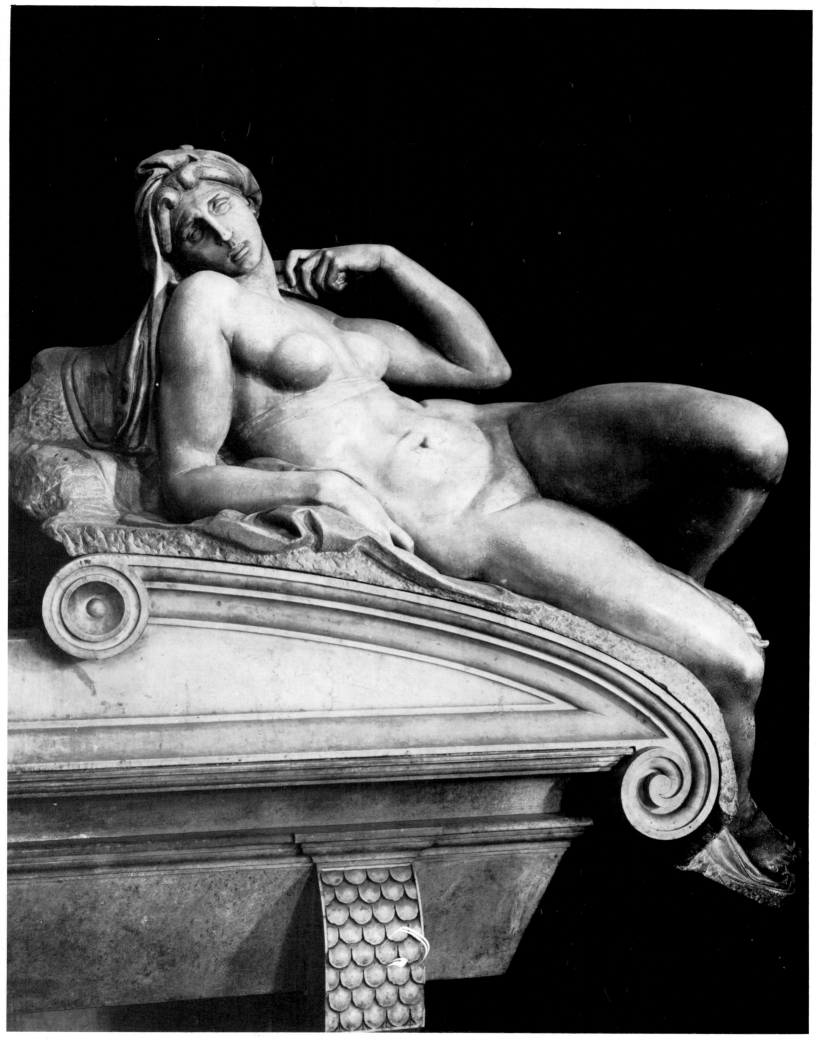

136.
DAWN. Detail of the tomb of Lorenzo de´ Medici. 1524–1531; Marble; 203 cm long

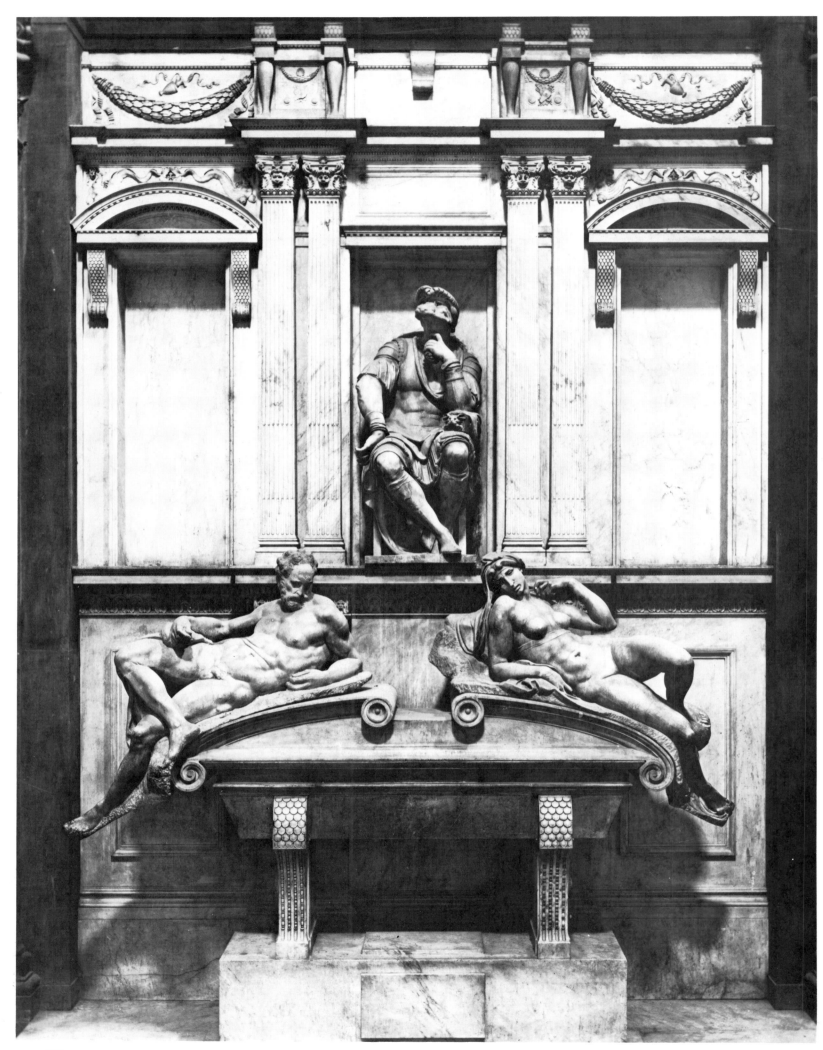

137.
TOMB OF LORENZO DÉ MEDICI.

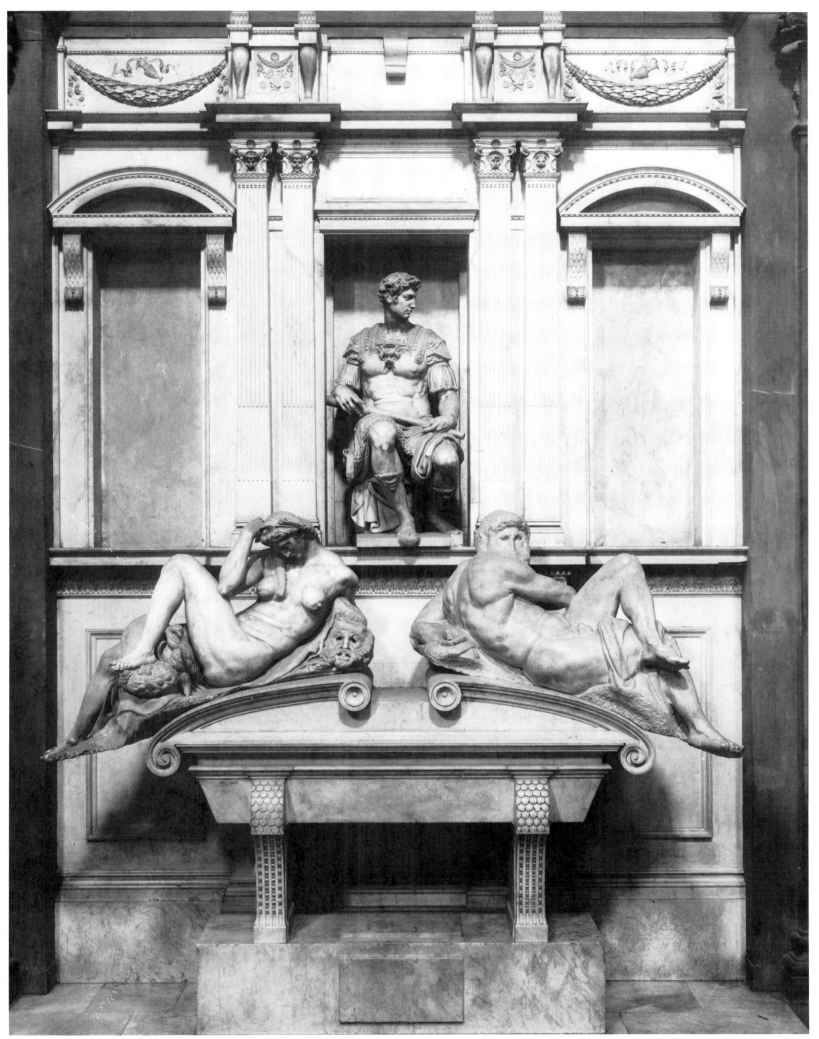

138.
TOMB OF GIULIANO DÉ MEDICI

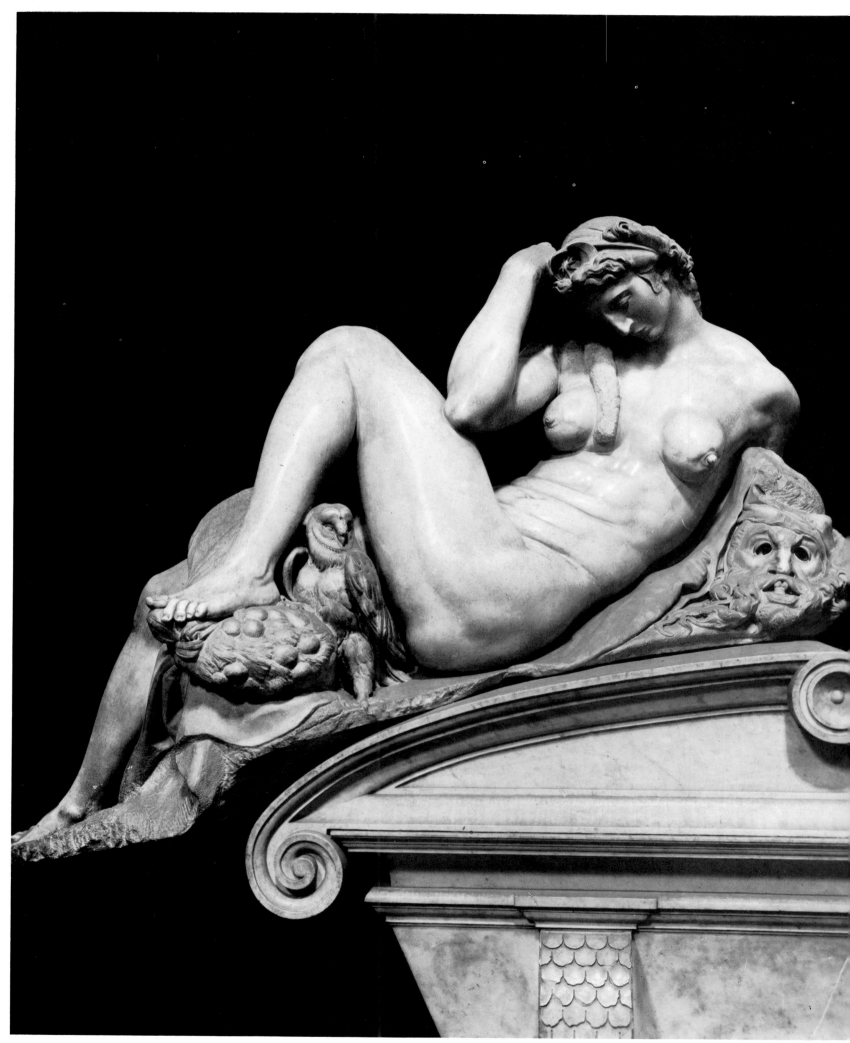

139.
NIGHT. Detail of the tomb of Giuliano de´ Medici. 1526–1531; Marble; 194 cm long

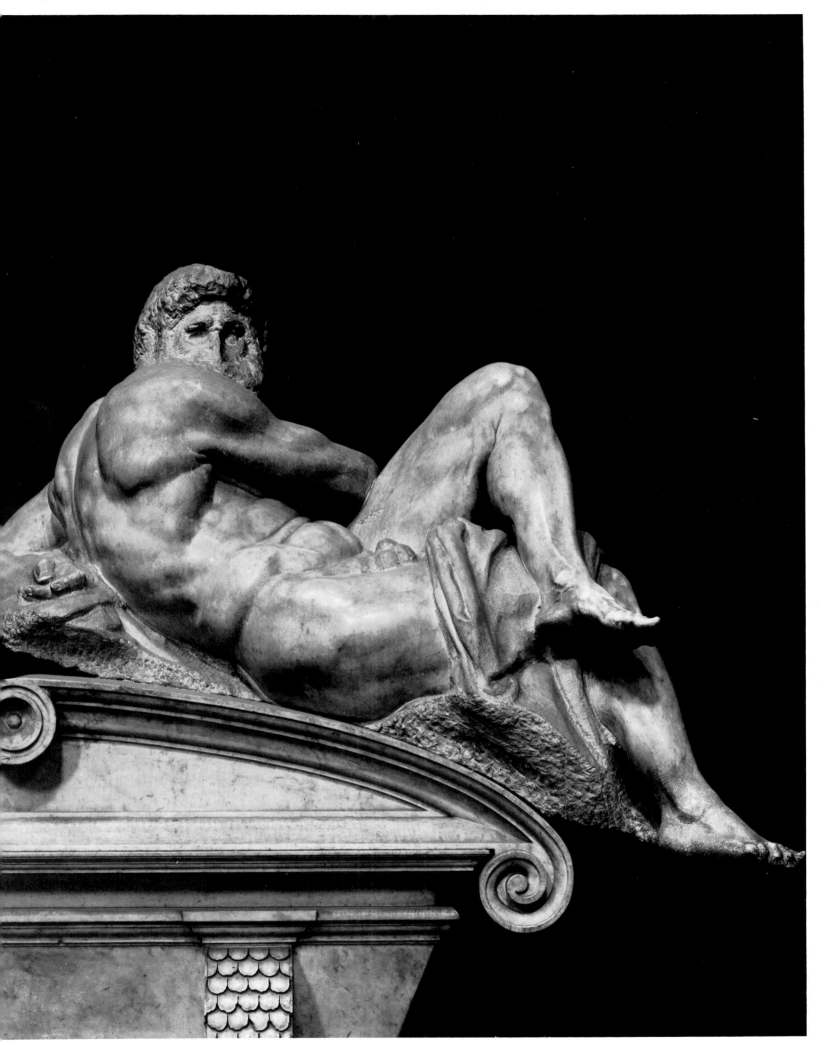

140.
DAY. Detail of the tomb of Giuliano de´ Medici. 1526–1533; Marble; 185 cm long

141. Following page.
MADONNA AND CHILD. 1521–1534; 226 cm high; New Sacristy of San Lorenzo

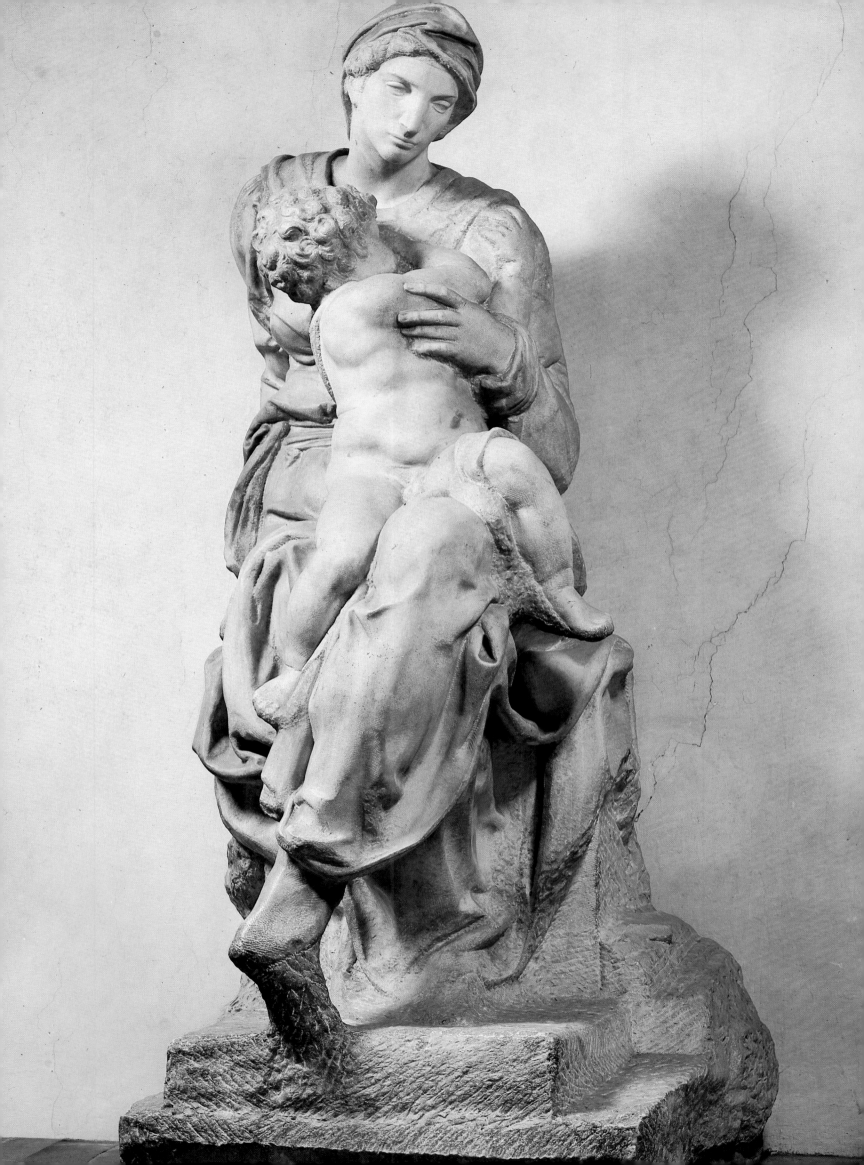

V

The Last Judgment The Pauline Chapel

While he was still working on the tomb of Julius II, Michelangelo in 1521 was completing the statue of *Christ Risen* for the church of Santa Maria sopra Minerva in Rome. This statue, commissioned during his stay in Rome in 1514, had never been completed, and Michelangelo had abandoned the project because of a defect in the marble. The work that comes to us is the second version using the same theme. This piece, a considerable departure from traditional iconography, represents the naked Christ holding a cross in reduced scale in comparison with his body and the various objects belonging to the story of the Passion, i.e., a sponge, some rope and the spear. The pose, for such a subject continues to surprise people. In contrapposto, as many of the master's works were, the body of the crucified Christ, seems to be executed in the style of antiquity—muscular, peaceful, distanced from the drama he symbolizes, almost resigned in insipid gracefulness. More than a sculpture, in the sense of the formal questioning that it would imply, in this statue Michelangelo has most likely projected his own drama.

Presumed portrait of Michelangelo (the flesh of St. Bartholomew, detail of the "Last Judgment").

Under the patronage of Clement VII, the sculptor Bandinelli had been placed in competition with Michelangelo. Bandinelli had been commissioned to sculpt a statue that would be placed opposite the statue of *David*. The mediocrity of his artist, who was probably encouraged by Michelangelo's enemies, had not escaped the Florentine, and on this occasion they side with the master against Bandinelli. The demise of the Medicis contributed to Bandinelli's downfall as well. The block of marble that was still in Bandinelli's studio was given to Michelangelo so that he could create a work. Yet once again, political and bellicose events prevented him from completing his work.

In April 1529, Michelangelo was named general governor of fortifications for the city of Florence. In a very short time, the defensive walls, small forts and bastions were built and resistance was organized against an imminent attack. To study the most perfected military architectural techniques, Michelangelo went to Ferrara, which was known for its fortifications throughout Italy. During this period, a tempera painting *Leda and the Swan,* was created; it was destroyed in 1643.

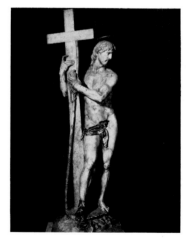

Christ Risen
(1519–1521).

After Florence surrendered, Michelangelo went into hiding, fearing reprisals from the conquerors. But the Pope soon granted the artist his favor and Michelangelo was forced to resume work in the Medici Chapel and execute the statue *David Apollo* for the Pope's emissary.

The statue is kept in the Bargello Museum. This figure of slightly fleshy muscled youth contrasts strongly with the *David* of the Seignoria. Apathetic, relaxed seemingly asleep and removed from reality as in a dream, it is difficult to identify his role in history.

At the end of September 1534, Clement VII died but not without ensuring that Michelangelo would paint the wall above the altar of the Sistine Chapel. He had also decided that the theme of the work would be the *Last Judgment*. His successor, Paul III Farnese, also wanted the artist to work exclusively for him and refused Michelangelo's request to complete Julius's tomb for the Roveres. However, the Pope did approve the commission of his predecessor, Clement VII, and Michelangelo began to execute the first cartoons in the autumn of 1535; the fresco was completed on November 18, 1541. This vast composition, measuring 17 meters high and more than 13 meters wide, takes up the entire wall that dominates the altar of the Sistine Chapel.

Condivi was obviously struck by this work and has left us a rather spectacular description: "In this work Michelangelo succeeds in expressing everything that painting can capture of the human body without neglecting any attitude or movement. The composition of the subject is moving and logical . . . in brief, we can say this ensemble is divided into right, left, upper, lower and central zones. In this final or central zone near the bottom, there are seven angels described by St. John in the Apocalypse, who are blowing their trumpets from the four corners of the world. They call the dead to the Last Judgment. Two are holding an open book so that everyone can read and review the history of their lives and judge themselves. At the sound of the trumpets, the tombs open and the bodies emerge with marvelous and diverse

attitudes. While some, according to Ezekiel, remain only as skeleton, others are barely covered by their own flesh; still other bodies remain intact. One is naked and another attempts to rid himself of his shroud or burial clothing. Some of the dead seem wide awake and stare at the sky wondering where divine justice will take them. It is beautiful to see them rise from the earth at the cost of great effort, while others raise their arms upward about to take flight to heaven. Still others are already ascending to heaven with varying gestures and expressions. Above the trumpeting angels the Son of God appears in all his majesty. His arms and powerful right hand raised in anger, he curses the guilty and dismisses them from his presence and in doing so damns them to eternal fire. His left hand is extended to receive the elect gently. The angels between heaven and earth rush to the right to carry out the sentence, either to assist the elect or prevent the damned from ascending to heaven. The angels on the left are repelling the damned who, by shear audacity, manage to elevate themselves. The latter are being dragged down by devils. The arrogant ones are pulled by their hair, the licentious ones by their genitals, and each sinner by the instrument of his sin. Below the damned, we see Charon with his boat as described in the *Marsh of Acheron* in *Dantes Inferno*.

"He raises his oar to beat the slowly disembarking souls, and as the boat pulls into the shore, all the souls rush out as in a race, prodded by divine justice so that fear, as the poet says, can be transformed into desire. Then, once Minos pronounces the sentence, the devils lead them toward the sinister inferno. Here we can see the scenes of cruel and hopeless suffering as only to be expected in such a place. In the clouds in the center of the fresco, the resuscitated Blessed form a crown around the Son of God. Separated from them, the Virgin Mary, in a very shy posture as if she dreaded God's anger and secret designs, seems to be seeking refuge close to her son.

"Saint John the Baptist, the apostles, and all the saints stand close to the Virgin. Each saint shows the terrible judge the object symbolizing the manner of his death: St. Andrew shows the cross; St. Bartholomew, his flayed skin; St. Lawrence, the grid; St. Sebastian, arrows; St. Blaise, the iron combs; St. Catherine, the wheel; and others, instruments of torture that identify them. Above them on either side, groups of angels in unusual and agreeable postures, offer the cross of the Son of God to heaven, the sponge, the crown of thorns, the nails, and column where he was whipped . . ."

Completed on November 18, 1541, it took Michelangelo fewer than six years to realize this fresco which he executed from top to bottom in successive stages. Then in his sixties, the artist had risked diversifying the realm of his experiences all his life. This monumental and dramatic work is clearly one of synthesis. The *Last Judgment,* probably not by chance frontal and monocentric, is a conclusion.

Conclusion and synthesis of an ambivalence composed of energy and melancholic contemplation that never ceased to haunt his work. In this fresco, it is no longer a matter of provocative demonstration of the excessive abilities of a formal decision in generalized expansion. Rather, here, during these last years, triumphal religious pessimism prevails and at its center, the heart and memory of the past years culminates in the forceful and vengeful figure of Christ. If we compare the fresco on the ceiling of the Sistine Chapel, the grandiose magnitude of the *Last Judgment* rests on Michelangelo's renewed concept of space; the narrative scheme still predominates. On the vault, by the artifice of the architectural elements and even by the organization of the painting revelations, Michelangelo placed the connecting scenes side by side with the intention of differentiating as well as linking the actors and the narration of their stories. In the fresco of the *Last Judgment,* the effect is quite different; Michelangelo stabilized the composition in the continuum of concentric circles that lead to the fatal gesture of the judge. In more than one scene our gaze is diverted to a texture and the impression of the immensity, nebulousness, intangibility and boundlessness based precisely on the dilution of the expressiveness of the figures without true hierarchy, on a dynamic centrifugal but superficial, nonperspective order. The descent of the damned on the right into the inferno and the ascent of the elect on the left emphasize the rotation of the image that finds its tumultuous balance in the bottom of an intangible abyss. The image of torsion, heliocentricism, and the curve obsessed Michelangelo throughout his life. In this sense, the *Last Judgment* is the absolute masterpiece of torsion and rotation. If it were not for the drama of the subject, the general form exhibited by the artist, would suffice to express all the dramatic power of this composition. The concentric orchestration aside, each figure is endowed with a special curve, a torsion, which emphasizes the apocalyptic atmosphere, and the unreality of the scene. The lack of solid support for these inverted figures in the continuum of celestial space, under the weight of the lunettes, emphas-

izes this unreality and consequently accentuates the grave and suspended figure of the Christ-Judge at the center of this vast whirlwind. Returning to the inflamed preachings of Savonarola, the fresco of the *Last Judgment* attests to the reformative ideas of the painter, his painful awareness of sin, and the austerity of his religious beliefs.

This new piety, this new solitude, and this progressive renouncement "of the frivolous promises" of love, were to be inflamed toward the end of his life by a friendship of intense spirituality, which dominates the poems he wrote during this period.

Vittoria Colonna, born in 1492, had married the Marquis of Pescara, whose leisured life led her to fulfill herself in the world of letters. When she became an inconsolable widow, Vittoria Colonna began to write poetry and lead a devout life in Ischia. Her poems soon became famous throughout Italy and her life was held as an exemplary one. An intimate of Castiglione and Aristo, she was also a friend of Marguerite of Navarre. In 1536, Michelangelo was introduced to her and a long friendship began, devoted entirely to the study of the holy scriptures and long discourses on the spiritual life. Not satisfied with his poems which proclaimed his pure love, Michelangelo made drawings for her, among them the *Crucifixion,* which inspired this sublime remark from her. " . . .I saw the Crucifix that crucified in my memory all the paintings I have ever seen . . ." Vittoria Colonna introduced the artist into the devout Roman circles, and Michelangelo, always so sensitive to Savonarola's sermons, as we have said before, again took up the reformist themes that were dear to him and sometimes brought him closer to the protestant thesis. Suddenly inspired by the desire to glorify the gift of faith alone, the artist in his abundant literary works as much as in his plastic expressions devoted himself to the exaltation of spiritual values in the knowledge of the approach of his own death.

While he was working on the *Last Judgment* in Rome, Florentine exiles enamored of the idea of the return of freedom for their native city planned an insurrection against Alessandro de´ Medici. All the outcasts, Michelangelo among them, united with Cardinal Ippolito de´ Medici and the former Florentine secretary of state and historian, Donato Giannoti. All the hopes of a liberated Florence rested with Ippolito de´ Medici, warrior, stateman, and man of the church. A conspiracy was hatched requiring the help of Charles V, the Holy Roman emperor. Charles went to Rome where he was received by Pope Paul III. On the way to Florence he was received in great pomp with a feast organized by Vasari. It was then that Alessandro was assassinated by his cousin, Lorenzino de´ Medici, aged 17, who succeeded him immediately. Lorenzino's dictatorial reign was worse than the previous one.

As Michelangelo was putting the final touches on the *Last Judgment,* Paul III immediately commissioned him to decorate his own private chapel called the Pauline Chapel, built by Antonio da Sangallo the younger. From November 1542 to 1550, the artist once again devoted himself to fresco painting; he made two of them, each extending more than 36 square meters. One describes the *Conversion of Saint Paul,* the other the *Crucifixion of Saint Peter.* These were the last of the monumental paintings from the artist who had reached the age of seventy-five at the completion of the second fresco. Most likely the themes of the frescos, which extend laterally on the two walls of the chapel, had been suggested by the Pope himself, who decided to glorify his namesake as well as the founder of the Papacy.

The Pauline Chapel.

The story of Paul of Tarsus, who will become Saint Paul, is known. Persecutor of the Christians, Paul was riding to Damascus to carry out some dreadful schemes, when, toward noon, a supernatural light enveloped him. A voice from the sky addressed him, "Saul, Saul, why do you persecute me?" Paul recognized the voice of God, who identified himself saying, "I am Jesus whom you persecute." Then the voice charged him to go to Damascus where instructions awaited him. If the horse is not mentioned in the Bible, oral tradition dramatized the conversion in the fall of the horseman. Michelangelo followed this tradition. This painting is organized in two groups of centrifugal levels. In the upper part of the fresco, the celestial group surrounding Christ is seen from the bottom to the top on a aerial space where the figures are floating. In his right hand Christ projects a luminous pillar of light that surrounds the crest of the lower group in the center. In the foreground, Paul is hurled to the ground. The connection of the rider to the horse is created by the opening in the group of Saul's companions. This naturally leads the eye to interpret synchronically the relation of the fallen rider to the rearing horse, which becomes the symbolic center of the composition, the remarkable event that enables us to remember the story of the fresco and its origin. There is no doubt that the features given to Saul of a blinded old man at the very moment of revelation from his wonderings and from the truth show the identification of the aged artist with the hero

he represents. If Michelangelo had broken with the tragic and dramatic scope of his earlier compositions, in this fresco once again, the prodigious circular dynamic warps the scene in the lateral interior confines of painting achieving the synthetic vision of orchestrated chaos.

The *Crucifixion of Saint Peter* illustrates the traditional themes of torture and nailing the founder of the Church to the cross upside down. The timing of the action, as interpreted by the artist, is the surprising characteristic of this scene. Michelangelo departs from the traditional representation in which the cross is raised upright after the torture has ended. Rather, we see the raising of the cross on which the martyr is resting. The imperious diagonal of the cross fixes the rotation of the image and its circular movement surrounds the place of the crucified body's elevation. As in the previous fresco, it is remarkable to see the same centrifugal movement exert itself around Saint Peter's head, which is turned toward the viewer of the painting. With an expression of profound supplication and by the anxiety of his stare, Saint Peter invites the viewer to participate in the drama of this scene. The group of executioners at the base of the cross as well as the armed men and the witnesses of the torture display a tranquility, even amazement, at the sight of these strange events.

These two frescoes mark an important stylistic departure from the principles that characterize the earlier works. The desire to express the physical demonstration of the body was abandoned. By the same token, Michelangelo's expressed manner of composing, i.e., by the juxtaposition of colored elements and by the assemblage of figures, was also abandoned in favor of the construction of an organic continuum and of the interrelation of subjects in the mass of the representation. This liaison by the structure of underlying ensembles, allowed him to add rhythm to his image, to place a sychronized movement of the subjects around the theme of the composition. The master had exhausted the resources and the pleasures of aesthetic idealization of his faith. Then in his seventies, he discovered the virtues of a faith freed from appearances and their effects. The idea of synthesis still dominates, no doubt, but the frescoes of the Pauline Chapel escape the rigor of theory to turn toward the circular fluidity of movement purely dedicated to spiritual values. The last years of Michelangelo's life were enlightened by the mystic friendship that tied him to Vittoria Colonna; but in the fall of 1532, the artist met and fell in love with a Roman gentleman, Tommaso Cavalieri. Michelangelo's poetic work was then devoted to praising his friend's beauty as much as to following the sacred path inspired by Vittoria Colonna. Distinguished collector and humanist, Tommaso Cavalieri was indisputably the great passion of an existence so devoted to art. The prudishness of commentators may cause them to overlook the artist's homosexuality, but at the same time they fail to recognize that the Renaissance, characterized by the taste for Greek and pagan antiquity, the cult of ideal beauty and the revival of platonism encouraged homosexuality. This was true throughout Italy and in the entourage of Lorenzo de´ Medici in particular.

Aside from the numerous poems dedicated to his friend, Michelangelo made several drawings for Cavalieri, inspired by pagan mythology, among them *Ganymede* and three versions of the *Fall of Phaeton*.

Michelangelo stayed in Rome until the time of his death in 1564. But from 1535 he had become as famous as the greatest of dignitaries. Honorary titles abounded, and in the eyes of his contemporaries the epithet of the "divine" characterized him as one of the greatest artists of all time.

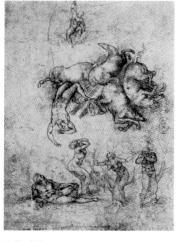

Fall of Phaeton.

There was a period of great unrest in Italy. The rivalries between the Pope, Clement VII, the king of France, Francis I, and Charles V and the formation and disintegration of alliances nurtured plots and intrigues. In May 1527, the sacking of Rome, the flight of the Pope from Castel Sant'Angelo, and the general pillage of the city by the germanic and Spanish armies created misery and famine for months, followed by plague. Imprisoned far from his retreat, the Pope could only stand by helplessly while the city was being plundered. In Florence, the Medicis were destitute and forced to leave the city; the Republic was newly declared, the gonfalon Capproni was elected and a great council was formed with Michelangelo as a member. At the end of December 1527, French troops, joined by a Florentine contingent, gave their assistance to the Pope, who was eventually freed under an agreement with the Spanish. The Pope took refuge in Orvieto, part of the papal territory, where he rallied his troops.

Just outside of Naples, the French troops were decimated by plague and famine and unable to seize the city; Northern Italy signed an agreement with Charles V, Clement VII planned to ally himself with Spain, while Florence, faced with these dangerous alliances, was without allies except for France, which was now incapacitated. A serious domestic crisis jolted the city; they discovered the secret negotiations between the gonfalon Capproni and the emissaries of the Medici Pope. Although the Pope was safe, the Capprone was removed from office and replaced by Carducci, which pitted Florence directly against the Pope, and forced him to form an outside alliance to recapture his native city. The difficult position of the French and the probable risk of invasion led the Council to plan a fortified defense of the city.

In Cambrai in 1529, the "Ladies' Peace" saw the French King's public renunciation of any claim to Italy, which assured the surrender of Florence to the Pope. The treaty signed by Charles V and Clement VII which led to the crowning of the emperor in Bologna, was also designed to prevent Florence from turning to the germanic empire for help. The siege of Florence by the papal and imperial armies began. Clement VII ordered the city to surrender and partisans to leave the city for the general assault. Many Florentines deserted, among them Michelangelo who was convinced of the chief of the Florentine army's' treason. He fled to Venice in 1529. Following the example of his rival Leonardo da Vinci, he considered exiling himself to France under the patronage of the king whom he knew was interested in artists and in his own work as well. The French ambassador was informed and immediately made offers to the artist, who nevertheless remained in Venice fearful of crossing enemy territory to reach his protector. But the Florentine decree announced the banishment of any fugitive who did not immediately return to the city. Michelangelo declared himself ready to return if they gave him a pardon. The pardon was granted and the artist returned to the city to devote himself to its defense. Soon the city was surrounded. Although they fought courageously and with remarkable unity, epidemics decimated the troops, and the city was forced to surrender in August 1530.

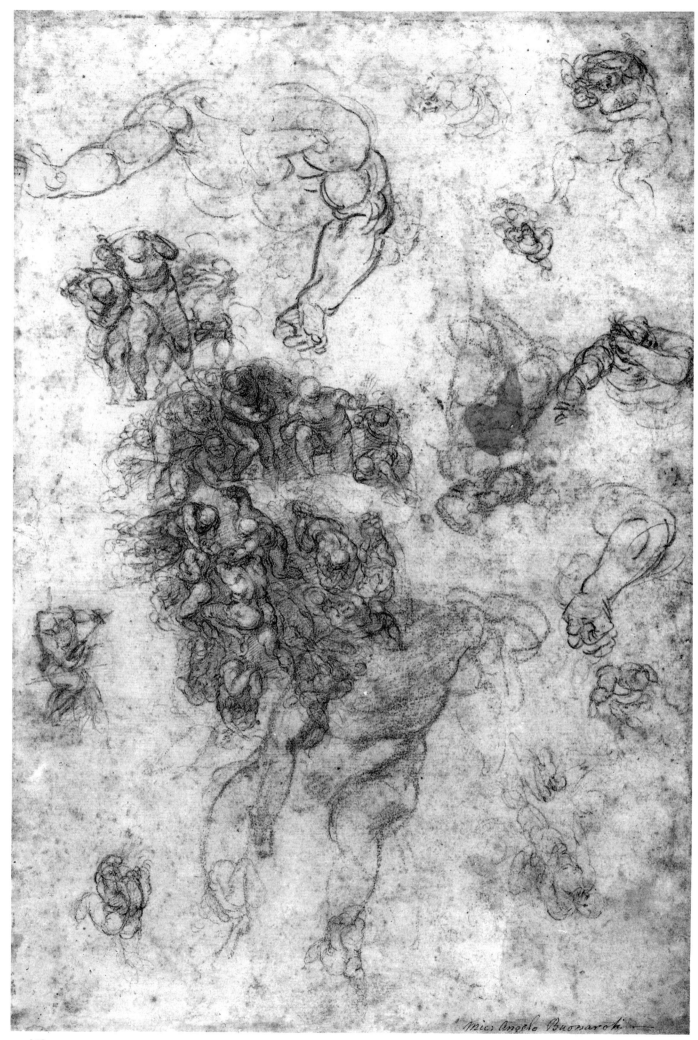

142.
STUDY FOR THE "LAST JUDGMENT". 1534; Charcoal drawing; 38.5 × 25 cm; British Museum, London

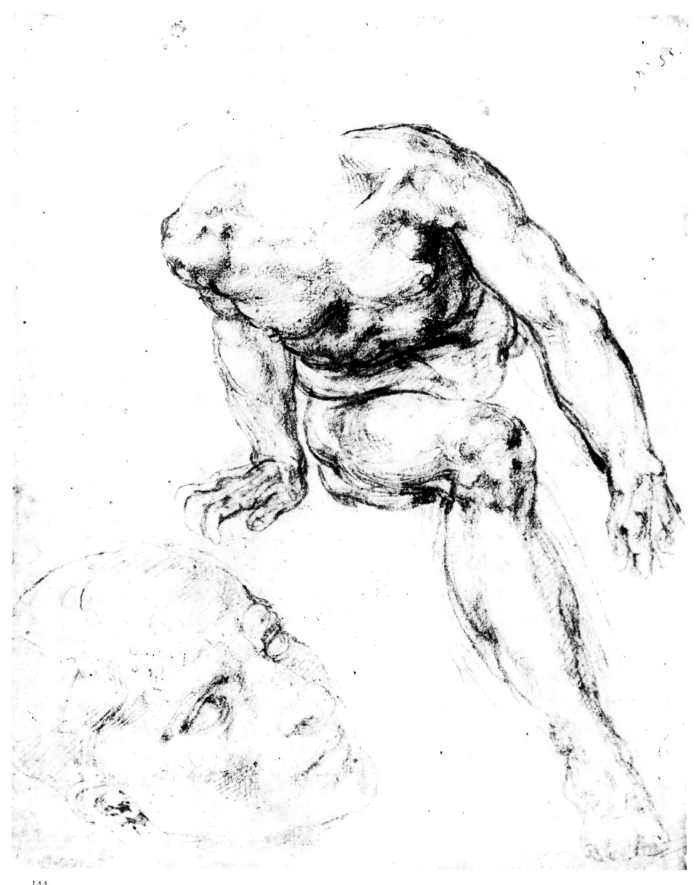

144.
STUDY FOR SAINT LAWRENCE OF THE "LAST JUDGMENT". 1534–1535; Charcoal drawing; 24.3 ×
18.5 cm; Teyler Museum, Haarlem

143. Following 2-page spread.
LAST JUDGMENT. 1536–1541; Fresco mural; 1700 × 1330 cm; British Museum, London

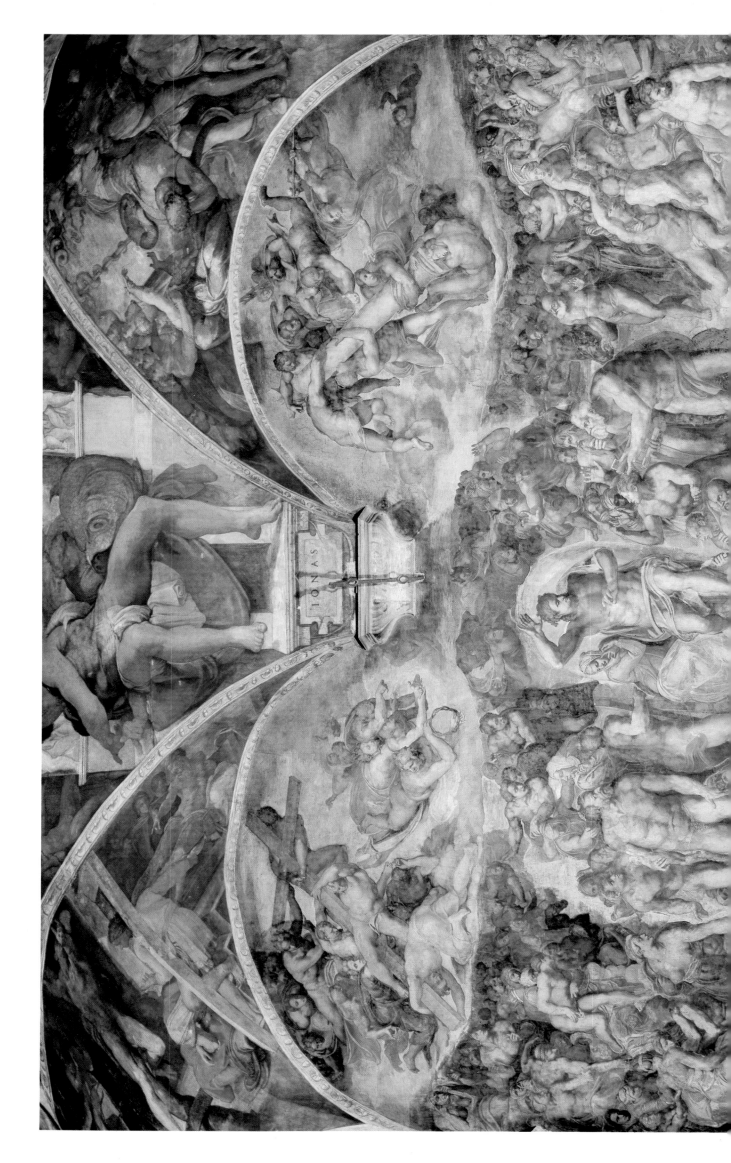

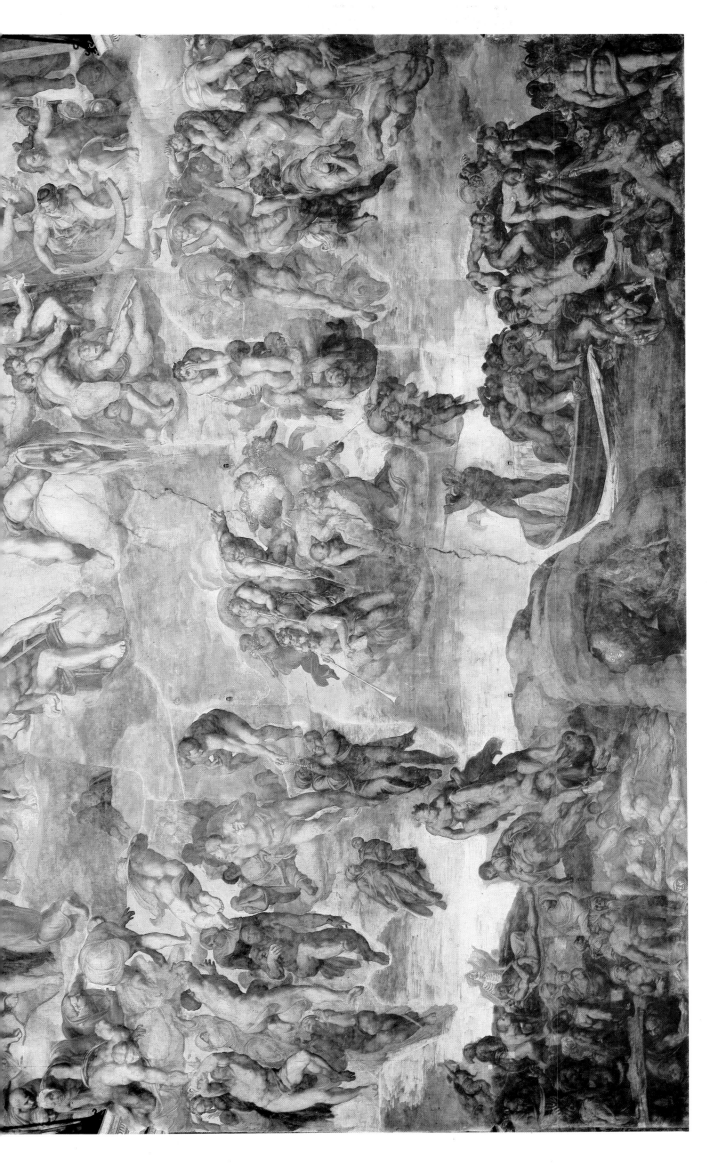

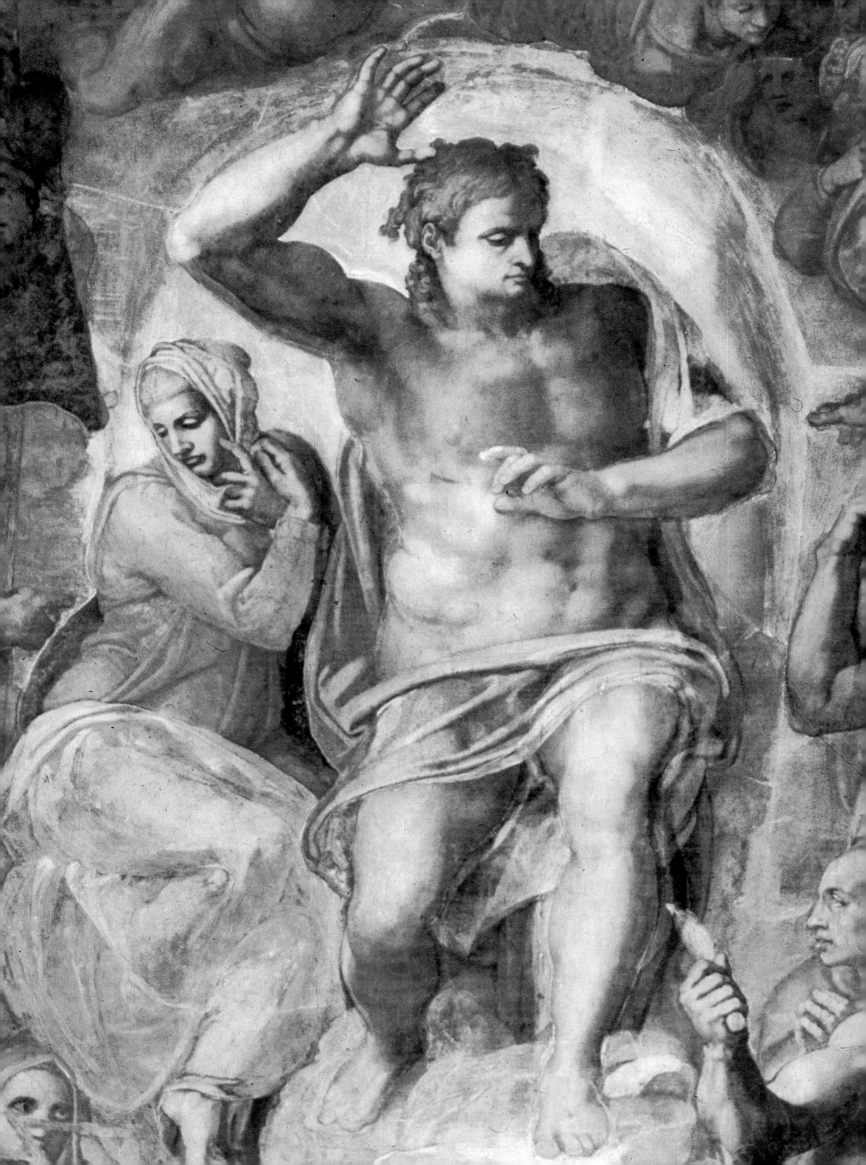

145. Facing page.
LAST JUDGMENT (detail): CHRIST THE JUDGE
AND THE VIRGIN

146. Above.
LAST JUDGMENT (detail): NIOBE OR EVE AND
A DAUGHTER

147.
LAST JUDGMENT (detail): SAINT LAWRENCE

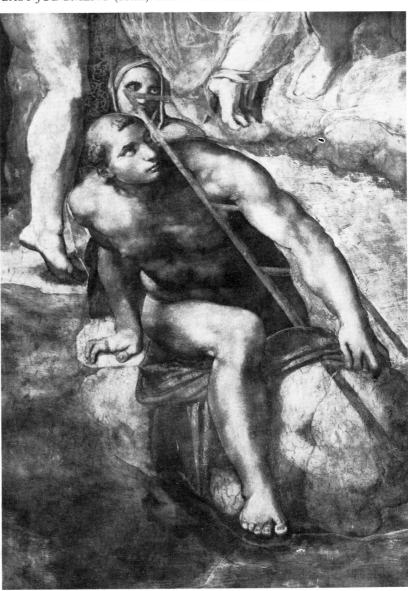

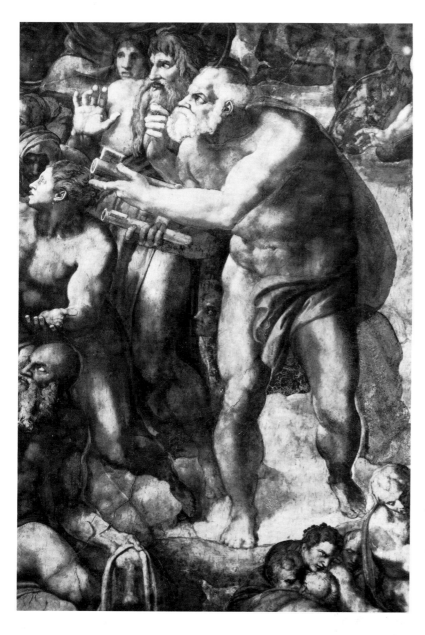

148. Left.
LAST JUDGMENT (detail): SAINT PETER

149. Below.
LAST JUDGMENT (detail): A MAN DAMNED
FOR HIS DESPAIR

150. Facing page
LAST JUDGMENT (detail): SAINT BARTHOLOMEW
(The flesh held in the saint's left hand is a self-
portrait of Michelangelo.)

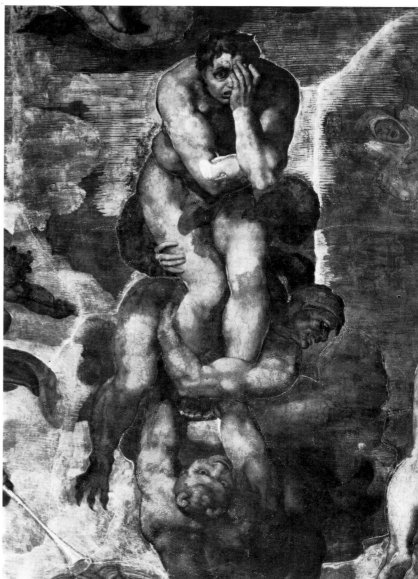

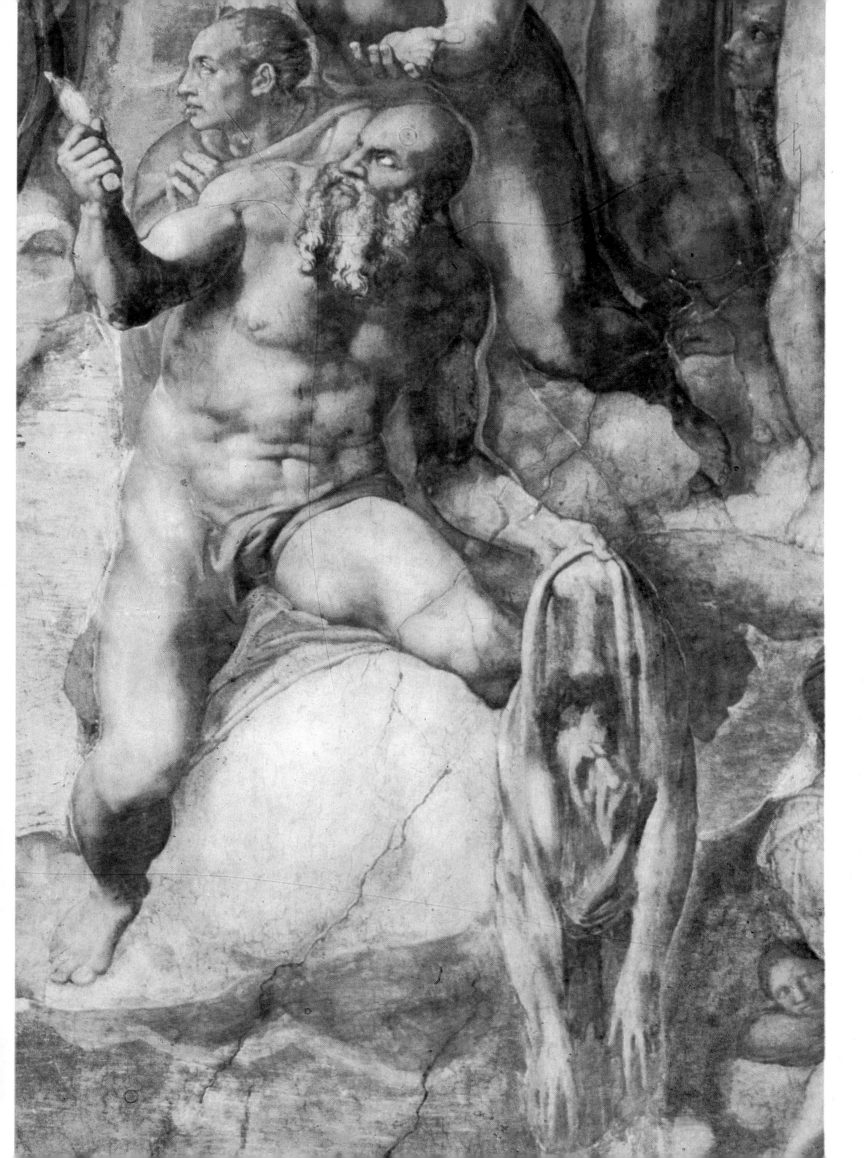

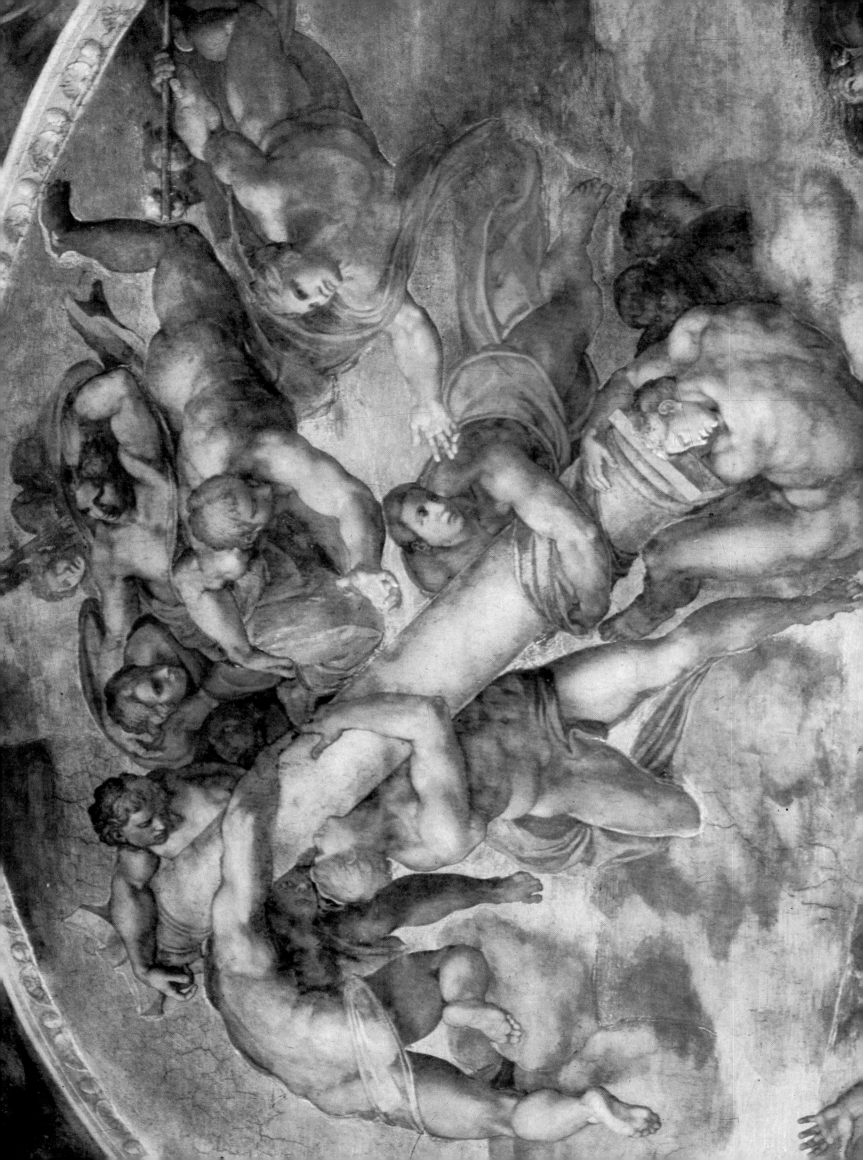

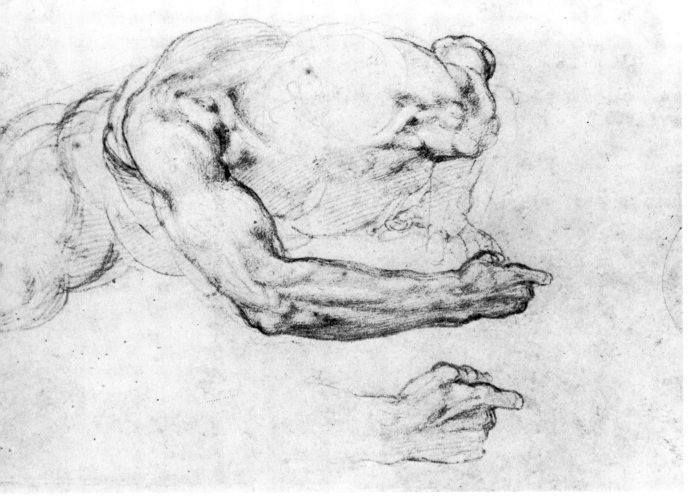

151. Facing page.
LAST JUDGMENT (detail): GLORY OF THE INSTRUMENTS OF THE PASSION

152. Above.
STUDY FOR THE LAST JUDGMENT. 1534–1535;
Charcoal drawing; 21.5 × 26.6 cm; Ashmolean Museum, Oxford

153. Below.
STUDY FOR THE LAST JUDGMENT: CHRIST
AND THE MARTYRS. 1534; Charcoal drawing; 19 × 38 cm; Uffizi, Florence

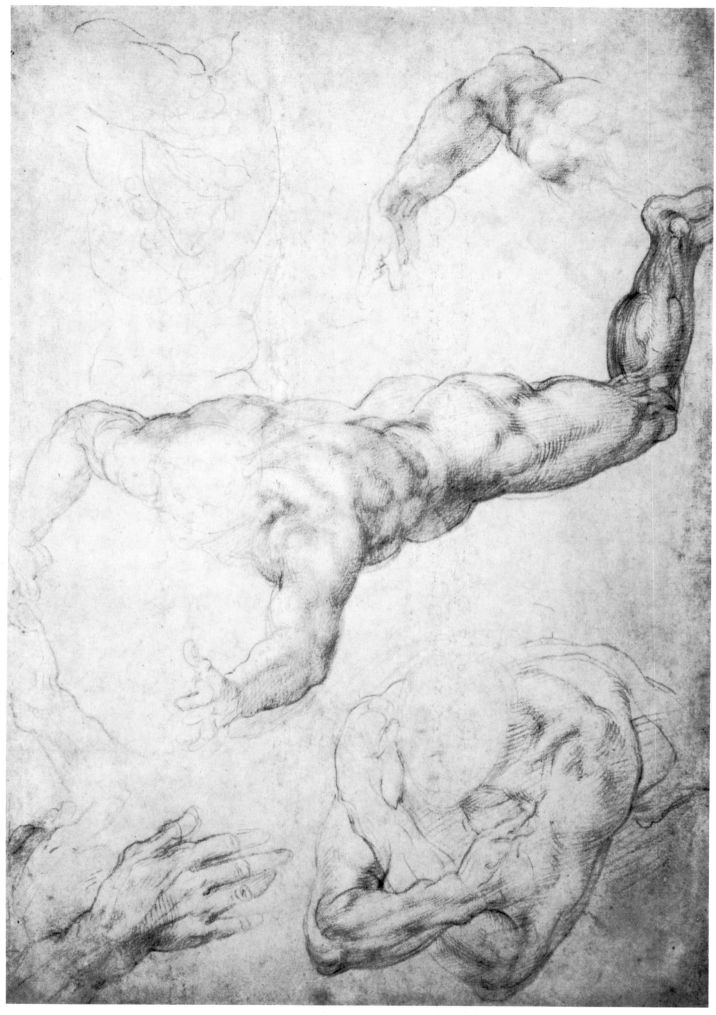

154.
STUDY FOR THE LAST JUDGMENT. 1534–1535; Charcoal drawing; 40 × 26 cm; British Museum, London.

155. Facing page.
LAST JUDGMENT (detail): CHARON'S BARK

156.
CONVERSION OF SAINT PAUL. 1542–1545; Fresco mural; 625 × 661 cm; Pauline Chapel, Vatican City.

157.
WOMAN'S HEAD. 1522–1534; Red chalk drawing; 20.3 × 16.5 cm; Ashmolean Museum, Oxford.

158.
STUDY FOR LEDA AND THE SWAN. 1529–1530; Red chalk drawing; 35.5 × 27 cm; Pauline Chapel, Vatican
City.

159. Facing page.
CONVERSION OF SAINT PAUL (detail)

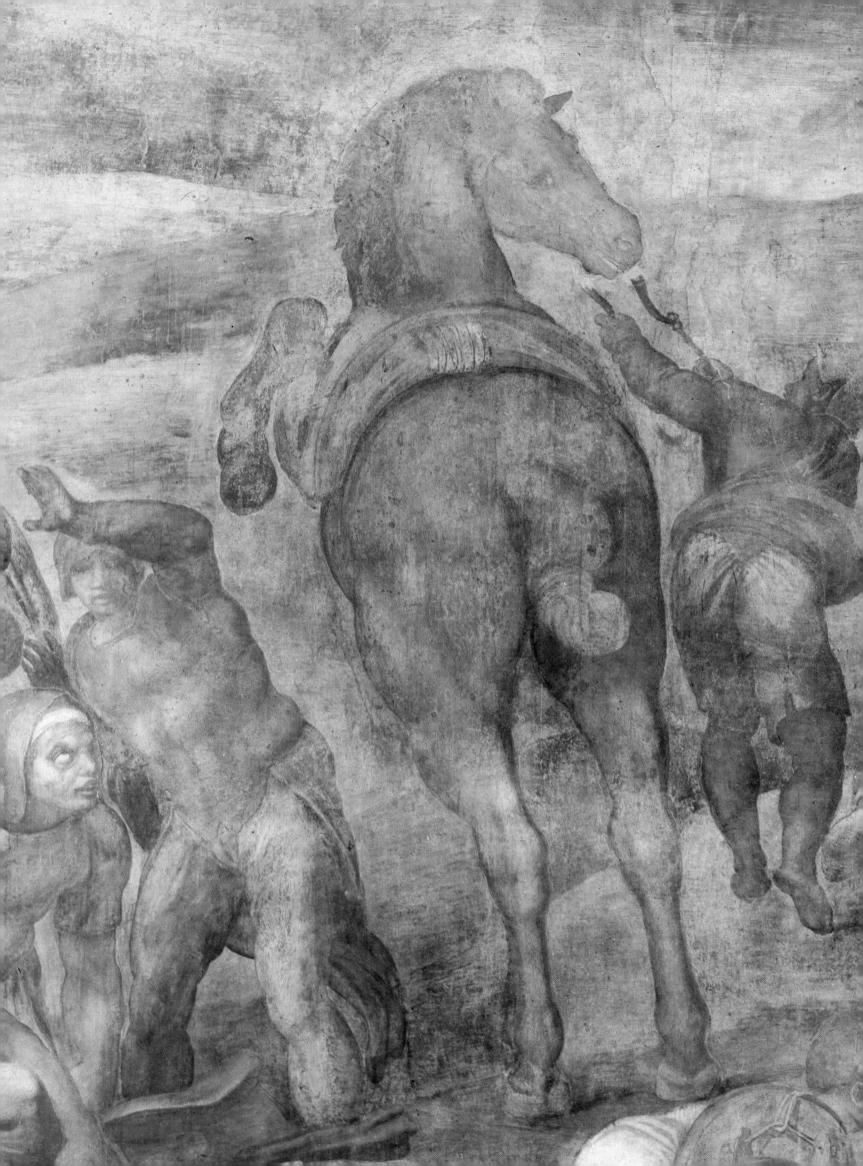

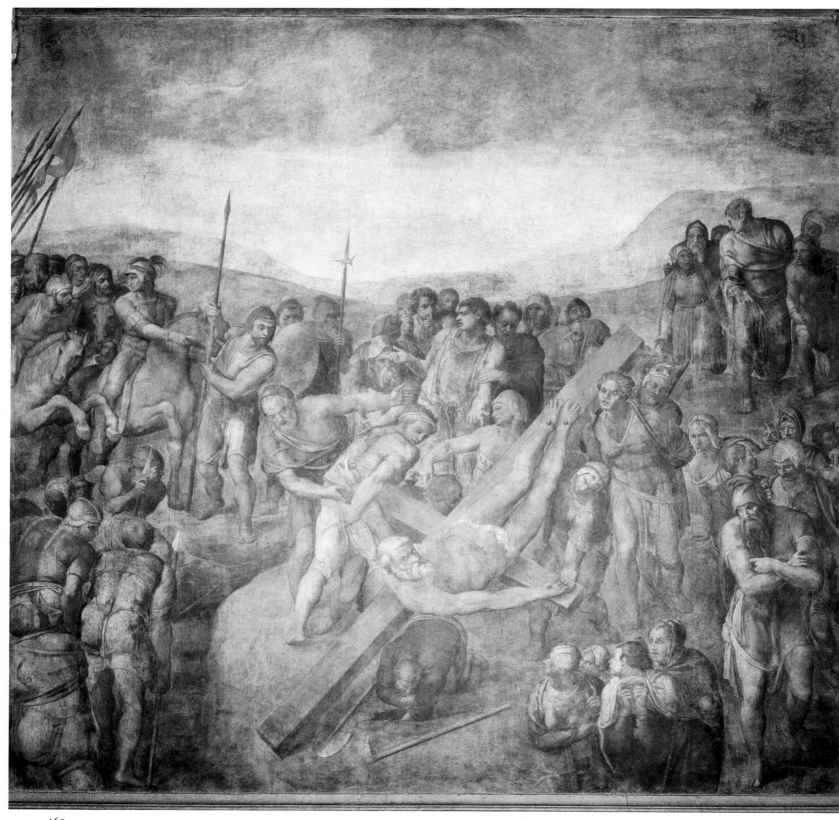

160.
CRUCIFIXION OF SAINT PETER. 1546–1550; Mural fresco; 625 × 661 cm; Pauline Chapel, Vatican City.

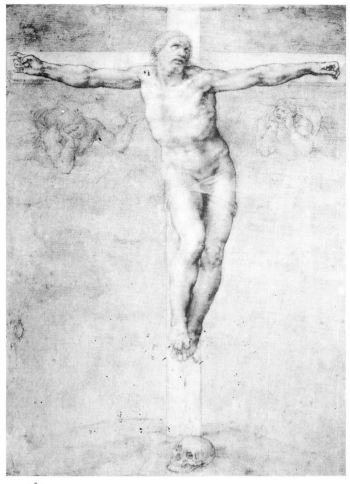

161.
CRUCIFIXION. 1538–1540; Charcoal drawing; 37 × 26.5 cm; British Museum, London.

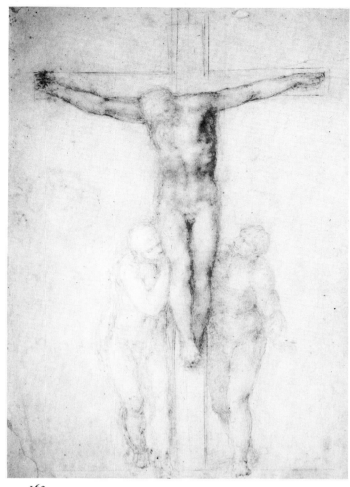

162.
CRUCIFIXION, VIRGIN AND SAINT JOHN. 1550–1560; Charcoal drawing; 42 × 28 cm; British Museum. London.

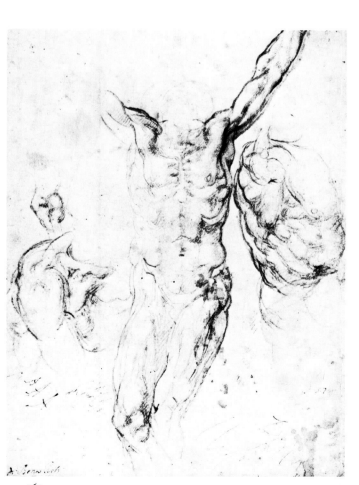

163.
STUDY FOR THREE CRUCIFIXES. Charcoal and red chalk drawing; 33.1 × 22.9 cm; Teyler Museum, Haarlem.

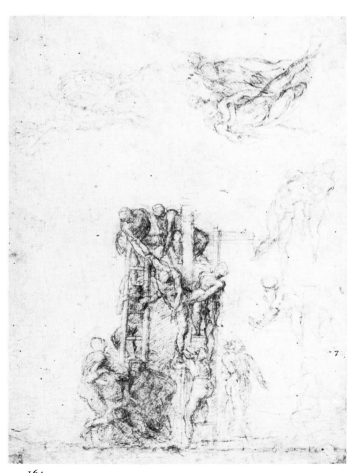

164.
DESCENT FROM THE CROSS 1536–1540; Red chalk; 27 × 18 cm; Teyler Museum, Haarlem.

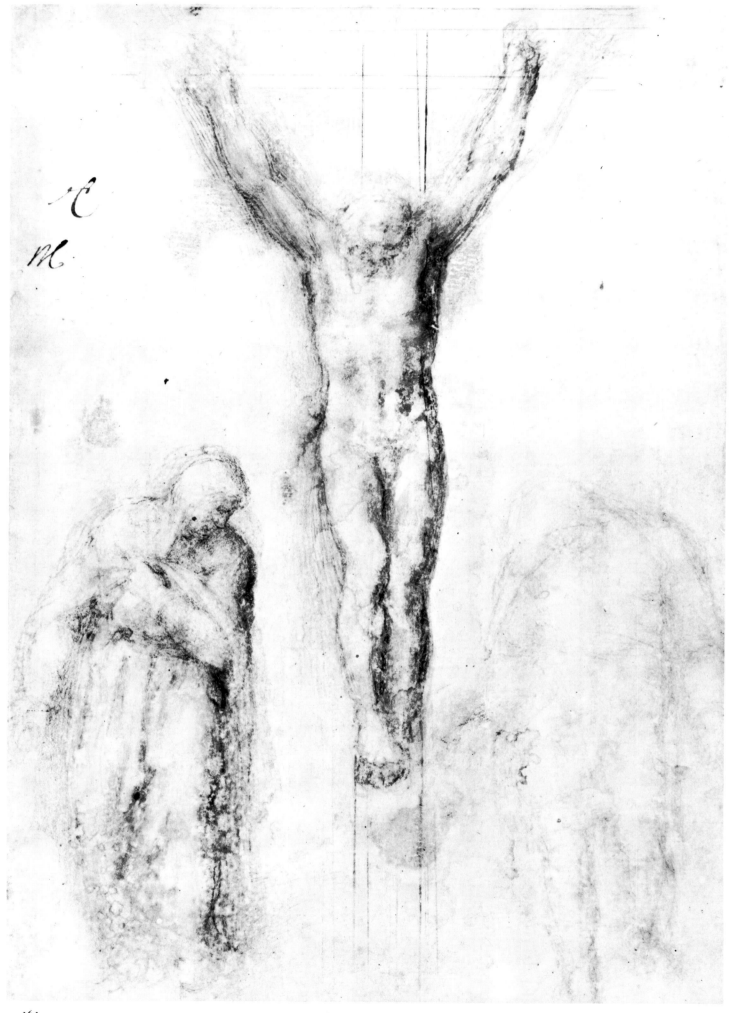

165.
CRUCIFIX WITH THE VIRGIN AND SAINT JOHN. 1550–1555; Charcoal drawing; 42 × 28.5 cm; Cabinet
des Dessins, Louvre, Paris.

166. Facing page.
CRUCIFIXION OF SAINT PETER (detail)

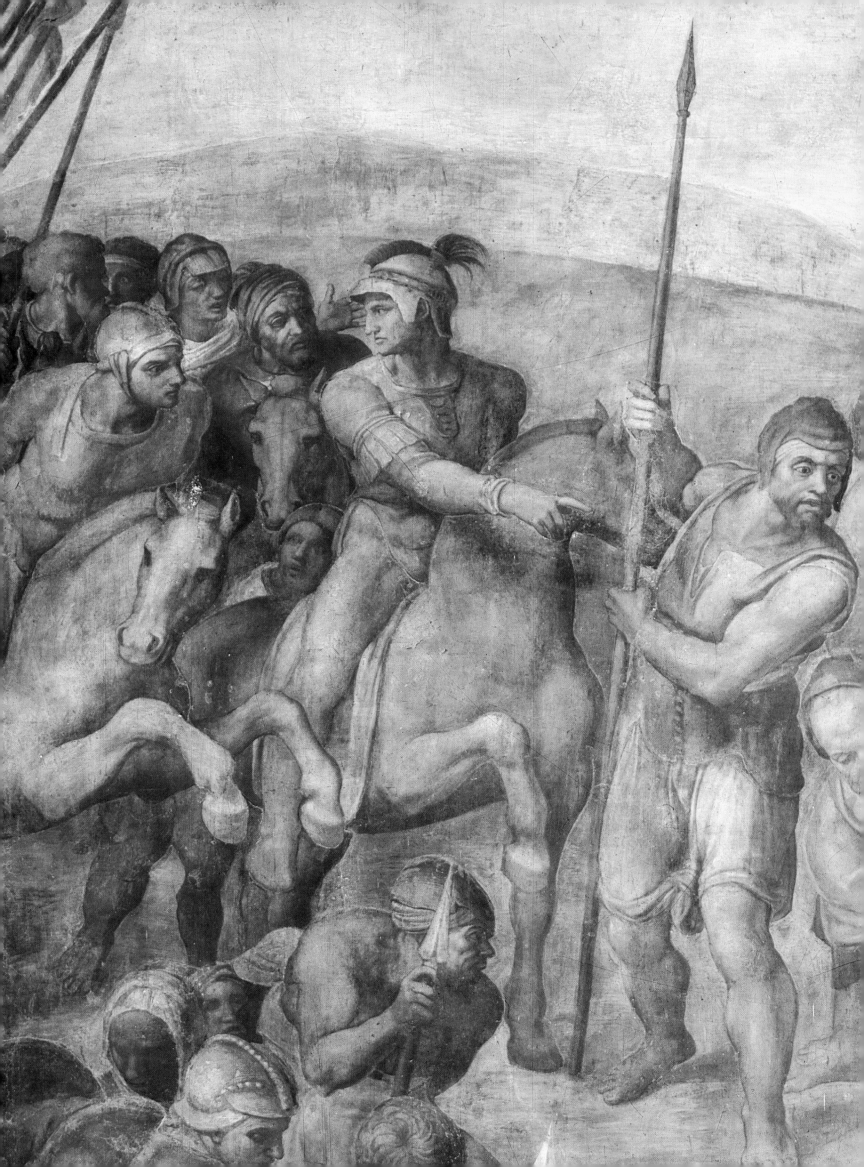

VI
The Last Sculptures

Michelangelo, who had embraced republican ideals since his youth, was commissioned by the historian Giannoti to create a bust of Brutus. Since Brutus was the object of cult worship by partisans hoping for the return of freedom, the commission had political overtones. Executed during the same period as the *Last Judgment,* this statue, today in the Bargello Museum in Florence, reveals the artist's democratic ideals. It is characterized by defiance and power. Michelangelo departs from the anatomical principles of his usual style in portraying a proud, determined, indeed severe, individual whose will dominates every phase of the protrait. The magnificent tension of this face is in the same lineage as the heroic *David,* indicating once again the artist's desire to crate an ideal model to serve a moral cause.

After the demonstrative eloquence of his maturity renouncing the demiurge for the monumental, Michelangelo, under the influence of Vittoria Colonna, who died in 1547, devoted the last years of his life to the execution of statues, seemingly unfinished, yet the most moving of all his works in which the artist concentrated the highest spiritual fervor. If he was depressed all his life, his last years, shown in the moral disposition of the poems, are years of profound melancholy. Michelangelo fluctated between the act of pure devotion and the despair of being abandoned by God under the weight of his sins.

If architecture and poetry seemed to absorb his attention in those last years, Michelangelo still remained most faithful to his vocation as sculptor. He was still to conceive three masterpieces in the form of the Pietá.

The first group was executed by the artist to decorate his tomb, which was to be placed in the church of Santa Maria Maggiore in Rome. This pietá, called the *Florence Pietá,* can be seen in the cathedral of Santa Maria del Fiore in Florence, where it was sent in 1721. If we compare this group with the Pietá in Saint Peter's Basilica in Rome, completed in 1499, we can assess the unfolding of the artist's suffering conceived, qualified and expressed in this long meditation upon death. The Roman *Pietá* is devoted to pure and balanced form. Each phase of the statue illustrates a refined aesthetic choice. By contrast the three groups of his last great period of achievement have the marvelous density of a devout emotional experience reaching out to touch upon the empire of death. Such was his genius: death is no longer a symbol or even a figure but a presence of incalculable wealth that momentarily tempts the viewer, forcing him to become one with the artist's intentions. If we can separate ourselves from these last creations, it is only because Michaelangelo was able to grasp the emotional sphere of the terrible oscillation between the desire to identify with death and the will to revive and to recall the one who just died.

The Florentine *Pietá* was restored by Michelangelo's student, Tiberi Calcagni. For some reason unknown to us, the master himself damaged the work. Dominating the other figures, at the point of the triangle, is Nicodemus, to whom Michelangelo gave his own features. He is placed between the Virgin Mary and Mary Magdalene, holding the body of Christ. In the triangular structure of the group, the figures are entwined by the encircling limbs of the dead Christ. The soft effulgence which emanates from the group comes from the subtle punctuation of sentimental effects on the faces of the figures. The contemplative kindness of Nicodemus that envelopes the mother's affectionate embrace for her son, the son's peaceful rest, his tilted head, the mother's face that merges with her son's head, and Mary Magdalene's beatific attitude, all converge synthetically to present an image of repose, natural, soft and peaceful death. These later works obviously express faith and bliss in the clear consciousness of the pain of death.

The *Pietà,* initially placed in the Barbereneni de Palestrina then transferred to the Accademia in Florence, always posed an enigma to the master's biographers. There is no evidence attributing this work to Michelangelo, which is odd considering the attention that always surrounding his representations. It was not until 1756 that this *Pietà* was first attributed to Michelangelo, an attribution that has continued to the present day. Charles de Tolnay

Presumed portrait of Michelangelo
Pietà, Cathedral of Santa Maria del
Fiore, Florence.

suggested that it is possible that Michelangelo conceived the idea of the group, but that his students carved the statue, actually executing the work.

The general assemblage of the figures is the reverse of the Florentine *Pietà* in Santa Maria del Fiore as far as the placement of the Mary Magdalene is concerned. The inversion of the position once again of Christ and of the Virgin, in the *Rondadini Pietà* completes the cycle period. The *Palestrina Pietà* shows the same juxtaposition of polished and perfected areas with rough-hewn areas. In this conception the work once again takes up elements of the previous piece without however achieving the same depth of contradiction between the tragedy of the subject and the peaceful harmony of the arrangement.

The artist's last work, the *Rondadini Pietà,* placed in the Sforza Castle in Milan, is the most intense and the most moving of the statues in this cycle. In its extemely technical concentration, the artist developed the most powerful metaphor of face, solitude and mesmerizing spirituality.

Six days before his death, Michelangelo was still working on this most grandiose antithesis of the *David,* showing how much of the artist's own life was invested in his work. While in the ealier *Pietàs* Michelangelo displayed a contrast between the sagging body of Christ—the central figure—and the witnesses who support him, the *Rondadini Pietà* follows a new rhythm, a new scheme of construction that condenses the bodies of Christ and the Virgin into one ambivalent movement. Two opposing forces infuse energy into the statue; Christ's bended knees add weight to his body and give the effect of mortal incarnation; the Virgin's dominating head as well as the elongated bodies and parallel justaposition of the two figures give the effect of elevation to the group. Organically connected, Christ and his mother merge in painful and spiritual ascension. Entirely spiritualized, united by pain and love, they manifest the supreme internalization of feelings. Their sublime blindness to earthly concerns reinforces the interior contemplative spirit of the essence of the mystery of Christ.

In search of the visible stages of the technical and operative consciousness that existed during the execution of a work, modern art has used and often abused the representation of the *non-finito*.

As we have noted, a number of the artist's sculpted works are in fact unfinished, and it is this unfinished quality that is the source of some of the emotions we feel when viewing them.

For many of our contemporaries, this unfinished quality contributes to the modernity of these works. Aru, in a desire to interpret this phenomenon, was able to synthesize the argument.

> Some critics have discussed this state of dissatisfaction that might have prevented Michelangelo from attaining full realization of his own vision, which also might have forced him to abandon a work, either because of tragic discouragement created within himself by the eternal dissension between spirit and matter, (Mariani) or the impossibility of adding mystical Christian context to the plastic pagan form (Thode). Others on the contrary conjecture that the sudden interruption of his work was caused by his satisfaction in reaching full realization of his vision: because of the emphasis that this unfinished quality gives to the sculptural relief compared with the finished quality (Venturi, Bertini); because of the greater emotional expression achieved by a rapid and audacious synthesis (Bertini); because of love for ancient sculpture, more powerful and more expressive when they are used and truncated (Toesca); or because of the suggestive power of the figures which emerge from the raw marble where the activity of the human spirit seems to be associated with the forces of the cosmos and consequently offers an infinity of ideals instead of a limited background of a personality or of an epoch.

Each of these varying interpretations deserves to be considered; however, it seems that we have not been insistent enough on two theses: one, technical and the other, ideological and cultural. First, Michelangelo sculpted his marble blocks in progressive stages, following sketches he had made earlier. Thus, in a way, the size itself was only the verification in the space of a preconceived plan.

Keenly aware of the irreducible identity and specificity of each discipline, it is quite possible that Michelangelo wanted to show the enormous gap between the two spaces representing each work. Using addition for drawings and subtraction for sculpture, Michelangelo

represented, in the *non-finito,* the material route and the progressive incarnation of the vision. The second thesis seems to be marginally, under the specific impulse of the master himself, the conflict of the relation between the model and the copy, a conflict that appears as early as the time of the *Doni Tondo.* Thus art was already a conceptual and expressive actualization that forced the master to augment his individual vision and progressively renounce the sacred imitation of nature.

Until his death, Michelangelo remained faithful to his republican ideals. While Cosimo I de Medici was master and tyrant of Florence, the artist saw Francis I as the potential liberator of the city. However Francis died and Emperor Charles V remained the only western leader allied with Pope Paul III against the Protestants. Once again treaties and accords, treacheries and betrayal punctuated the relations between the two powers. The Council of Trent or the Counter-Reformation marked the apogee of the bloody struggle throughout Italy against the Protestants, supported by Charles V against the Protestant princes of the germanic empire. Yet the master stood apart from the Reformist ideas.

However under the Aretino instigation, which published a declaration of Michelangelo's alleged impiety and his immoral relationship with Tommaso Cavalieri, he also suffered from the terrorist climate of the Inquisition. Moreover, when Duke Cosimo I banished him from Florence, he was exposed to the reprisals of the tyrant's agents even in Rome, where spies watched the movements of the Florentine duke's opponents.

The death of Pope Paul III deprived Michelangelo of a sincere protector. Paul's successor, Julius III, was also attracted to the arts and to artists. Julius guaranteed Michelangelo his support, going so far as to state that he would have offered years of his own life to the master if such a thing were possible. He added that he wanted to be buried close to the "divine" so that the artist's lessons would survive after his death. Julius III, a liberal, stopped the persecutions against the Protestants and concerned himself with enhancing his family and solidifying his pontificate by commissioning a few prodigious works such as the construction of the Villa del Monte, designed by Ammannati, Della Porta, and Vasari. Michelangelo, who was Julius's permanent adviser in artistic matters, was entrusted with the realization of the Belvedere Staircase. Despite the many intrigues against him, Michelangelo maintained a respectful friendship with Julius III and was, as he intended, able to devote himself to the progressive conception of the dome of Saint Peter's.

Siena was destroyed on August 2, 1554 while the war was at its peak in Tuscany under the instigation of the Strozzi, who wanted to seize Florence with the help of the banished Florentines. After the bloody battle, four thousand bodies lay dead on the battlefield, the banished Florentines were taken prisoner, Duke Cosimo I was the victor, and he invited Michelangelo to return to Florence.

The death of Julius III and the accession to the throne by Marcello II, an enemy of the artist, almost provoked the realization of Cosimo's wishes. But Marcello died three weeks after his election. Cardinal Carafa succeeded him and took the name, Paul IV. He immediately suspended the Council of Trent and promulgated a series of drastic measures intended to improve Roman morals; he created the Index, gave full power to the Inquisition, favored the Jesuits, and canceled Michelangelo's allowance. However, he supported the master's work on the dome of Saint Peter's despite the appointment of another artist, Piero Ligerio, an enemy of Michelangelo's and an accomplice of da Sangallo's.

This pontificate was a reign of terror. Heretics were mercilessly pursued, tortured and put to death. Intolerance was associated with cruelty. Corpses of those judged heretics were unearthed for burning. The energy of Paul IV was equalled only by his bloodthirsty hatred of the Reformation, whose influence had spread throughout Europe. The Renaissance, as well as humanist and liberal ideals, was dead. In addition to his struggle against the infidels and his fanatic zeal, Paul IV wanted to reestablish absolute power and prestige in Rome; he wanted to expedite the renovation of Saint Peter's, which would become the global symbol of this reestablished power. Michelangelo, then eighty-two years old, devoted his last energies to the execution of this work that he said would dominate Christianity until the Last Judgment.

When Paul IV died in 1559, the Romans freed themselves from the chains that had bound them for too many years. The statue of the Pope was destroyed, and the prisoners of the Inquisition were freed by the rebels.

Pius IV, who succeeded the torturer, revived the Council of Trent, which would conclude in 1563. A liberal and patron of the arts, Pius resumed Michelangelo's allowance. Despite Michelangelo's old age, the Pope begged him to continue the work on the dome. At

the age of eighty-six, as he saw his strength declining, the artist was aware that he would not be able to complete the work, and on the advice of Tommaso Cavalieri, he made a wood miniature model that could be followed after his death.

Until the end, Michelangelo was the object of endless plots aimed at stripping him of the successive patronage of the popes. His last work in Rome was the transformation of the baths of Diocletian in the church of Santa Maria degli Angeli. In January 1564, a weakened Michelangelo was still working on the *Rondadini Pietà;* on February 14th, the old master took to his bed. Tommaso Cavalieri and Diomede Leni were at his bedside; his friends and servants surrounded him; he dictated his will; and at approximately five o'clock on Friday, February 18, 1564, Michelangelo was no more. By the intervention of the Florentine ambassador, Michelangelo's studio was moved to Florence. Thanks to a ruse, the coffin containing the body of the artist left Rome for Florence, where it arrived on March 11th. Amidst the throng of the Florentine people, the mortal remains of the "divine" master were buried in Santa Croce. In July the official state funeral was held in the church of San Lorenzo.

The authorities feared riots in the city, but nothing happened. Those who might have construed his return to Florence as a symbol of lost freedom were dead. The prince was now all-powerful. The people dared not rebel, and the leisure classes, comprising the hierarchy of society, bowed under Cosimo's rule. Of the democratic Renaissance, not even memory remained.

167.
STUDY FOR THE RESURRECTION. 1532–1533; Charcoal drawing; 32.4 × 28 cm; British Museum, London

168.
WOMAN'S HEAD IN THREE-QUARTER PROFILE. 1533–1534; Charcoal drawing;
21 × 14 cm; Royal Library, Windsor

169.
HEAD OF A GIANT (attributed to Michelangelo). Ink and red chalk drawing; 28 × 30 cm; Cabinet des Dessins,
Louvre, Paris

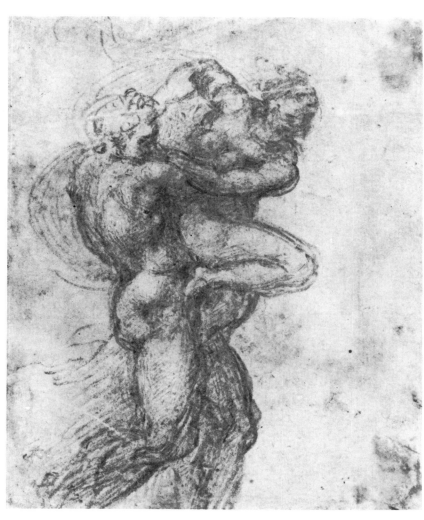

170.
ABDUCTION OF THE SABINES. 1550; Charcoal drawing; 33.1 × 2.4 cm; Teyler Museum, Haarlem

171.
ARCHERS. 1533; Charcoal drawing; 21.5 × 31.7 cm; Royal Library, Windsor.

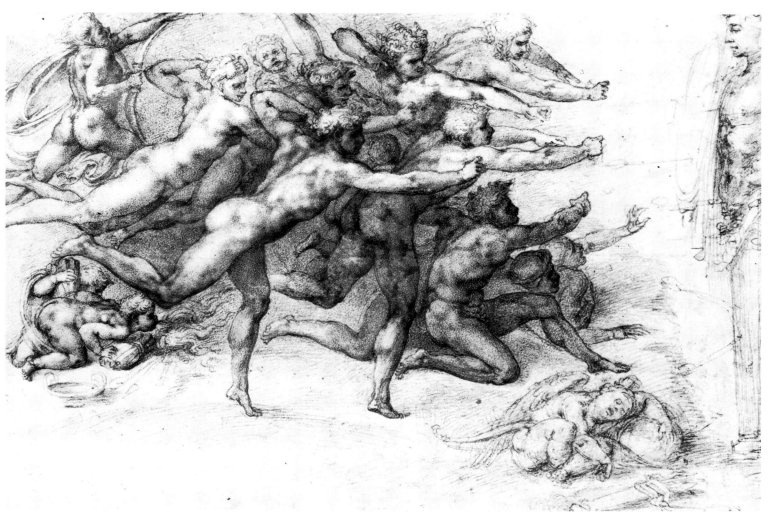

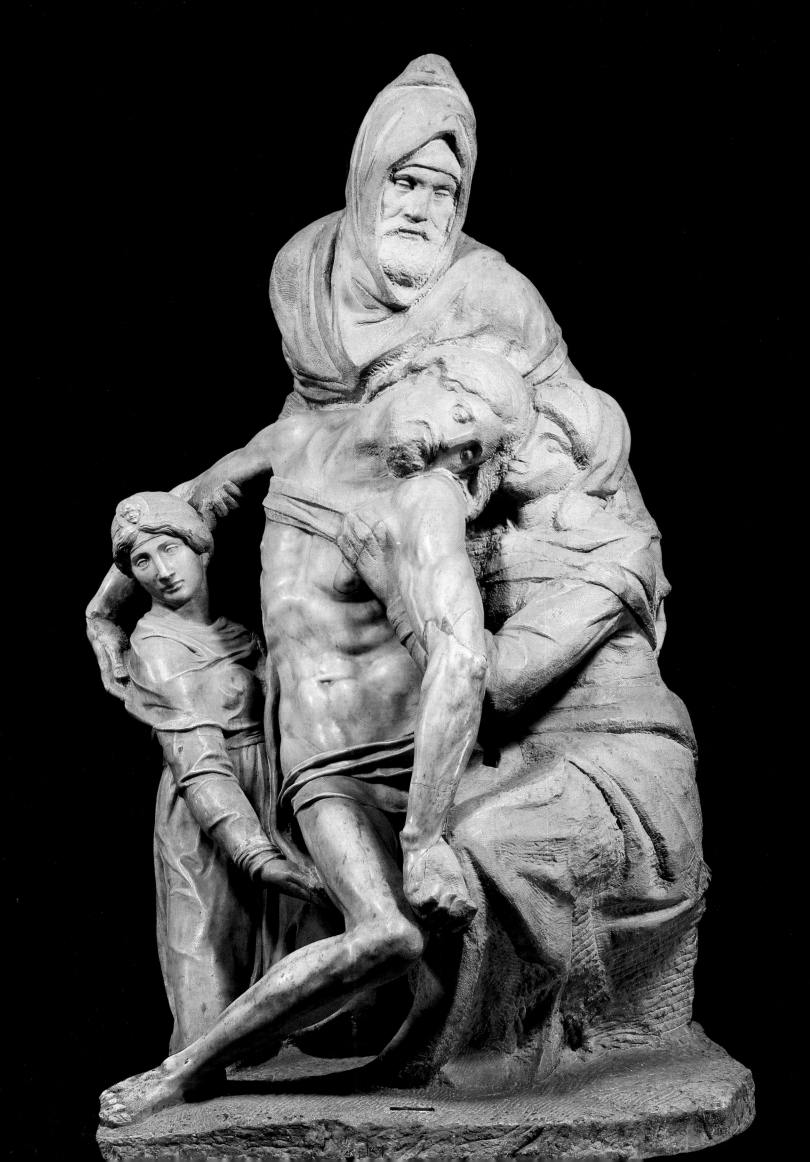

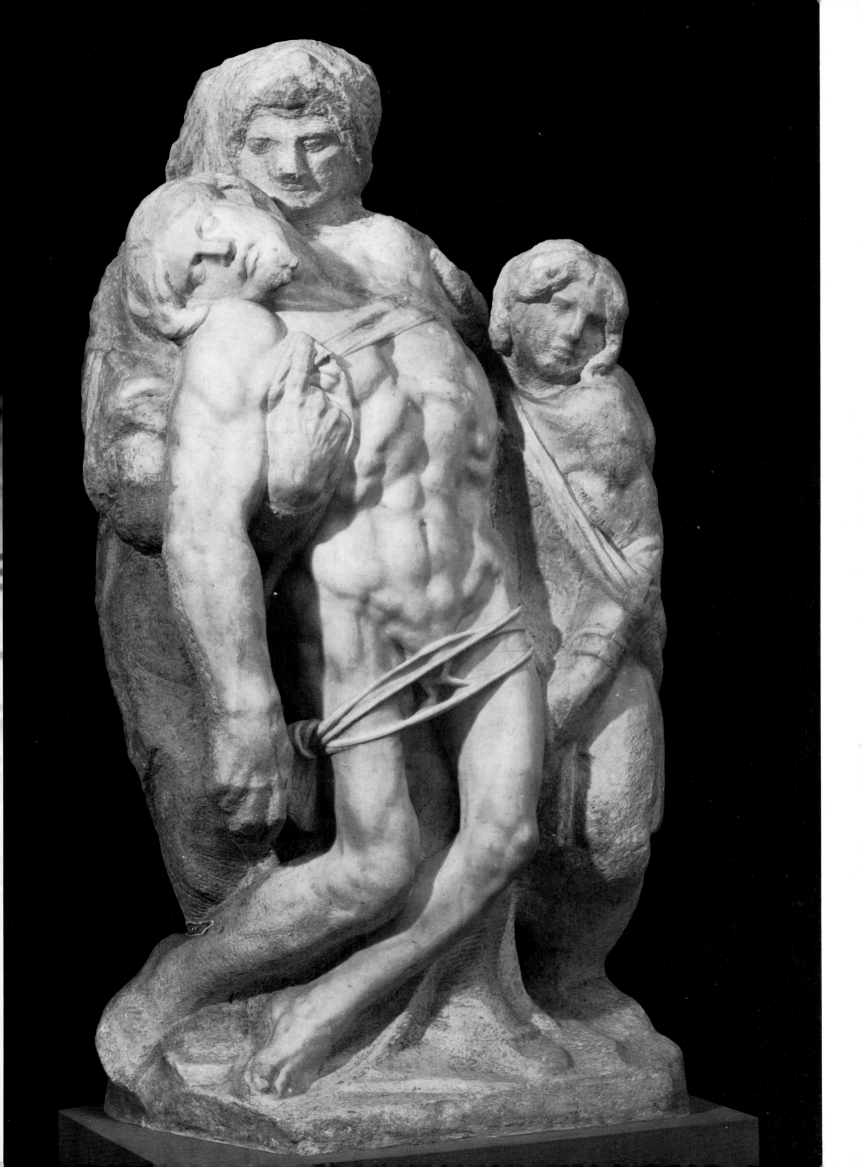

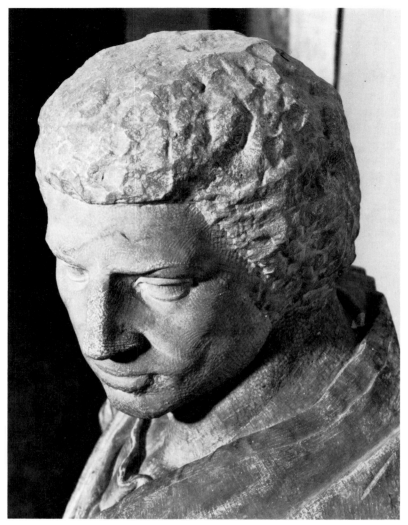

172. Preceding left page.
PIETÀ. Circa 1546–1555; Marble; 226 cm high; Santa Maria del Fiore, Florence.

173. Preceding right page.
PALESTRINA PIETÀ. 1550–1560; Marble; 253 cm high; Accademia, Florence.

174. Below:
PALESTRINA PIETÀ (detail)

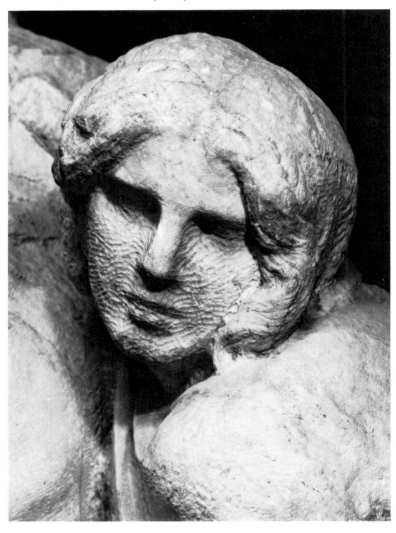

175. Brutus
Circa 1539; Marble; 74 cm; Bargello Museum, Florence.

176. Facing page.
RONDADINI PIETÀ. 1552–1564; Marble; 195 cm; Sforza Castle Civic Museums, Milan.

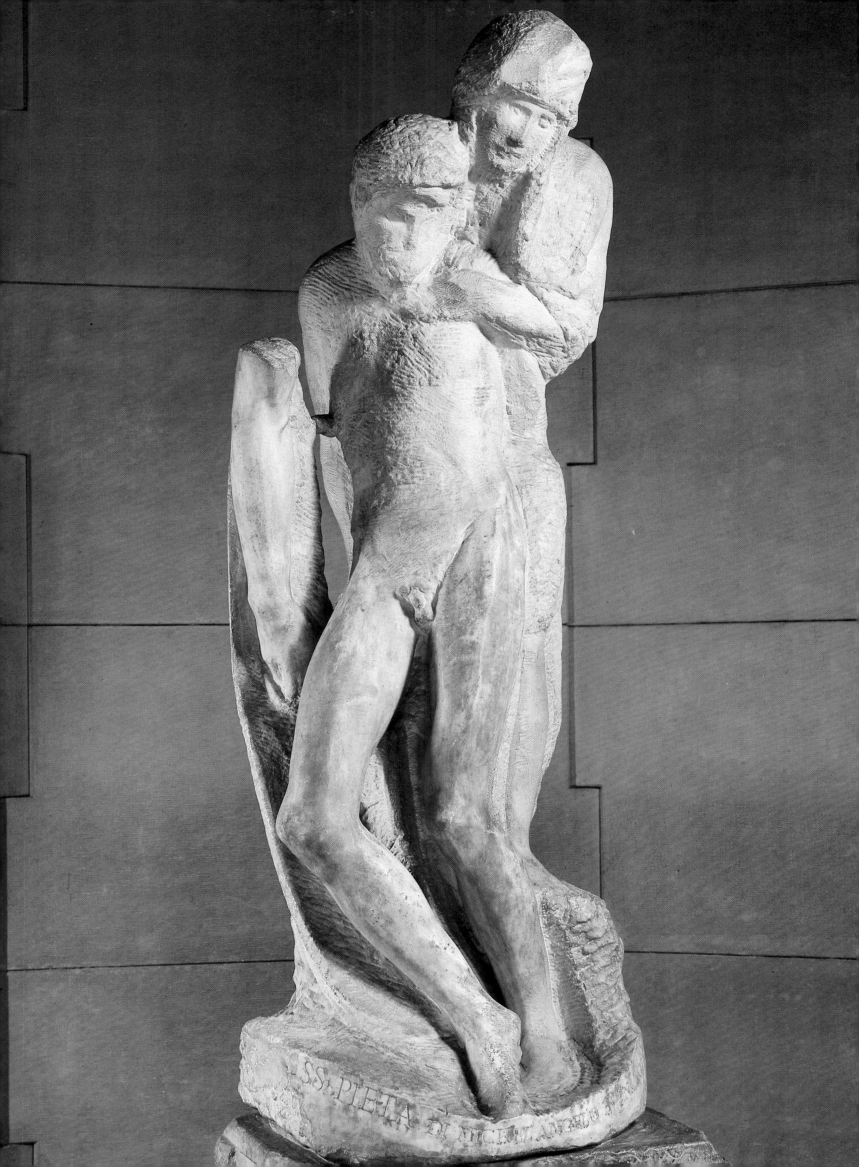

VII
Michelangelo—Architect and Poet

THE ARCHITECT

As we have already seen, Michelangelo was a brilliant artist; but he was more: he was a total artist. Two periods of his life were devoted primarily to architectural structures in the two places where he spent his time, Florence and Rome. It was probably not a field where the artist could venture authoritatively. And yet, in keeping with his general vision of art and form, Michelangelo conceived, in his early period, an architecture that bears the imprint of his expressive will; then in his later years in Rome, he realized projects whose spatial conception profoundly changed the art of construction.

Portrait assumed to be of Michelangelo (detail of the "Last Judgment")

Michelangelo's first important architectural project was the façade of the church of San Lorenzo, a commission from Pope Leo X de´ Medici, who wanted to honor his family.

In a project design competition, the Pope and Cardinal Julius de´ Medici chose Michelangelo's design over those presented by the most prominent artists of the time. Baccio d'Angelo, Michelangelo's assistant on this project, build a model based on this design. It was rejected. A new model built by Michelangelo and Pietro Urbano won the Pope's approval two years later; unfortunately, the work was interrupted and was never completed.

An analysis of successive projects for the façade reveals a progressive simplification of the structure; the pedestal of the pilasters of the upper story is organically linked to the building. On Giuliano da Sangallo' model for the project for the same building, which was inspired by antique monuments, Michelangelo projected the massive attic story on a ground level support of the light columns. In this way, he could create a bold relationship of contrasting energies, of opposite rhythms where the tension of the structure is manifested in the classic appearance of the whole.

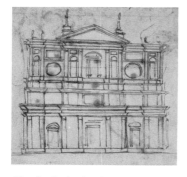

Plan for the facade of San Lorenzo (1517)

This first project was conceived by a sculptor. The ten figures of the façade were to be placed at the intersections between the verticals and horizontals. It is likely that Michelangelo's first commissions, consisting of ornamenting structures already built, facilitated the possibility of breaking the classic, organic harmony between the internal structure of buildings and their faithful reproduction on the façade. Thus, he was the first to conceive of the independence between the interior and exterior, believing the exterior to have a public ornamental function.

The second important commission given to Michelangelo, following the accession of Clement VII de´ Medici to the papal throne, concerned the erection of the Laurentian Library adjacent to the Cloister of San Lorenzo. The year 1524 was devoted to the preparatory studies. From August 1524 to 1534, Michelangelo supervised the work. The Library was finished in 1560 by Ammannati.

As functional architecture, the Library breaks with the only model of religious or official structures, which was revolutionary for the time. A place for retreat and meditation, which would also serve to house the collections of manuscripts and books of the Medici family, the Laurentian Library is above all, in Michelangelo's conception, a spiritual space. The entrance vestibule is conceived as a meditation between the exterior and interior, which prepares the visitor for the austerity of the reference rooms. According to his general principle, Michelangelo applied his sense of the organic interdependence of the parts to the whole in his architecture. The reading room, immense in width, has bays of desks on the two sides of a central corridor. The walls are composed of pilasters whose restraint contributes to the impression of the room's austerity. Between the pilasters, there are frames without ornamentation. This austere architecture, sometimes judged monotonous, corresponds, in fact, to Michelangelo's concern to free the spirit of the place reserved for meditation.

The absence of decorative elements, except for the ceiling, which is ornamented with antique motifs, is a complete departure from all the Florentine principles of construction, but will soon become a model repeated in the erection of public buildings of the Cinquecento.

The staircase at the entrance of the Library is in itself a remarkable piece. Here, Michelangelo breaks with the purely functional aspect of that element to incorporate it as an entirely separate architectural piece in the imposing volume of the vestibule, which at the same time is reduced to serving as a stairwell. This monumental staircase, which will later serve as a model in baroque architecture, is composed of a series of steps divided by two banisters in the center. Two angular lateral staircases surround the central staircase of convex steps. The landings of the lateral staircases open at a right angle onto the central staircase, which seems to be an architectural aberration, where only the ornamental intent guided the master. The three staircases lead to the same center door at the top of a central axis.

Besides the construction of this prestigious building, Michelangelo was to realize or plan architectural works of lesser importance. Thus, in 1532, Clement VII asked the artist to work on a gallery destined for the preservation of the relics for the church of San Lorenzo, and as we have seen, Michelangelo was for a time occupied with the realization of Florentine fortifications against the risk of invasion.

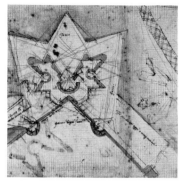

Fortifications

These fortifications change from top to bottom the data for these specific constructions as we restore the plans preserved at the Casa Buonarroti. For the first time, the builder thinks as much about defense as offense, from the interior towards the exterior, achieved by spaces with a clear view, placed between the bastions in the form of pliers or claws which enclose the uncovered areas. As de Tolnay noted, the plans for the fortifications would have a decided influence on one of the greatest architects of strategic construction, Vauban.

During a period of about twenty years, Michelangelo ceased all activity of an architectural nature to devote himself to numerous commissions for sculpting and painting; yet from 1546 to the end of his days architecture occupied more and more of his attention. Despite their autonomy and their true originality, the architectural conceptions of Michelangelo were linked in the early period to the heritage of Giuliano da Sangallo and in the second period of those of Antonio da Sangallo, the Younger, a number of whose works, Michelangelo would finish. The two major works that would mobilize all the attention of the artist's old age concerned the commissions of Paul III, who wanted to establish Roman supremacy by the reconstructions of St. Peter's and the Campidoglio. Of course, these projects were finished after the artist's death, but the numerous preserved plans and sketches prove that they were completed in accordance with the architect's wishes.

The splendor occasioned by the visit of Charles V to the Eternal City anticipated the replanning of the Piazza Campidoglio. Because of a lack of finances, it was not until 1539 that the Senate, following the will of Paul III, appropriated the first funds for the construction, whose care was soon entrusted to Michelangelo. The first problem was to create harmony and an organic place between the two buildings, the Palazzo Senatorio and the Palazzo Conservatori, from different aspects around the antique equestrian statue of Marcus Aurelius, placed in the center of the Piazza from 1538, and whose pedestal Michelangelo reshaped in an oval to lighten the statue itself and then to harmonize it with the new oval plans for the Piazza. Michelangelo's first concern was to plan the unification of the façades, to make them symmetrical, by creating a new building, which would close the Piazza, the fourth side consisting of a staircase, assuring passage between the Campidoglio and the city. The general plan of the Piazza is composed of a central oval representing the *caput mundi* surrounded by an open base trapezoid with the balustrade of the staircase. Here is an extraordinary theatricalization of the space, consisting of a center towards which the star shaped design of the Piazza converges. The façades of the Palaces represent the tension of embedded monumental forces. Horizontals and verticals fit together violently in the form of Ionic columns and Corinthian pilasters that give an age-old character to the whole of the setting.

The reconstruction of St. Peter's had already been envisaged by Julius II; a contest was then organized, and Michelangelo's rival, Bramante, emerged the victor.

Before his death, Bramante only realized the beginnings of the construction and Raphael succeeded him, proposing new plans. Upon his death, Antonio da Sangallo, the Younger, assumed the direction of the work, as chief architect. In 1546, he died and Michelangelo became the master of Roman architecture and resumed Bramante's initial plan. Around four central interior columns, Michelangelo created a simple structure in the form of a Greek cross, as Bramante had planned, but simplifying the different successive projects of his predecessors. The central structure is in the shape of a square, open on one side to form a portico of six columns supporting a triangular pediment. Michelangelo had studied the model of the cupola of the Duomo in Florence from which he conceived the soaring dome that overhangs

the structure. Faithful to its traditional conception, Michelangelo, for this church, the greatest in all Christianity, created a bond of contradictory forces linked together in the unity of the symbolic heightening of the dome. While a building of small proportions had already been constructed by Antonio da Sangallo, the Younger, Paul III declared a competition open to the greatest architects of the time for the construction of the largest private palace in Rome, the Palazzo Farnese, for the Pope's son, Pier Luigi Farnese. Michelangelo won the commission. It is recognized today that the part attributed to Buonarroti is relatively modest, Sangallo's plans having prevailed. However, Michelangelo constructed the cornice of the building and it is remarkable. At its summit it accentuates the whole of the building and unifies it like a frame that contains the structure. In the center of the building, the first floor, the work of Sangallo, is broken by a balustrade that dominates the door of the building. This addition by Michelangelo, as well as the coat of arms over the center window, adds some life to the façade, which is relatively austere. The *Palazzo Farnese* completed, Michelangelo, near the end of his life, realized several more building plans, such as the church of San Giovanni dei Fiorentini, a religious structure which was supposed to be built between the Via Giulia and the Tiber, in the heart of the Florentine quarter of Rome. Plans have also survived for the conversion of the Diocletian Baths into a church called Santa Maria degli Angeli. Sketches by the master concerning the commission for the Sforza Chapel in Santa Maria Maggiore, and the Porta Pia have also been preserved. The architectural work of Michelangelo cannot be separated from the entirety of his artistic problematics. In the same way, two fundamental lines are apparent, which inscribe the artist's own genius in this field. First, his capacity to synthesize elements borrowed from the past, then, his will to produce a powerful work. Forceful and massive architecture, Michelangelo's construction is symbolic; each element is significant in its totality and the direction of a spiritual and cosmic project.

THE POET

For centuries, the power of the sculpture and the glory of the artist have overshadowed an aspect of no less importance in the titanic work of Michelangelo: his uncontroverted literary contribution, particularly in the area of sonnets. Besides the literary quality of the pieces in verse, which place Michelangelo among the greatest of the Italian poets, these sonnets, as well as the artist's correspondence, reveal decisive insights into the spiritual and intellectual intentions of the man. It is to the twentieth century's credit that it has placed this work, previously much too neglected, in all its scope, on a level with his creation in the plastic arts. This expressive will, in a linguistic framework, and the expansion of this production obviously finds its roots in the context of the artist's youth within the Florentine humanist circles under the protection of Lorenzo, where the study of language and its discursive modalities constituted an object of general interest. We must take into account as well the the vitality of Tuscan literature, which served in many instances as a model and sometimes as a source of inspiration to Michelangelo, namely Dante, Boccaccio and Petrarch.

Just as the artist could not submit to the nominal laws of conformity in his work on the body, so the writer, in as much as he did not subscribe to any social or private order, was of major importance for his rejection of the literary rules of the time, the stipulated themes from antiquity, and the decadent formality of his peers. For the author as well as for the sculptor, the only thing that counted was the power of the expression of the subject as opposed to the power of the reproduction of established codes and accepted rhetoric.

The enormous correspondence undertaken by the artist, five hundred letters have come down to us, covers three particular themes: family letters, business letters and finally, spiritual letters. The family correspondence occupies a choice place; it is addressed on two major levels, a biographical source of the greatest importance. First, in the domestic area, the relations between the artist and his family are largely described in these letters as well as the manifestation of the ambitions that Michelangelo never ceased to cherish for his family, synchronizing his own success with the establishment of his family in Florence. Orders, advice, strategies, and tactics abound in these letters in which Michelangelo appears to be the patriarch of a lineage, which he instructs to defend his honor and his interests. These letters underline the constant effort, the perpetual concern for the "divine" to raise his modest family to the ranks of the Florentine aristocracy by way of financial, spiritual and religious success, of which he, himself, is the apostle.

While the family letters allow us to follow the development of the artist's existence, his choices or political uncertainties, his financial investments and the entirety of his material organization, as well as his emotions for his family, the business letters open areas of the artist's creation where the means and the end are bound together. These letters, more than the others, represent the intense physical and material involvement necessitated by the plastic universe that he developed. They are often the letters of a man with a righteous pride, but overwhelmed by the enormous responsibility incumbent upon him. This solitary debate of a man haunted by his work in the face of resistance by men and the elements; the recurring incomprehension presented a model of romantic individualism, as it would develop several centuries later. The business correspondence also provides invaluable information in the form of advice to the overseers or workmen on the technical methods the master envisaged. This correspondence likewise informs us of the conscientious, actual approach of the materials used; it is striking to note the finicky interest that the artist brings to the slightest details of a choice of marble or the transportation of a stone.

We have seen that during his lifetime, many of his contemporaries were jealous of Michelangelo; plots and intrigues never stopped, and the artist often had to explain himself in these letters, complain sometimes, express his indignation. Sources of unappreciated information, we read the master's interpretation of his disagreement with Pope Julius II, under the pressure and combined jealousy of Bramante and Raphael, and then Michelangelo lost his temper, "All that Raphael knew about art, he took from me." Ambition and pride are certainly the qualities which characterize that letter. Indignation, which the artist manifested very often in his difficult position, has however, a source outside the artist himself, which is important to note. Michelangelo, in effect, an intermediary of the representatives of the spiritual powers, was soon to consecrate himself as a servant of divine causes, as well as to attribute his success to his celestial inspiration. This double link allows him in fact to depersonalize his genius all the while complaining of a lack of understanding of conditions in store for a servant of God, inspired directly by Him. There is no egocentricity or narcissism in this complaint, but only the righteous desire that his work and his mission be recognized in their origin and their destiny, from which he removes his personal role.

The spiritual letters of Michelangelo form the third section of this activity. Least in number, they occur during the twilight years of his life, and concern his devotion for Vittoria Colonna and his friendship for Tommaso Cavalieri. These letters emphasize how closely he was inspired by the poems, which are their contemporaries. These letters reveal the mysticism and spiritual unrest of the artist and the ambition of his general cultural ventures. But it is old age and the approach of death, with his advancing years, which form the ultimate core of the letters which Michelangelo composes for official people and for his friends. Thus, the letter sent to Duke Cosimo de´ Medici to decline his invitation to return to Florence, concludes in this way: "I will go back to Florence after, hoping to rest with death, with which I seek to become acquainted, so that it will not treat me worse than the other old men." Or the lovely conclusion to a letter written to Vasari from the same period, "I know that you can tell by my writing that I am at the end of my days, and that no thought is born in me which does not have death carved in it. May God grant that I make it wait a few years more." This slow contemplative approach of death inspires the writer to his most profound meditations as far as the power to draw out the construction of the sentence in the course of writing with a fatalist and resigned intimacy. Another romantic attitude of an exceptional conscience, soon engulfed in the common run of people.

While the general correspondence is the fruit of necessity or of a free outpouring, the poems, on the other hand, are organized with great concern for construction for the literary effect itself, to the extent of sometimes risking affectation. Condivi reports on Michelangelo's literary tastes as follows: "Between us, he particularly admired Dante, whose admirable genius enchanted him to the point that he had entirely memorized him. He was equally appreciative of Petrarch." For Michelangelo, these two authors probably assumed the role of a cultural background more than a direct inspiration, even though certain common motifs can be found, which perhaps are, above all, the themes generally inspired by the interests of the age in neoplatonism and aristotelianism. In truth, the influence of these two authors on the poet is found at two different stages in his literary development. From Dante, Michelangelo received a philosophic and sensitive lesson, which the court of Lorenzo glorified. It is mostly Petrarch's technical solution of expression that inspired Michelangelo to the point of approaching plagiarism occasionally; rejecting, however, Petrarch's content, the naive naturalism so much emu-

lated in the Cinquecento. In its ensemble, the poetry of Michelangelo manifests the permanence of a dualistic thinking, which, on the emotional or suggestive level turns to the sign of symbols, such as opposition, combat, intertwining, distinction. It is not by chance that the modern romantic critic has the privilege of rediscovering the literary work of the master. The writer's themes—love, death, pessimism, the sense of the drama, the struggle between spirit and matter, the glorification of the solitude of the subject, the inexorable destiny—are as much the parameters that are woven anew into romantic literature, thus finding in Michelangelo a brilliant predecessor of its motif.

TO VITTORIA COLONNA

XII
A MATCHLESS COURTESY
TO VITTORIA COLONNA
Felice spirto

Blest spirit, who with loving tenderness
Quickenest my heart, so old and near to die,
Who 'mid thy joys on me dost bend an eye,
Though many nobler men around thee press!

As thou wert erewhile wont my sight to bless,
So to console my mind thou now dost fly;
Hope therefore stills the pangs of memory,
Which, coupled with desire, my soul distress.

So finding in thee grace to plead for me—
Thy thoughts for me sunk in so sad a case—
He who now writes returns thee thanks for these.

Lo! it were foul and monstrous usury
To send thee ugliest paintings in the place
Of thy fair spirit's living phantasies.

TO CHRIST

LXV
ON THE BRINK OF DEATH
TO GIORGIO VASARI
Glunto è già

Now hath my life across a stormy sea
Like a frail bark reached that wide port where all
Are bidden, ere the final reckoning fall
Of good and evil for eternity.

Now know I well how that fond phantasy
Which made my soul the worshipper and thrall
Of earthly art, is vain; how criminal
Is that which all men seek unwillingly.

Those amorous thoughts which were so lightly
 dressed,
What are they when the double death is nigh?
The one I know for sure, the other dread.

Painting nor sculpture now can lull to rest
My soul that turns to His great love on high,
Whose arms to clasp us on the cross were spread.

FOR THE DEATH OF VITTORIA COLLONA

LXII
LOVE'S TRIUMPH OVER DEATH
AFTER THE DEATH OF VITTORIA COLONNA
Quand' el ministro de´ sospir

When she who was the source of all my sighs,
Fled from the world, herself, my straining sight,
Nature, who gave us that unique delight,
Was sunk in shame, and we had weeping eyes.

Yet shall not vauntful Death enjoy this prize,
This sun of suns which then he veiled in night;
For Love hath triumphed, lifting up her light
On earth and 'mid the saints in Paradise.

What though remorseless and impiteous doom
Deemed that the music of her deeds would die,
And that her splendour would be sunk in gloom?

The poet's page exaults her to the sky
With life more living in lifeless tomb,
And Death translates her soul to reign on high.

TO TOMMASO CAVALIERI

LV
LOVE'S ENTREATY
Tu sa'ch'l'so, Signor mie

Thou knowest, love, I know that thou dost
 know
That I am here more near to thee to be,
And knowest that I know thou knowest me:
What means it then that we are sundered so?

If they are true, these hopes that from thee flow,
If it if real, this sweet expectancy,
Break down the wall that sounds 'twixt me and
 thee'
For pain in prison pent hath double woe.

Because in thee I love, O my loved lord,
What thou best lovest, be not therefore stern:
Souls burn for souls, spirits to spirits cry!

I seek the splendour in thy fair face stored;
Yet living man that beauty scarce can learn,
And he who fain would find it, first must die.

From *The Sonnets of Michel Angelo Buonarroti,* translated into Rhymed English by John Addington Symonds, Gramercy Publishing, New York, 1948.

177.
"KNEELING" WINDOW. Circa 1517; Palazzo Me-
dici; Riccardi, Florence

178.
PORT PIA IN ROME. 1561–1565

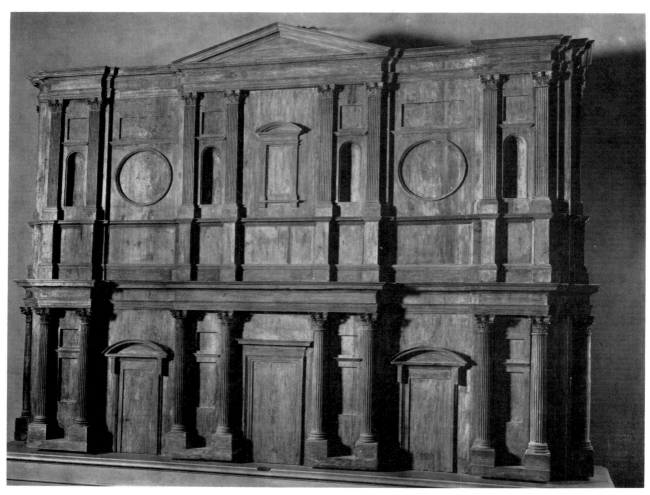

179.
WOODEN MODEL FOR THE FACADE OF SAN LORENZO IN FLORENCE

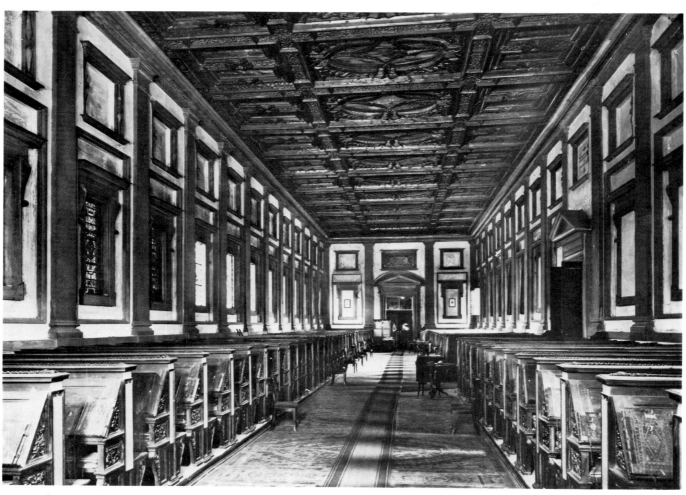

180.
LAURENTIAN LIBRARY. 1523–1560; Convent of San Lorenzo, Florence

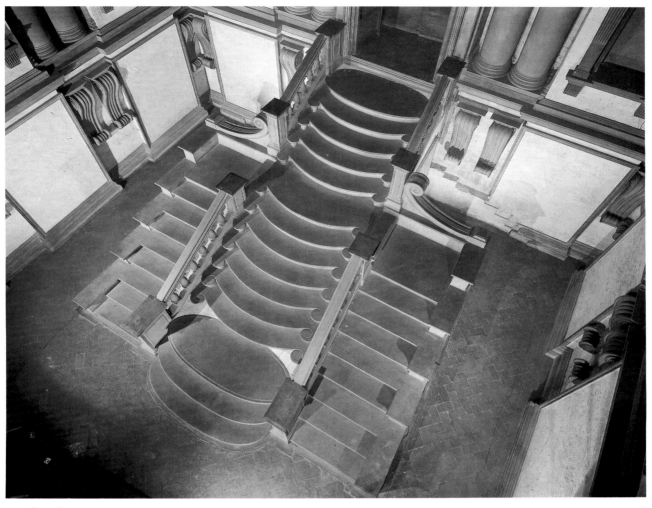

181–182.
STAIRCASE OF THE LAURENTIAN LIBRARY. 1523–1560; Florence

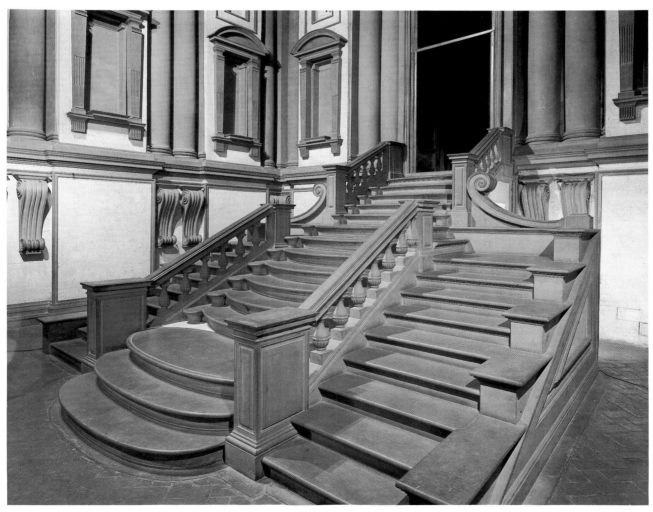

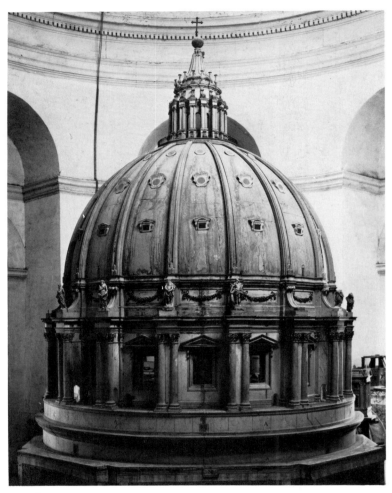

183.
STUDY FOR THE CUPOLA OF ST. PETER'S IN
ROME

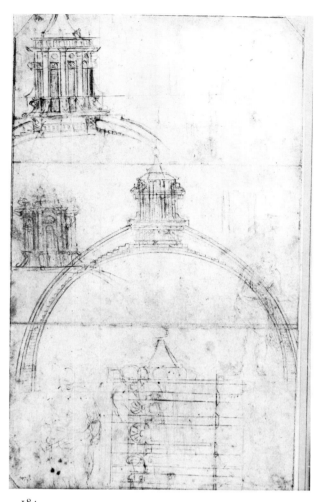

184.
STUDY FOR THE DOME OF ST. PETER'S.
Charcoal drawing; 39.9 × 23.6 cm; Teyler Museum,
Haarlem

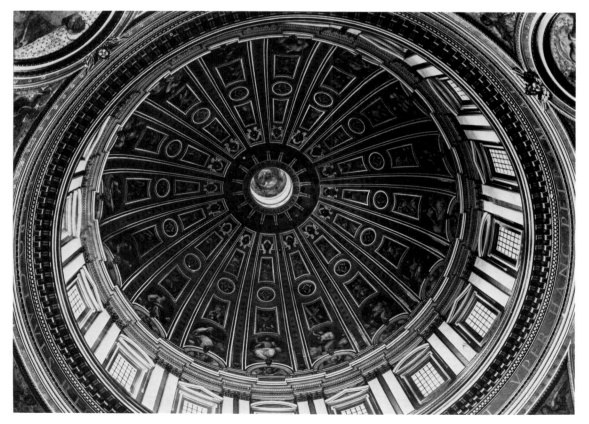

185.
CUPOLA OF ST. PETER'S,
INTERIOR VIEW

186. Facing page.
CUPOLA OF ST. PETER'S
IN ROME

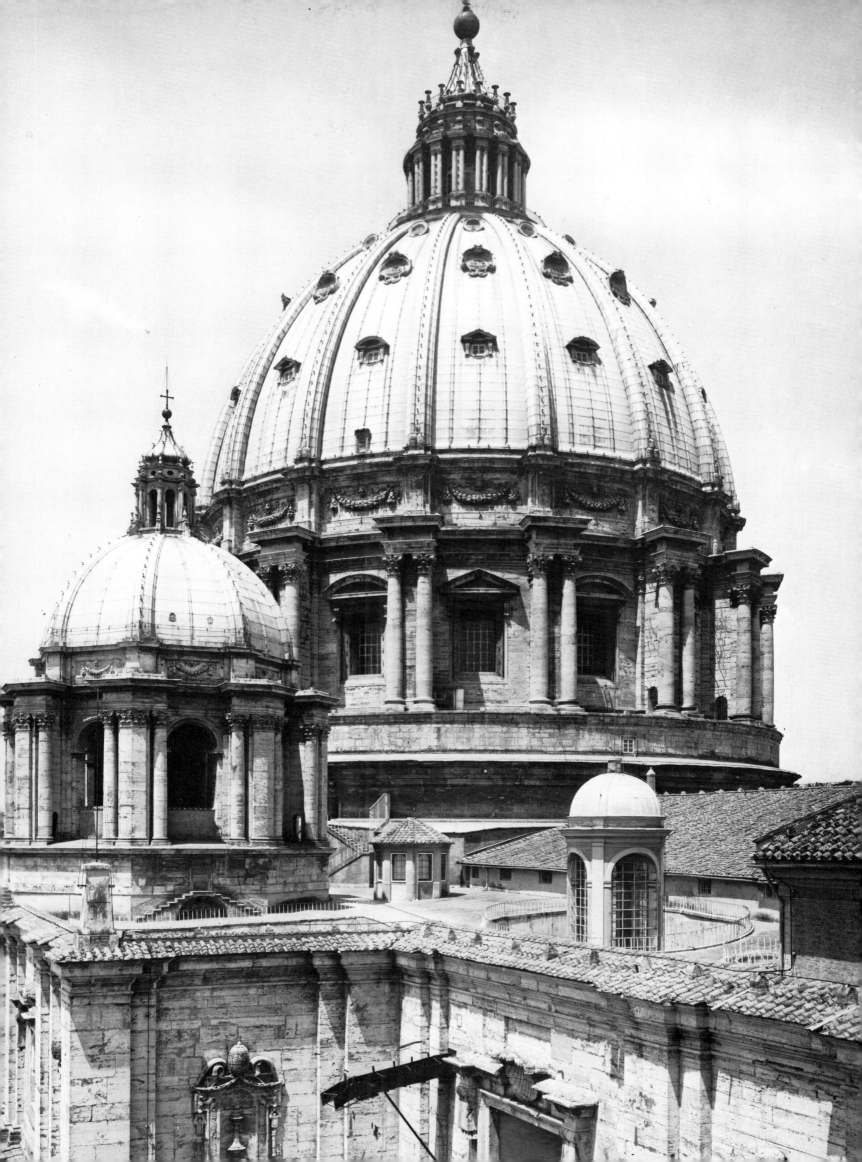

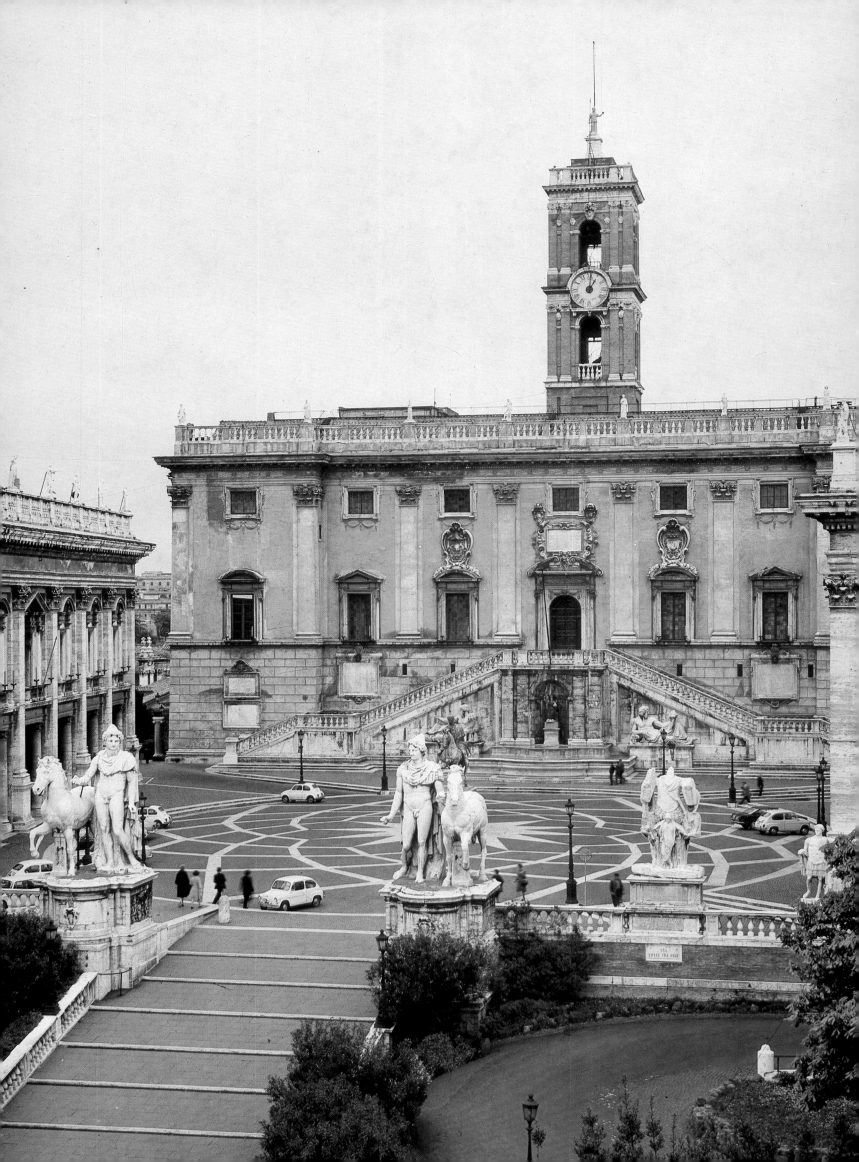

187. Facing page.
PIAZZA DEL CAMPIDOGLIO IN
ROME. 1546–1564

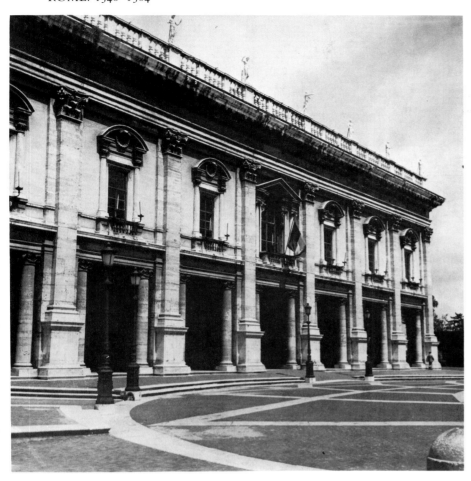

188–189.
VIEWS OF THE PIAZZA DEL CAMPIDOGLIO

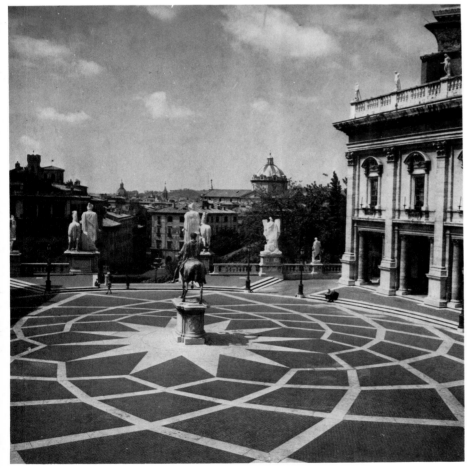

191.
FORTIFICATIONS FOR THE BASTION FOR
THE PORTA AL PRATO D'ORGNISSANTI. Casa
Buonarroti, Florence

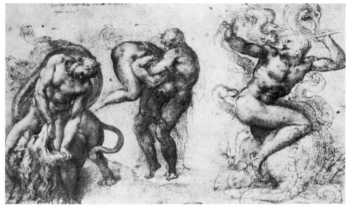

192.
THREE LABORS OF HERCULES. Circa 1528; Red
chalk drawing, 27 × 42 cm; Royal Library, Windsor

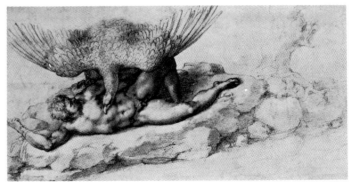

193.
TITYUS OR THE PUNISHMENT OF TITUS
(probably dedicated to Tommaso Cavalieri). 1532;
Charcoal drawing; 19 × 33 cm; Royal Library, Windsor

190. Following page.
FAÇADE OF THE
PALAZZO FARNESE
IN ROME. 1546–1549

VIII
Conclusion

The conclusion of this work can only point to Michelangelo's far reaching historic influence. His world is genetically a two-fold system continually expanding. Measuring his internal development from the *Virgin of the Stairs* through the *Battle of the Centaurs* to the last *pietàs,* we view the path of an experience in which each stage provides the foundation for the next, from sculpture to painting, painting to architecture, architecture to the art of poetry. How can we not be moved by this will, anxious to express the new by using traditional means? At the same time we are aware of the power of his influence. First mannerism, then Rubens, Delacroix, William Blake, Rodin, Pollock and DeKooning found in him a model on which they could base their own creations. But the "divine" Michelangelo is more than that. In the western world, he was the first—Picasso the last—to regard himself as an absolute and mythic cultural experience. Once again, we can turn to *Moses,* raise our eyes to the ceiling of the Sistine Chapel, take in the *Rondadini Pietà,* mix our own fervor with that of *David* and the texture of an entire culture emerges: the piety of Dante, the neoplatonic questioning of appearances of Ficino, the furor of Savonarola, and the cult of emotional expression of a man of profound

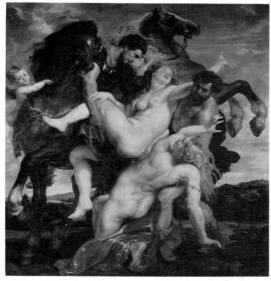

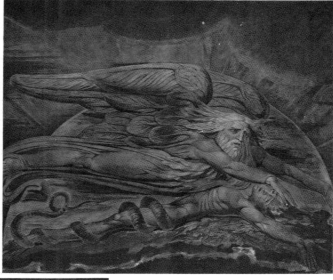

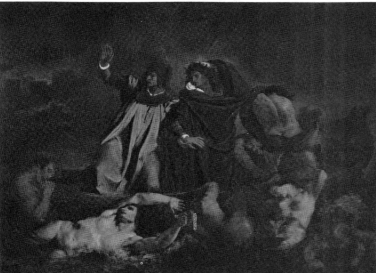

RUBENS:
RISING OF THE DAUGHTERS OF
LEUCIPPUS
Oil on canvas, 222 × 209 cm

WILLIAM BLAKE:
THE CREATION OF ADAM
1795—Watercolor, 43 × 53 cm

DELACROIX:
DANTE'S BARK
1822—Oil on canvas, 189 × 246 cm

BRONZINO:
THE ALLEGORY
OR CUPID, VENUS, FOLLY,
AND TIME Oil on a panel, 144 × 115
cm

ROSSO:
MOSES DEFENDING
THE DAUGHTERS OF JETHRO
Circa 1520—oil on canvas, 150 × 117
cm

JACKSON POLLOCK: NUMBER 33
Enamel and aluminum on paper,
57 × 79 cm

PICASSO: GUERNICA
1937—Oil on canvas, 351 × 782 cm

experience, different from the culture of his time, and yet bursting forth with the most intense and glorious meditation, generous, demanding, suffering at the extreme end of the arch, passing from birth to death, from genesis to the collapse. Because he knew better than anyone else how to make use of the knowledge and ideas of his time in the elaboration of his language, because he knew how to add on to the material history of his language the variety of human feelings, because he knew how to take advantage of his self-sufficient qualities, personalizing aspects of reality, which he selected with passion and stubbornness, Michelangelo dominated his time, the Renaissance. He is part of its myth. Like all mythic creation, he appears with the same vigor, the same impact, the mystery of origins, the comprehension of the moment and the interpretation of final endings. It is hard to imagine a more attentive and ambitious creation on these three points united by the energy of the most universal expression possible of that fulfillment we call destiny.

No epoch, no artist of even the slightest talent has not had to contend with the shadow cast by this illustrious Florentine. His uncompromising presence has sometimes given rise to caricature. This caricature arose simultaneously with the first signs of European mannerism. There is no doubt that Michelangelo is the originator of two different trends in painting, mannerism and baroque, the latter being a certain manner, extension, or dramatization of the former. If this is not the place to write a thesis on mannerism, we must bear in mind the basic elements that influenced the artists of the sixteenth century, from Parmigianino, Ross, Bronzino, Pontormo, to Durer and Greco. Opposed to the classicism of Leonardo, for example, which sought a harmony of proportions in the measure of a synthetic equilibrium of each detail of the configuration, mannerism discovers formal freedom in the sign of a visual effect. Thus it is less concerned with spiritual, intellectual and moral values, preferring the systematic exploitation of a scale of visual excesses that confirms the personal "manner" of the artist. By a drastic

186

geometrism, an immoderate use of chromatic dissonances and serpentine line, a frenzied passion for the muscular, the exaggeration of multiplicity and discontinuity, the primacy of attached drawing to isolate the figures within a context of violent, florid oppositions, mannerism, as opposed to classicism, is the triumph of imagination over imitation. One clearly finds the fundamentals of mannerist art in the work of Michelangelo, be it in the contrasting coloring of *Doni Tondo* or in a more general sense, the exacerbation of the anatomical figure stressing death and melancholy, in harmony with fantasy or morbid representation. In these themes and in his work, Michelangelo initiated mannerism. But particularly perhaps, the "divine" Michelangelo initiated this splendid divergence by predisposing a problematic base on the subjective engagement of the artist, an unprecedented valorization of the role of the subject in multiple contradictions with a formal representation, guaranteeing this representation the energy and the depth of the flow of effects. In some ways, Michelangelo's art is a science of contradictory divergences, an organic logic of distortion, subject to a will of incomparable power of envelopment and a demonstration of peripheries. He was the father of mannerism, but also of baroque. Baroque is the art of assembling disparities; if the distortions, the peripheral writings are largely maintained, baroque art molds them to the regulation of a single movement, charged with containing the characteristics of mannerism, i.e., ascendance, involution or evolution, the kaleidoscope of lateral effects. On this point, the gyrating art of Michelangelo, as majestically expressed in the *Last Judgment* or in the frescoes of the Pauline Chapel, constitutes a model for creating structure, which baroque art will magnify.

An art eminently demonstrative and declarative, baroque constitutes a recantation on the ascendance of the unitary subject, or hypostatic composition, by a concentric flow of qualifying signs, scattered, yet nevertheless unified, which discovers the nature of the essence of the subject, even though its efforts are contradictory. From this point of view, the composition of the *Last Judgment* is majestic as much by the force of its technical execution as by the use of

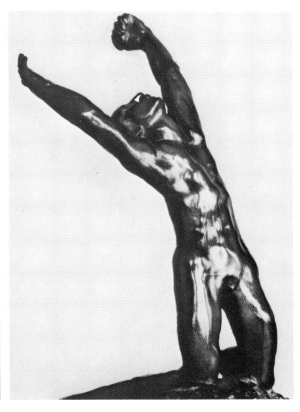

STUDY FOR HAMAN'S PUN-
ISHMENT. 1511; Red chalk drawing;
40.5 × 21 cm

MICHELANGELO· RONDADINI
PIETÀ
1552–1564—Marble, 195 cm high

RODIN: PRODIGAL SON
1888—Bronze

the multiplicity of tensions, antagonisms, rhythms, and the progressive regulated directions, which are to the power and glory of the virtuous symbol. Such is the richness of the plastic experience and cultivated representations of this work that one must identify with it, no matter how briefly.

We must mention those artistic beacons, whose approach to this exorbitant heritage was the most dynamic, those who interpreted the work of the master with the same creative devotion he concentrated on his own work. We see, from this point of view, Rubens breaking away from the traditional forms of representation. It was he who came closest to creating the idea of the human form as revealed by Michelangelo. It is not original to point out that western society is overwhelmed by a constant repression of the body and the image of the body, under religious, moral and political discourse charged with repressing, codifying and concealing it. We must give credit to Michelangelo, then to Rubens for the great representations that they made of human anatomy, which were often despised, declared vile and shameful under the rule of Christianity. Ruben's six-year sojourn in Italy between 1603 and 1609 gave him the opportunity to discover Michelangelo's work. The Italian master's influence on the Flemish artist went beyond the synthesis of the image, to an evocative and expressive inspiration in the creation of the body, contrary to the mannerists, who would branch off to create their own symbols. Rubens, like Michelangelo, combined two traditions: he spread the pagan formal feast on the foundation of spiritual Christianity. In corporeal exposition, Michelangelo sought new, expressive dispositions for the stages of his cultural and religious consciousness. By the same device, Rubens declared more than just the story that he presented; he declared the irreducible pictorialism of the accentuated figure. This extravagant corporeal carnival served as an experimental base realizing the very modern concept of the materiality of the colored surface. Delacroix would be less comprehensible without Rubens, and from Michelangelo to the painter of the *Massacre of Shio,* we witness the same will, translated differently, the will to go beyond the painting, to go beyond the real format by a violent internal twisting of the image under the graphic form of the ascensional curve and rotation. Among many other paintings, Ruben's *Rising of the Daughters of Leucippus,* Delacroix's *Bark of Dante* or the *Death of Sardanapalus* or even more *Liberty Leading the People* produce this feeling of ascension or rotation by a structural orchestration of the multiplicity of contradictions of tension and direction.

We could also analyze the importance of Michelangelo's heritage to William Blake, the artist who perhaps knew best how to retrace the essentials of the master's discoveries, taking once more the synthesis between the forces of anatomic apotheosis and the paths of dramatic spirituality.

We could also refer many of the greatest twentieth century paintings to the fundamental model of this sensational dimension, which must have stupified the Romans upon first sight of the ceiling of the Sistine Chapel, exceeding all limitation, a multidimensional dynamic absorbing the contours under the diffuse pressure of a lateral thrust. If we cite only Picasso, Pollock and DeKooning, whose works radically challenged traditional representation, we immediately notice the sign of expressionism, the community of a major theme concerning the extravagant expansion of painting.

Using sculpture as a model, conceiving, in his irreducible expressive determination by a new construction of volume, Michelangelo broke the principle of his pictorial universe, seeking the real volume on the plane of spatial diffusion. This illusion of voluminous amplification, of the subject, its multiple contradiction of formal representation, of expansive density, solely directional energy, would find a profound echo in the twentieth century. Without doubt, Jackson Pollock, in the major success of his action paintings, no longer relied on the figure as an end of painting itself. But considering the genesis of Pollock's work, we witness progressively the elaboration of a pure, expansive energy under the discipline of a method that permits the painter to lay out the boundlessness of his gesture. Michelangelo painted the moral of a boundless affirmation of his aesthetic ideal and his art reflected that unique purpose; by comparison, Pollock had really drawn the categorical imperative. In this sense, his expressionism is the real and literal application of the same will to reveal the possible under the guidance of truth.

Perhaps it is time to step back from this dazzling contemplation of an incomparable force, the unforgettable feeling that his work can inspire in us.

I want to speak of the terrifying feeling engendered by the sight of this body of work. The man who created it was concerned with a destiny, a destiny of language and a destiny of an entire culture. How can we not be shaken by the force that this man manifested in

every domain that he worked? His only vocation was the affirmation of himself taking charge of his time.

At this point, we touch upon the question of the myth of Michelangelo. If indeed we understand the man and the work in the elucidation of the principles that govern the formation of his art, and the consciousness that produced it, we must acknowledge that Michelangelo is a myth, or at least has appropriate and expressive mythic elements. The myth is a reconciliation between man and the irrational elements that reside within him. This symbolic reconciliation works by uniting heterogeneous elements for the recital of a tale illuminating the same beginnings and endings, following the stages of a logic, a continuity between two poles by the relation of elements that make up the reality. Michelangelo did not control his work otherwise; haunted by genesis, he did not cease to question death, and in order to create this two-fold question, his work uses all the means, all the diverse materials, through varied ensembles—the same instance of representation and unity of elements that are only functional adjectives, qualifying the double binding of the complete works.

BIBLIOGRAPHY

WORKS ON MICHELANGELO

Bernice, Fred, *La Vie de Michel-Ange*, Paris, 1965.

Bottari, G., *Raccolta di letter sulla pittura, scultura ed architectura*, 7 vols., Rome, 1754–1773.

Brion, Marcel, *Michel-Ange*, Paris, 1969.

Carli, E., *Michelangelo*, Bergamo, 1948.

Clements, R.J., *Michelangelo. A Self-Portrait*, New York, 1963.

Condivi, Ascanio, *Vita di Michelangelo Buonarroti*, Rome, 1553; revised 1966.

Einem, H. von, *Michelangelos*, Stuttgart, 1959.

Freud, Sigmund, "Le Moïse de Michel-Ange." In *Essai de psychanalyse appliquée*,

Frey, K., *Dichtungen-Briefe*, Berlin, 1899.

———, *Michelagniolo Buonarroti*, Berlin, 1907.

———, *Handzeichnungen*, Berlin, 1925.

Frey, D., *Michelangelo, Studien*, Vienna, 1920.

———, *Michelangelo Buonarroti*, Architetto, Rome, 1923.

Goldscheider, Ludwig, *Michelangelo*, Cologne, 1964.

———, *Les Sculptures de Michel-Ange*, Paris, 1953.

Grimm, Hermann, *Michel-Ange et son temps*, Paris, 1934.

Hartt, Frederick, *Michelangelo*, Milan, 1964.

———, *Toute la sculpture*, Paris, 1971.

Hibbard, Howard, *Michel-Ange*, Lausanne, 1978.

Mariani, V., *Poesia di Michelangelo*, Rome, 1940.

Marnat, Marcel, *Michel-Ange*, Paris, 1974.

Michel-Ange, 2 vols., edit. Atlas, Paris, 1976.

Michel-Ange, Collection Genies et Realities, Paris, 1961.

Michel-Ange, *Sonnets*, traduction de Georges Ribemont-Dessaignes, Paris, 1961.

Milanesi, G., La correspondence de Michel-Ange, Paris, .

Pogetto, Paolo dal, *I desegni murali di Michelangelo*, San Lorenzo, Florence, 1978.

Poggi, Rarrochi, and Ristoli, *Cortegio di Michelangelo*, Florence, 1965.

Rolland, Romain, *Michel-Ange*, Paris, 1961.

Salvini, Roberto, *Michel-Ange*, Paris, 1976.

Saponaro, Michela, *Michel-Ange*, Neufchatêl, 1950.

Steinmann and Wittkoller, *Bibliographie de Michel-Ange*, 1510 à 1930.

Tolnay, Charles de, *Michel-Ange*, 5 vols., Princeton, 1960.

——— and Ettore Camesca, *Michel-Ange, Tout l'oeuvre peint*, Paris, 1960.

———, *Michel-Ange. Collection Images et Idees*, Paris, 1970.

Thode, Heinrich, *Michelangelo und das Ende de Renaissance*, Berlin, 1913.

Varchi, Oraison funèbre de Michel-Ange, Florence, 1564.

Vasari, Giorgio, *Le Vite di Michelangelo*, 1550–1558, Edition en 1962.

OTHER WORKS OF INTEREST

Bertela, Gaeta, *Donatello*, Florence.

Berti, Luciano, *Pontormo*, Milan, 1973.

Boucher, François, *Rubens*, Paris.

Boussel, Patrice, *Leonardo De Vinci*, Paris, 1980.

Butlin, Martin, *William Blake*, London, 1978.

Marchini, Guiseppe, *Filippo Lippi*, Milan, 1975.

Malraux, André, *Goya*, Paris, 1978.

Sekullaz, Maurice, *Delacroix*, Paris.

Zerner, Henri, *Raphaël*, Paris, 1969.

GENERAL BIBLIOGRAPHY

Argan, G. C.: *Storia dell'Arte Italiana*, Sansoni Éd., Florence, 1968.

Berenson, Bernard: *Les peintres italiens de la Renaissance*, Paris, 1969.

Blunt, Antony: *La Theory des arts en Italie en 1450 à 1500*, Paris, 1956.

Burckhardt, J.: *Civilisation de la Renaissance en Italie*, 3 vols. Paris, 1958.

Chastel, Andre: *Fables, Formes, Figures*, 2 vols. Paris, 1978.

———: *Le Grande atelier d'Italie de 1460 à 1500*, Paris, 1965.

Dubois, Claude-Gilbert: *Le Maniérisme*, 1979.

Fernandez, Dominique: *L'Arbe jusqu'aux racines*, Paris, 1972.

Garin, Eugenio: *Moyen Age et Renaissance*, Paris, 1969.

Heydenreich, Ludwig and Gunther Passavant: *Le Temps des genies. Renaissance italienne de 1500 à 1540*, Paris, 1974.

Malraux, Andre: *La voix du silence*, Paris, 1951.

Panofsky, Erwin: *Essais d'iconologie*, Paris, 1967.

———: *L'Oeuvre d'art et ses significations*, Paris, 1969.

Tapie, Victor: *Baroque et classicisme*, Paris, 1972.

Vasari, Giorgio: *Vite de Pitori scultori ed architectori*, Florence.

Venturi, Lionello: *Histoire de la critique d'art*, Paris, 1969.

Wölfflin, Heinrich: *Renaissance et Baroque*, Paris, 1967.

LIST OF PLATES AND REPRODUCTIONS